Drawing
Space, Form, and Expression

Fourth Edition

Wayne Enstice
School of Art, University of Cincinnati

Melody Peters
Sculptor and Designer

Boston Columbus Indianapolis New York San Francisco Upper Saddle River
Amsterdam Cape Town Dubai London Madrid Milan Munich Paris Montreal Toronto
Delhi Mexico City São Paulo Sydney Hong Kong Seoul Singapore Taipei Tokyo

In memory of Eleanor Frances Enstice and John Francis Enstice
—Wayne Enstice

To all my siblings, nieces, and nephews
—Melody Peters

Editorial Director: *Craig Campanella*
Editor-in-Chief: *Sarah Touborg*
Acquisitions Editor: *Billy Grieco*
Editorial Project Manager: *David Nitti*
Editorial Assistant: *Jessica Parrotta*
Vice-President, Director of Marketing:
 Brandy Dawson
Executive Marketing Manager: *Kate Mitchell*
Managing Editor: *Melissa Feimer*
Senior Production Project Manager:
 Barbara Cappuccio

Senior Operations and Manufacturing Manager:
 Mary Fischer
Senior Operations Specialist: *Brian Mackey*
Senior Art Director: *Pat Smythe*
Cover Design: *Pat Smythe*
Pearson Imaging Center: *Corin Skidds*
Full-Service Project Management: *Mary Tindle,*
 S4Carlisle Publishing Services
Composition: *S4Carlisle Publishing Services*
Cover Printer: *Phoenix Color, Corp.*
Printer/Binder: *Courier/Kendallville*

Cover image: Michael Kareken, *Magnet,* 2009 Conté on drafting film, 24½ × 19¾"

Library of Congress Cataloging-in-Publication Data
Enstice, Wayne
 Drawing : space, form, and expression / Wayne Enstice, Melody Peters. — 4th ed.
 p. cm.
 Includes bibliographical references and index.
 ISBN-13: 978-0-13-603190-1 (alk. paper)
 ISBN-10: 0-13-603190-0 (alk. paper)
 1. Drawing—Technique. I. Peters, Melody. II. Title.
 NC730.E65 2012
 741.2—dc22

2011012454

ISBN 10: 0-13-603190-0
ISBN 13: 978-0-13-603190-1

Instructor's Review Copy
ISBN 10: 0-205-81662-2
ISBN 13: 978-0-205-81662-0

à la carte
ISBN 10: 0-205-20396-5
ISBN 13: 978-0-205-20396-3

10 9 8 7 6 5 4 3 2 1

Contents

Section Four: Portfolios

Preface

We began work on the first edition of this book over twenty-five years ago. Encouraged by the local success of our own instructional program for teaching the basics of drawing, we set out to meet the needs of college art-foundation students in a national arena. The thin volume of that first edition has evolved in large part due to helpful suggestions by users and reviewers of our book. In response, we added a chapter on color and a portfolio of student drawings to the second edition, and a chapter on figure drawing to the third edition. These improvements have increased the utility of our book; it is now used by students as a complete guide to drawing, from foundation courses through advanced undergraduate study.

New to This Edition

Those acquainted with our earlier editions will notice a broad organizational change in the fourth edition. In this edition we have divided the chapters into four sections.

 Section One: Space focuses on the facts of seeing within a spatial context. Chapters 1 and 2 introduce the concept of spatial illusion in relation to the picture plane and explore shape and its role in modern art; specific instructions for utilizing the picture plane to aid in proportion and layout are the subject of Chapter 3, while the basics of linear perspective are presented in Chapter 4.

 Section Two: Form begins with an emphasis on the depiction of three-dimensional form. Chapter 5 urges students toward an understanding of the structural properties of form through diagrammatic analysis; the observation of surface phenomena as revealed by light is stressed in Chapter 6. In Chapter 7 we explore the formal properties of two-dimensional art by considering the role of design in drawing; human form is the topic of Chapter 8.

 Section Three: Expression looks in depth at issues of content in works of art. Covered in these later chapters are the expressive values of subject-matter narratives, an extended investigation of the expressive potential of pictorial form including the role of abstraction as both a process and a style in drawing, the challenge of drawing from the imagination; and the expressive uses of color in drawing.

 Section Four: Portfolios comprises two specially selected collections of drawings with accompanying discussion. Inspirational works of peers are once again concentrated in the wholly revised chapter "Portfolio of Student Drawings," which showcases 29 sustained drawings. By devoting a chapter solely to student works, accompanied by a text that examines the form and content of each image, we attempt to furnish realistic benchmarks of quality and ambition for the student

reader. The substantially revised and updated "Portfolio of Contemporary Drawings" features a much expanded introduction that illuminates in comprehensible terms the complex ideas embodied in aesthetic Modernism and Postmodernism. By exploring today's trends through images drawn by leading contemporary artists, advanced students may begin in earnest regard their own drawings within the context of current theories and professional practice.

Left intact in this new edition is our commitment to showcasing a vital mix of old and new masterworks. The richness of these images selected from across the arc of history not only serves as an essential complement to the written word, but each image stands on its own as an exemplary visual model, able to teach volumes through the silent power of significant form. Looking to strengthen and diversify the graphic definition of our book, we have for this new edition replaced over a quarter of the artworks, including close to 70 new professional works and almost 90 new student works dispersed throughout the text. The 127 student drawings overall in the fourth edition represent 26 schools and departments of art nationally.

In order to accommodate the increased number of illustrations without affecting the book's price, we have removed one feature of our previous editions. The Glossary of Media may now be viewed on our associated website www.mysearchlab.com.

Acknowledgments

Organizing a book that contains over five hundred illustrations and much technical information could not have been accomplished without the assistance of many people. Our greatest debt of gratitude is to all the living artists who have contributed images to this book. We are especially grateful to all the professional artists, including emerging artists and well-known professionals, who have allowed us to reproduce their drawings without fee. A book of this sort simply would not have been possible without their generosity. We do not have space to list all the gallery and museum personnel, both here and abroad, who have gone out of their way to help us in obtaining reproduction rights and photographs for the fine works of art you see on these pages. We must, however, specifically acknowledge one prime resource: The Drawing Center in New York. Their invaluable website enabled us to discover many wonderful emerging artists. On the domestic front, we are profoundly indebted to our respective spouses, Marie Enstice and Jay Vosk, for their valued assistance and unstinting forbearance. We also extend our gratitude to the University of Cincinnati for Wayne Enstice's sabbatical leave to work on the fourth edition; to University of Cincinnati librarian, Elizabeth Meyer, and library assistant, Sara Mihaly, for their research help; to Billy Grieco, our acquisitions editor; Jessica Parrotta our editorial assistant; and David Nitti our project manager. Each, with equanimity and professional acumen, has shepherded us through the labyrinthine processes involved in seeing our book through to its completion.

We appreciate the assistance of former graduate teaching assistants and instructors from around the country who have contributed student examples. Graduate teaching assistants from the University of Arizona include: Nancy Hall Brooks, Gary Buhler, Linda Caputo, Lynn Charron, Maureen Ciacco, William Greider, Catherine Nash, Carol Saarinen, and D.P. Warner. Art faculty with continued representation of their student work in this fourth edition are: Luis Alonso, Pratt Institute and Rhode Island School of Design; Anthony Batchelor, Art Academy of Cincinnati; Jane Burgunder, Middle Tennessee State University; Sean Gallagher, Central Connecticut State University; Christi Harris, Iowa State University; David James, University of Montana; Mary Frisbee Johnson, University of Northern Iowa; Al Kogel, Cochise College; Billy Lee, University of North Carolina, Greensboro; Perry Mahler, Kendall College of Art and Design; Susan

Messer, University of Wisconsin at Whitewater; Sheila Pitt, University of Arizona; Janice Pittsley, Arizona State University; Jan Reeves, University of Oregon; Chuck Richards, Iowa State University; William B. Sayler, Pratt Institute; Robert Stolzer, University of Wisconsin, Stevens Point. Instructors of art who helped us invest this edition with fresh student examples are: colleagues at the University of Cincinnati, including Denise Burge, Kimberly Burleigh, Tarrence Corbin, Don Kelley, Carol Tyler, Jim Williams, and Charles Woodman; Barb Bondy, Auburn University; Ann Coddington Rast, Eastern Illinois University; Jan Fordyce, Metropolitan State College; Dale Leys, Murray State University; Ken O'Connell, University of Oregon; Darice Polo, Kent State University; Nancy Quinn-Budde, Boise State University; John Rise, Savannah College of Art and Design; Jason Urban, University of Texas at Austin. Finally we would like to acknowledge the following colleagues for their helpful reviews of our manuscript: Fred Behrens, Columbia State Community College; Benjamin Billingsley, Cape Fear Community College; Pamela Blum, Dutchess Community College; Dennis McNamara, Triton College; Scott Raynor, High Point University; Susan D. Savage, Westmont College.

Wayne Enstice and Melody Peters

Introduction

So you have the urge to draw! This urge is something you share with millions of people, from prehistoric times (Fig. 0–1) to our own day. Young children, whose primary activity is making sense of the world, seem naturally inclined to draw. As they reach preteen years, however, many, if not most, stop drawing, due perhaps to self-consciousness, frustration, or simply a decreasing need. Those of us who resume drawing as adolescents and adults and spend a large part of our waking hours in the pursuit of art may feel that our compulsion to do so sets us apart somewhat from the rest of society. Yet, we also know that making art puts

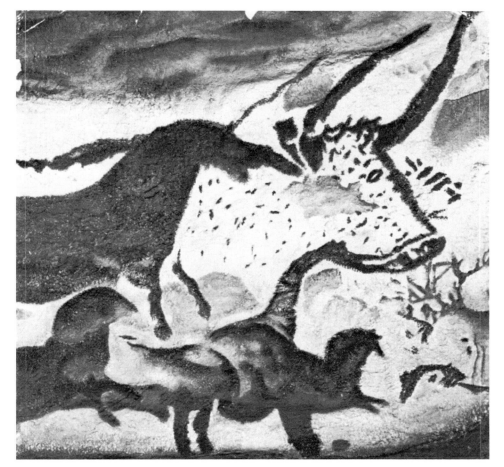

FIGURE 0–1
Prehistoric Art
Cave painting of great black bull and red horse at Lascaux, France

us in touch not only with ourselves but also in a very special way with visible and even invisible realities. You will repeatedly experience this sense of communion while making art of any kind, but most frequently this will come as a result of drawing, the most intimate and spontaneous of all visual-art practices.

The professional artist and serious student alike use drawing for a multitude of purposes. Making drawings for their own sake is common practice today. Drawing is also used to record, explore, or consolidate visual ideas. In this respect, drawing is the visual counterpart of writing and like writing can be used to utilitarian or expressive ends.

In this chapter we introduce you to the drawing tradition and its practice. We begin by tracing the impact that Renaissance attitudes have had in shaping drawing's role within the visual arts. Included is a review of developments in drawing today, which will help you relate your daily pursuits in the medium to the larger historical mainstream of drawing activity.

The remainder of this chapter centers on advice we customarily give our beginners to smooth their entry into the world of drawing, which, for all its excitement, may at times seem a bit overwhelming. The benefits of much of this advice will become more apparent as you progress; in the meantime, the counsel you receive here will help you get an early start on developing good drawing habits.

The Legacy of Drawing

We think of drawing as the primary field of study for the aspiring artist since its practice is the most expedient way of training the eye to observe accurately. This is of enormous benefit to anyone who wants to be involved with representing perceived reality. Practice at drawing and close observation will also prepare you to visualize things that exist only in your imagination.

Our interest in making accurate representations of visual reality has its foundation in Renaissance art. Before that time, artists were more concerned with the symbolic import of their subject matter. And in most cases, conventions for representing common subjects eliminated the necessity for the artist to engage in firsthand observation of natural appearances.

In the Renaissance period, scholars began to redefine the relationship between the secular and spiritual worlds. For the first time, artists began to feel justified in taking more interest in the material world around them. As a result, Renaissance artists disciplined themselves to look at and think about what they saw in a manner that would have been foreign to previous generations of artists. And for the first time, Western artists devoted a great deal of rational thought to the problems of form and space. They also had to work hard to sharpen their perceptual skills. This reliance on personal observation backed up by rational thought informed a new spirit of drawing, as seen in the Leonardo da Vinci (Fig. 0–2).

The increased availability of paper in Europe during the fifteenth century did much to encourage the practice of drawing. Before this time, the cost of drawing materials, such as parchment or prepared wooden panels, limited the practice of experimental drawing. With paper, however, the artist could afford to draw in an exploratory way, making many studies of one subject before settling on a final image (Fig. 0–3). Because of its new investigative role, drawing in the Renaissance gained the prestige of a science. This spirit of investigation has been with the study of drawing ever since and accounts for the existence of art programs in colleges and universities today.

In the two centuries following the time of Leonardo, the radical scrutiny of human anatomy as practiced by Renaissance artists became conventionalized. As an example, look at a life drawing (or *academie*, as it was called) by the

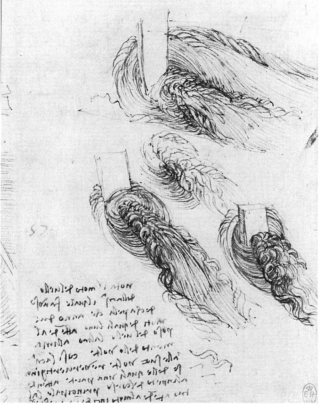

FIGURE 0–2
LEONARDO DA VINCI
Four Studies of Swirling Water
Pen and ink

FIGURE 0–3
CLAUDE LORRAIN
Landscape Studies, 1630–1635
Pen and brown ink,
$22\frac{7}{8} \times 11\frac{7}{8}$"
(verso of *Wooded View*)

eighteenth-century sculptor and academician, Bouchardon (Fig. 0–4). Note that in this drawing there is a very systematic way for representing the figure in its environment. The artist employs only three categories of marks. A pattern of lines is used to indicate the background; shorter strokes are used for the surface of the body. The most varied stroke is reserved for the outside edges of the figure.

FIGURE 0–4
EDME BOUCHARDON
(French 1698–1762)
Standing Nude Male with Staff
Red crayon on paper, 22⅞ × 11⅞"

*Santa Barbara Museum of Art,
museum purchase*

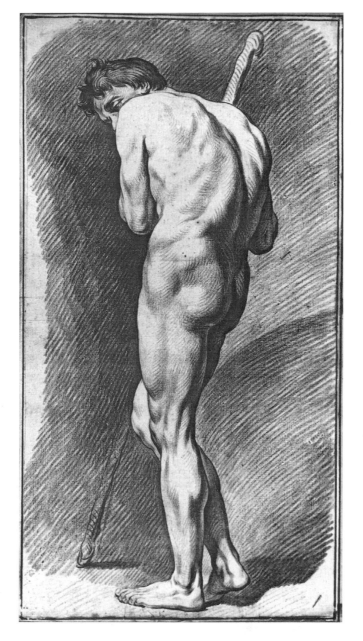

This conventional use of line was common practice in life drawing of the period. To enhance the presence of the figure, artificial light was used, which had the effect of throwing the anatomy into sharp relief while letting the background drop away.

It is instructive to compare the Bouchardon with a work made a generation later (Fig. 0–5). In this drawing, Ingres *does not* dramatically set the figure apart from the background. The same natural light that illuminates the lively features of the sitter also brightens the haze below and is a harbinger of the increased role that nature would play in French art during the rest of the nineteenth century.

How very different is the attitude toward light, form, and space in the self-portrait by Courbet (Fig. 0–6). Here light is not that flattering, all-pervasive entity that it is in the drawing of Ingres. Instead, it is harsh and reveals the forms of the artist's face roughly and imperfectly. The parts of the face obscured

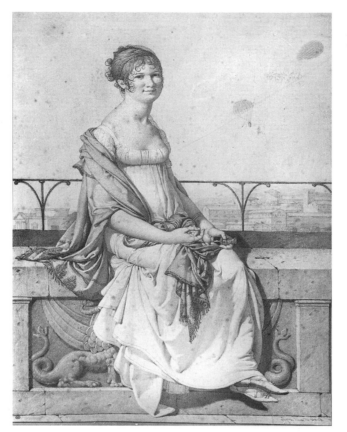

FIGURE 0–5
J.A.D. INGRES
Portrait of Barbara Bansi

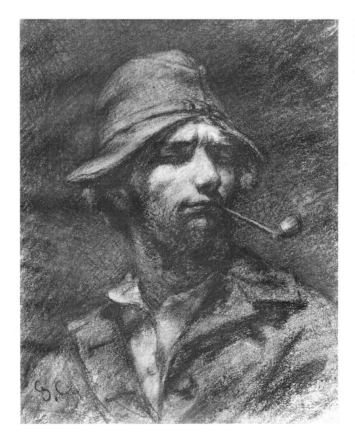

FIGURE 0–6
GUSTAVE COURBET
Self-Portrait (The Man with the Pipe),
c. 1849
Charcoal, 11½ × 8¾"

FIGURE 0–7
Claude Monet
Two Men Fishing, ca. 1880–1882
Black crayon and scratchwork
on paper coated with gesso
and incised with fine lines for
reproduction by "guillotage,"
$10\frac{1}{16} \times 13\frac{9}{16}$"

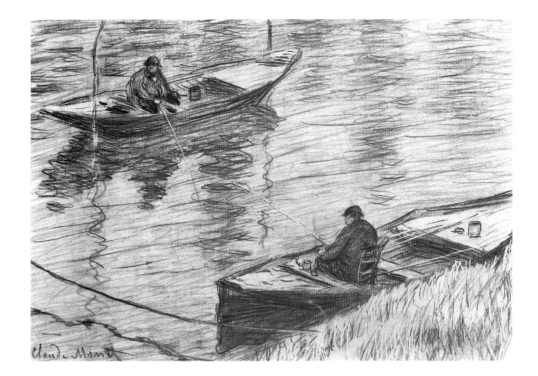

by shadow merge with the gloom that envelops the figure. As a realist, Courbet demonstrated that the natural tendency of strong light is not to separate the figure from the background but rather to break up form so that parts of it become indistinguishable from the space around it. By observing the impartiality of natural light, the artist effects a brutish realism. Once again, the investigative potential of art is fully present, and objective observation is seen as an end in itself.

Later in the century, the Impressionists achieved a directness in their use of media that was unprecedented. In paintings and drawings, they asserted the actuality of their media to recreate the ephemeral aspects of constantly changing moments in the natural world. Look at the drawing by Monet (Fig. 0–7) and compare its inventive use of marks to the more convention-bound approach of Bouchardon (Fig. 0–4). Note how in the Monet, many of the marks achieve a physical presence that recalls our experience of actual objects. One kind of mark stands for the fishermen's rods, another for the twisted cable, and yet another for the wavering reflections of the cable.

So, the Impressionists, rather than imitating the surface appearance of natural things, let the actual stuff of their media stand as a visual metaphor for the physical reality they described on paper and canvas. This insistence on the physical nature of the artist's media is just one of the Impressionist traits that began to undermine the long-lived Renaissance tradition of illusionistic realism.

Look again at the Monet drawing and take note of the care given to its design, or composition. Our attention is drawn immediately to the two boats that virtually mirror each other. Looking at the boats as shapes, observe that they subdivide the whole composition into a series of diagonals. Running counter to these diagonals are reflections that appear as vertical bands on the mirror-like surface of the water. These verticals function to stabilize the image. This interplay of diagonal and vertical forces within the rectangle of the picture heightens our awareness of its two-dimensional nature. Monet's emphasis on two-dimensional

organization at the expense of the more traditional illusion of deep space marks a general trend toward the flattening of the picture image in the late nineteenth and early twentieth centuries. (Observe also, that a sense of depth is restricted by the elimination of the horizon line.)

Extending the Definition of Drawing

Drawing today is firmly established as a medium in its own right. Drawings now have an aesthetic and commercial value that gives them a stature equivalent to that of painting and sculpture. But this has not always been the case.

Renaissance concepts about the role of drawing within the visual arts were deeply influential for a long time. During the Renaissance, skill at drawing was highly valued and was in fact considered the most precious tool at the artist's command. Nevertheless, drawings themselves were not accorded the status of a legitimate art form, but were regarded merely as preparatory studies for painting and sculpture.

For centuries after the Renaissance, drawing had two functions. First, it was the customary means of training young artists. Second, it became a way for more established artists to try out ideas before embarking on their more ambitious work, as we may see by comparing the study and final painting by Tintoretto in Figures 0–8 and 0–9.

Today, drawing continues to fulfill both these functions. It remains the accepted foundation for aspiring artists, and the use of drawing to work out ideas persists unabated. In fact, the preparatory studies, or **working drawings**, that artists make are frequently held in high esteem by the art-viewing public. Let us examine why.

Among all visual-art forms, preparatory drawings put the viewer most in touch with what an artist thinks and feels. This opportunity for an intimate look at the origins of a work has a special attraction for viewers and has given rise to

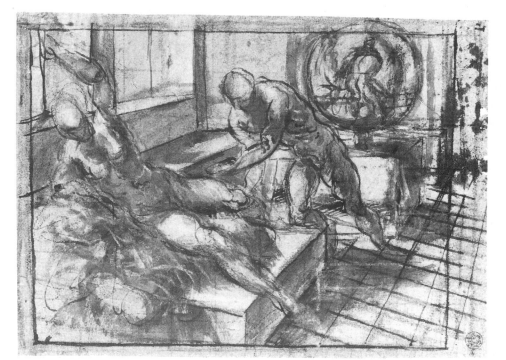

FIGURE 0–8
JACOPO ROBUSTI TINTORETTO
Venus and Vulcan, c. 1550
Pen and brush, black ink
and wash, heightened with
white on blue paper, 20.1 × 27.2 cm

FIGURE 0–9
Jacobo Robusti Tintoretto
Venus, Vulcan and Mars from
the copper pass cabinet Berlin
inclusive. Versand.
Oil on canvas, 135 × 198 cm

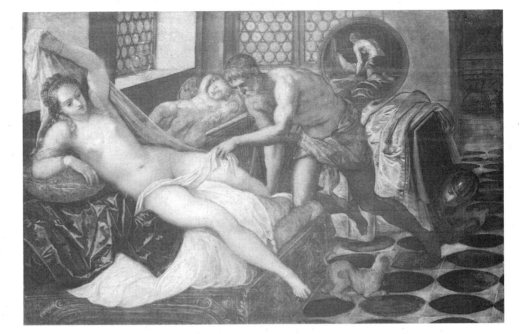

FIGURE 0–10
Barry Le Va
*Drawing Interruptions: Blocked
Structures #4*
Mixed media, 48 × 72"

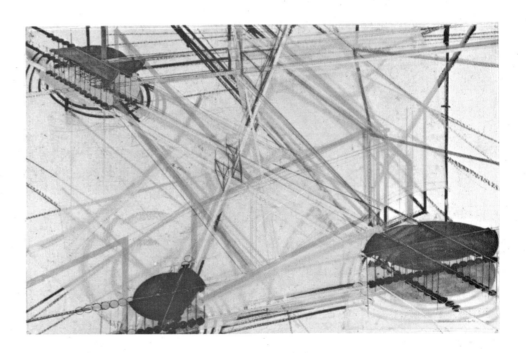

numerous exhibitions of artists' working drawings. Compare, for example, the
drawing by Barry Le Va (Fig. 0–10) with one of his works as it appeared installed
in a gallery (Fig. 0–11). The representation of space in the graphic work is surpris-
ingly different from the effect of the installation. The drawing has a sense of inte-
rior, psychological space and as such lends an unexpected romantic slant to what
in the installation appears to be a matter-of-fact assembly of objects on a floor.

In addition to the popularity of working drawings, a finished drawing by
an artist is today regarded as a complete and independent art form. Accompany-
ing this loosening of the Renaissance concept of drawing has been a profusion of

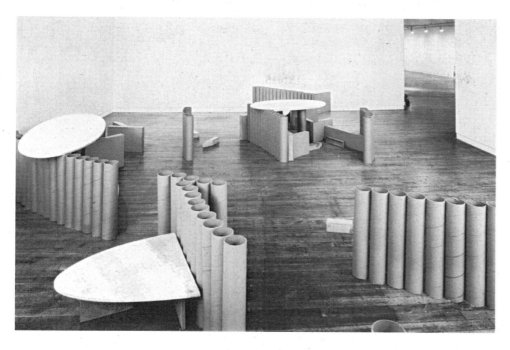

FIGURE 0–11
BARRY LE VA
Twisted Chain (of Events): Sketching a Possibility
Particle board, homosote, wood, cardboard tubing. Dimensions variable. Installation at Sonnabend Gallery, New York City, 1981

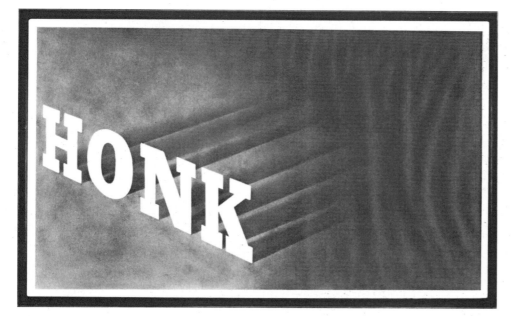

FIGURE 0–12
ED RUSCHA
Honk, 1964
Gunpowder on paper, 14½ × 23"

interpretations as to what defines contemporary drawing. Particularly today, in an age marked by aesthetic "pluralism," the diversity of drawing styles seems unlimited (Figs. 0–12 and 0–13).*

In the midst of this unprecedented wealth of drawing styles, two tendencies prevail in contemporary drawing. On the one hand, the Renaissance concerns for representing forms in space continue to thrive (Fig. 0–14). Simultaneously, a

*For further examples and a discussion of contemporary drawing styles, see Chapter 14, "Portfolio of Contemporary Drawings."

FIGURE 0–13
ROBERT BECK
The Funnel (The Modern Man's Guide to Life by Denise Boyles, Alan Rose, Alan Wellikoff), 2000
Charcoal on paper, Sheet (Irregular), 120 × 107"
(304.8 × 271.8 cm)
Whitney Museum of American Art, New York; purchased with funds from the Drawing Committee 2000.252.

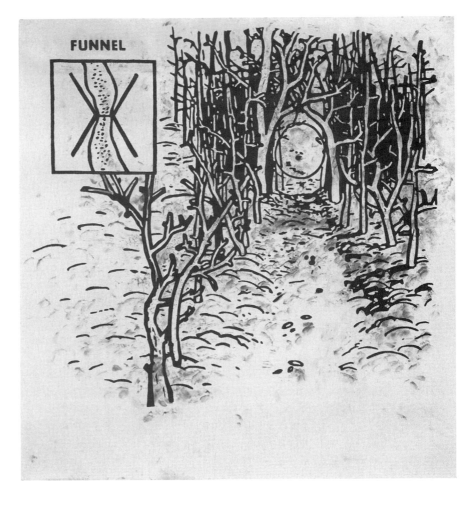

FIGURE 0–14
ROBERT ALAN BECHTLE
Nancy Ironing, 1977
Graphite, 12⅞ × 15"

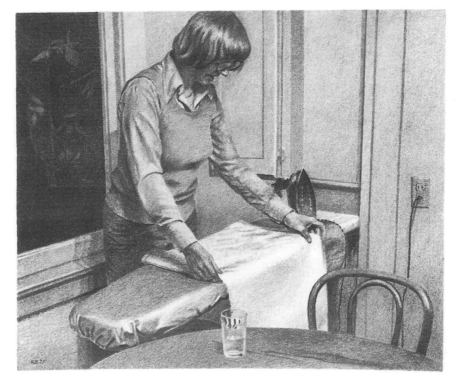

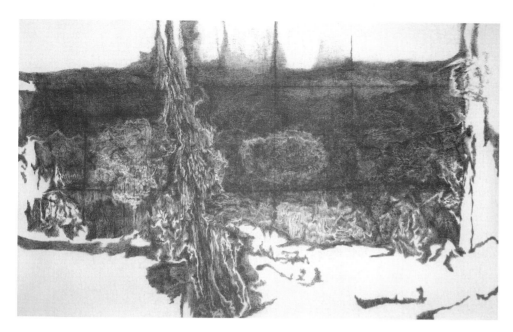

FIGURE 0–15
A. Van Campenhout
Untitled No. 3, 2009
Charcoal on paper, 60.24 × 93.31"

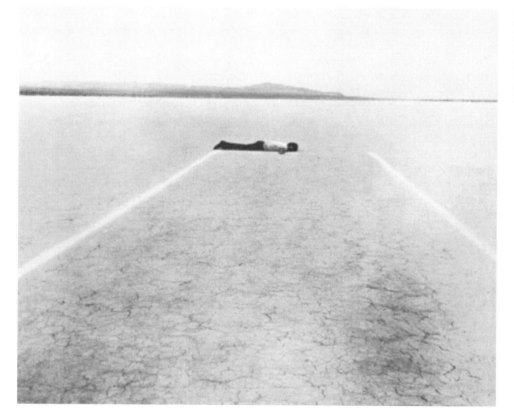

FIGURE 0–16
Walter De Maria
Mile Long Drawing, 1968
Mojave Desert, California. Two parallel chalk lines on desert dry lake. One mile long, lines 12 feet apart and 3 inches wide, artist lying on the desert floor

more modern bias toward the actuality of media has emerged as a viable alternative (Fig. 0–15). Less predictable is the genre of works that challenge conventional beliefs about drawing, such as Walter De Maria's *Mile Long Drawing* (Fig. 0–16), which consists of two parallel mile-long lines of chalk drawn twelve feet apart in the Mohave Desert.

The Student and Master Drawings

Presumably, we all look at master drawings for enjoyment. That enjoyment might include anything from the simple wonder that an artist could achieve so realistic a likeness of a particular thing to the more sophisticated appreciation of an inventive use of composition and imagery.

To increase your skills as an artist, you will also be studying master drawings to find out what gives them so much expressive power. While seeking this information, you will become more familiar with the basic principles of drawing and gain a sense of how and why those principles have been manipulated to meet specific ends. Moreover, spending time with drawings from various phases of art history will help you to see the relationship between past and present drawings. You also will find countless instances when new forms of expression coexisted with older drawing practices. Indeed, even the most startlingly reshaped concepts have never invalidated drawing in traditional terms.

The Issue of Talent

When you look at works by esteemed masters, you may find yourself in awe of their virtuosity. Your admiration for these works may lead you to wonder if you have sufficient talent to undertake a serious study of drawing. This question is frequently expressed by beginners and usually results from a misunderstanding about what it takes to learn to draw.

Learning to draw is an acquired skill. The fundamentals of drawing form a body of knowledge well within the reach of the college student. This body of knowledge is imparted through concepts that are often easy to grasp but require repeated application to fully comprehend. Through consistent application, you will obtain a set of measurable skills that you will use as if by second nature.

Learning to draw is also based on desire. Talent, viewed in this way, is more a matter of inclination than anything else. Someone with the ambition to draw well can learn to excel. But the person possessing sound basic skills and a personal need to express ideas visually will be equipped to do work of a more serious and personal nature.

The Public Side of Drawing

The bulk of your learning will take place while you are drawing. In this respect, learning to draw is like learning to ride a bicycle. The theory of what to do can only be imperfectly explained. Actual understanding must be gained from the experience of getting onto the bike or applying marks to paper.

At first, many students are uncomfortable when drawing in the presence of others. After all, drawing is an intimate activity, and what you make is always to some extent autobiographical. Ironically then, the most common setting for learning to draw is the *public arena* of the classroom.

Fortunately, your participation in the drawing process will ease such anxieties. You will find that the challenge of drawing requires such concentration that you will become oblivious to the presence of other people in the classroom. And attaining this level of concentration will make it easier for you to draw, unhampered by the insecurities of working in a relatively public setting. Later, when you notice the very rapid development of your drawing skills, you will probably appreciate the energy and support of the classroom situation.

Seeing versus Naming

Achieving feelings of privacy while drawing in a crowded classroom is the result in large part of switching your thinking from the usual verbal mode to a nonverbal mode. Whenever you concentrate on a nonverbal task, such as drawing, you will be inclined to block out verbal distraction, such as a conversation taking place in the same room. This nonverbal state of mind has another, and even more important, role to play in your drawing practice, however, since it encourages you to focus on the *visual* character of your subjects rather than relating to your subjects on the basis of their *names* and *uses* in the everyday world.

Since our main form of daily communication is verbal, or symbolic, we tend to deal with the world on the basis of objects we can name: telephone, car, dog biscuits. In drawing, this situation is almost reversed, since we attribute meaning to our subjects more fully on a visual basis. Correspondingly, their worldly associations are de-emphasized—or at least, they should be.

But beginners often feel more secure if a subject is loaded with meaning, in the verbal sense, or has an abundance of nameable parts. The more nameable parts, they feel, the more likely the drawing will succeed as a recognizable image. For example, let us say a beginner were asked to draw a still life containing an old boot and some draped cloth. Attracted to the boot because of its more specific cultural identity, the beginner will record individual details much as an itemized grocery list is compiled: two broken laces, twelve hooks and eyelets, one stiffened tongue, and so on. Less scrutiny will be given to the general form and structure of the boot, and far less information given about the draped fabric. This tendency to draw each unit of the subject separately arises from the habit of naming and usually results in a drawing that looks fragmented and superficial in its treatment of the *form* of the subject matter.

On the other hand, beginners who emphasize a subject's visual character are able to see its wholeness and the way each part is integral to that whole. In a visually oriented state of mind, the beginner might, for instance, decide to exaggerate the robust solidity of the boot in contrast to the more delicate, linear twisting of the cloth (Fig. 0–17).

So, *seeing* means to stress a *visual* interpretation of the subject to be drawn. Your ability to overcome the tendency to name what you see (three pencils on a tabletop) and depend instead on visual insight (three diagonals on a flat surface) may take some practice to develop. But a visual approach yields far more satisfactory drawings than one that accentuates a subject's everyday identity and symbolic connotations.*

Drawing as a Process

Making a drawing is like participating firsthand in the development of an organism. This development is a natural process, from the drawing's genesis to its completion.

In this regard, consider that making a drawing is a process of *forming* something; it is a way for the artist to materialize responses to things that are real or imagined. Although process is integral to the realization of any artwork, its visual traces are usually obliterated by the time a work is completed. However, we are afforded insights into the developmental process of a work of art when different states are preserved. In Figures 0–18 and 0–19, two successive impressions of the Rembrandt print *Christ Presented to the People* show, among other changes,

*This is not to deny the cultural content in subject matter. At this stage, however, the *visual* content of what we draw cannot be overemphasized. For further discussion of content that is culturally based, see Chapters 9, "Subject Matter: Sources and Meanings," and Chapter 14, "Portfolio of Contemporary Drawings."

FIGURE 0–17
Mikal Korostyshevsky, Pratt
Institute
Student drawing: still life with
visual character of subject
emphasized, 4 × 5"

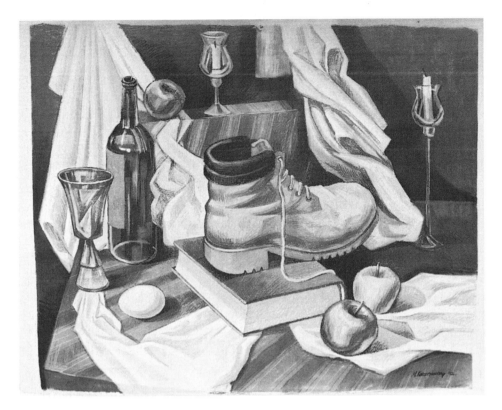

FIGURE 0–18
Harmensz van Ryn Rembrandt
Christ Presented to the People, State IV
Etching 14⁵⁄₁₆ × 17⁷⁄₈"

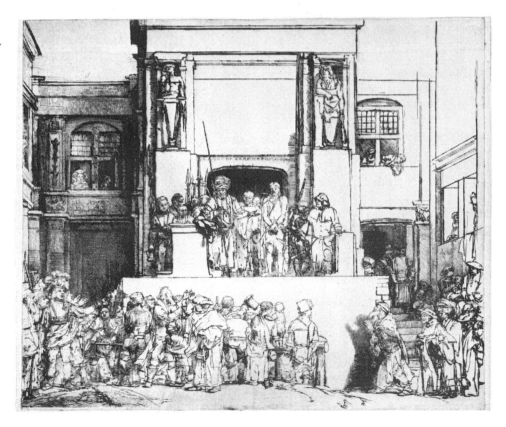

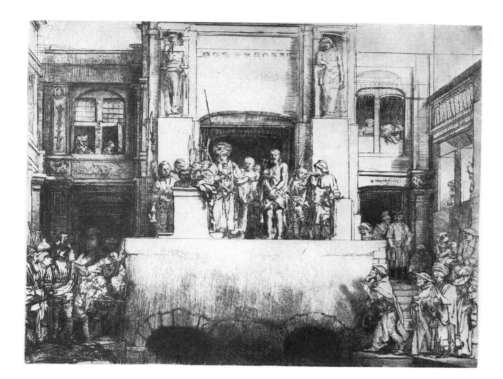

FIGURE 0–19
HARMENSZ VAN RYN REMBRANDT
*Christ Presented to the People,
State VIII*
Etching 14 × 17^{15}/$_{16}$"

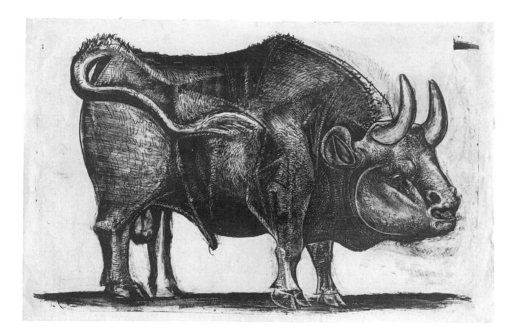

FIGURE 0–20
PABLO PICASSO
Bull, State III, December 18, 1945
Lithograph, printed in black,
composition, 32.5 × 44.4 cm

the crowd in front of the podium replaced by two rusticated arches. Serial images may also provide evidence of an artist's process, as in Figures 0–20, 0–21, and 0–22, which showcase Picasso's mastery of form improvisation.

So, like any organic thing, a drawing must be permitted to grow and change. In the larger sense, drawings, and especially ambitious ones, are the result of seemingly infinite adjustments. And the process of making a drawing is most successful when the artist is alert and responsive to this potential for change as the drawing is being formed.

FIGURE 0–21
PABLO PICASSO
Bull, State VI, December 26, 1945
Lithograph, printed in black,
composition, 32.6 × 44.4 cm

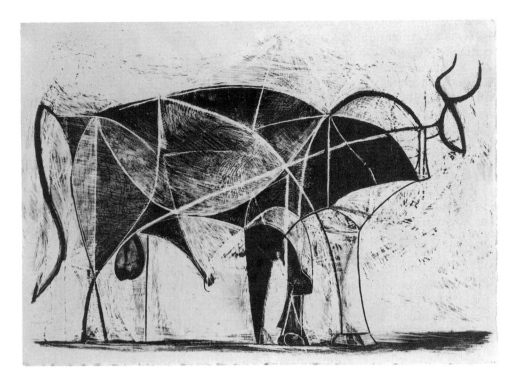

FIGURE 0–22
PABLO PICASSO
Bull, State XI, January 17, 1946
Lithograph, printed in black,
composition 37.2 × 44.4 cm

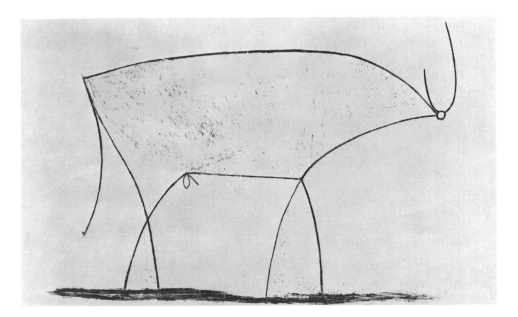

In practical terms, this means that your drawing method should not be limited to only up-close, detailed work. Working up close does have its benefits since you can concentrate on the refined execution of certain passages. But working at arm's length or less throughout the duration of the process will make it difficult to see how all the parts of a drawing fit together.

To fully gather in the whole effect of a drawing, it is necessary to "shift your perception" away from the representation of subject matter detail. One means for doing this is to physically move back—several paces from your drawing—to gain an overview of its progress. Another way is to turn the drawing upside down or view

it in a mirror to reverse the image. These simple strategies will help you diagnose problems that might otherwise escape your notice. They also place you in a better position to see, and take advantage of, new possibilities emerging in a drawing.

Regularly taking stock of a work in progress has the added value of helping you appreciate a drawing's identity as an independent, created object. You will become more accustomed to the fact that all drawings, even those filled with convincing descriptions of things, have their own logic quite apart from those properties of illusion or imitation of the natural world.*

The Merits of a Sketchbook

A sketchbook is a handy means for accelerating your progress in drawing. Bound sketchbooks may be purchased at any art supply store, although some artists prefer to bind their own so that they can insert papers of different weights, surfaces, and colors. Media of all kinds are suitable for a sketchbook; indeed, part of the pleasure of keeping a sketchbook is experimenting with media not commonly used in the classroom, such as ballpoint pen, felt-tip markers, or collages made with found materials. For many artists, the act of filling a sketchbook has almost magical significance, as we sense when looking at Figure 0–23, which is clearly obsessive in character.

Often considered an artist's personal diary, the sketchbook is an excellent context for recording a whole range of ideas, verbal as well as visual. There will be times when you are flooded with ideas, some of them related to a particular endeavor and others coming seemingly from out of the blue and distracting you from your major purpose. In your sketchbook you are free to jot down all those ideas without the pressure of making them relate to each other (Fig. 0–24); and, at a later date, should you need any of those conceptual fragments you will know where to find them.

There will be times when you will use your sketchbook in a more directed fashion. You might use your sketchbook as a vehicle for sharpening your perceptual skills, filling it with literally hundreds of drawings of things encountered in

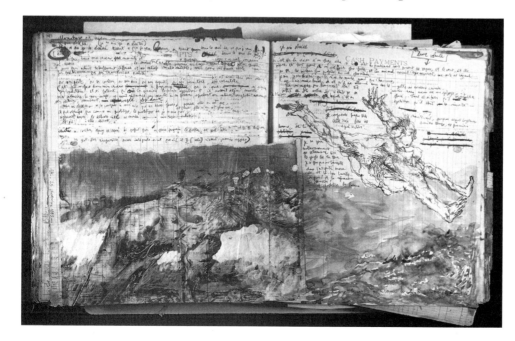

FIGURE 0–23
UR
Stinking King, Book # 3, Oct 9th, 1994
Pencil, watercolor, ink, and oil on paper, 18 × 16"

*For more on the drawing process, see "Troubleshooting Your Drawings" in Chapter 10, "The Form of Expression."

FIGURE 0–24
JAMES ENSOR
Head in Profile and Other Studies, n.d.
Black crayon

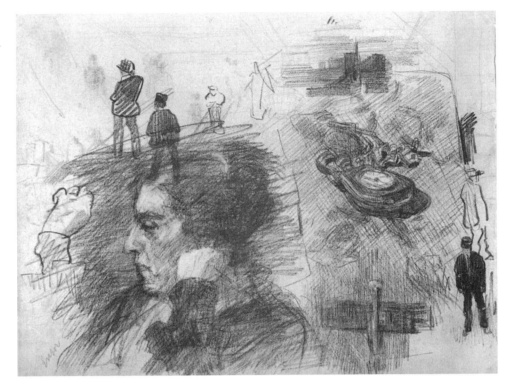

FIGURE 0–25
EDWARD HOPPER
Artist's Ledger—Book III, page 13
Rooms for Tourists, 1924–1967
Pen and black ink, graphite pencil,
colored pencil, and collage on
paper. Commercial cloth binding.
Overall (closed): 12⅜ × 7⅝ × ¾"
(31 × 19.4 × 1.9 cm) Overall
(open): 12³⁄₁₆ × 15¼ × ½"
(31 × 38.7 × 1.3 cm)
*Whitney Museum of American Art, New
York; Gift of Lloyd Goodrich 96.210a-hhhh.
© Whitney Museum of American Art,
New York*

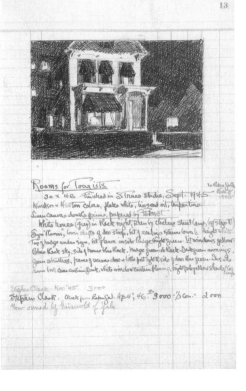

daily life. The sketchbook can also serve as a complement to studio practice, as it
is one of the best places to try out ideas for more prolonged works (Fig. 0–25). In
addition to the benefits bestowed by such constant application to drawing, leafing
through an entire book of sketches will assure you of your growing skill.

The itinerant artist of the past used the sketchbook to record things observed in distant lands (Fig. 0–26), a practice continued today. The travel journal page by contemporary artist, Ken O'Connell, (Fig. 0-27) includes sketched fragments of sights that caught his eye during a trip to Europe, including a Pantheon column, an iron railing on a hotel, and a pastry. Note the postage stamps that pay homage to artists from their home countries.

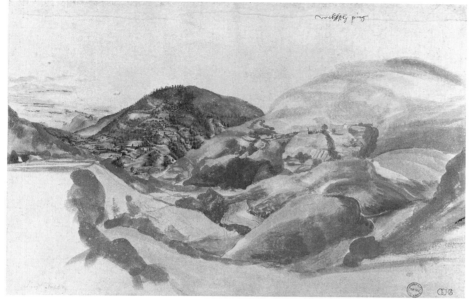

FIGURE 0–26
ALBRECHT DÜRER
Alpine Landscape
210 × 312 mm

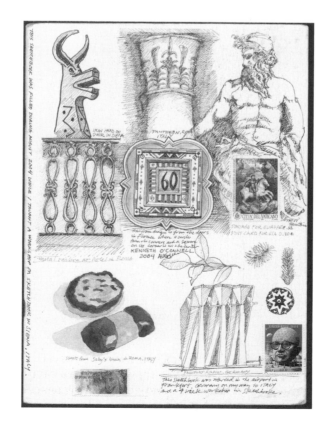

FIGURE 0–27
KEN O'CONNELL
Title Page Sketchbook Number 60, 2004
Ink and watercolor on paper,
8.3 × 11.7 cm

FIGURE 0–28
GAIA PERSICO
New York, USA, 2004
Biro on hotel paper,
12⅜ × 7⅝ × ½"

Finally, it is important to mention that the definition of the term "sketchbook" may be loosened to include drawing on other surfaces that might at the moment be handy, as in Figure 0–28, which uses hotel stationery as a support.

The Three-Dimensional Space of a Drawing

When was the last time you dragged your finger across the condensation on a car window? Or had the urge to make your mark on the surface of a building, an underpass, or a freshly leveled sidewalk?

As kids, most of us loved to make marks on available surfaces. As adults, some of us still do, using art as an outlet for these energies. This chapter invites *you* to explore mark making anew and with a refreshed purpose. You will observe how the marks you make suggest space in a drawing; and you will learn the organizational principles behind this phenomenon, principles that will be fundamental to your growth in descriptive drawing.

Making Your Mark

The word *mark* as we have been using it has three major ramifications in regard to artistic expression:

1. Its primary meaning is a trace or blemish left on a surface. As such, it may be a scratch, dent, hole, stain, or deposit. In shape it may range from that of the meaningless smudge, spot, tick, or line to the more meaning-laden forms of punctuation marks, letters of the alphabet, or corporation logos.

2. A mark also records the presence of the agent that made the mark. The graffiti artist who sprays a cryptic sign or tag on a subway train is in effect indicating a territorial claim to a piece of corporate property. Likewise, a manufacturer stamps a trademark on a product not only to indicate its origin but also to stake a claim on the public's consciousness.

3. Finally, a mark is often used as an indicator of spatial quantities: Spatial distance may be indicated by road markers; area by boundary markers; and volume by calibrations such as those found on a measuring cup.

A mark in a drawing may take into account all three meanings. First of all, artists are generally concerned about the quality and range of marks they make on the surface of their paper. Second, a mark is a record of the action taken by the artist who made it. Third, the artist, as one who is interested in making visual representations of nature, uses marks to measure relative spatial quantities in the world (Fig. 1–1).

FIGURE 1–1
JOHN MARIN
Schoodic Point, 1941
Crayon on paper, 10½ × 13½"

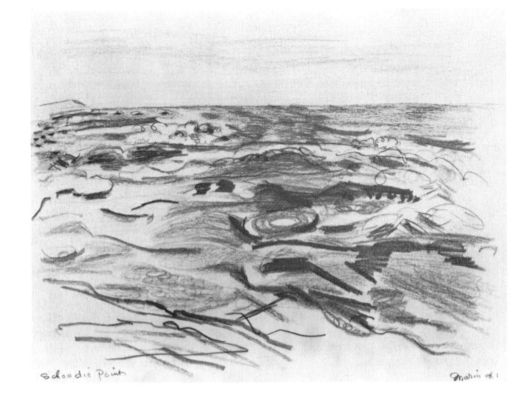

The Mark versus the Line

The conception that most people have of a drawing is that of a picture made with line. The use of flowing line is particularly suited to the portrayal of subjects of great complexity, but a line is only one kind of mark, and for many artists, a much larger repertoire of marks is in order. Many other kinds of marks are the result of short, direct gestures. They are, therefore, relatively abrupt in appearance. Such marks are seldom used for full-blown representation; instead, they most often function as spatial indicators in a drawing, as in their verbal counterpart, "mark that spot" (Fig. 1–2). A variation on this concept, applied to a more shallow space, is found in Figure 1–3, where the profusion of marks appear to move back and forth between the surface of the drawing and the sketchy image of a cup.

Figure–Ground

As soon as you put a mark on a surface, you set up a figure–ground relationship. To clarify this, place a blank sheet of drawing paper in front of you. Consider it carefully. It has a particular tone (in most cases white or off-white), a particular shape (usually rectangular), and a particular size and texture. This clean, flat surface is the **ground** of your drawing.

Make a single mark on this ground, and you have created a thing of visual interest, or what we call a **figure**. A figure in a drawing may represent a recognizable object or it may be a nonrepresentational shape, but in either case, it is something that may be readily distinguished from its visual context. The term *figure*, as used here, is not limited to the human body. A figure may be, for instance, the representation of a tree, an invented symbol, or a letter of the alphabet (Fig. 1–4).

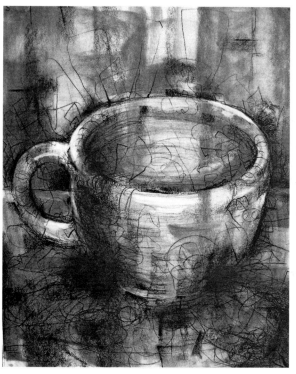

FIGURE 1–3
SABINE DEVICHE,
Arizona State University
Coffee Cup
Student drawing: marks
representing a shallow space
Charcoal on paper, 24 × 18"

FIGURE 1–4
DANIEL BERGMAN
Graphos
Graphite on paper, 22 × 34"

This first mark (or figure) you make heightens your awareness of the area of your ground by making the vertical and horizontal dimensions of the drawing paper more apparent (Fig. 1–5). It is as if a magnetic attraction exists between the mark and the edges of your paper.

Let us return to our example of a blank sheet of paper. Looking at this paper with a different intent, you can probably conceive within its emptiness the existence of an amorphous and relatively infinite space. Imagining this space will take an act of will on your part. Experiencing it will be somewhat akin to staring at a patch of clear blue sky—there is no beginning, middle, or end.

One mark dramatically alters this perception of space (Fig. 1–6). It is now as if a solitary bird has appeared in that blue sky, giving you a single point of spatial reference. This first mark on a page changes the formless character of the space into a more defined and tangible volume. In a sense, the mark creates the space in which it exists.

A second mark of a lighter or darker tone than the first increases the illusion of a specific spatial volume (Fig. 1–7). Appearing to be at a measured distance from the first, it provides a second point of reference in the space of the drawing. Each mark thereafter adds another station to the space, thereby increasing its structural definition.

So, the first two marks on your paper may be seen as figures against a ground, in which case they make the physical presence of the ground easier to grasp. They may also be seen as two spatial points in your drawing that open up the ground to create an illusion.

Artists frequently play one mark against another to create spatial tension. In this regard, let us look at the Dana Velan drawing pictured in Figure 1–8. You will note that, in general, the marks are different in some way from one another. It is that difference, what we might call the distinguishing character of a mark, that influences how we read a mark's position in space. And by extension, it is the range of differences in the accumulated marks that expresses the kind of space in total that is portrayed.

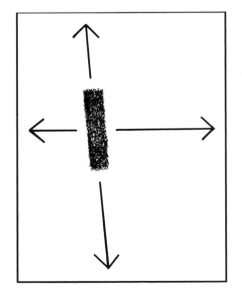

FIGURE 1–5 FIGURE 1–6 FIGURE 1–7

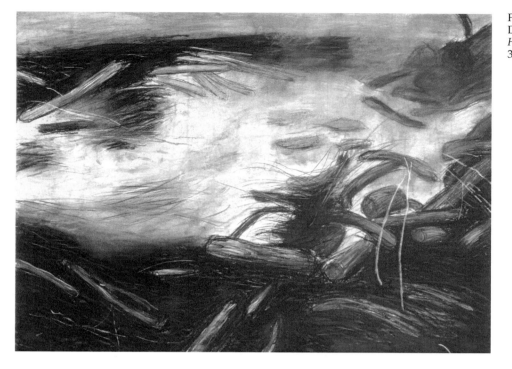

FIGURE 1–8
DANA VELAN
Hearths, 1997
38 × 50"

The Picture Plane

The space represented in a drawing is a semi-enclosed volume. Except for the potential of unlimited depth, the illusion of three-dimensional space in your drawing is bounded on all four sides by the edges of your paper and in front by the transparent "wall" we call the **picture plane**.

Common usage has given the term *picture plane* two meanings. First, it refers to the actual flat surface, or opaque plane, on which you draw. Second, it is often regarded as an imaginary, transparent "window on nature" that represents the format of your drawing mentally superimposed over the subject you wish to draw (Fig. 1–9).

The act of drawing links the two meanings of the term *picture plane*. When drawing, you look through the imaginary picture plane to gather information about the space and form of your subject, and you transfer this information to the actual picture plane of your drawing surface. As a result of this process, your drawing paper is virtually equivalent to the window on nature that you have imagined.

Of course, the imaginary picture plane does not actually exist except as an abstract concept to assist the artist in depicting things as they appear. Looking through this artificial plane can be compared to sizing up a subject through the viewfinder of a camera: You are framing, or selecting, that portion of the subject you wish to draw from the visual field before you. In so doing, you have taken the first step in organizing the illusion of three-dimensional space of your drawing.

This concept was developed (actually rediscovered) in the early Renaissance, at which time artists were becoming increasingly involved in duplicating natural appearances. Not only did they develop the idea of the picture plane as a mental device, but they also experimented with mechanical means for transferring points located on actual objects in space onto the flat surface of the picture plane (Fig. 1–10).

FIGURE 1–9

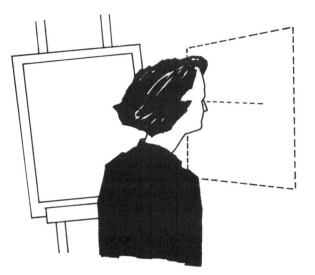

FIGURE 1–10
ALBRECHT DÜRER
*The Artists' Treatise
on Geometry*, 1525
Woodcut, 12³⁄₁₆ × 8³⁄₈"

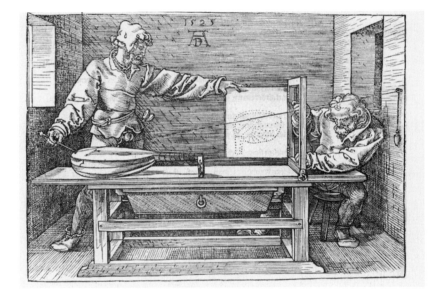

The Picture Plane Begins Your Space

To reinforce your understanding of the concept of the picture plane, we offer the following scenario. Imagine that you are looking through a picture window at a gorgeous meadow backed by rolling hills. All of a sudden, a large and colorful insect lands with a smack on the pane of glass. Made aware of the window's presence, you would no longer be looking through the glass, but *at* it. And the thought may even have struck you that this window is the beginning of the space opening up before you.

The picture plane in a drawing may be thought of in the same way. In fact, if we interpret the atmosphere of natural space as a series of receding planes, we are ready to regard our "transparent" picture surface as the first plane in the series. With this in mind, let us look at two illustrations.

The female figure in Wayne Thiebaud's painting (Fig. 1–11) sits securely in a shallow space. Yet we cannot help but notice the illusion that her big toes are pressed against the back of the picture plane. In Figure 1–12, the inner rectangle has a slablike appearance. This effect gives the picture plane a more immediate physical presence (it seems more real than the actual paper margins) and makes it clearly the initial contact point through which an atmospheric vista unfolds.

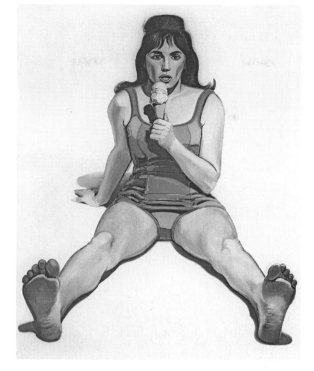

FIGURE 1–11
WAYNE THIEBAUD
Girl with Ice Cream Cone, 1963
Oil on canvas, 48 × 36"
Collection of Mrs. Edwin A. Bergman.
Art © Wayne Thiebaud/Licensed by VAGA,
New York

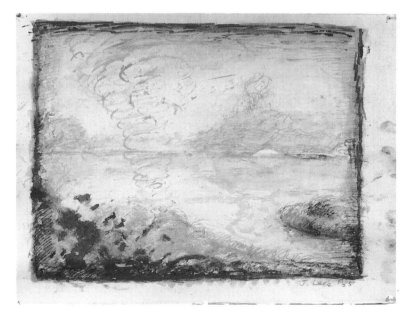

FIGURE 1–12
JOHN LEES
Study for a Landscape, 1985
Pencil, ink, gouache on paper,
12 × 15"

In each case, then, the primary position of the picture plane in the spatial illusion has been asserted, whether by pressure against its surface or by heightening its physical palpability.

These exercises will enable you to transform your sheet of paper into an imaginary space of unlimited depth. You will need the following drawing media: vine and compressed charcoal, conté crayon, graphite stick, kneaded and artgum erasers.

Exercise 1A

Drawing 1: *To create your spatial illusion, use a variety of marks. These marks should not be descriptive of objects. Instead, each mark should simply indicate a distinct physical point in the illusion of space you are making. Do your best to vary your marks in terms of size, tone (lightness and darkness), and clarity to create the illusion that they are set at different depths in a spatial field (Fig. 1–13).*

Experiment freely with your media. Use your fingers, chamois, or side of your hand to blur some of the marks. Maneuver about so marks are distributed at various places across and up and down your paper. Apply some marks with heavy pressure using the motion of your entire arm; arrive at others by merely flicking your wrist. Make some fast, some slow. And do not forget to explore the mark-making possibilities of your erasers. By erasing into dark areas you can make white lines and marks that seem to glow from a brilliant inner light. Also, try smearing heavy deposits of media with your erasers or rubbing lightly to soften them. Both of these techniques will soften dark marks, making them appear more hazy, or atmospheric (Fig. 1–14).

Drawing 2: *Your objective here is to make a more finished-looking drawing. Begin by once again using marks to represent a space. But as your drawing develops, consolidate your marks until more definite areas of light and dark appear. The Barnes drawing (Fig. 1–15) is a fine example of how this mark-making approach can be extended to yield a finished work of great textural and spatial complexity.*

FIGURE 1–13
A. Van Campenhout
Zonder titel, 1998
No. 4, Charcoal on paper,
150 × 117 cm

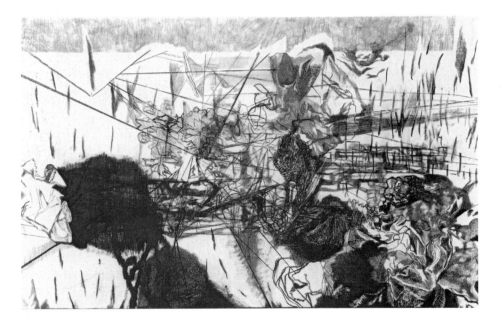

FIGURE 1–14
Michael Kareken
Scrap Engines #1, 2009
Conté on drafting film, 16 × 20"

FIGURE 1–15
Jeanette Barnes
Limehouse Excavation–
Docklands, 2000
Conté crayon, 150 × 211 cm

Fundamental Methods for Creating Three-Dimensional Space

What you will have observed thus far is that although any collection of marks on a page will imply a space of some sort, strong differences in the character of marks intensify a drawing's spatial impact. The next step is to support this observation with basic information about how you can more decisively create and control an illusion of three-dimensional space in your drawings.

Most of the methods we describe below for creating space were used by artists before the advent of linear perspective in the fifteenth century. Although these devices were eventually united with linear perspective, they remain viable outside the strictures of that highly rationalized system.*

RELATIVE POSITION

In a spatial illusion, things located on the lowermost portion of the picture plane generally appear closest to the viewer. Conversely, the higher something is placed on the picture plane, the farther away it appears. Note, for instance, that the figures of Christ and the two Old Testament prophets in the upper section of Figure 1–16 are read as farther back in space by virtue of their position on the picture plane relative to the three kneeling Apostles below. A similar phenomenon occurs in the Thiebaud drawing (Fig. 1–17), in which the gradual upward disposition of the pastels suggests increasing amounts of depth.

DIAGONALS TO CREATE DEPTH

The diagonal is a simple but effective means for creating the illusion of depth in a picture. Its effect is, in part, derived from the fact that similar objects receding diagonally into space appear to diminish in size (see Fig. 1–18). But to best understand

*A full discussion of the rules of linear perspective appears in Chapter 4, "Linear Perspective."

FIGURE 1–16
DUCCIO DI BUONINSEGNA
The Transfiguration, 1311
Tempera on poplar, 44 × 46 cm

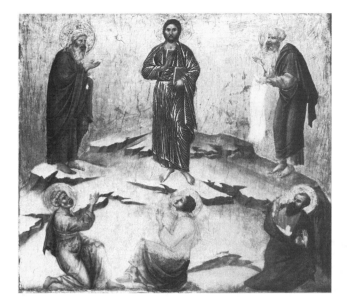

FIGURE 1–17
WAYNE THIEBAUD
Pastels, 1972
Pastel, 22⅛ × 30"
*Art © Wayne Thiebaud/Licensed by VAGA,
New York*

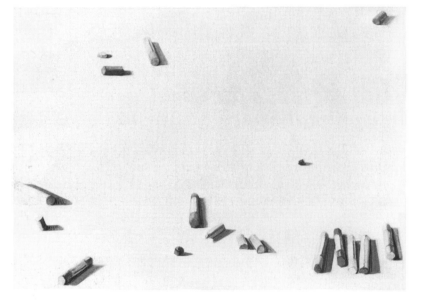

FIGURE 1–18
ÉDOUARD MANET
*La Rue Mosnier (now La Rue de
Barne)*, c. 1878
Brush and tusche, over graphite,
on paper vegetal transfer paper,
laid down on creave wove paper,
279 × 442 mm

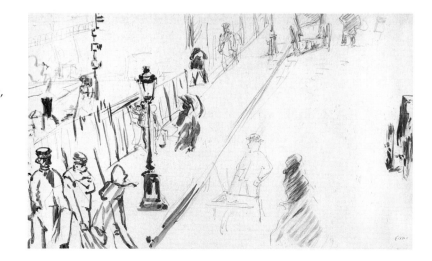

the diagonal's power, we must compare it with its directional counterparts in two-dimensional art, the vertical and the horizontal.

The vertical mark echoes our vertical condition as human beings, so we most readily identify with it (Fig. 1–19). A related issue is the somewhat confrontational effect of a vertical mark: It may function as an obstacle as well as a marker in our spatial field.

The horizontal mark opposes our orientation and thereby gives refreshed emphasis to our verticality. The thrill we experience before a sweeping landscape or ocean vista is due in part to the horizontality of its lines and planes. The horizontal line often elicits a feeling of calm associated with an uninterrupted flow of space. A horizontal located overhead, however, can be oppressive or even ominous, as in Shinn's drawing (Fig. 1–20).

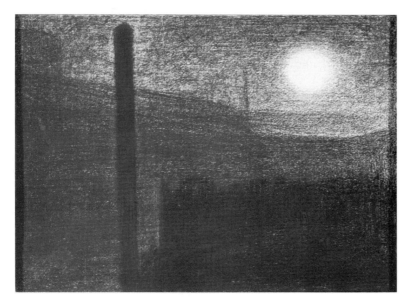

FIGURE 1–19
GEORGES SEURAT
Courbevoie: Factories by Moonlight
Conté crayon, 9⁵⁄₁₆ × 12¼"

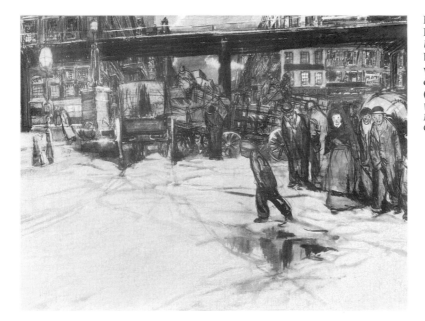

FIGURE 1–20
EVERETT SHINN
Under the Elevated
Brush and black ink, opaque watercolor, pastel, and charcoal on paper, 21⅞ × 27½"
(55.6 × 69.9 cm)
Whitney Museum of American Art, New York; Gift of Mr. and Mrs. Arthur G. Altschul 71.230

It is important to realize that vertical and horizontal marks, aside from their direct relation to our human posture, also repeat the vertical and horizontal axes of the paper on which we draw. By virtue of this harmony, vertical and horizontal marks lend drawings a feeling of structural stability (Fig. 1–21). We may validly sense, then, a relationship between our vertical condition, the rectangular or square orientation of our drawing paper, and the vertical and horizontal marks we make.

In contrast, the diagonal mark is more dramatic and suggestive of action. It is antagonistic to the stability of our bodily orientation and the orientation (horizontal and vertical) of our drawing surface. Lacking an axial equivalent, the diagonal mark creates tension as it transports us with great immediacy into an illusion of space (Fig. 1–22).

OVERLAPPING

Overlapping occurs when one object obscures part of a second object. Before the invention of linear perspective, overlapping was a very common and effective strategy for organizing space in art, as may be seen in Figure 1–23.

The phenomenon of figure–ground is made more complex by overlapping. When forms are overlapped, the relative nature of figure to ground becomes evident. In Charles Sheeler's *Of Domestic Utility* (Fig. 1–24), for instance, the forms moving sequentially back into space may be seen to alternate their roles as either figure or ground. The circular pan, sandwiched between two logs, serves as a ground for both the pitcher and the log that are foremost in our field of vision. In its turn as figure, the pan is seen against a variable ground that includes the distant log plus floor and wall planes. Even the body of the pitcher may be seen as a ground, for against it we observe the form of the handle. This type of progression, in which figure and ground are relative designations, is often referred to as **figure–ground stacking**.

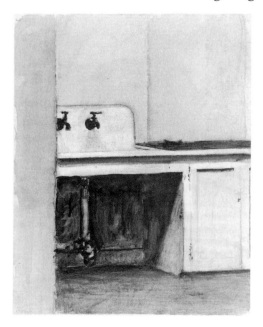

FIGURE 1–21
RICHARD DIEBENKORN
Sink, 1967
Brush and black ink over charcoal with white opaque watercolor, Sheet: 630 × 478 mm (24¹³⁄₁₆ × 18¹³⁄₁₆")
The Baltimore Museum of Art: Thomas E. Benesch Memorial Collection, BMA1969.2. © The Estate of Richard Diebenkorn

FIGURE 1–22
JOHN MARIN
Lower Manhattan, 1920
Watercolor and charcoal on paper,
21⅞ × 26¾"

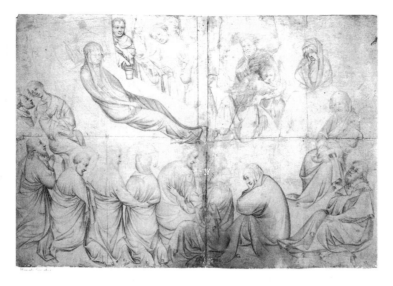

FIGURE 1–23
NETHERLANDISH ANONYMOUS
The Death of the Virgin, c. 1390
Silverpoint on blue-green
prepared paper, 11⁷⁄₁₆ × 15¾"

FIGURE 1–24
CHARLES SHEELER
Of Domestic Utility, 1933
Conté crayon on paper, 25 × 19½"

ATMOSPHERIC PERSPECTIVE

Atmospheric perspective (also called aerial perspective) has been employed by artists for a long time (the Chinese had mastered the technique by the tenth century). It is based on what any of us may observe by looking out the window: Objects close at hand are crisply defined; those at a greater distance lose their definition appreciably.

Technically, it is the moisture and particles of dust in the air that obscure our vision of distant things. The greater the amount of air between us and the forms we observe, the less clearly are we able to perceive them. So, in general, atmospheric perspective is most apparent when we are confronted with deep space (Fig. 1–25) or when the atmosphere is made denser by mist or fog (Fig. 1–26).

To be more specific, the effects of atmospheric perspective can be achieved in a drawing by paying attention to these two principles:

1. The clarity of forms diminishes as they recede into the distance. Surface detail and texture are less apparent; with very distant forms, detail and texture may disappear altogether.

2. When objects are viewed in deep space, the contrast between light and dark tonalities is reduced. Medium and dark tones often become lighter and may even blend into a uniform light gray.

FIGURE 1–25
ALEXANDER COZENS
A Mountain Lake or River Among the Rocks, 1775–1780
Brush and black ink wash,
31.3 × 23.3 cm

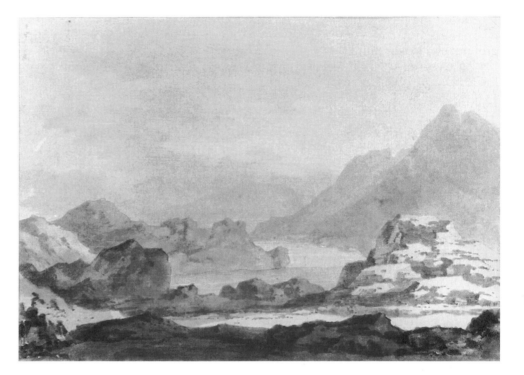

FIGURE 1–26
HASEGAWA TŌHAKU
Pine Trees
One of a pair of six fold screens, ink on paper, height 61.7"

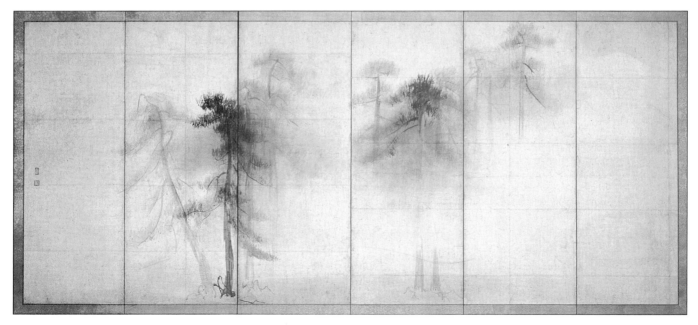

Sometimes this second principle misleads students into believing that only forms close to the picture plane should be drawn with the darkest tones. This is incorrect, since there are occasions in nature when the perceived tone of a more distant form will approach, equal, or even exceed the darkness of forms that are nearby. In this case, remember that it is the tonal contrast of a form (relative to its context) in comparison with other areas of a drawing that helps determine spatial position.

ORGANIZING A DEEP SPACE

The volume of air, or atmosphere, between us and the forms we perceive in the distance can be understood as a series of receding planes (as we discussed in the section on the picture plane). A convenient system for organizing these planes is to group them into three distinct zones of illusory space: foreground, middleground, and background.

In Figure 1–27 all three zones are clearly present and are coordinated with the illusion of atmospheric perspective.

RELATIVE SCALE

The concept of relative scale is closely allied to notions of foreground, middleground, and background. Things that are larger in scale usually seem to be in the **foreground**, or closer to us. Conversely, when there is a relative decrease in the scale of forms, we judge them to be receding into the **background**. The intervening spatial zone is the **middleground**. In the drawing by Emil Nolde (Fig. 1–28) marks are uniformly black so there is no atmospheric perspective contributing to a sense of spatial depth. Instead it is the pronounced scale changes of the marks and shapes that guide us through the three spatial zones.

The use of relative scale is particularly effective when the forms that diminish are understood to be of similar size, as in the Goya drawing (Fig. 1–29). Consider

FIGURE 1–27
BEN SCHWAB
Rainy Day Drawing, 2006
Graphite on gesso panel, 19 × 25"

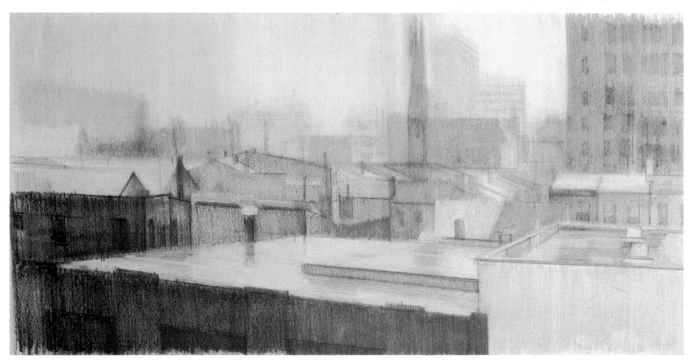

FIGURE 1–28
EMIL NOLDE
Harbor Scene, c. 1910
Brush and india ink,
325 × 467 mm

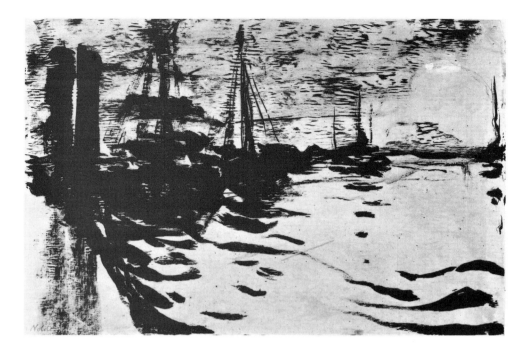

FIGURE 1–29
FRANCISCO DE GOYA Y LUCIENTES
A Crowd in a Park
Brush and brown wash 8⅛ × 5⅝"

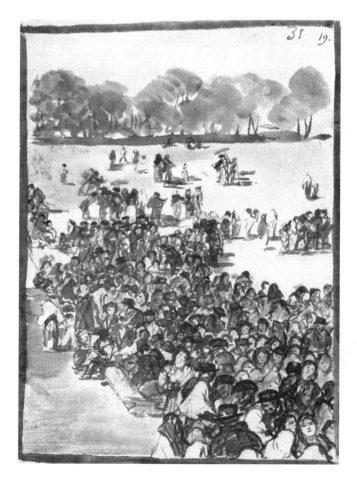

as well Goya's use of relative position, atmospheric perspective, and the diagonal to achieve a convincing sense of space.

Armed with an increased knowledge of spatial concepts, you are now in a position to choose between representing deep illusionistic space or, if it better suits your expressive ends, a flattened type of space. The following exercises are an introduction to these two alternatives.

Exercise 1B

Drawing 1: *Set up to draw on one side of the largest room available to you. Spend a few moments letting your eye travel from point to point within this space. You might also try to imagine your drawing paper as a transparent window superimposed over your subject.*

Now, select an object in the midst of this interior and put a mark on your paper representing it. Do not attempt to outline the object or depict any of its detail; your concern should be only with that object's location in space. Next, select an object or point that lies behind the first one. Indicate its position with another mark. You will probably wish to make this mark lighter in tone, or at least more diffuse, to have it appear farther away. Note also its relative position on the page. Is it closer to the top?

Next, look at an object that is closer to you. Using a bolder and sharper mark, indicate this object. Continue to add marks to the page showing the relative locations of other objects in the room. Be sure to consider the intensity and clarity of your marks and their relative position and scale; make use of any naturally occurring overlaps to reinforce your illusion of space.

Figure 1–30 is an example of marks used to create a feeling of space in a room.

Drawing 2: *Spread a number of small objects on the top of a table. Station yourself so that you are looking almost directly down at your subject. You will notice that the plane of the tabletop corresponds to the picture plane of your drawing surface. Notice, too, how the articles on the table appear to adhere closely to the plane of the tabletop. Your intent in this drawing should be to re-create the feeling of limited depth that you observe in your subject.*

Draw the arrangement of objects so as to maintain the integrity of the picture plane; that is, avoid all the devices normally used to create an illusion of deep space, such as overlapping, atmospheric perspective, and relative scale. To further emphasize the literal flatness of the picture plane, you may even wish to use one of your objects as a stencil (Fig. 1–31).

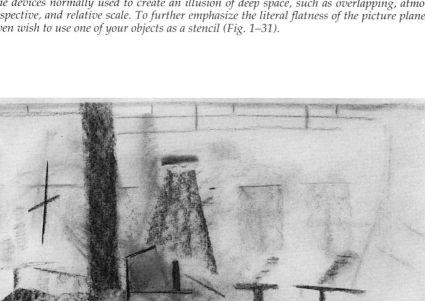

FIGURE 1–30
GEORGEANNE COOPER,
University of Oregon
Student drawing: using horizontal and vertical lines to depict the spatial positions of objects within an interior

FIGURE 1–31
WILL PEREIRA,
University of Montana
Student drawing: still life in which
a tabletop corresponds to the
picture plane, 18 × 24"

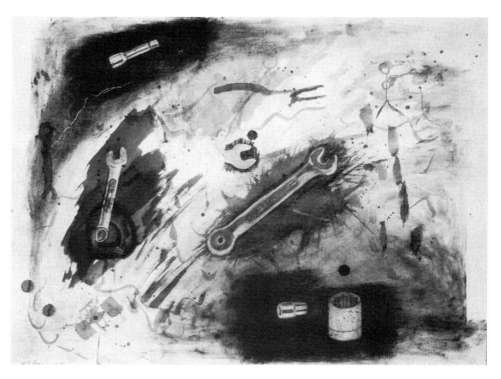

Looking at Space

Now that you have some experience with the very basics of spatial illusion, let us go on to investigate the various conceptions we have of space. Science tells us that space is the dominant medium, whether we consider the ample spaces seen from a mountaintop or the microscopic dimensions of space within each atom. Perhaps the most basic idea of space is as an expanse of "empty" air. But this fundamental conception may be experienced and interpreted in ways that fall into three broad categories: distance, area, and volume.

Standing in a Kansas wheat field and looking at a corn silo on the horizon, you will experience a sense of distance, or what we might call a one-dimensional measure of space. But people most often experience space with boundaries of some sort. The space of your street, for instance, or by extension your town as a whole, can be thought of as a particular area of space. Each has boundaries, definite or implied, that delineate its length and width; and each is divided into sections of space by such things as city parks, buildings, and highways (note the term *subdivison* in the builders' lexicon). As an example, look at the drawing by Sidney Goodman (Fig. 1–32), in which the sensation of a bounded spatial area is heightened by the row of massive and dramatically represented trees.

Two interesting variations on the themes of area and distance are provided by Figures 1–33 and 1–34. The Annie Wildey drawing establishes a contrast between the shadowy foreground space enclosed with masonry walls with the light-filled space in the distance. The drawing by Ben Schwab affords an aerial view of the partitioned areas, or zones, of a modern urban landscape.

Moving down the ladder of magnitude from the Kansas wheat field and city park, our next stop is the interior space of a room. In a typical room, the space is enclosed on six sides, creating a spatial volume.

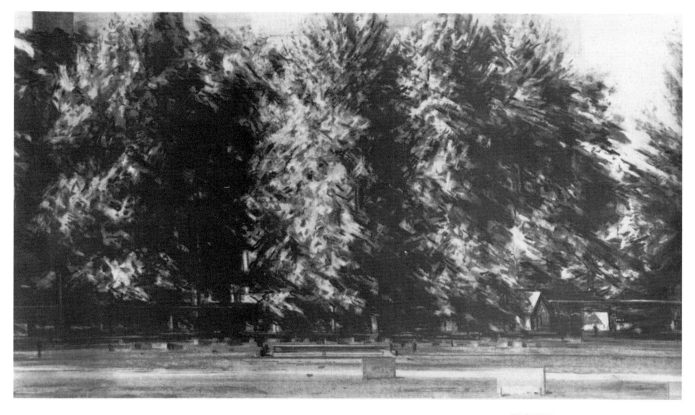

FIGURE 1–32
SIDNEY GOODMAN
Wald Park, 1970
Charcoal, 23½ × 41¼"

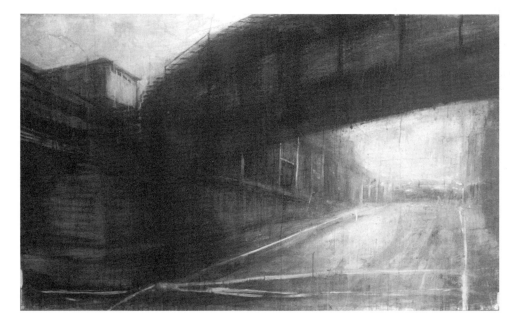

FIGURE 1–33
ANNIE WILDEY
Urban 2, 2008
Mixed media/paper, 60 × 92"

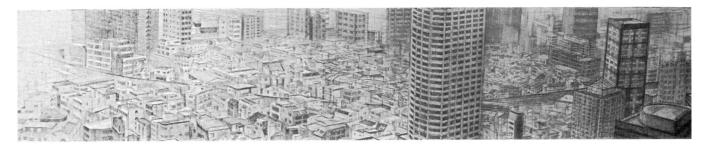

FIGURE 1–34
Ben Schwab
Tokyo, 2009
Graphite on panel, 3 × 20"

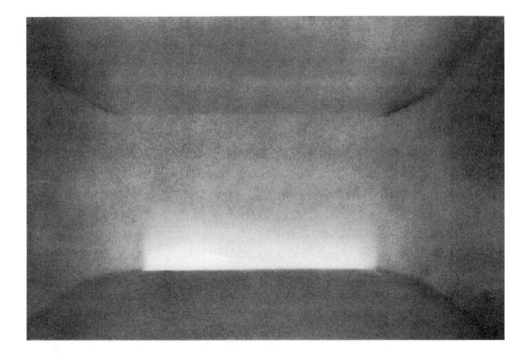

FIGURE 1–35
Elyn Zimmerman
Untitled, 1976
Powdered graphite, 14¼ × 19¼"

To develop an awareness of space as volume, you must learn to treat it as though it were a palpable substance. It may help to imagine the air as tinted with a color, clouded with smoke or vapor, or replaced with a substance such as water or oil. Notice in this regard the density of atmosphere portrayed in the work by Elyn Zimmerman (Fig. 1–35).

The sensation of spatial volume is maximized when objects divide a space into yet more visually manageable and intimate volumes. Look at Ruth Cleland's drawing of a department store interior (Fig. 1–36). While we are aware of the central spatial expanse, we are also drawn to poke about in a series of smaller sections displaying merchandise. Our experience of space as a volume need not be limited, however, to areas divided into human-scaled segments. The presence of uninterrupted, monumental masses of air pressing against the architectural framework of large halls, churches, and theater interiors can fill us with awe (Fig. 1–37). And this

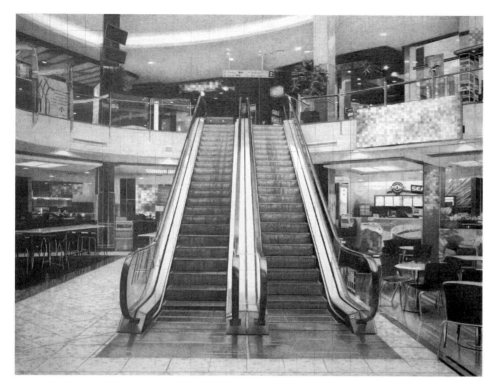

FIGURE 1–36
RUTH CLELAND
Escalator, 2007
Graphite pencil on board,
16 × 21.9"

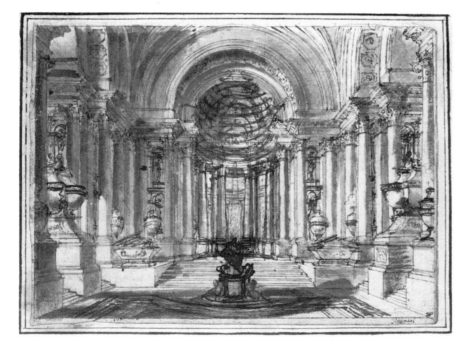

FIGURE 1–37
GIOVANNI BATTISTA PIRANESI
Large Architectural Interior
Pen and brown ink, with gray and
brown wash, details in red chalk,
over black chalk, on paper,
7⅜ × 9¹¹⁄₁₆"

is not to say that our awareness of spatial volume cannot be stirred in an exterior setting. In Michael Mazur's untitled landscape drawing (Fig. 1–38), a volume of space is powerfully implied in the center, formed by the arching canopy of tree branches.

FIGURE 1–38
MICHAEL MAZUR
Untitled, 1985
Charcoal #4500, 42½ × 60"

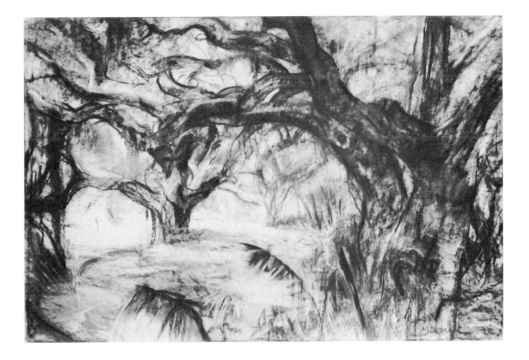

We urge you to take account of the different spaces you encounter in daily life. Concentrating on spaces instead of things will probably mean reversing your normal visual habit. It is suggested you do this so you can intensify your awareness of space. But this sort of activity will have an even broader application, because when you shift your attention from what you are accustomed to seeing, you help yourself develop a new vocabulary of expectations and responses. This may be awkward at first, and it definitely takes practice. But it is good to break visual habits. Doing so makes you more receptive to, and eventually eager for, the challenge of new visual perceptions.

Gesture Drawing as a Means of Capturing Space

If you wish to address the essence of a set of spatial relationships with directness and immediacy, you will do a **gesture drawing**. In general, the term *gesture* refers to the expressive posture of a human being, and indeed gesture drawing is an ideal means for capturing spontaneous human actions (Fig. 1–39). For artistic purposes, however, gestural characteristics may be interpreted from most of what we observe. For example, the nose of the helicopter in Figure 1–40 appears to point like a giant forefinger to the target below, mimicking a common human gesture.

Gesture drawing is a rapid sizing-up of the primary physical and expressive attitudes of an object or a space. Description in the gesture drawing is limited to the subject's essentials, which are searched out intuitively. Quick by

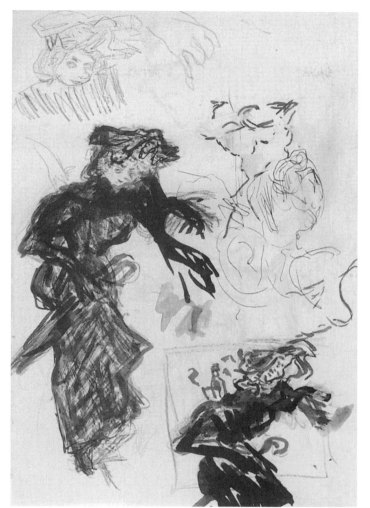

FIGURE 1–39
PIERRE BONNARD
Sheet of Studies, *Woman with Umbrella*, c. 1895
Graphite, pen and black ink, brush and black wash, and watercolor, on ivory wove paper, 312 × 199 mm

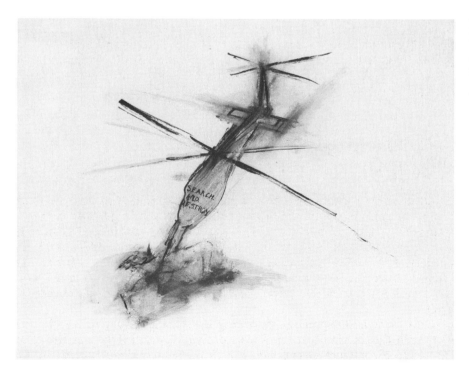

FIGURE 1–40
NANCY SPERO
Search and Destroy, 1967
Gouache, ink, 24 × 36"
© The Estate of Nancy Spero Licensed by VAGA, New York/Courtesy of Galerie Lelong, New York

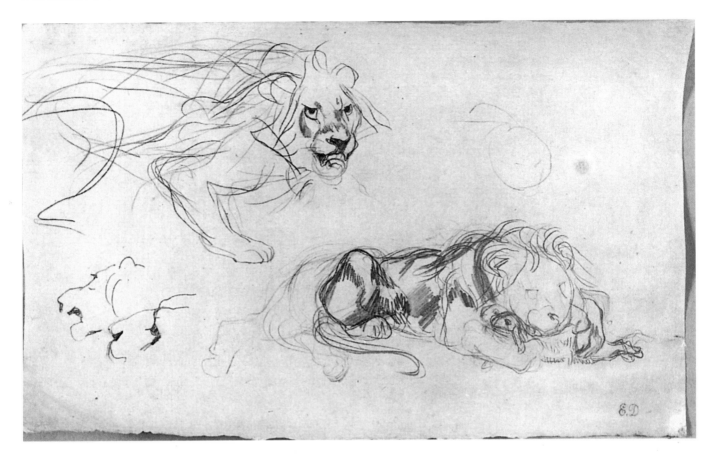

FIGURE 1–41
EUGÉNE DELACROIX
Study of Lions
Graphite on tan laid paper,
227 × 342 mm

definition, gesture drawing urges the artist into a frame of mind where details are ignored in favor of a subject's basic visual character. For this reason, artists often do gesture drawing to warm up prior to an extended period of work (Fig. 1–41).

A gestural approach also may be the basis for a final artwork. In Figure 1–42, for example, the record of the repeated sweeps of the artist's arm creates a gestural panorama at the scale of an installation piece. And gestural exploration can serve as the initial visual concept for a drawing that is meant to be developed into a finished work.* But regardless of how gesture drawing is used by the artist, the emphasis is on process—a process of search and discovery whereby immediate visual experiences are translated into the medium of drawing.

The more specific term **spatial gesture** may be defined as the gestural movement implied by an imagined linkage of objects distributed in space. This approach may be seen in the drawing by Alberto Giacometti (Fig. 1–43), in which a network of spatial linkages is created by lines that careen from one point to another in the depicted interior setting.

*For information about the relationship of gesture drawing to design, see Chapter 7 "The Interaction of Drawing and Design."

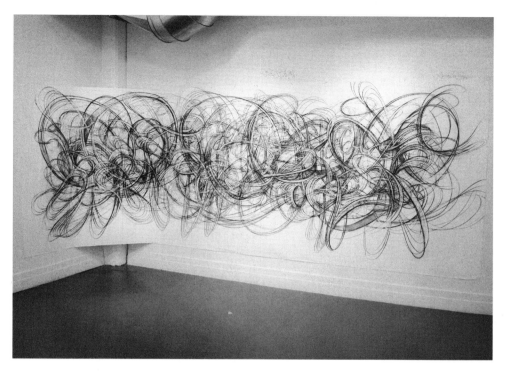

FIGURE 1–42
JENNIFER WROBLEWSKI
Slave to Love, 2009
Charcoal on paper, 72 × 190"

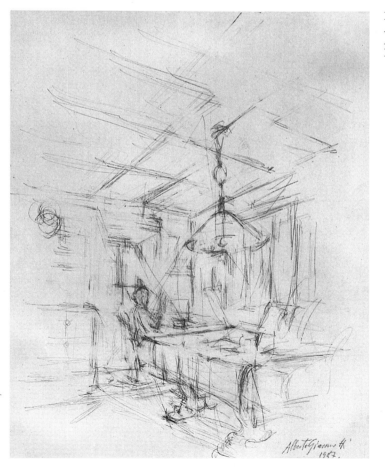

FIGURE 1–43
ALBERTO GIACOMETTI
Interior, 1957
Pencil on paper, 35¾ × 19¾"

Mapping Out Your Drawing Using Constellations

Seeing in terms of spatial gesture takes practice. Let us suppose that you are in a room that is filled with objects. To see the gesture in this room, let your attention bounce from object to object. Think of each object as occupying a particular spatial station; if the objects are large, select noticeable points on the objects such as a corner of a table, or the base of a lamp. Next, in your mind's eye try connecting a series of these points or stations until you are struck by a certain spatial gesture. A spatial gesture could consist of an imagined route that sweeps across the room pulling a sequence of objects—e.g., bicycle, chair, and birdcage—into one grand arc that takes visual possession of the space before you.

Be on the lookout for dynamic gestures that move diagonally through a space and help the eye to understand the receding planes of foreground, middle-ground, and background. Record this imagined gesture with a broad movement of your charcoal on the page, maintaining awareness of the deep spatial path your eye is following even while your hand sweeps across the flat surface of your paper. Now, although these objects have different names and uses in everyday reality, you have found a *visual* way to organize them.

While drawing, you may extend this process to fully map out the complex of major spatial gestures represented within your subject. Remember that each object in a space before you may be interpreted as occupying a specific point or station in that space. Next, realize that a grouping of selected points may be equated with the way stars in the sky are converted into dots that are eventually connected to outline the shape of an identifiable figure, or "constellation." Plotting or "mapping out" one or more constellations of points you see in the room before you should help you with scale and proportion as you transfer what you see in the world of real space to the two-dimensional surface of your drawing.*

A mapping approach can be observed in the Deigaard drawing (Fig. 1–44) in which the shadows attached to the bases of trees spill across the ground plane, suggesting conceptual paths or routes that connect the distance between trees. If you allow your eye to connect the fragmentary shadows cast high up on the tree trunks, you will in effect be forging aerial paths that should make you aware of the volume of light-filled space these trees inhabit.

Exercise 1C *The two drawings suggested in this exercise require you to concentrate on a particular linkage of objects in space. The purpose is to heighten your awareness of how space may appear to gesturally unfold.*

Drawing 1: From your easel or drawing table, choose a path through the objects in the room space before you. Take your drawing tool and re-create that path on your paper, using a simple, meandering line. It is advisable to look as much out at the space you are trying to represent and as little at your paper as possible.

As you draw, you should be convinced that you are steering your line into the space. Use sound effects as you (SQUEAL!) veer around one object to get to the next; or as you (GRUNT!) have to make several hard passes with your drawing media to get beyond an "obstacle" that is especially large or heavy, as in Figure 1-45.

*For a discussion on how constellations can help you draw objects in proportion, see "Spatial Configurations" in Chapter 3.

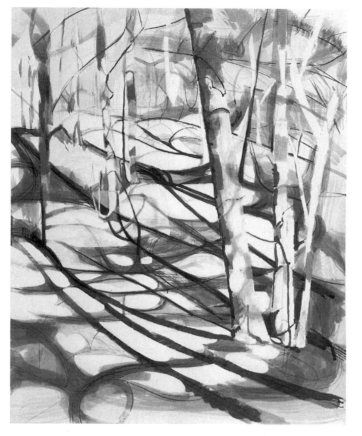

FIGURE 1–44
LEE DEIGAARD
Untitled (Wildwood), 2009
Sumi ink on paper,
29 × 23"

FIGURE 1–45
AMANDA NURRE, University
of Cincinnati
Student drawing: spatial gesture
Charcoal on paper, 18 × 24"

FIGURE 1–46
GEORGEANNE COOPER,
University of Oregon
Student drawing: diagonal lines
added to horizontal and vertical
lines to represent obstacles in an
interior

Drawing 2: *Do a second gesture drawing using the same concept of a spatial route. But this time look at your paper and make an even more varied set of marks to express the character of what you see along this path and the feelings that are aroused in you as you proceed.*

Work quickly, but be alert to the need for exerting varying pressures on your medium to suggest weight, scale, and speed changes along your journey. Remember that by thinking of objects as things that slow down and divert your course through space, you will naturally become more aware of the space between these objects (Fig. 1–46).

When you are finished, the expressiveness of these drawings might surprise you. But think of the personal decisions you had to make during the process. First, you singled out objects that divided the space in an interesting way; then, you had to choose what kind of marks would best express the responses you had as your eye followed along your selected path.

2

The Two-Dimensional Space of a Drawing

In Chapter 1, "The Three-Dimensional Space of a Drawing," we explored ways to create the **pictorial** illusion of three-dimensional space. The picture plane in this case was conceived as a window on nature. We also noted that the second definition of the term *picture plane* is the flat surface on which a drawing is made. That flat surface, usually a sheet of paper, represents the *actual* space of a drawing.

More specifically, this actual space of a drawing is two-dimensional. It is the *area* of the drawing, the product of the length times the width of the paper or support on which an image is drawn. And it is a space limited to the paper's surface and bounded by its edges.

So, flatness of surface is the fundamental property that links all the drawings you make. Indeed, even when you are concerned primarily with depicting an illusion of three-dimensional space, you also need to consider how best to lay out or divide the area of your page. This chapter stresses the primacy of the flat picture plane and introduces ways to address its two-dimensional space.

Two-Dimensional Space and Modern Art

Many modern artists have emphasized the actual two-dimensional space of the picture plane over its potential for three-dimensional illusion. Wishing to avoid what might be termed the "artificial" nature of illusionistic space, these artists have exploited the flat character of the drawing surface with the intention of "preserving the integrity" of the picture plane. In Figure 2–1 the right half of the drawing appears utterly flat in relation to the left half in which a rotating circular object appears to cut through the picture plane.

Other artists have chosen to actually extend their images *out* from the picture plane into the spectator's space. Collage, assemblage, and relief (Fig. 2–2) are some of the ways artists have opted to incorporate the space in front of the picture plane into their two-dimensional art forms.

Later in this chapter (see "Ambiguous Space") we discuss other ways in which modern artists have asserted the integrity of the flat picture plane, but first we must define more fully the two-dimensional character of a drawing. We begin by emphasizing the shape of the surface on which we draw.

FIGURE 2–1
ANDREW TOPOLSKI
Overground II, 1994
Graphite, pigment, and transfer
type on frosted mylar, 49¼ × 36⅛"

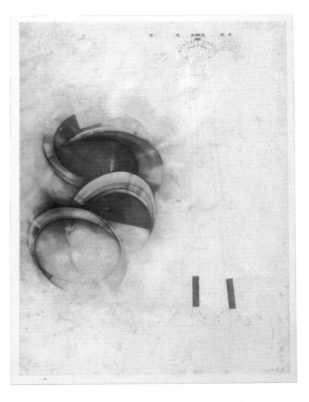

FIGURE 2–2
BRUCE CONNOR
Untitled, 1960
Mixed media (oil, wire, nail)
on canvas, 9¾ × 8⅛"

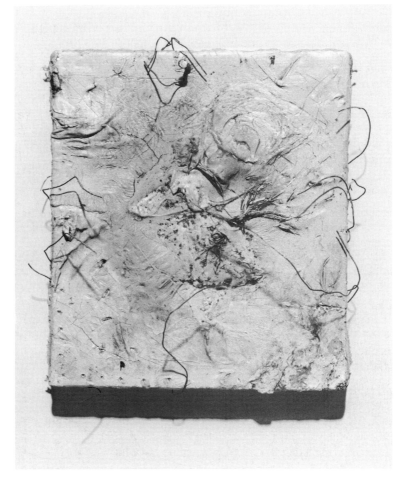

The Shape of a Drawing

The paper we draw on has a shape. (By **shape**, we mean a flat area with a particular outer edge, or boundary.) Since a sheet of paper is itself a flat shape, it follows that any image we draw on it will be, first and foremost, a shape. Let us take, for example, the drawing of a couple of pears by Michelle Cooke (Fig. 2–3a). The fruit, solidly modeled, exert a strong sculptural presence within the small format. And yet common sense tells us that the pears do not really exist on that page. Instead, we respond to a drawn image of those objects, an image that is convincingly modeled with charcoal to look round but is, nevertheless, in its truest physical definition a flat shape.

Positive and Negative Shape

From an artistic standpoint, subjects in the real world consist of two basic realities: the *positive forms* of objects and the *negative spaces* surrounding these forms or contained by them (such as the space between the handle and body of a coffee cup).

When you draw, the positive forms and negative spaces of your subject are converted into their pictorial counterparts on a flat surface: **positive** and **negative shapes**. Positive and negative shapes taken together constitute what we call the "**overall image**" in a work of art. To clarify this, let us look at Figure 2–3b (in which we have reduced the drawing by Michelle Cooke to its simplest shape state) and consider the following two points:

1. The entire rectangular surface of the Cooke drawing is divided into distinct positive shapes (P) and negative shapes (N).

2. The illusion of the two pears joined as single sculptural volume surrounded by space occurs within the actual shape divisions of the flat picture plane.

In truth, then, whenever we represent an object or a space on a page, we are creating a shape. And the first shape that is made automatically creates one or more additional shapes from the area of the drawing sheet. These shapes are designated as either positive or negative.

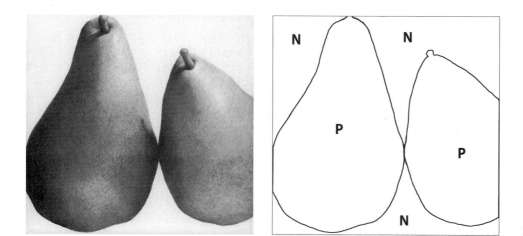

FIGURE 2–3a (left)
MICHELLE COOKE
Pear Series #27, 2008
Graphite on panel, 8 × 8"

FIGURE 2–3b (right)

Implications of the Term Negative Shape

The term *negative shape* carries connotations that may interfere with an appreciation of positive and negative relationships in a drawing. Unfortunately, negative shapes are sometimes defined as the empty, or passive, areas of a picture that remain after the positive image has been drawn. This may lead students to believe that negative shapes are somehow "second-class" and thus do not require the attention given to positive areas.

A related problem is the tendency for students to label as "background" all the areas of their drawing that lack prominent object symbols.* Referred to in this way, *background* really means "backdrop," or the subsidiary part of a drawing against which the positive image stands out. This tendency is caused in large part by the material conditioning of our culture; those things we can name usually take precedence in our minds.

But negative shapes aren't simply a backdrop, or what's left over when a positive image is drawn. *They are an integral part of a drawing.* When beginning to draw, be sure to regard the *entire* shape area of your empty sheet of paper as important. So it follows that *all* the shapes resulting from a division of that surface are also important and deserving of careful attention.

Each time you draw a positive shape on your page, you are simultaneously shaping the negative areas of your drawing. This means that positive and negative shapes have an immediate and reciprocal influence on one another. Therefore, any approach that neglects the negative shapes of a drawing will flaw the wholeness of a work and its expression. It will also limit your ability to take advantage of the total visual potential in both your subject and its translation onto a sheet of drawing paper. In view of all this, we are inclined to say that decisions about how best to break up the surface of your picture plane into positive and negative shapes are among the most creative of the drawing process.

Accentuating the Positive or the Negative

In summarizing what we have established so far in this chapter, we acknowledge that a drawing surface is flat and that all parts of an image, regardless of how convincingly they are modeled as volumes, are most essentially shapes. Thus, we may conclude that the substance of a drawing is crucially linked to the quality of its positive and negative shapes.

Furthermore, each of the shapes we make in a drawing exist apart from the real forms and spaces they portray. So a positive shape that represents something we recognize from the natural world is not inherently more important than a negative shape that stands for an uninhabited plane or space. The way shapes *do* derive their level of importance in a drawing is from the specific artistic treatment they receive.

Although the five-bladed saw is the subject matter in Figure 2–4, it is the exchange between positive and negative areas in this drawing that confers meaning and compels our interest. Note how the negative zones switch from a recessive role in the upper portion of the image to a suggestion of mass and volume at the bottom. (The handle can be read as sitting at the threshold of a dark cavity with the effects of chiaroscuro illuminating the surfaces that curve away from it.)

In the center of this drawing, the presence of the blades is implied by employing selective contours (observe the variety of marks and lines used to

*The term *background* as used here is not to be confused with its spatial application in Chapter 1, where it was grouped with the terms *foreground* and *middleground*.

FIGURE 2–4
JIM DINE
Untitled from "Seven Untitled
Drawings (5-Bladed Saw)," 1973
Charcoal and graphite on buff paper,
25⅝ × 19¾"

FIGURE 2–5
GEORGE SEGAL
1965–4
Conté on newsprint, 18 × 24"
*Art © George and Helen Segal Foundation/
Licensed by VAGA, New York*

punctuate the edges of the blades). Visually, this bare-bones conception enables the flat planes of the blades to engage the back space, transforming the negative ground into positive form and convincingly placing the blades into the light and atmosphere of the spatial illusion. Expressively, the contrast between the sturdy, well-defined handle and the fleet gesture of the blades is directly associated with the differing functions of different parts of the tool. In this way, positive and negative treatment is inseparable from the drawing's content.

In the pastel drawing by George Segal (Fig. 2–5), it is the negative shape that presses for our attention. Thus, Segal heightens viewer fascination by providing what is least expected: a negative, "empty" shape occupying the central portion of the drawing, a place typically reserved for positive shapes.

Exercise 2A

As we have indicated in this chapter, many of us are so accustomed to looking at positive forms that negative spaces often go unnoticed. Yet by virtue of their unpredictability, the negative spaces of a subject can have as much visual and expressive potential as their positive counterparts (Fig. 2–6). By isolating them for interpretation as flat shapes, this exercise will heighten your awareness of the "hidden" resources of negative spaces.

Select some objects that have distinct negative spaces. Ladders, chairs, stools, tires, and the like make ideal subjects for this kind of drawing. Jumble and overlap these items to maximize the number and variety of negative spaces (Fig. 2–7a). If you turn some of these objects upside down you will find it generally easier to ignore their real-world function and concentrate instead on their shape potential. Negative spaces may also be accentuated by keeping the room light low while turning a strong spotlight on the setup.

FIGURE 2–6
CONSTANTIN BRANCUSI
View of the Artist's Studio, 1918
Gouache and pencil, 13 × 16¼"

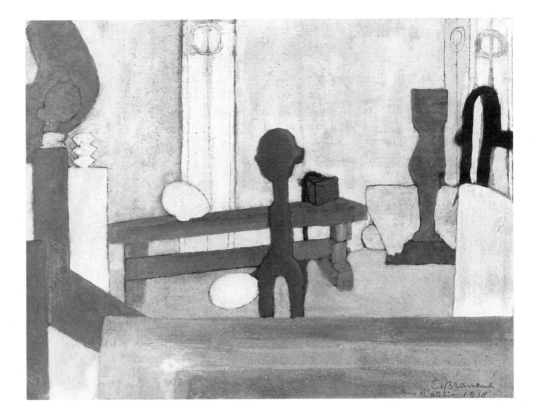

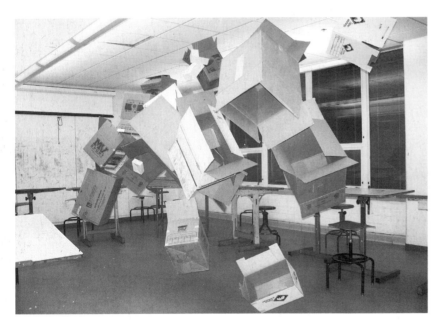

FIGURE 2–7a
Photograph of objects arranged
in a studio to create distinct
and varied negative spaces

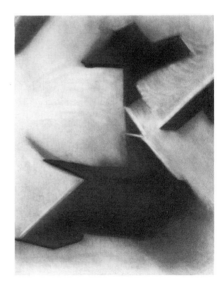

FIGURE 2–7b
BETSY MCCALLEN,
Auburn University
Student drawing: drawing
negative shapes to represent
form and space
Charcoal on paper, 24 × 18"

Next, find a viewpoint that offers the best assortment of negative spaces and translate them into darkly toned shapes on your drawing paper. Avoid using an outline to describe these shapes; instead, select media that come in a block form (such as lecturer's chalk, compressed charcoal, or a graphite stick) and draw the negative shapes by applying broad, vigorous strokes (Fig. 2–7b).

Ambiguous Space

At the beginning of this chapter we mentioned that many modern artists have de-emphasized (or rejected entirely) the illusion of three-dimensional space, wishing instead to accentuate the two-dimensional character of pictorial art (Figs. 2–1 and 2–2). This does not mean to imply, however, that these artists abandoned spatial interplay in their work, but rather that they wished to achieve the sensation of space while maintaining for the viewer a firm awareness of the flat picture plane.

One of the most enduring ways for modern artists to accomplish this seeming contradiction of space and flatness in pictorial art is by creating what is often referred to as **ambiguous space**. Ambiguous space can be described as a visual phenomenon in which the spatial relationships between positive and negative shapes are rendered perceptually unstable or uncertain. To clarify this description, we turn now to a discussion of three kinds of ambiguous space: interspace, positive–negative reversal, and figure–ground shift.

INTERSPACE

The term **interspace** is sometimes considered synonymous with negative space. But in the work of some modern artists it may be applied more appropriately to describe shapes that simultaneously depict illusions of depth and some degree of form.

To grasp this, look at the Cézanne (Fig. 2–8) and locate the large central negative shape defined by the tree trunks on the drawing's left and right sides and by the overhanging bough above. Clearly, we can *look into* this negative shape and enjoy the illusion of receding planes in a landscape. Also take into account, however, the modeled lines that define the two edges where this central negative zone meets the image of a tree on both sides of the drawing. These edges appear to be slightly rounded, or beveled, and express a subtle play of light and shadow. As a result, this dominant "negative" can be likened to a tangible puzzle piece snapped into place on a flat surface, one which we *look at*, even as we see the illusion of depth.

So, Cézanne provides enough visual clues in his treatment of the drawing's primary negative area to give it the suggestion of planar volume. Although this shape scarcely competes as a rounded volume with the more "concrete" positive

FIGURE 2–8
PAUL CÉZANNE
Sketchbook: *Landscape with Trees*, ca. 1885–1887
Chappuis 915, pencil,
124 × 217 mm

tree parts, it is, nonetheless, more present as a surface form than empty negative spaces are often thought to be.

Thus, our alternately spatial and tactile reading of this central area in the Cezanne furnishes it with its intermediate, or "interspace" character. And by calling attention to this negative area as a *shape*, Cezanne reaffirmed the surface of the flat picture plane.

Areas of interspace in a drawing give otherwise passive shapes a more active role, enabling, for example, untouched negatives to accumulate energy and direction. Note in this regard, the drawing by Degas (Fig. 2–9), in which all of the negative areas bluntly press against the image of the horse. The uppermost negative gains a sense of mass as it moves down from the top of the paper to meet the top edge of the horse's head. The large, lower negative portion fully implicates the left and lower paper margins as it sweeps across and slightly up from the left side of the drawing, gradually swelling and pushing as if it were a cushion in support of the quivering head.

A witty variation on the concept of interspace is found in the Neil Welliver (Fig. 2–10), where the veiling effect of light through water converts positive sections of the fish into an intermediate step that bridges full-blown positive-image areas with negative backspace.

POSITIVE–NEGATIVE REVERSAL

Ambiguous spatial relationships may also be achieved through **positive–negative reversals**, which occur when shapes in a drawing alternate between positive and negative identities. These alternations make the artifice of illusion more apparent and thereby acknowledge the presence of the work's actual two-dimensional surface. A good example of positive–negative reversal can be found in Figure 2–11, in which the white shapes may, at first glance, appear to be positive "islands" floating forward against a dark ground. But stare at the central black zone for

FIGURE 2–9
Edgar Degas
Head of a Horse
Pencil on paper, 6⁹⁄₁₆ × 4¾"

FIGURE 2–10
NEIL WELLIVER
*Study #2, For Trout
and Reflections*, 1982
Watercolor and pencil on paper,
22⅜ × 30⅛"

a moment and the reverse begins to happen: the black, formerly negative shape emerges as a positive "presence," and the white shapes seem to drop back like the sides of a box. What we may conclude from this is that either the black or the white shapes in Figure 2–11 may be understood as positive or negative according to viewer perception.

This phenomenon may also be used to great effect in drawings that feature some level of representation. Look, for instance, at how the two dark shapes at the top of Figure 2–12 may be read as either positive, cloudlike images on a gray ground or as negative cavities representing eyes on a face. The reversal of the right-hand shape is especially apparent; it seems to change its positive–negative identities continually. This is because one end of this shape coincides with the edge of the format, which heightens our variable reading of it as either an area drawn on the paper surface or as the illusion of a shape cut out from that surface.

FIGURE–GROUND SHIFT

The two previous topics have indicated ways in which individual shapes in a drawing may have two different identities. This may happen either simultaneously (as in the case of interspace) or alternately (as in the case of positive–negative reversal). A third type of spatial ambiguity aggressively combines aspects of both interspace and positive–negative reversal. It is commonly known as **figure–ground shift**.

Figure–ground shift occurs when all or most of the shapes in an image are given a suggestion of volume, and when virtually all the shapes appear to be constantly shifting, or slipping in and out of positive (figure) and negative (ground) identities.

In large part, figure–ground shift is the result of concentrating on the edges of shapes in a pictorial work of art. Varying the tone, thickness, and speed of edges can impart a positive, or figurative, weight to all the shapes in an image. And by making different portions of edges dip and rise, these variations also create an intricate webbing of overlaps that reinforces the physical existence of the flat picture plane. Consider, for example, *Black Untitled*, by Willem de Kooning (Fig. 2–13), in which each of the shapes interlock, with edges that twist back

FIGURE 2–11
DONALD SULTAN
Menorca, August 17, 1978
Ink and graphite on paper,
12⅛ × 12⅛"

FIGURE 2–12
SIGMAR POLKE
Physiognomy with Car, 1966
Ballpoint pen and gouache
on paper, 11⅝ × 8¼"

FIGURE 2–13
WILLEM DE KOONING
Black Untitled, 1948
Oil and enamel on paper mounted
on wood, 29⅞ × 40¼"

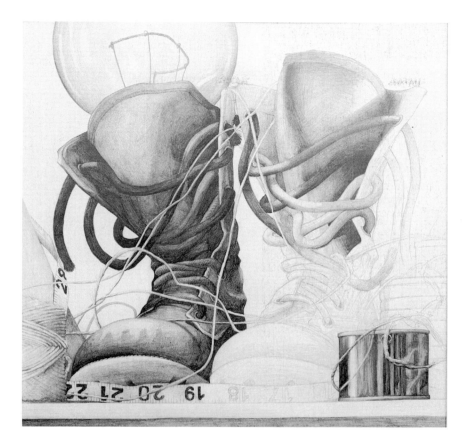

FIGURE 2–14
BETHANY BERG, Savannah College
of Art and Design
Student drawing: negative areas
given the illusion of interspace
Graphite on paper, 12 × 12"

and then forward, to create complicated spatial puzzles that the viewer cannot rationalize or solve.

In this drawing you should attempt to create a sense of interspace by giving equal weight to positive and negative shapes.

Exercise 2B

Choose a subject with a considerable number of framed negative spaces, such as a construction site, playground equipment, a large plant, or a still life. No special lighting is required.

As you draw, give simultaneous emphasis to both positive and negative shapes. It may help to think of all shapes, positive and negative, as having some degree of volume. This is the case in Figure 2–14, in which the spaces between objects may easily be perceived as interspaces.

In this drawing you will again be looking at positive and negative shapes, but this time you will be weighting and distributing these shapes so as to effect a positive–negative reversal.

Exercise 2C

Although traditional dry media such as charcoal or pencil will work well, you might consider as an alternative the use of black ink on paper or black and white paper collage.

Again construct a suitable still life or seek out in your environment a subject that suggests strong shape possibilities, such as a collection of items mingled with the drainpipes under your kitchen sink. Draw the objects using only black and white shapes. As you draw, be especially aware of how the shapes relate to each other and to the entire shape of your page. Your ultimate goal is to set up a relationship in which the dark and light shapes can be read as either positive or negative (Fig. 2–15).

FIGURE 2–15
Jamie Geiser,
University of Wisconsin
at Stevens Point
Student drawing: weighting and
distributing dark and light shapes
to create the effect of positive–
negative reversal
Charcoal on paper, 18 × 24"

3

Shape, Proportion, and Layout

In drawing from nature, you will be concerned with questions of proportion on two different levels. Perhaps foremost in your mind will be the problem of drawing your *subject* in proportion, by which we mean that you will want to observe and record correctly the relative sizes among the parts of your subject and the relationship of the parts to the whole. This problem is the focus of the first half of this chapter.

The second half of this chapter is devoted to the question of the proportional relationships *within the work of art itself*. In the most general terms, these relationships are established by how you choose to divide the two-dimensional surface of your drawing. Because these decisions are personal, they have a great impact on the expressive value of your drawing. Luckily, the same strategies for objectively observing proportion in your subject can be extended to aid you in the more subjective activity of determining the proportional relationships of your drawing as a whole.

Drawing in Proportion

Any subject you draw has proportional relationships. If the subject is a familiar one, such as a human figure, it is likely you will be able to tell when it is incorrectly drawn. In such cases, you may be able to correct the drawing using an educated guess, but in the vast majority of situations you will not have had sufficient familiarity with your subject to allow you to make intuitive judgments about its proportions.

Because artists since the Renaissance have been concerned primarily with depicting the *appearances* of their subjects, they have over time invented ways of using the picture plane to aid them in accurately measuring proportion. This chapter provides you with a number of devices, some traditional and others new, that will enable you to better judge the proportions of things as you see them.

Shape and Proportion

Take a moment and look at some common object before you. Notice the main shapes that make up the object and their proportions, or sizes relative to one another. Change your position, and you will find that those shapes have changed right along with you. Clearly then, each time you alter your position in relation to any object other than a sphere, you will be presented with a new set of shapes

and proportions. And in only a few views of a subject will the proportions of its shapes as seen correspond to that subject's actual, measurable proportions.

To better understand this, compare the drawing by Leonardo da Vinci (Fig. 3–1) with a painting by Andrea Mantegna (Fig. 3–2a). In the Leonardo, the figure is positioned so that its relative height and width may be easily judged.

FIGURE 3–1
LEONARDO DA VINCI
Drawing of ideal proportions of the human figure according to Vitruvius' first cent. A.D. treatise "De Architectura" (called "Vitruvian Man"), ca. 1492

FIGURE 3–2a
ANDREA MANTEGNA
Dead Christ

FIGURE 3–2b

In the work by Mantegna, however, the relative dimensions of the shape of the figure do not match those of the subject's real dimensions, since the vertical dimension of the shape is only slightly longer than its horizontal measurement. This may be seen quickly when the human attributes of the figure are masked out, as in Figure 3–2b.

Shape and Foreshortening

When an object is situated so that its longest dimension is parallel to the picture plane, as in the Leonardo, the object is seen in its unforeshortened view. When the longest dimension of the object is at an angle to the picture plane, the object is said to be **foreshortened**. In the Mantegna, the longest dimension of the body is almost perpendicular (at a right angle) to the picture plane, making it an example of extreme foreshortening.

Leonardo's figure, comfortably circumscribed by circle and square, is not in conflict with the two-dimensional space of the page. In this case, the representation of the figure does not demand that we become involved with pictorial space. Mantegna, on the other hand, pushes this demand almost to its limit. The peculiar shape of the figure lets us know that we are seeing a body extended into space. And at the same time that we are made to acknowledge this deep, fictive space, we may also become aware of the compression of the figure into a flat shape on the picture plane.

Herein lies the paradox of shape: It is in itself flat. Yet when we grasp the proportions of a shape in relation to the object it represents, that flat shape serves as a powerful indicator of the object's spatial position in relation to us.

So when the image of an object is projected onto a picture plane, it exists as a shape. This shape has measurable proportions within itself. And as a unit of area on the picture plane, it may be compared in size with other shapes and with the shape of the whole page. Therefore, whenever you have difficulty seeing an object's proportions relative to itself or to its surroundings, it is helpful to ignore its three-dimensional character and concentrate instead on its shape.

FIGURE 3–3

Measuring with Your Pencil

Measuring with your pencil will assist you in seeing the proportions of a particular shape. To measure with your pencil, look at the shape of the object you wish to draw and decide which are the longest and the shortest of its dimensions, or axes. Then determine how many times the smaller dimension of the shape goes into its larger dimension by following the steps demonstrated in Figure 3–3.

This procedure may be used to compare any measurements in your drawing. The accuracy of the procedure depends on maintaining the pencil at a constant distance from your eyes (full arm's length is advised) and on keeping the pencil parallel to your imaginary picture plane.*

Using the Viewfinder to See Proportion

A viewfinder may be described simply as a framed opening through which you can view a selected portion of the visual field in front of you. More than likely, you have already had the experience of looking into the viewfinder of a camera to anticipate how your subject will look in a photograph.

When you are making a drawing, a viewfinder that corresponds to the shape, or format, of your drawing paper can be helpful in selecting the exact subject you wish to draw. In discussing a drawing, the word **format** is used to describe the total shape, size, and orientation of the drawing surface.

You can make a viewfinder by cutting a window in a piece of lightweight cardboard. As indicated above, the proportions of this opening should correspond to the format of your paper. As an example, if the dimensions of your paper are eighteen inches by twenty-four inches, the ratio of the sides of the viewfinder window will be three to four, and the opening that you cut in your cardboard will be three inches by four inches (Fig. 3–4).

For a full discussion on the picture plane, see Chapter 1, "The Three-Dimensional Space of a Drawing."

FIGURE 3–4

You will probably find the viewfinder an invaluable aid when it comes to observing proportion, largely because it will enable you to instantly recognize the shapes inherent in your subject. This is because the (usually rectangular) opening of the viewfinder itself will impress you as a strong shape, encouraging you to readily perceive the objects seen framed within the opening as smaller shape divisions of the whole.

When using a viewfinder, imagine that its format edges match exactly the edges of your drawing paper. Then draw the shape of your subject so that it fills the page in the same way the image fills the viewfinder. It is helpful to pay special attention to the negative shapes lying between the subject's outer edge and the boundaries of the viewfinder because you may find it easier to judge the proportion of these abstract shapes than the shapes of nameable objects. In this regard look at Figure 3–5 in which a viewfinder was used to zoom in on a still life. Using the viewfinder when doing the small preparatory sketches informed the student artist that larger, more dramatic shapes could be obtained by cropping most of the objects.

For the sake of greater accuracy, some students prefer to use a gridded viewfinder. This can be made by punching holes into the margins of the view-finder at equal intervals and running thread from one side to the other, forming a grid. If you place the holes at one-inch intervals in a three-by-four-inch opening, you will divide the opening into twelve one-inch squares (Fig. 3–6a). To use this viewfinder effectively, you should also divide your eighteen-by-twenty-four-inch paper into twelve six-inch squares. What appears in each square of the viewfinder can then be transferred to the corresponding square on your drawing.

A simpler alternative is to divide your viewfinder into only four rectangles. This will keep you aware of how your composition is centered without requiring that you painstakingly copy exactly what you see in each square of the grid (Fig. 3–6b).

FIGURE 3–5
HALEY ASKENAS, Savannah
College of Art and Design
Student drawing: viewfinder
used to crop image
Watercolor on paper, 22 × 30"

FIGURE 3–6

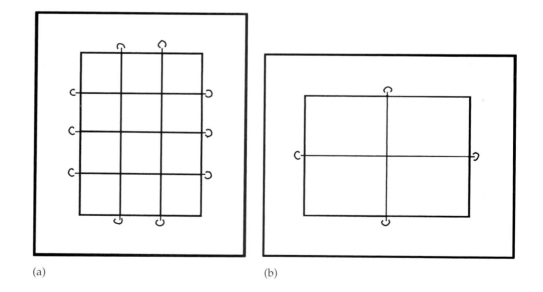

(a) (b)

Spatial Configurations

Thus far in this chapter we have been discussing how seeing objects as flat shapes
can aid you in drawing them in correct proportion. However, this process may
also be applied to help you see proportional relationships between various points
in the spatial field before you. By connecting selected points on objects and sur-
faces distributed through a space, a distinctive shape is formed.

The best analogy to this activity is the practice of naming constellations. **Constellations** are actually three-dimensional configurations; in other words, the stars making up a constellation are located at various distances from the earth, and the difference between these distances may be measured in thousands of light-years. But we are generally unaware of the vast depth discrepancy between stellar positions in the deep space of the universe; consequently, we perceive the apparent groupings of stars as flat shapes. So when we see the shape of a big dipper or a scorpion in the night sky, we are actually seeing the **shape aspect*** of a configuration of points in very deep space.

Angling and the Picture Plane

Our environment is full of horizontal and vertical lines. Linear elements from the environment that are vertical almost always appear as verticals on the picture plane. But linear elements that are horizontal (such as windowsills and baseboards) often appear as diagonals on the picture plane. To transfer the angle seen in the environment to the drawing surface, we use a technique called **angling**.

We have broken down the angling procedure into the following steps:

Step 1. Stand at about arm's length from your easel. If you are right-handed, position your easel so that you are looking at your subject past the left margin of your page.

Step 2. Face your subject. Now imagine that a pane of glass is at about arm's length in front of you. Grasping your pencil between thumb and fingers, move the pencil up and down to get the feel of this imaginary plane.

Step 3. Single out some item in the room that has a vertical line (such as a doorjamb). Still keeping your pencil pressed against the "glass," align it with the vertical line of the doorjamb. Now single out a line that is not vertical, such as one formed by the junction of the ceiling and the wall. Pivot your pencil on the imaginary pane so that it is lined up with that diagonal (or horizontal). Practice aligning your pencil with various linear elements in your environment, *taking care not to point through (or into) the imaginary pane of glass.*

Step 4. Station yourself at your easel. Choose one of the lines you have just practiced angling. Now swing your arm to your paper, keeping the angle of the pencil constant. Lay the pencil against the paper and draw a line parallel to it.

Step 5. Check the angle by repeating the process until the angle comes out the same each time.

A variation on the angling method is to pretend that the imaginary pane of glass in front of you is the face of a clock and that your pencil represents the hands of that clock. Grasping your pencil in the middle, hold it on a vertical—that is, six o'clock. The correct "time" for a horizontal is, you guessed it, quarter of three. When you apply this technique to angles in real space, first decide if the angle in question is closer to the vertical or the horizontal. If it is closer to the vertical, line up your pencil with the actual angle and, looking only at the top half of your pencil, determine how much before or after six that angle represents (five of six, ten after six, and so on). In the case of a horizontal, you will gauge the direction of the left half of your pencil to determine whether the actual angle is closer to two-thirty or three o'clock (twenty-five of three, or five of three, and so on). When you transfer the angle to your paper, check to see that it tells the same time as the actual angle you are drawing.

*By *shape aspect*, we mean the shape of something seen from any one vantage point.

ANGLING BETWEEN SPATIAL POINTS

The methods just described for angling linear elements in your subject may also be used to measure the degree of angle formed by any two points in your visual field.

First, select two easily distinguished points in the space before you (such as the corner of a table and the center of a clock). Next, angle these two points with your pencil (taking care not to point through the picture plane) and transfer that angle onto your drawing.

TRIANGULATION

Angling between a set of three points on the picture plane can be an invaluable aid in correctly positioning the overall image on your page. To triangulate, first angle between two points and then angle from these two points to locate the third.

The procedure for triangulation is shown in Figure 3–7. When you have followed this procedure, and if you have angled accurately, you will have established three widely spaced points in your drawing. You may then accurately locate other points in your picture by angling from any two points already determined.

TIPS ON TRIANGULATION

1. Always look for the largest possible triangle of points within your subject matter. The closer the points come to filling up your format, the more valuable the triangle will be in setting up the entire image.

2. Always try to find a roughly equilateral triangle. If your triangle is made of obtuse and very acute angles, any error in angling will throw off your proportions. If all legs of the triangle are about the same length, a slight miscalculation of angle will not make much difference.

3. If your pencil is not long enough to angle between the two desired points, you have two options: (a) find something longer to angle with, such as a ruler or yardstick; or (b) hold the pencil closer to your eyes.

4. If you have great difficulty picking up the technique of angling, try using the edge of a broad ruler or plastic triangle in lieu of a pencil. The plane of the ruler or triangle will remind you where your picture plane is so that you will have less of a tendency to point through it.

Advice on the Use of Proportioning Techniques

All the devices introduced in this chapter require that you make conscious use of shape and the picture plane to arrive at correct proportions. In many circumstances, the viewfinder will be the first proportioning device to which you will turn. Not only can it help you to select that part of your subject that you wish to draw, but its use will enable you to quickly lay out the overall proportions of your subject on your page. With the information you gather from observing the way in which the shapes of objects fill up the opening of your viewfinder, you will be able to sketch in the skeletal structure of your drawing before concerning yourself with any fixed measurement.

Your second choice should be triangulation, the method used to fix the larger relationships between spatial points. It is a speedy and accurate way to proportion the overall image of your drawing. For more localized measurements, you may use the techniques of angling and measuring with your pencil. Measuring

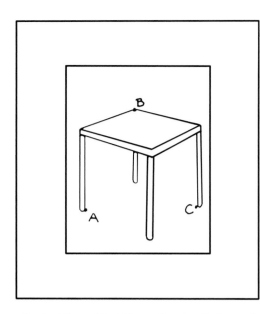

a. Look at the subject through a viewfinder and select three points that roughly form an equilateral triangle

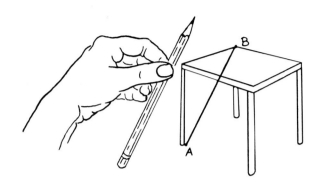

b. Angle your pencil between A and B, record this angle, and mark the points

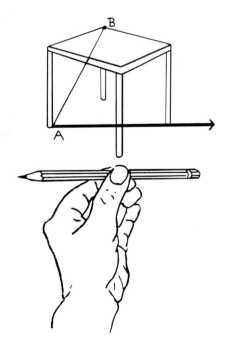

c. Now record the angle that goes from A through C. Extend the line from A beyond where you think C is located

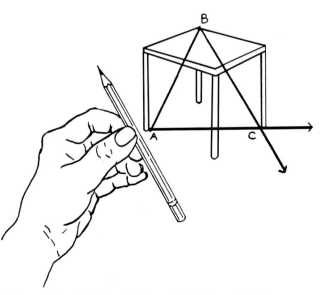

d. Record the angle from B through C. Where this line intersects the previous one is the location of point C

FIGURE 3–7

FIGURE 3–8
JESSICA ENGLUND, University of
Arizona, School of Architecture
Student drawing: viewfinder used
to explore subject from various
viewpoints
Pencil on paper, 14 × 17"

with your pencil on the picture plane will give you a sense of the proportions of
any individual shape you see and may also be used to determine the relative di-
mensions of separate shapes.

Although an overdependence on these mechanical devices can result in
drawings that look stilted, the procedures described are beneficial beyond their
immediate use for plotting proportions more accurately. First, they will sensitize
you to the presence of the picture plane. Second, these techniques will, through
repeated use, become internalized, so that eventually you will begin to see shape
relationships without actually having to go through the motions of angling,
measuring, and so forth.

And anytime you are perplexed because a subject is unusual or over-
whelming, you may be helped by recourse to one or more of these proportion-
ing devices.

Exercise 3A *Drawing 1:* *This drawing will help you understand how the viewfinder may be used as a pro-
portioning device for drawing complex subjects. Choose or set up a subject that features negative
spaces, such as chairs with rungs, a ladder, or a bicycle. Looking through your viewfinder, scan your
subject until you find an appealing arrangement of positive and negative spaces. Do a series of
quick studies, from several different viewpoints recording the size, position, and shapes of the spaces
as they appear in relation to your viewfinder's format (Fig. 3–8).*

Drawing 2: *In this drawing you will be using triangulation to measure the relationship of points
in your visual field.*
*Look for three widely spaced points in your visual field and triangulate between them.
Remember that the three points that compose the corners of your triangle do not need to belong to the
same object or be on the same plane, as illustrated in the example in Figure 3–9, in which the lowest
rib and toe of one model are connected by triangulation with the groin of the second model, located
closer to the viewer. Note also in this example that the student has combined triangulation with the
use of a viewfinder, a practice that assists in determining the widest possible spacing of points.*

Laying Out Your Drawing

The basic arrangement of the parts of an image within a two-dimensional format
is referred to as the **layout** of a drawing. Before you lay out the basic blueprint of
your drawing, however, it is crucial that you spend some time considering the
visual and expressive potential of your subject.

FIGURE 3–9
JENNIFER O'DONOGUE,
Cochise College, AZ
Student drawing: proportion
and layout achieved with the
combined assistance of viewfinder
and triangulation
Charcoal pencil

EXPLORING THE VISUAL POTENTIAL OF YOUR SUBJECT

Because almost any subject you choose to draw will yield a variety of shapes when regarded from different points of view, it is generally advisable to explore your subject's visual potential before you begin to lay out your drawing. Spend some time moving around your subject, sizing it up from various vantage points and generally experiencing how different orientations provide different visual aspects of the same source material.

Avoid the all-too-common practice of taking the same seat or easel each time you enter the classroom and then remaining there as if anchored. On the face of it, this practice may seem harmless enough, but it amounts to allowing chance to determine what you will draw.

So as a beginner, you must consciously take the initiative to find a meaningful approach to your subject matter. And remember that the drawing process really begins as you study your subject in order to see and weigh the aesthetic possibilities it offers. This process of personal exploration is vital because you will gain a sense of control over what may be a complex situation; your ambitions for your drawing will be more clearly formulated; and you will feel that whatever point of view you ultimately take is one you have chosen for its expressive potential.

PROPORTION AND LAYOUT

Until now we have been discussing proportion in terms of correctly observing and recording the size relationships within your subject. However, proportion is also an issue when you as an artist must decide how best to subdivide the surface area of your drawing.

Artists usually lay out, or sketch in, the major shape divisions of their drawing before working on any one area. But even before you put down the first mark, you are faced with the overall proportional relationship of your drawing surface, namely, the ratio of its length to its width. In standard drawing pads, the ratio of length to width is often three to four. But you do not have to accept the ratio dictated by the manufacturers of your pad. If you wish a particular drawing to have a square format (or a circular, triangular, or cruciform format, for that matter) you can either cut your paper to the desired shape or even more simply, draw the new format border within the paper you have at hand.

Before you begin to draw you should also decide how to turn your pad so that it is best suited for drawing your subject. Because the standard pad is usually bound along one of its smaller sides, many students automatically set the pad with the bound side uppermost, so that the paper will not flop over. When the pad is in this position, with its longer dimension vertical, the format is called a *vertical format*. Turn the pad ninety degrees and you have a *horizontal format*. (If you customarily stand your pad at a bench or easel and wish to leave your paper in the pad while using a horizontal format, you can use clips to keep the paper from falling forward.)

SCALING THE IMAGE TO THE FORMAT

A major consideration of layout and proportion is how large you should draw a subject in relation to the page.

Some students draw a subject so large that it will not fit comfortably on their paper. But a far more common problem, especially for beginners, is that of drawing a subject so small that it resembles an island floating in the middle of the page. Aside from looking timid, such drawings suffer from a lack of illusionistic depth, since the drawn image in this case reads as a single figure in an unspecified ground (Fig. 3–10a). And the overall surfaces of these drawings remain visually inactive, as there is little or no tension between the drawn image and the edges of the format.

Before you begin to draw, try studying your subject for a few moments through the viewfinder, not only holding the viewfinder at different distances from your eyes but also shifting it vertically and laterally so that you can see different areas of your subject in relation to a format. Note that when you focus on details, some of the objects may not be seen in their entirety. This tends to make those objects less recognizable and therefore more easily perceived as abstract shapes.

This process of adjusting the size of what you draw to the size of your page is called "scaling the image to the format." If you have difficulty scaling the image to your format, consider using the proportioning devices introduced earlier in this chapter.

When using triangulation as an aid in scaling your image to the format, choose three points from your subject that form an approximate equilateral triangle and then transfer them to your paper as described in the section on triangulation. To fill your format, locate these points as close to the edges of the format as possible. Triangulation may also be used as a first step in the process of using a constellation of points to map out your drawing. (See Chapter 1 for additional information on mapping out your drawing.)

By adjusting the distance at which you hold your viewfinder (anywhere from a couple of inches from your face to full arm's length) you can view a subject at various sizes in relation to the format. If the viewfinder is held very close, the

(a)

(b)

(c)

FIGURE 3–10

subject may appear to dwindle in relation to the space around it; at half arm's length, it may appear to push insistently against the edges of the format, and at full arm's length you may observe only details of the object. The experience of changing the distance at which your viewfinder is held is akin to manipulating a zoom lens on a camera.

Figure 3–10a, b, and c show how the scale of a subject in relation to the format changes as the viewfinder is held at varying distances from the eyes.

Tips on Selecting a Vantage Point

Generally, a subject seen in a foreshortened view will appear to engage space more actively than it will in an unforeshortened view. To demonstrate this, compare a drawing of a bicycle by Alan Dworkowitz (Fig. 3–11) with a commercial illustration of the same subject (Fig. 3–12).

FIGURE 3–11
ALAN DWORKOWITZ
Bicycle II, 1977
Graphite, 20 × 18"

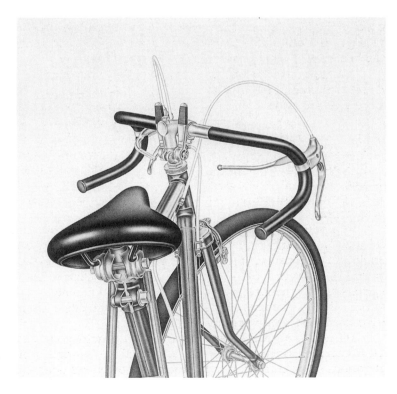

FIGURE 3–12
Bicycle advertisement

Both drawings may be considered realistic in that they depict the subject in a fair amount of clear and precise detail. There are, however, some fundamental differences between the two. The illustration presents the bicycle in an unforeshortened view so that the potential consumer may see at a glance the various components and accessories this model has to offer. Correspondingly, the illustration avoids a unique vantage point because any part of the presentation that calls attention to itself would detract from the primary intent of the drawing: to sell bicycles.

On the other hand, the intent of Dworkowitz's drawing is not to saturate us with facts but rather to captivate us *visually*. Depicted from a much less expected vantage point, the foreshortened frame of the bicycle enters the illusory space of the drawing in a very aggressive way. With the handlebars and front wheel turned out to the right-hand margin of the page, we may sense an invitation to mount the bicycle, straighten the wheel, and go off touring countrysides.

Tips on Laying Out Your Image

In Figures 3–11 and 3–12 we saw very different treatments of a bicycle in space. A further comparison will show how differently these two images have been laid out on the page. In both drawings, the bicycle is featured as a single, isolated figure. But in the illustration, the entire bicycle is depicted and there is no boundary between the picture space of the illustration and the printed part of the page. For the purposes of the illustrator, the ground has no character in its own right; it does not imply space, nor does it have any limits that define it as a shape.

In contrast, the drawing by Dworkowitz is made visually exciting by its layout. How the image is laid out is as important as its depicted spatial orientation and precise detail. The fact that the image is cut off so that we see only the front half of the bicycle directs our attention to the space beyond. The empty ground here is dramatically contained; like an empty stage, it anticipates action.

You can see, therefore, that while you are examining the subject from various angles, you should at the same time be thinking about how you are going to lay out that subject on your paper. Even when you are concerned primarily with the spatial aspect of your subject, the expressive potential of your page as a flat surface divided into a set of particular shapes must be reckoned with. If you take into account the entire surface of your drawing's format, all the areas, positive and negative, will have meaning, as in the student drawing in Figure 3–13.

FIGURE 3–13
Student drawing: effective
subdivisions of the drawing's
surface into positive
and negative areas

As this chapter suggests, such seemingly mechanical decisions about where to sit, which way to hold your pad, and the format to use are actually the underpinnings of your drawing's expression. This project is designed to guide you through these early stages of making a drawing, helping you to understand their sequence and their importance.

Exercise 3B

Drawing 1: *Choose a subject that is visually diverse and that also allows you to view it from a number of angles. Next, with viewfinder in hand, move around your subject, carefully considering its visual potential from different vantage points. Narrow down your options and make a set of studies.*

Begin your studies by loosely (gesturally) describing your subject. Take into account the scale of the entire image in relation to its format and how the flat surface of your drawing is being laid out, or subdivided, into positive and negative zones (Fig. 3–14).

FIGURE 3–14
Jack Long, Rhode Island
School of Design
Student drawing: layout study

FIGURE 3–15
Angela Burch Tingle,
Oklahoma State University
Student drawing: four studies,
two of which introduce
improvisation
Pencil, 18 × 24"

Drawing 2: *Once you have become accustomed to the process of selecting portions of your visual field for their design potential, you might try improvising on what you see within your viewfinder. Look at the student drawing in Figure 3–15. On the left-hand side of the page, the student started with two straightforward details of a clothespin. The images on the right are more imaginative, as she has bent the forms and elaborated on their patterns.*

<div style="text-align: right; font-size: 3em;">4</div>

Linear Perspective

Because linear perspective has the aura of a technical subject, many students think it is difficult to understand. But while perspectival systems involving complex mechanical procedures have been developed for people who do technical drafting (such as architects, designers, and engineers), the basic concepts behind linear perspective are few and simple, and therefore easily within the grasp even of those who are not technically minded.

Point of View

In its broadest sense, perspective drawing refers to the representation of things as they are arranged in space and as they are seen from a *single point of view*. Therefore, what is central to the issue of drawing in perspective is the concept of the artist's bodily position in relation to the things represented.

When looking at a drawing or painting, we tend to identify with the implied point of view; that is, we instinctively know whether the artist was looking up, down, or straight ahead at the subject. In the drawing by Henry Schnakenberg (Fig. 4–1), for instance, there is no doubt about the artist's viewpoint. In consequence, our own inferred position is consistent and clear, perched as we are above this forest floor covered with leaves and needles.

FIGURE 4–1
HENRY SCHNAKENBERG
Forest Carpet, 1924
Watercolor and graphite pencil
on paper, Sheet (irregular):
12 × 16" (30.5 × 40.6 cm)
Whitney Museum of American Art,
New York; purchase 31.463/Courtesy
of Kraushaar Galleries, New York

Because a fixed viewpoint in a picture helps establish a convincing illusion of space, it is generally recommended that aspiring artists understand how to achieve a fixed viewpoint in their work. It is important to recognize, however, that an artist's choice to develop a consistent viewpoint in a particular work depends on the demands of subject matter and expression. For example, the multiple points of view in Mstislav Dobuzinskij's drawing (Fig. 4–2) serve to disorient the viewer and reinforce the work's phantasmagorical quality. On the other hand, the untitled drawing by Vincent Desiderio (Fig. 4–3) elicits a strong response from the viewer due to its unconventional, yet thoroughly consistent, point of view.

THE CONE OF VISION

To better understand the three-dimensional character of things you see, think of your field of vision as a conical volume whose apex is located at your eyes. Since this cone extends as far as you can see, there is no fixed or actual base to the cone, but when you imagine a picture plane (window on nature) intersecting this cone, its base lies within the plane (Fig. 4–4a).

FIGURE 4–2
Mstislav Valerianovic
Dobuzinskij
The End, ca. 1918–1921
Brush and black and gray wash with charcoal and graphite on ivory wove paper laid down on cream wood-pulp laminate board, 615 × 455 mm

FIGURE 4–3
Vincent Desiderio
Untitled (one of a series of
four drawings dedicated to
Salvador Allende), 1985
Charcoal on paper, 50" (diameter)

Take a moment to investigate the cone of vision. If you were to lift your eyes from this book and look across the room, or better yet, out a window, you would note that your eyes can take in the entire image of something large when it is a fair distance away. For instance, you would be able to see the full image of a medium-sized building at a single glance if it were across the street from you. Something much smaller and yet far closer, such as this book held broadside against your nose, however, could more than fill up your cone of vision. This little experiment should make you more conscious that what we think of as a field of vision is actually a conical volume.

If you tilt your head back to look up, the cone of vision will be angled away from the ground. The picture plane, which contains the base of the cone of vision, will also be at an angle, as illustrated (Fig. 4–4b), but still in the same relationship to the eye.

FIXED POSITION

Students not trained to draw in perspective often combine what they *see* with what they *know* in such a way as to produce contradictory information. As an example, compare the freehand drawing a beginning student might make of a

FIGURE 4–4

(a)

(b)

square-topped table (Fig. 4–5a) with the drawing the student would make if the image were traced on glass (Fig. 4–5b).

The student knows that the table has a square top and four vertical legs. In actuality the top of the table is perceived as a square only when it is parallel to the picture plane (as when seen from directly above), and from this vantage point it would be impossible to see any of the table legs. So, the student makes the compromise of drawing what is known (that the tabletop is square) with what can actually be seen from that vantage point (three out of four table legs). In effect, Figure 4–5a attempts to show two entirely different views of the table.

The drawing in Figure 4–5b, on the other hand, shows what the table would look like from a single point of view. Notice that you still have no difficulty recognizing that the tabletop is square, although it is not drawn that way. The diamond shape that represents the tabletop is, in fact, what we expect to see when a square is at that particular angle to the eyes. Furthermore, it is consistent with the position of the table legs.

A picture in which everything is drawn so as to be consistent with a single point of view conveys a sense of fixed position. **Fixed position** may be defined as the exact location of the viewer's eyes in relation to a subject. To achieve a consistent point of view in your drawing, it is important to maintain a fixed bodily position in relation to your subject. In other words, do not move closer or farther, or to the left or the right, and do not stoop down or stand on tiptoe to obtain another view of what you are drawing.

THE CONCEPT OF EYE LEVEL

A key term for determining eye level is **ground plane**, which refers to the horizontal surface you occupy, such as a floor or a patch of earth, when observing subject matter.

Eye level may be defined as the height at which your eyes are located in relation to a ground plane. Although it is often taken for granted, an awareness of eye level is essential to the understanding of fixed position.

In a three-dimensional space, eye level should be thought of as the horizontal plane in which your eyes are located. To get a better idea of this concept, it might be helpful to hold up a piece of thin cardboard horizontally to your eyes so that you can see only the edge of it. Since you can see neither the top nor the bottom of the cardboard, we can describe the cardboard in this position as a diminished horizontal plane.

FIGURE 4–5

(a)

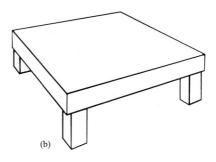

(b)

If you are standing on level ground, the diminished horizontal plane will be parallel to the ground plane. But because of your vantage point, the ground plane will *appear* to tilt up to meet the diminished horizontal plane. The apparent intersection of these two planes forms what we will call the **horizon line**.

Eye level is described as high or low by virtue of its distance from the ground plane. We think of normal eye level as that of an average person when standing up—say about five and a half feet above the ground plane. Many representational drawings make use of this conventional eye level, but any time a drawing is executed from a vantage point radically different from the normal one, we are aware that its implied eye level is unusually high or low. In the Laurence Channing drawing (Fig. 4–6), the very high vantage point implied by the view of so much ground plane suggests that we are seeing this industrialized landscape from a very tall building or low-flying aircraft.

When looking at works of art, however, we are generally more concerned with the implied eye level in relation to the subject than we are with the artist's actual eye level at the time of execution. In the Joel Janowitz drawing (Fig. 4–7), the artist's actual eye level is unknown, but we have no reason to believe that it

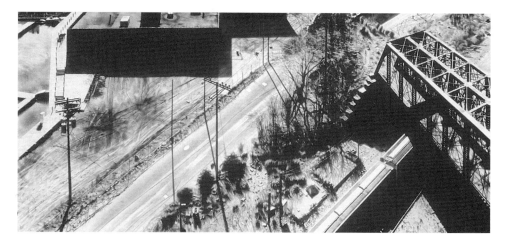

FIGURE 4–6
LAURENCE CHANNING
Gyre, 1996
Charcoal on paper, 80 × 40"
Courtesy of the Addison Gallery of American Art, Philips Academy, Andover, MA

FIGURE 4–7
JOEL JANOWITZ
The Painter, 1974
Charcoal, 28 × 38¾"

departs radically from the height of a standing person. What we do notice is that we seem to be looking almost straight up at the subject. So in this case, we would describe the eye level of the drawing as low because of its relation to the subject. Notice that, in both this drawing and in the Channing, the eye level is so extreme that horizon lines do not even appear within their formats.

So, establishing the eye level in a drawing means that all the subject matter has been portrayed from a consistent view point. Eye-level options include a normal, straight-ahead point of view; a point of view that looks up at the subject matter (it is above eye-level, or seen from what is commonly referred to as "worm's-eye" view); or a point of view that looks down at the subject matter (it is below eye-level, or seen from what is commonly referred to as "bird's-eye" view). Sometimes artists draw a horizontal line across their paper to indicate their eye-level.

Exercise 4A *A consistent viewpoint in a drawing helps to establish a convincing illusion of space; it also immediately communicates to the viewer an important aspect of the way you perceived your subject.*

For this exercise, draw a still life that consists of small objects, or even a single object, from various eye levels. Figure 4–8a and 4–8b show arrangements of objects from different points of view.

FIGURE 4–8a
Julia Huang, Savannah College of Art & Design
Student drawing: objects seen from a low eye-level, or "worm's-eye" view
Charcoal and pastel dust on paper, 22 × 30"

FIGURE 4–8b
NICHOLAS LEOPOULOS, Savannah
College of Art & Design
Student drawing: objects seen
from a high eye-level, or
"bird's-eye" view
Charcoal and pastel dust on
paper, 22 × 30"

Convergence and Fixed Position

One of the concepts central to the study of linear perspective is that parallel lines in the environment appear to converge (come together) as they recede. This phenomenon, **convergence**, is such an integral part of common experience it has even been the basis of a popular cartoon (Fig. 4–9). If you followed the angling exercise

FIGURE 4–9
WEBER
"Look here, men, shouldn't that be
the other way around?"
Cartoon

in Chapter 3, "Shape, Proportion, and Layout," you probably verified the apparent convergence of parallels in your subject for yourself. And if you were very observant, or already possessed some knowledge of linear perspective, you noticed that this convergence occurs at eye level.

Before the invention of the system of linear perspective, artists had recognized that receding parallels translate into diagonals on a picture's surface. The rules governing the use of these diagonals were very general. As you may see in the Giotto fresco (Fig. 4–10a), there is an understanding that sets of parallel lines should converge. But notice that if these lines are extended, instead of meeting at a single point, they converge at different points along a central vertical axis (Fig. 4–10b).

Now, compare the Giotto fresco with the one painted by Masaccio in 1425, shortly after the development of linear perspective (Fig. 4–11). We see a marked difference between the new system used here and the less complete system used by Giotto. Notice in Masaccio's fresco that all the diagonals in the architecture can be extended to meet at a single point located at the base of the cross. This point indicates the viewer's fixed position as centered laterally on the composition and at a low eye level.

Our own culture has come to expect pictures to have a fixed point of view. The prevalence of photography in our society reinforces this expectation. (The forerunner of the photographic camera is in fact the *camera obscura*, an instrument that aided the artist in recreating a perspective view of a subject by funneling its image through a small aperture, thus simulating a single point of view.)

Artists in general, but especially film makers, often use perspective to impart a heightened sense of drama. The vivid film still in Figure 4–12, for example, may trigger feelings of disorientation by virtue of the tilted camera angle, aided by the flickering pattern of lights and darks. But the expressive impact of this frame depends primarily upon its unmistakably low-vantage point. As viewers, we involuntarily assume the location of the camera's "eye." As a result, we are thrust as a protagonist into the psychological suspense of the scene, swept along the converging parallels of banister, stairs, and wall to meet the startled gaze of our adversary.

Having made these general observations about the artistic uses of two concepts central to linear perspective—fixed position and the convergence of parallel lines—we will now explain the whole system in greater depth.

FIGURE 4–10
GIOTTO DI BONDONE
*Pope Innocent III Approves
the Rule of the Order*

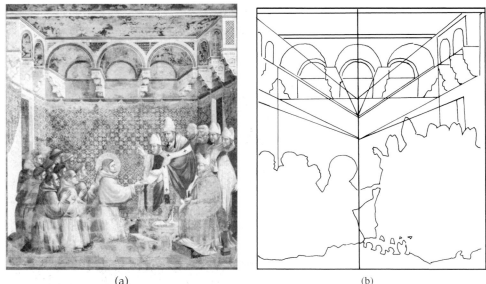

(a)

(b)

FIGURE 4–11
MASACCIO
Trinity with the Virgin and St. John,
c. 1425
Fresco, full view

THE DIMINUTION OF OBJECTS

The convergence of parallel lines on the picture plane is directly related to the phenomenon of more distant objects appearing smaller. This phenomenon can be explained by examining how two things of identical size, but at different distances from the spectator, relate to the spectator's cone of vision.

FIGURE 4–12
Film still from David Miller's
Sudden Fear, 1952

(a)

(b)

FIGURE 4–13

Station Point

Let us suppose you are standing in a position where you can see two elephants in profile. One is perhaps thirty feet away from you, and the other only ten feet. The closer elephant will be located nearer the apex of your cone of vision. In an illustration of this (Fig. 4–13a), the trunk is barely included within the farthermost right ray of vision. There is a space of about one-third of the elephant's body length left between the tail and the left ray of vision. Therefore, in Figure 4–13b, the shape of the elephant fills three-quarters of the binocular shape that makes up the field of vision. Let us say that the second elephant is the same size as the first. As it is farther from the apex of the cone of vision, the length of its body takes up a far smaller proportion of the cone. The image will therefore take up correspondingly less area in the field of vision.

THE CONVERGENCE OF PARALLEL LINES

The principle of the diminution of objects can be used to explain the apparent convergence of parallel lines as they recede from the spectator's station point. We will use the familiar image of the railroad track disappearing into the distance to demonstrate the idea of convergence. (Note that when dealing with the system of linear perspective, the fixed position you occupy in relation to your subject is referred to as the **station point**, abbreviated SP in our illustrations.)

In Figure 4–14a, you are standing on a railroad track, midway between the two rails. The track a few feet ahead of you fills up the lower part of your field of vision. As the track recedes, it takes up proportionately less space in both your cone of vision and your field of vision (Fig. 4–14b).

One-Point Perspective

The example of the railroad track is a classic demonstration of **one-point perspective**. The "one-point" referred to is the vanishing point.

THE VANISHING POINT

The illustrations in Figure 4–14 depict only the near sections of the railroad track. If you were to stand at the center of a straight stretch of railroad track, you could look down the rails until they appear to finally converge. This point of

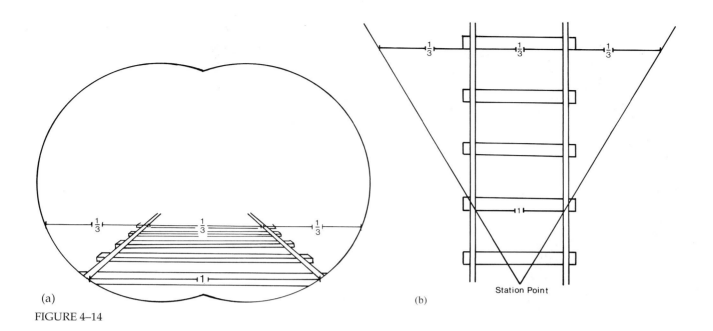

(a)

(b)

FIGURE 4–14

convergence is called the **vanishing point** (abbreviated VP in our illustrations). Presuming that the ground plane we are standing on is flat, the vanishing point will be located on the horizon line.

EYE LEVEL AND THE RATE OF CONVERGENCE

If you had a view of the track from the top of an engine, you would see the tracks converging at a slow rate toward a high vanishing point (Fig. 4–15a). If, however, you had the misfortune to be tied to the railroad track, you would see the tracks converging sharply to a low vanishing point (Fig. 4–15b).

FIGURE 4–15

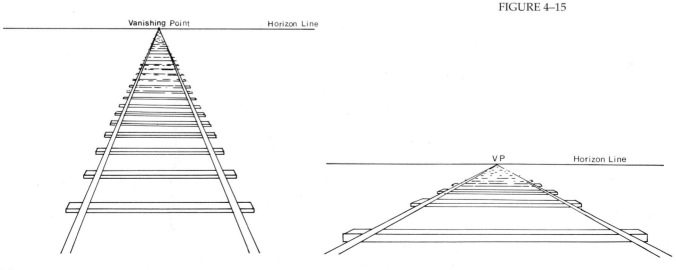

(a)

(b)

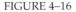

FIGURE 4–16

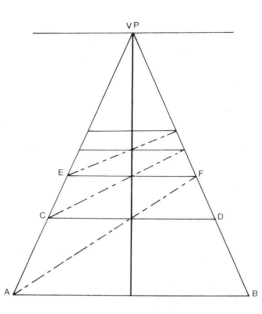

DIMINUTION OF UNITS ON A RECEDING PLANE

In studying the preceding illustrations, you probably noticed that the spaces between the railroad ties became progressively smaller as the tracks converged. Refer to the illustration in Figure 4–16 and follow the three steps below used to arrive at the proper spacing of the ties.

1. Draw the first tie at the bottom of your page. Carry a line from the center of the first tie up to the vanishing point. This line will bisect the angle formed by the two tracks. Draw the second tie at an appropriate distance from the first. (If you were drawing from nature, you could arrive at this appropriate distance through angling or measuring with your pencil, as described in Chapter 3).

2. Draw a diagonal line from point A through the point at which the line bisecting the angle of the tracks intersects with tie CD. Where this diagonal line intersects the track on your right put another horizontal for EF.

3. Successive ties can be located by repeating the procedure.

THE RECTANGULAR VOLUME: INTERIOR VIEW

The preceding demonstration showed how to draw a railroad track from a vantage point above the center of the track. In this case, there was one set of parallel lines that appeared to converge at one point on our eye level. Now we will add a second set of parallel lines above the eye level (Fig. 4–17). A line of telephone poles running parallel to each track would carry cables that also vanish at the same point as the railroad tracks. (Note that in spacing the telephone poles we use a procedure similar to that described for placement of the railroad ties. In this case, the first operational line is extended from the midpoint of the first telephone pole to the vanishing point. This line will divide the height of each pole in half.)

If we were to enter a long, rectangular room from a doorway located at the center of one of its shorter walls (Fig. 4–18), we would see a space similar to that of the railroad track flanked by telephone poles. The perspective of the room is, of course, more subtle, since the vanishing point is obscured by the end wall. But note that in the illustration, the receding lines of the floor, wall, and ceiling, if continued, converge at one vanishing point located at eye level. The horizon line in this case may be observed through the windows.

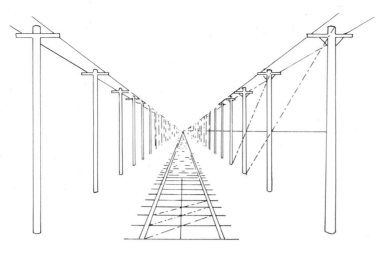

FIGURE 4–17

Note also that all horizontal lines on the wall facing the viewer, and any other horizontal line parallel to the picture plane, appear as horizontal. Any horizontal line located at the eye level appears as a horizontal, regardless of its angle to the picture plane. All vertical lines retain their vertical aspect.

To apply what you've learned about one-point perspective, find a long, rectangular room or corridor. Station yourself at the center of one end. Notice that all the receding horizontal lines on the walls, ceiling, and floor converge at the same point. **Exercise 4B**

Drawing 1: Draw the corridor using your skills at angling to find the vanishing point. To achieve proportion, use a combination of triangulation and measuring with your pencil, as discussed in Chapter 3. Figures 4–19 and 4–20 are examples of spacious interiors drawn in one-point perspective. In both drawings, the low eye level is key to expressing the scale of the space. In the Bosboom drawing, the drama of the massive architectural setting is heightened by the play of light and shadow.

Drawing 2: Find an outdoor space in which a scored sidewalk leads perpendicularly up to a glass-fronted building. Center yourself between two edges or scored lines of pavement so you can see your reflection in the glass directly ahead of you. Using two long pencils (or rulers, or dowel rods), angle both diminishing lines of the pavement simultaneously to determine the vanishing point. Where is the vanishing point located in relation to your reflection? Make a drawing of what you observe, and the whole system of one-point perspective will become clear to you.

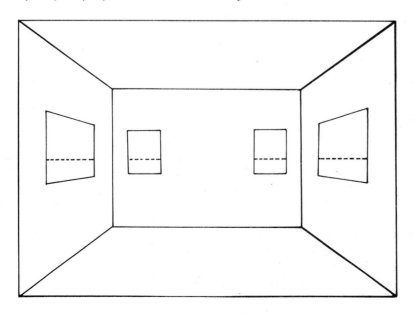

FIGURE 4–18

FIGURE 4–19
Jacob Etheredge, Iowa State
University
Student drawing: architectural
interior in one-point perspective

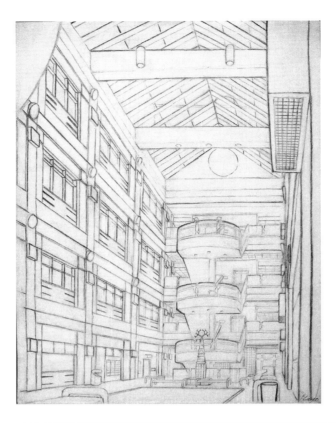

FIGURE 4–20
Johannes Bosboom
Church Interior, n.d.
Watercolor and gouache over
graphite on cream laid paper,
410 × 312 mm

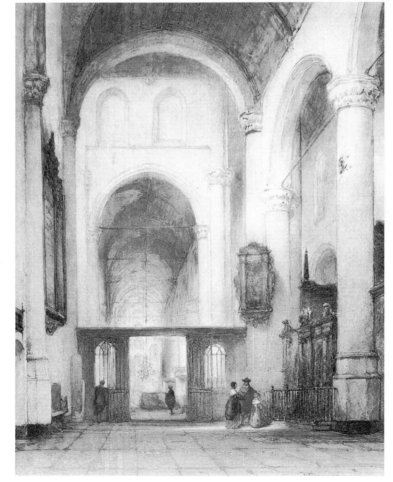

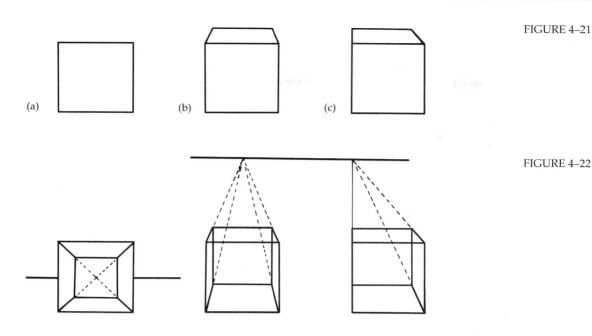

FIGURE 4–21

FIGURE 4–22

THE RECTANGULAR VOLUME: EXTERIOR VIEW

Now that you have an understanding of the interior of a rectangular volume viewed from one end, the next step is to look at the volume from the outside. If the rectangular volume or box is held at eye level so that its front face is parallel to the picture plane, it will appear as a flat rectangle (see Fig. 4–21a). This view does not give any information about the three-dimensional nature of the box. If, however, the box is lowered slightly so that we see its top as well as its front, it will appear as it does in Figure 4–21b. Right away we have an indication not only of the box's three-dimensional nature but also of our own eye level in relationship to it.

If the box is shifted so that it is not quite centered on your line of vision, but not so far that you can see a third face (see Fig. 4–21c), you will still be able to draw it in one-point perspective.

Study Figure 4–22 to understand how the concealed faces of these boxes would be drawn if the boxes were transparent.

Find a rectangular volume of some sort. A box or block of wood will do. It may be a cube but it need not be.

 Place it so that one face is roughly parallel to the picture plane. Draw the box at different relations to your eye level. To determine the vanishing point, angle the converging lines.

Exercise 4C

Two-Point Perspective

THE RECTANGULAR VOLUME IN TWO-POINT PERSPECTIVE

When a rectangular volume is positioned so that none of its faces is parallel to the picture plane, you will no longer be able to draw it using one vanishing point. Figure 4–23 shows three cubes positioned so that their vertical faces are at a forty-five-degree angle to the picture plane. Notice that in this schematic drawing, the cubes are stacked so that they all share the same two vanishing points.

In most drawing encounters with boxlike forms, you will make use of two-point perspective. But although all items in a given situation may require treatment in two-point perspective, they will not necessarily share vanishing points. Figure 4–24 shows a variety of boxes drawn in two-point perspective. As they are all positioned with their base planes on or parallel to the ground plane, the vanishing points will be located on the horizon line.

FIGURE 4–23

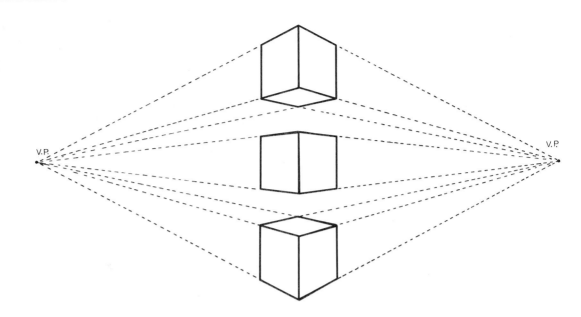

Notice that the cluster of boxes labeled A shares common vanishing points, whereas cluster B does not. Box C is drawn as if transparent. Box D is positioned so that we see a great deal more of one face than the other two. In such a case, the vanishing point for the greater face will be located farther away. (The placement of vanishing points is based on judgment. Sometimes you may find it necessary to locate either or both points outside the format of a drawing. What you want to avoid, however, is the distortion that occurs from placing the vanishing points too close together, as in box E.) The top of box F is located at eye level and is therefore not visible.

Look carefully at the McPherson drawing (Fig. 4–25) and note that at a certain distance from the top of the page the tops of the buildings all line up along one horizontal line (note the similarity to 4–24F). This horizontal establishes the viewer's eye level at about eight stories above ground.

FIGURE 4–24

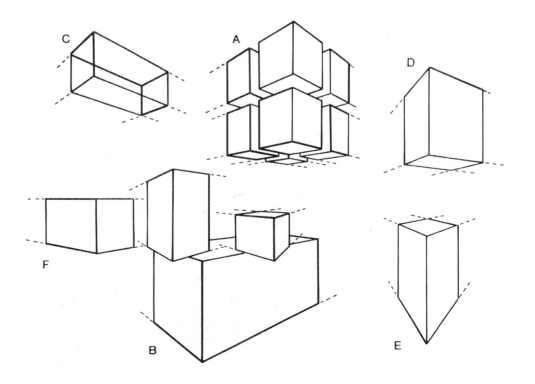

FIGURE 4–25
CRAIG McPHERSON
168th St. Schematic (Detail), 1979
Graphite on paper, 18 × 72"

Try these two applications of two-point perspective.

Exercise 4D

Drawing 1: *Draw a group of rectangular volumes in two-point perspective. A bunch of cardboard cartons or an architectural setting would serve as good models for this exercise. The drawing in Figure 4–26 shows a two-point perspective rendition of a vise attached to a workbench.*

Drawing 2: *Design a piece of furniture or architectural conglomeration using your knowledge of two-point perspective. Your design may be practical, or fantastic, as in Figure 4–27, but make sure to apply the rules of linear perspective consistently.*

FIGURE 4–26
NANCY WILKENS, University of Montana
Student drawing: vise and workbench in two-point perspective
26 × 20"

FIGURE 4–27
Toni Spaeth, Art Academy of
Cincinnati
Student drawing: imaginary
architecture in two-point
perspective
Ink and colored pencil

THE BOX TILTED AWAY FROM THE GROUND PLANE

So far we have been dealing with boxes that *sit on*, or *float parallel to*, the ground plane. The faces of these boxes are all either horizontal or vertical, and so all the vanishing points are located at eye level. If the box is *tilted* in relation to the ground plane, however, it will no longer have any horizontal or vertical planes, and none of the vanishing points will be located at eye level. Normally, a box positioned in this way will be drawn using two-point perspective (see Fig. 4–28). Later in this chapter, a case will be made for drawing some tilted boxes in three-point perspective.

FIGURE 4–28

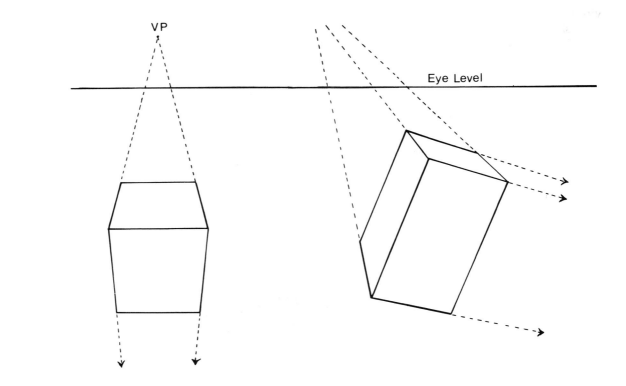

The Circle in Perspective

Circles in perspective are drawn as ellipses. When it is necessary to find the center of a circle in perspective, the ellipse is drawn within a square in perspective. Figure 4–29 shows how this is done.

Figure 4–29a is an unforeshortened view of the circle within a square; its center is found at the intersection of the diagonals connecting the corners of the square.

If the square containing the circle is tipped away from the picture plane, the circle appears as an ellipse (Fig. 4–29b). We have added a dotted horizontal line to divide this figure in half. This has been done to show that the front half of the circle appears fuller than the rear half. Note also that the undotted horizontal line through the center of the circle does not correspond with the fullest horizontal measurement of the ellipse. This is indicated by the dotted line.

Figure 4–30 demonstrates what is happening to the circle in relation to the cone of vision. In Figure 4–30a, the center line of vision goes through the center of the circle. The rays of sight from the station point (SP) are tangential to the circle. A horizontal dotted line connecting these two tangential points locates the fullest dimension of the circle that the eye will perceive. This line falls well below the horizontal through the center of the circle.

This fullest visible dimension of the circle seen in perspective (indicated by the dotted line) becomes the major axis of the ellipse when the circle is drawn on the picture plane (Fig. 4–30b). To locate the major axis of the ellipse, draw a rectangle around it and then draw diagonals connecting the corners of the rectangle. The major axis of the ellipse is drawn horizontally through the point where the diagonals intersect (Fig. 4–30c).

The minor axis of the ellipse coincides, in this case, with the vertical line going to the central vanishing point. *The minor axis of the ellipse is always drawn perpendicular to the major axis.*

This method of drawing ellipses pertains to any situation in which the major axis of the ellipse is horizontal and parallel to the picture plane.

Whenever the major axis of an ellipse is horizontal, the ellipse can be drawn within a square in one-point perspective. This is because the circle, unlike any other shape, appears the same when rotated within its plane.

So far we have been discussing how to draw circles located in a *horizontal* plane. A circle situated in a *vertical* diminishing plane can also be drawn in one-point perspective. Simply turn diagram 4-30b ninety degrees to understand how this is done. A circle drawn with a tilted plane will need to be drawn within a square drawn in two-point perspective.

When drawing an ellipse that represents a foreshortened circle that is not horizontal, start by angling with your pencil to find the major axis of the ellipse. Record that angle and lightly draw an ellipse around it. Use measuring to determine the relative lengths of the major and minor axes of the ellipse.

FIGURE 4–29

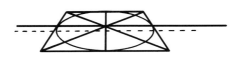

(a) (b)

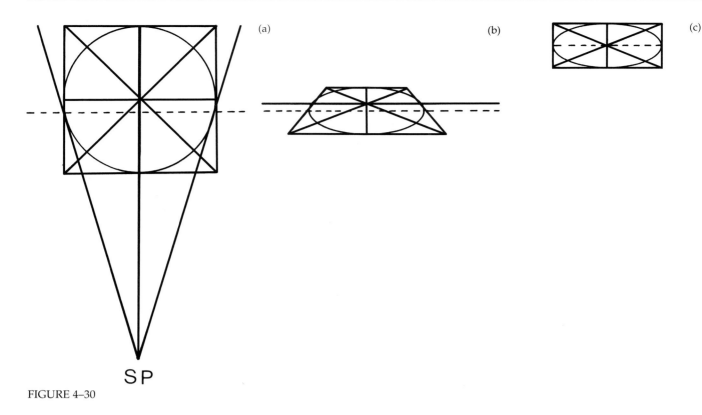

(a) (b) (c)

SP

FIGURE 4–30

Exercise 4E *Find or construct a box or block that has at least two square sides. On one square face of the box draw an "X," corner to corner, to find the center of the square and use this point to draw a circle with a compass that extends to the edges of the box. Draw additional lines through the circle dividing the square into quarters. Do a series of drawings of the box tilted at different angles in order to get a feel for drawing the circle in two-point perspective. When you have mastered that, draw a design based on a circle on the other square face and then draw this design in perspective (Figure 4–31).*

FIGURE 4–31
YUKATA SONE
Untitled, 2004
Pencil and charcoal on paper,
59¾ × 59½"

FIGURE 4–32

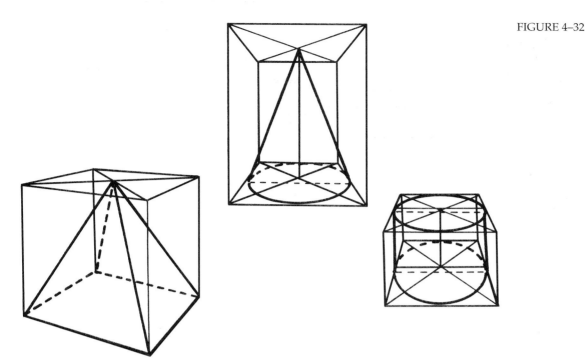

Other Geometric Volumes and Near-Geometric Volumes

You can apply your knowledge of drawing boxes and circles in perspective to drawing other basic geometric forms, such as cylinders, cones, pyramids, and spheres (Fig. 4–32). Many manufactured objects can be drawn with greater understanding if you try to relate them to the geometric forms they most closely resemble. Flowerpots, drinking glasses, and lampshades are basically conical; most furniture is rectangular; tree trunks and bottles are cylindrical; and many vegetable forms, such as fruits, flowers, bushes, and trees, are spherical.

Converging Verticals and Two-Point Perspective

One assumption on which the systems of one- and two-point perspective operate is that the picture plane is literally a vertical plane through which we gaze directly out at things some distance away from us. When our gaze is level, our picture plane is vertical. In this case vertical lines in our environment are parallel to our picture plane and therefore should be drawn consistently as verticals.

But what happens if we look sharply up or down at a subject such as a tall building or a cardboard carton located close by on the floor? As we have pointed out earlier in this chapter, the angle of the picture plane can shift away from its conventional vertical position when we direct our gaze sharply up or down (see Figure 4-4). When the picture plane is angled in this way, vertical lines from our environment are no longer parallel to the picture plane and they will appear to converge. Look at Figure 4-33 to see how a shift in the angle of the picture plane will affect the way

FIGURE 4–33

(a) (b)

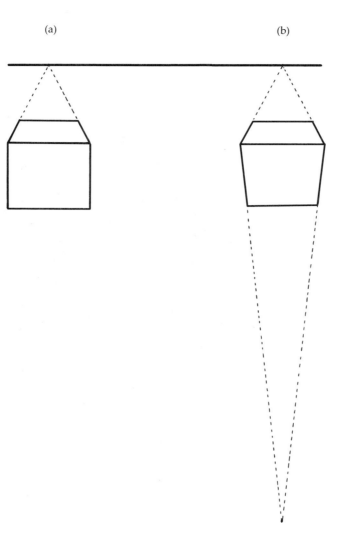

a box will be drawn. Figure 4–33a is drawn in traditional one-point perspective, since the front plane of the box is parallel to the vertical picture plane. Figure 4–33b shows the box as it would be seen if we were looking sharply down on it. Compare the two drawings and you will notice that the box with converging verticals has the spatially aggressive character that you might find in contemporary graphics.

Three-Point Perspective

While the use of converging verticals is optional for depicting subjects that could otherwise be drawn in one- or two-point perspective, there are situations in which the employment of converging verticals is absolutely necessary. When you are facing the corner of a very large (or very close) boxlike form, you will need to make use of three-point perspective. If you are, for instance, standing at street level looking up at the corner of a skyscraper, you will see vanishing points not only for the horizontal lines but also for the vertical ones, as in the Diane Olivier drawing, Figure 4–34. Notice that in this work the sides of the buildings converge at a point beyond the top of the page.

THREE-POINT PERSPECTIVE AND THE TILTED BOX

When a box is tilted away from the ground plane, a case can be made for drawing it in three-point perspective. The necessity for this treatment is especially clear when you tilt an oblong box toward or away from your picture plane, as in Figure 4–35.

FIGURE 4–34
Diane C. Olivier
Sansome and Battery
Charcoal on paper, 84 × 66"

FIGURE 4–35

Exercise 4F *These projects will enable you to apply the rules of three-point perspective.*

Drawing 1: Find an oblong box or block of wood. Prop it up so that it is leaning toward you. Draw it, taking care to angle all the sides carefully.

Drawing 2: Put a large cardboard box on the floor. Situate your easel as close to it as you can, yet retain a view in which you can see two side faces and a top face (or interior) of the box. Do the vertical sides of the box appear to converge at a point below the floor? Draw the box using a combination of angling and your knowledge of perspective.

Any rectangular object or group of objects, such as the stack of books in Figure 4–36, can be substituted for a box in this exercise.

Drawing 3: Situating yourself cater-cornered to a very tall building, draw it in three-point perspective.

FIGURE 4–36
Nam Kim, Pratt Institute
Student drawing: stack of books in
three-point perspective
18 × 24"

5

Form in Space

Have you ever had the experience of looking at an object and suddenly feeling that it possessed an extraordinary power? It may have been an intricately organized flower that you investigated carefully for the first time, a worn coiled rope glistening with tar and resins that you unexpectedly glimpsed along the railroad tracks, or a rusted, unidentifiable machine part that you picked off a vacant lot as a child and kept for years before throwing it out in a fit of spring cleaning.

The word *presence* is used to describe this mysterious power that is sometimes inferred from the forms of objects. Objects are said to command our attention in this way when they seem to be charged with hidden meanings or functions that, like some secret code, we cannot penetrate. This can hold true even for things we have seen and used and taken for granted, such as objects of common utility. Seen in a different context or from an unusual viewpoint, an otherwise ordinary object may suddenly assume a totally new identity.

From time to time, many people experience this rather romantic and usually fleeting impression that objects can have hidden, extraordinary meanings. This is especially true of artists, who are accustomed to finding significance in form and who return to these experiences as models for the quality of presence that they wish to achieve in their own works.

Most artists, in fact, become so sensitized to visual phenomena that they regularly sense undiscovered powers in forms that they encounter. For them, the powers sensed in an object can be translated into expressive potential when they draw. But first they must complement these sensations with a more deliberate search for the prominent form characteristics of the object in question. For example, in his drawing of a screw (Fig. 5–1), Claes Oldenburg identifies spiraling movement and linear direction as those characteristics essential to the form. He exaggerates these properties, thus greatly increasing the object's spatial gesture. Moreover, the monumental scale that he gives this most commonplace of small objects invests the image with all the fearsome torque of a tornado.

The Oldenburg drawing succeeds in evoking presence because it takes distinctive characteristics of "screwness"—spiraling movement, tensile strength, and linear direction—and gives them unanticipated emphasis. But to achieve this without resorting to caricature, the artist had to have a clear concept of the actual physical form of the screw.

FIGURE 5–1
CLAES OLDENBURG
Poster Sketch for Show in Japan
of Giant Balloon in the Shape
of a Screw, 1973
Charcoal, pencil, watercolor,
29 × 23"

The Visual and the Tactile

We use two perceptual systems to acquaint ourselves with the three-dimensional condition of an object: vision and the sense of touch. Psychologists tell us that these two senses work in tandem and that knowing what one sees is to a great extent dependent on being able to verify it by the sense of touch.

Although drawing is a visual medium, those drawings that strike the deepest chord within us usually recall a memory of tactile sensations. In the portrait by Edwin Dickinson (Fig. 5–2), the illusion of the elderly woman's soft flesh and

FIGURE 5–2
EDWIN DICKINSON
(American 1891–1978)
Portrait of Mrs. B., 1937
Graphite, with estampe
and erasure, 10¹⁵⁄₁₆ × 12¹⁵⁄₁₆"
The Baltimore Museum of Art:
Thomas E. Benesch Memorial Collection,
BMA1974.5

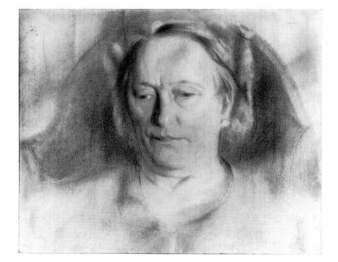

FIGURE 5–3
MICHELANGELO
The Crucifixion

thinning hair evokes an almost physical response in the viewer. In the Michelangelo drawing, on the other hand (Fig. 5–3), the tactile stimulus is located in the concentric searching lines. The viewer empathizes with the artist's repeated attempts to recreate on the surface of the paper how it would feel to physically embrace each of these forms.

Form and Gestalt

All three-dimensional objects possess mass, volume, and form. For the purpose of the artist, **mass** can be defined as the weight or density of an object. In most cases, weight and density are experienced through tactile, as opposed to visual, means. The term **volume** expresses the sheer size of an object and by extension the quantity of three-dimensional space it occupies.

Form refers to the three-dimensional configuration of an object. Form sets the specific spatial limits of an object and also encompasses the notion of its structure or organization. Of these three properties, mass, volume, and form, it is the latter that interests artists the most.

Form is most easily grasped by visual means, and yet we can receive only a limited amount of information about an object's form from any single point of view. To get a more complete picture of a whole form, we must obtain several views of it and synthesize them in our mind's eye. The more complex and unfamiliar a form is, the more difficult this process will be. Figure 5–4 shows how Leonardo da Vinci gradually rotated an arm to assist his understanding of its musculature.

The term **gestalt** is used to describe a *total* concept of a form. Some objects have a strong gestalt; that is, when seen from a single point of view, their entire three-dimensional character is readily comprehended, as is the case with simple

FIGURE 5–4
LEONARDO DA VINCI
Muscles of the Right Arm, Shoulder and Chest
Pen and ink with wash, over traces of black chalk

structures, such as the basic geometric solids (the sphere, cone, cylinder, pyramid, and cube). The immediate gestalt recognition of these forms is due in part to our familiarity with them. But they are also each defined by a set number of surfaces that are at predictable relations to each other.

Take a moment to obtain a gestalt (or total picture) of something with which you have daily contact—say, a coffee mug. Pick it up and get to know its various surfaces. Can you remember the motions you go through when washing it? How much coffee does it hold compared with other mugs that you use? After you have asked these questions, set the mug down and look away from it. You should be able to retain a concept of its three-dimensional form in your mind's eye and even be able to recreate different views of it. This exercise will greatly increase your ability to imagine forms in the round and draw them convincingly.

Approaches to General Form Analysis and Depiction

At some point you have probably had the desire to draw a highly complex form. Confronted with an object whose surface was characterized by a wealth of detail or numerous subtle turns, you may have felt at a loss about where to begin. But essential to a strong representation of any form is a feeling for its overall spatial structure. To assist you in depicting the overall structure of forms, we now present several simplified approaches to form analysis. While it may benefit you at the start to try these approaches separately, you will eventually wish to use them in combination to produce richer and more resonant drawings.

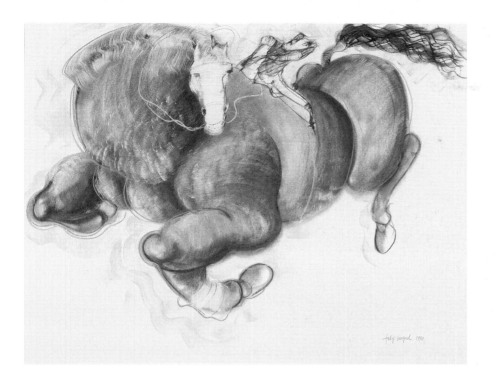

FIGURE 5–5
FELIX ANGEL
Untitled, 1990
Pencil, wax crayon, and acrylic

GENERALIZING THE SHAPE AND STRUCTURE OF COMPLEX FORMS

When setting out to draw a complex object, you should simplify your initial approach to its form. Form summary and shape summary are two specific methods for summarizing the form of complicated objects.

Form summary is a technique that is used to describe a more complex or articulated (jointed) form in simpler terms. When summarizing such a form, you need not feel restricted to using boxlike volumes. In Figure 5–5, Felix Angel aligns a series of elliptical masses to create the illusion of a cavorting horse seen in a foreshortened view.

Shape summary is another means to generalize form. Shape summary does not entail an exact delineation of the outer contour of a shape. Rather, when making a shape summary, one first sizes up the major areas of a three-dimensional form and then records them in terms of flat shape. The Theo van Doesburg drawing of a cow (Fig. 5–6) is a good example of shape summary. Notice that the head is seen in terms of a series of rectangular shapes, the neck and shoulder as a triangle, and the haunch as an inverted triangle.

GESTURE AS A MEANS OF EXPLORING FORM

In Chapter 1 we discussed gesture drawing as a way to represent the general pattern of things as they are arranged in space. Extended to the practice of depicting form, gesture drawing can be useful not only for revealing those aspects of a form that can be seen but also for suggesting something of the form's internal forces and stresses.

Gesture drawing requires that an artist empathize with the subject. That is, the artist must try to express with marks, tones, or lines the essential structure and energies of what is being drawn. To this end, Rodin let the gesture of his pencil line recreate the spirit of a dance (Fig. 5–7).

The subject in the Matisse (Fig. 5–8) is more static in nature. Here the outer contour of the figure seems to have been arrived at through a series of trials that have left a radiating energy about its form. But much of the gestural force of the

FIGURE 5–6
THEO VAN DOESBURG
Study for the Composition (The Cow),
1917
Pencil, 4⅛ × 5¾"

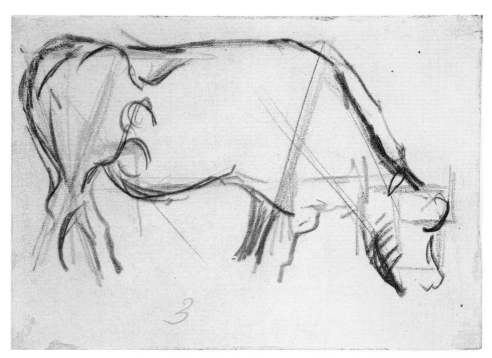

FIGURE 5–7
AUGUSTE RODIN
Isadora Duncan
Dancing clothed female figure
with arms raised over head
forgery by Odilon Roche
Graphite and watercolor
on wove paper, Sheet: 14 × 9"
(35.6 × 22.9 cm)
*Philadelphia Museum of Art: Bequest
of Jules E. Mastbaum, 1929*

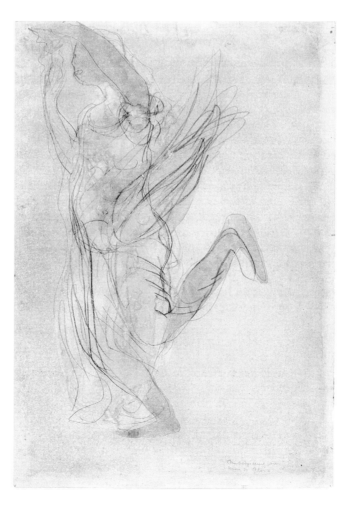

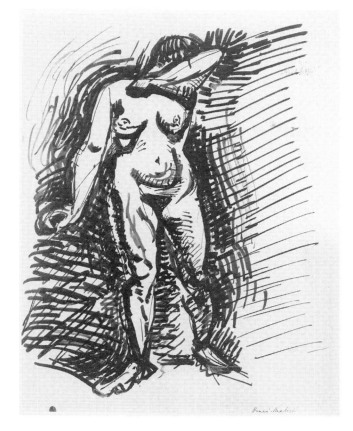

FIGURE 5–8
HENRI MATISSE
Standing Nude (Nu Debout), Paris,
ca. 1907
Brush and ink on paper, 10⅜ × 8"
*The Museum of Modern Art/Licensed by
SCALA/Art Resource, New York; © 2011
Succession H. Matisse/Artists Rights
Society (ARS), New York*

drawing is a result of the feeling for internal stresses expressed by the sharply contrasting lights and darks in the weight-bearing leg. This plus the effect of the other leg dragging through the shadows help us to identify with the physical gesture of the model.

Artists frequently use gestural marks to diagnose and express the relative position and scale of an object in space. These marks are generally called **diagrammatic marks** because they are often so direct and graphic, as in Figure 5–9. Or look at the drawing by Wolf Kahn and see how his stroking, gestural marks "feel out" his tactile impressions of a cow (Fig. 5–10). And note how the contrast between the well-defined marks portraying the handlelike tail and the sketchier ones indicating her head gives us a strong sensation of the way the cow is oriented in space.

Gesture drawing is admirably suited to a moving subject, as in Figure 5–7. But the intense energy and level of identification required for gesture drawing also make it an important means for sustained studies of inanimate objects (Fig. 5–11).

The Chan drawing of freight train cars (Fig. 5–12) is another example of how a subject of considerable complexity can be accurately drawn without sacrificing the gestural energy of its general form. The structural detail in this image stirs the fascination many have with these marvels of early modern engineering. It is easy to imagine a conductor hoisting himself onto the stirrup step and climbing the ladder to the brake wheel. But notice that each of those details, including the outside braces, coaxes our eye to circle the car in a step-by-step progression, while the bold marks indicating the expanse of metal surfaces and dark shadowed areas convince us of its intimidating mass. Such an illusion of mass and potentially crushing weight would not have been possible unless the artist had started out by gesturally possessing his subject's overall sculptural presence.

FIGURE 5–9
LOWELL BROWN
Dead Fish, 1996
Pencil, marker, pastel,
correction fluid, 11 × 8½"

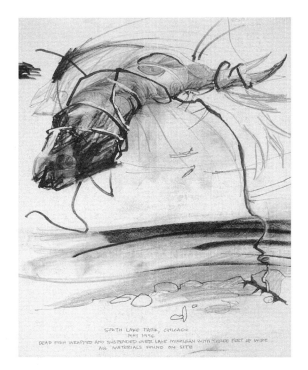

FIGURE 5–10
WOLF KAHN
Prize Cow, 1955
Pencil on paper, 9 × 12"
*Art © Wolf Kahn/Licensed by VAGA,
New York*

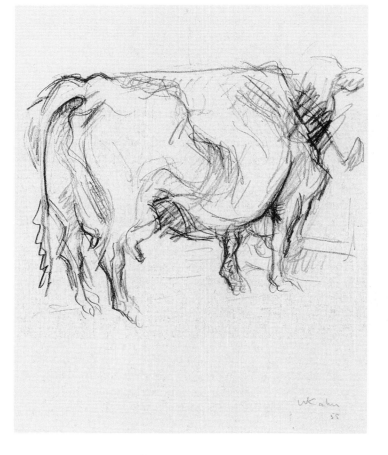

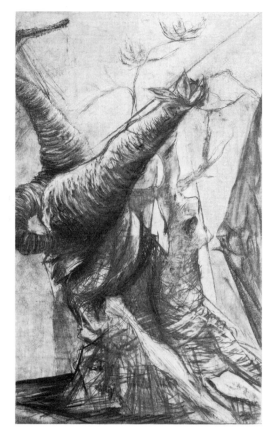

FIGURE 5–11
Mark Ferri Intreccio, University of Cincinnati
Student drawing: gesture study of inanimate object
Charcoal on paper, 57 × 34½"

FIGURE 5–12
Ying Kit Chan
Coal Car, 1984
Charcoal on paper, 42 × 84"

FIGURE 5–13
C. Brent Ferguson
Student drawing: contour study
of a houseplant
18 × 24"

LINE AND SPATIAL STRUCTURE

You will find that line is an invaluable tool for analyzing the spatial aspects of form, and many artists recommend the practice of linear drawing as the most expedient way to improve perceptual skills (Fig. 5–13). What makes line so effective in showing the turn of surface on a three-dimensional form is, strangely enough, its unidirectional character. By definition, line travels from point to point. To illustrate this, look at the drawing by Agnes Denes (Fig. 5–14), in which the delicate diagrammatic lines connect carefully plotted points to direct the eye around the form in a measured way.

OUTLINE VERSUS CONTOUR LINE

Before we proceed to discuss the potential of line to depict form, it is necessary to differentiate between outline and contour line. **Outline** can be defined as a boundary that separates a form from its surroundings. Usually regarded as the most primitive of all artistic techniques, outline works best when it is reserved for depicting literal flat shapes. The tendency for outline to direct the viewer's attention to the two-dimensional spread of the area it encloses confounds any power it might have to depict three-dimensional form. Additionally, the uniform thickness, tone, and speed of an outline does not distinguish between those parts of a form that are close to the picture plane and those that are farther from it. Thus, the outlined image of a man walking his dog (Fig. 5–15) looks as flat as the images of road signs in a driver's manual.

 Another long-held objection to outline is that in recording the outer edge of an object, one unavoidably draws attention to that part of the object farthest from the eye. Because of the dynamics of figure–ground play, outline tends to push forward, allowing the interior of the shape to fall back. Thus, a circle drawn

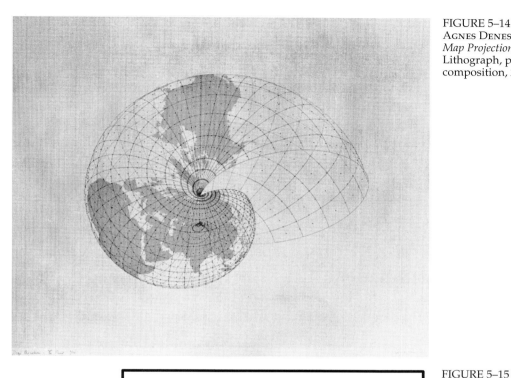

FIGURE 5–14
AGNES DENES
Map Projection—The Snail, 1976
Lithograph, printed in color,
composition, 24¹⁄₁₆ × 30"

FIGURE 5–15

to represent a sphere will look more like an empty hoop, especially if it is drawn with a line of consistent thickness.

An alternative to outline is the **contour line**, which can also be used to describe the outer edge of an object. But unlike the outline, which functions as a neutral boundary between the object and its surroundings, the contour line gives the impression of being located just within this border. So contour line more properly belongs to the form of an object, as we can see in the Picasso work *Portrait of Derain* (Fig. 5–16). When you look at the outer contour, you will see that the artist is alluding to this edge as the last visible part of the form before it slips away from sight.

FIGURE 5–16
PABLO PICASSO
Portrait of Derain, 1919

FIGURE 5–17

It is its varying thickness, and often tone and speed, that gives contour line its capacity to suggest three-dimensional form. To demonstrate this, we have traced the Picasso drawing with a drafting pen so as to render the image with a line of uniform thickness. The result (Fig. 5–17) appears flat when compared with the original, in which no line retains the same thickness for long.

Contour line can also be applied within the outer borders of a depicted form. In the Picasso drawing, this use of contour is especially evident in the delineation of the folds in the sitter's jacket sleeve. An even more structural use of contour may be observed in the way the nose is drawn. Here contour is used to indicate a break in planes.

A further example of the modeling effect of contour can be found in the drawing by Jean Ipousteguy (Fig. 5–18). The use of line is both economical and strikingly varied in tone, thickness, speed and clarity. Observe and enjoy the zip of the bold, sweeping lines that define the frontal planes of the torso, in contrast to the leisurely contour along the back of the figure that melts into the atmosphere.

Exercise 5A *Blind contour is one of the best ways to get acquainted with how line may be used to express the structure of forms in space. It is a tactic used by artists to heighten their awareness about how the form of what they draw "feels" to the eye.*

Drawing 1: Using a pencil, marker, or technical pen, do a series of blind contour drawings of some fairly complex subject, such as your own hand or feet in different positions (Fig. 5–19). Remember that blind contour drawing entails letting your eye creep around the contours of a form while your

FIGURE 5–18
JEAN IPOUSTÉGUY
White (Blanche), 1970
Charcoal on paper mounted
on board, 21½ × 29½"

drawing hand follows the movement of your eye. Be sure to enter within the confines of the form's outer contour to indicate major plane breaks.

Blind contour drawings will always look slightly imperfect, as if parts of the subject have been somewhat jostled. Even so, these drawings have the appeal of the immediacy of optical perception.

Drawing 2: Arrange some objects that have a lot of curves into a simple still life. Vegetables such as cabbage or cauliflower, kitchen gadgets, and overstuffed furniture all make good subjects. Do a blind contour drawing of these objects, but this time change the thickness and value of the line more emphatically, exaggerating to some extent the principles of atmospheric perspective. In other words,

FIGURE 5–19
TRISHA BROWN
Footwork #13, 1995
Ink on paper, 17⅜ × 22¼"

where a form moves aggressively toward you, increase the speed and pressure with which you draw to thicken, darken, and add clarity to your line. But as edges begin to drop from sight, slow down and let up on the pressure so that your line becomes thinner and less distinct.

Suggested media include a fountain pen or brush with ink, the sharp corner of a conté crayon or graphite stick, or a carpenter's pencil.

Drawing 3: *Use the insights you've gained from your second blind contour study to make a more precise contour-line representation of a still life, this time looking at your paper.*

Refer to Figures 5–20 and 5–21, both handsome line drawings. Note that one uses lines that are relatively close in weight to define the forms and their orientation in space, while the other expresses layers of space through conspicuous variations in line thickness.

MASS GESTURE

We use the term **mass gesture** to describe a complex of gestural marks that expresses the density and weight of a form. Artists have several ways of communicating that forms have weight and spatial presence. Among them is the laying in of marks, one on top of the other, until a sense of impenetrable mass is achieved (Fig. 5–22). In the Mazur drawing (Fig. 5–23), dark gestural marks imply the bulk of a human head.

Exercise 5B *Prepare yourself for this exercise in mass gesture by imagining what it would be like to tunnel into a mountain or to bore a hole through a block of granite.*

FIGURE 5–20
Yusuke Ito, University of Texas
at Austin
Student drawing: lines of similar
weight to represent forms in space
Charcoal on paper, 30 × 22"

FIGURE 5–21
Hea Jung Kim, Savannah College
of Art and Design
Student drawing, lines of varying
weights to represent forms in space
Graphite on paper, 23 × 29"

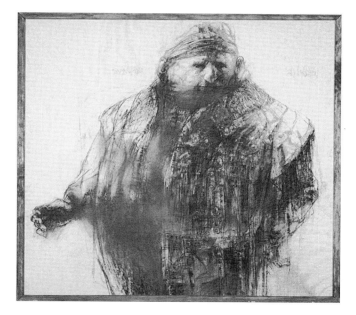

FIGURE 5–22
HERBERT OLDS
Sage, c. 1975
Charcoal on brown paper, 46 × 49"

FIGURE 5–23
MICHAEL MAZUR
Untitled (Head), 1965
Charcoal on paper, 25 × 19"

Drawing 1: *Using a stick of charcoal, draw from objects that are simple and compact in form (such as boulders, root vegetables, tree stumps, or stacks of books), concentrating on the sheer quantity and density of their matter. As you draw each object, begin by scribbling some tight, hard, knotlike marks to represent its core, or most active part. Ask yourself, if you had x-ray vision, where would your eyes have to pass through the most matter to come out on the other side? Without lifting your charcoal from the paper, build out from the core with random scribbling, gradually lightening your pressure on the charcoal until you have reached the outer surfaces of the form. Alternatively, use broad strokes with a soft medium such as chalk or charcoal to express the sheer bulk of a large form, as in the Rembrandt drawing of an elephant (Fig. 5–24).*

Drawing 2: *Another way to indicate mass is through exploratory contour. Choosing a more complex subject this time (such as a human figure), indicate with a flurry of small marks those portions of the form that are turning away from the picture plane (Fig. 5–25).*

FIGURE 5–24
Rembrandt
An Elephant, 1637
Black chalk, 17.9 × 25.6 cm

FIGURE 5–25
Tamara Malkin-Stuart, New
York Studio School of Drawing,
Painting, and Sculpture
Student drawing: mass expressed
using an exploratory contour
Conté crayon, 22 × 30"

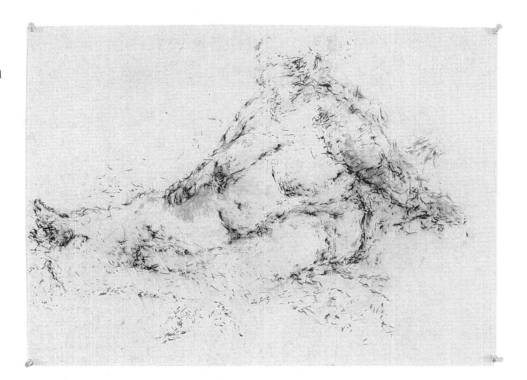

CROSS CONTOUR

Cross contours are lines that appear to go around a depicted object's surface, thereby indicating the turn of its form. You have already seen cross-contour lines in the drawing by Agnes Denes (Fig. 5–14).

Some forms have cross-contour lines inherent to their structure, such as the wicker beehives in Figure 5–26. In the Rockwell Kent drawing (Fig. 5–27), the natural contour lines existing on the slatted outer surface of the lifeboat are visible in the small illuminated triangle on the right. These lines are lost on the shadowed side of the boat, but the artist indicates the shadow with lines that curve around the boat's surface in the way that the natural cross-contour lines do.

Cross-contour line need not be as precise or literal as in the above-mentioned illustrations. In the drawing by Ernst Barlach (Fig. 5–28), the cylindrical masses of the woman's body are forcefully shown by the gestural lines sweeping across her

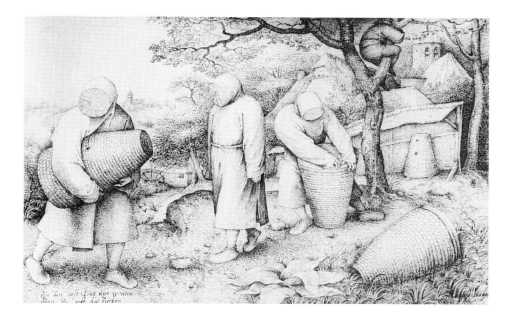

FIGURE 5–26
PIETER BRUEGHEL THE ELDER
The Bee Keepers, 1567
Pen and brown ink on laid paper,
20.6 × 31.6 cm
Fine Arts Museums of San Francisco,
Achenbch Foundation for Graphic Arts
purchase and William H. Noble Bequest
Fund, (1978.2.31)

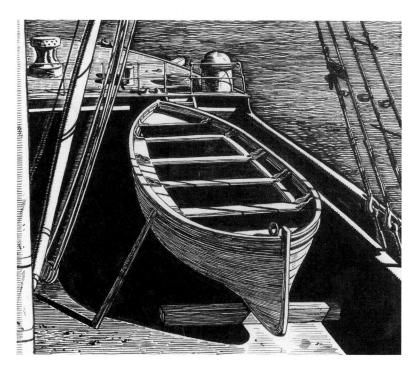

FIGURE 5–27
ROCKWELL KENT
The Kathleen, 1923
Pen and black ink on paper,
6⅞ × 7¾"
(17.5 × 19.7 cm)
Whitney Museum of American Art,
New York; Gift of Gertrude Vanderbilt
Whitney 31.548a-b

FIGURE 5–28
ERNST BARLACH
Woman Killing a Horse, 1910–1911
Charcoal on paper,
$10^{11}/_{16} \times 15^{5}/_{16}$"

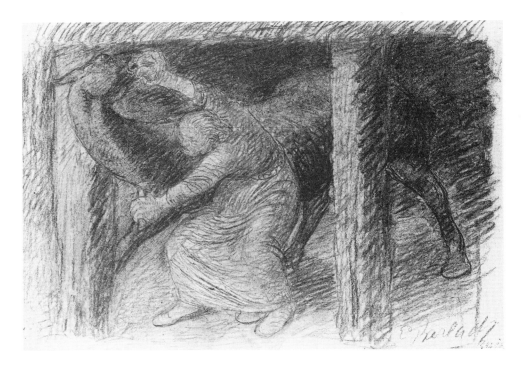

form. These lines impart to her image an illusion of solidity and power that makes credible the idea that she is more than a match for the much-larger horse.

In his drawing of vessels, Figure 5–29, glass artist Dale Chihuly developed a strong sense of form with no recourse at all to outer contour. The heavily dimpled surface of the top study is amply indicated by a loose and varied collection of cross-contour lines and marks. In the two spherical forms at the bottom of the page, the lines weave about in a more continuous fashion, giving the impression of massive but transparent receptacles.

FIGURE 5–29
DALE CHIHULY
Macchia, 1983
Graphite and watercolor
on paper, 22 × 30"

Cross-contour marks and lines reinforce the apparent solidity of depicted forms. To become more adept at executing cross contour, follow the steps of this exercise.

Drawing 1: *Find a subject with naturally occurring cross-contour lines. Objects such as birdcages or open-weave baskets make ideal subjects because their relative "transparency" allows you to trace their cross-contour lines around to the far side of their forms.*

In the beginning, be selective, especially if your subject is very detailed, as in Figure 5–29. Observe how the cross-contour lines reveal the structure of your object. Avoiding the outer edges of your subject, draw only those lines that record the major angles and curves of its cross-contours. Once you have summed-up the overall form through gestural cross-contour lines, you can refine the drawing to reflect the complexity of your subject.

Drawing 2: *Find an object with both swelling and indented surfaces. If possible, draw directly on the object, creating a series of parallel lines that circle around its form. (Think of them as the latitude lines on a globe.)*

Represent your subject with a loose system of cross-contour marks, referring to the parallel lines on the form to better understand the major turns of direction of the form's surface. If your approach to this drawing is very gestural, use marks that appear to wrap around the entire form, as in the Chihuly drawing (Fig. 5–29).

PLANAR ANALYSIS

To investigate and give spatial definition to curvaceous forms, artists sometimes turn to planar analysis. **Planar analysis** is a structural description of a form, in which its complex curves are generalized into major planar, or spatial, zones.

Planar analysis is especially helpful in depicting the surface of a form that is composed of numerous undulations, or if the outer contour of the form gives no clue to the surface irregularities within its shape. A pillow, for instance, may have a geometric shape from some aspects, but this shape will not communicate the plump curves of its form. In Figure 5–31, the volume of a pillow has been expressed through planar treatment.

Artists frequently find planar analysis a valuable aid in portraiture, as it enables them to grasp the large general forms of the face and how they interlock. Notice that in Figure 5–32, each facet has been given an informal "hatched-line" pattern that further defines the structure of the face. (The term **hatched line** refers to an area of massed strokes that are parallel or roughly parallel to each other.)

In Figure 5–33, planar analysis is used to make the spatial gesture of articulated forms more apparent. And in turn, the choreographing of these blocked-in figures dramatizes the depth of the stagelike space.

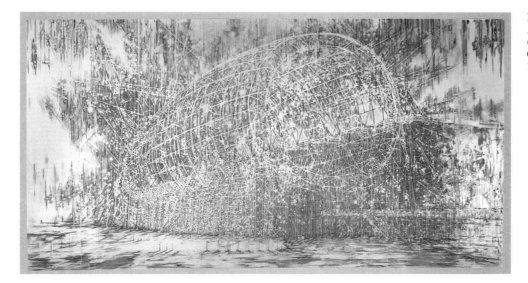

FIGURE 5–30
ALISON NORLEN
Glimmer (zeppelin), 2010
Chalk, charcoal, ink,
10 × 22'

FIGURE 5–31
ALBRECHT DURER
Six Pillows, 1493
Pen and brown ink,
$10^{15}/_{16} \times 7^{15}/_{16}$"

FIGURE 5–32
SEAN P. GALLAGHER
Interior (planar analysis self-portrait)
Graphite on paper, 24 × 18"

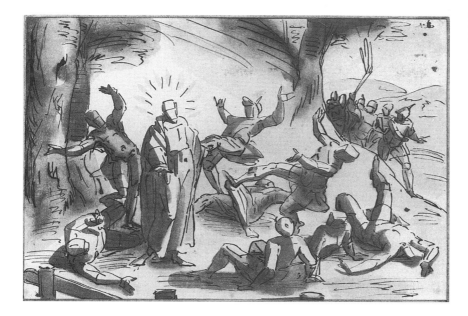

FIGURE 5–33
LUCA CAMBRIASO
The Arrest of Christ, c. 1570–1575
Pen and ink, 9¼ × 11½"

Planar analysis is an excellent way to uncover the large, simpler structure that underlies complex-looking forms. As a practical introduction to planar analysis, we have designed this exercise.

Exercise 5D

Choose a soft or semisoft form to draw. A sofa cushion, a slightly dented felt hat, or a half-stuffed canvas or leather bag are all good subjects. If you are particularly ambitious, you may choose to make a planar analysis of a model's face, as in Figure 5–34.

Look at the curved surfaces of your subject. Can you consolidate them into a series of abutting planes? To help, look for noticeable creases, raised or indented, that might be interpreted as a major planar division. A small lamp or flashlight may help you see these divisions. If possible, outline them by drawing directly on the surface of the object. Continue tracing these planar divisions until the entire form appears to grow logically from these individual facets.

Do a drawing of your object, copying the planar structure that you have imposed on it. To indicate the changing inflections of the surface, you may wish to add a hatched line pattern to the individual planes, as in Figure 5–32.

Surface Structure of Natural Forms

The landscape by Ruskin (Fig. 5–35) is an example of how the surface structure of inanimate forms can be dramatically shaped by powerful, cumulative outside forces. This drawing depicts a monumental concave scar in a mountainside, evidence of the grinding passage of a departed glacier. Within a much shorter temporal span, we may witness the concave shapes caused by the action of wind on sand dunes or the pressure of wind on a sail.

Forms that are a result of natural growth rarely possess any true concavities. If you carefully scrutinize any apparently concave surface on a living form, chances are you will discover that it is actually made up of several convex areas. This is demonstrated well in the Segantini (Fig. 5–36) where there are many points at which the outer contour of the form becomes concave. Yet in all cases, these apparent concavities are explained by the coming together of two or more convex forms.

Convex forms give the impression of dynamic internal forces. Most organic forms possess an internal structure that thrusts against the surface at particular points. Bones protrude against the skin at the joints, contracted muscles bulge at specific places, peas swell in their pods, and so forth. The presence of internal force points is elegantly shown in Ingres's drawing of a male nude (Fig. 5–37).

Whenever you draw a form that has compound curves, you should stop to analyze the forces that make them concave or convex. And remember that concave forms are generally caused by external forces, and that organic forms, or

FIGURE 5–34
BRAD KUENNEN, Iowa State
University
Student drawing: self-portrait
using planar analysis
and hatched line
36 × 24"

FIGURE 5–35
JOHN RUSKIN
*Study of Part of Turner's Pass
of Faido*

those created by growth from within, are generally convex. (This holds true, as well, when you make sculpture. Convex surfaces seem to belong naturally to their volume, whereas concave forms suggest the hand or tool of the sculptor.)

TOPOGRAPHICAL MARKS

Topographical marks are any marks used to indicate the turn of a depicted object's surface. Cross-contour lines and the hatched lines that artists frequently use to show the inflection of planes are both topographical marks.

FIGURE 5–36
GIOVANNI SEGANTINI
Male Torso
Black crayon and charcoal fixed on
buff wove paper, 31.1 × 19.6 cm

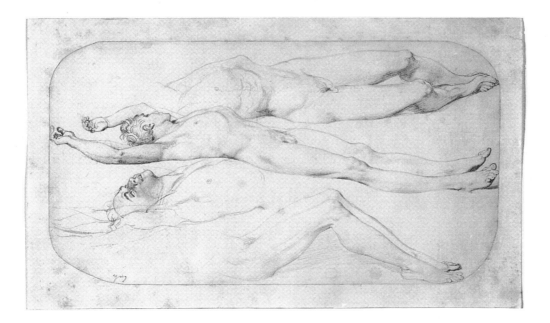

FIGURE 5–37
JOHN AUGUSTE
DOMINIQUE INGRES
*Three Studies
of a Male Nude*
Lead pencil on paper,
7¹¹⁄₁₆ × 14¾"

Topographical marks can be seen in the Kollwitz (Fig. 5–38), in which short, parallel strokes follow the surface curvature of the heads. This work is of special interest because the smaller sketch, in which the marks describe the general form of the head, appears to be preparatory to the larger one, in which the topography of specific facial forms as well as the texture of the hair are indicated.

A looser and more spontaneous application of topographical marks can be seen in the drawing by Marsden Hartley (Fig. 5–39). The speedy marks in this drawing clearly suggest the presence and turn of rounded surfaces but seem reluctant to pin them down, an effect well befitting a portrayal of human work rhythms.

Topographical marks can also be highly controlled, as in the drawing by Victor Newsome (Fig. 5–40). This drawing uses several different systems of marks to indicate the form of the head. The general form is built out from the picture plane by a set of concentric oval shapes, which function similarly to the contour lines showing relative altitude on a topographical map. A second set of lines crosscuts and circles the head, like the latitude lines on a globe. A third set includes the ribbed bands that wrap around the head turban-style and the fine lines running in general over the terrain of the skull, which indicate the play of light and shadow.

TEXTURE

Another topographical feature that you might wish to consider when dealing with the surface of an object is *texture*.

The texture of an object is sometimes directly related to its overall structure or organization, as in the convolutions of the human brain or the spiny, corrugated texture of a cactus. The texture of foliage, so skillfully rendered by Thomas Ender (Fig. 5–41), is a further example of texture that is inseparable from form.

At other times, texture is a mere surface effect that bears no direct relation to the internal structure of the form; fur on an animal, the clothes on a human body, and the shiny chrome on a car fender are all examples of texture that is "skin deep."

But even a superficial texture will sometimes provide you a valuable clue about the particular turn of a form, as can be seen by looking at Figure 5–42, in which the pencil strokes that indicate the fine texture of the hair and beard also model the volume of the head.

FIGURE 5–38
Kathe Kollwitz
Two Studies of a Woman's Head, c. 1903
Black chalk on tan paper,
19 × 24¾"

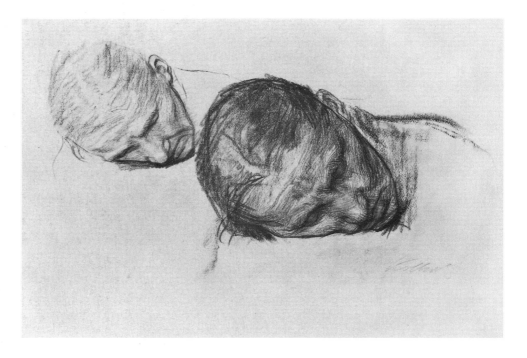

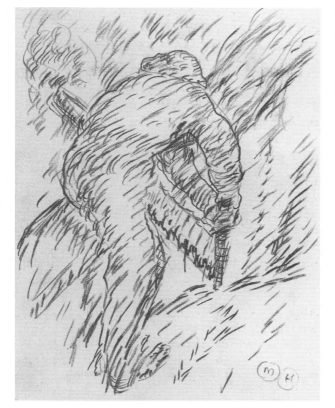

FIGURE 5–39
MARSDEN HARTLEY (1877–1943)
Sawing Wood, c. 1908
Graphite pencil on paper,
Sheet: 12 1/16 × 8 15/16"

*Whitney Museum of American Art,
New York; Gift of Mr. and
Mrs. Walter Fillin 77.39*

FIGURE 5–40
VICTOR NEWSOME
Untitled, 1982
Pencil, ink, and tempera,
22 7/8 × 23 1/2"

FIGURE 5–41
THOMAS ENDER
*Woman and Children in Front
of a Tree*
Pencil, 9 × 7½"

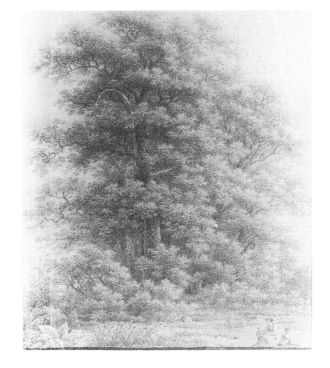

FIGURE 5–42
WILLIAM CONGER
Self-Portrait, c. 2000
Pencil on paper with gouache
touches, 13 × 10"

PATTERN

Surface pattern helps a viewer grasp the curvature or shifting angles of a surface.

In the John Biggers (Fig. 5–43), the planar mass of the lower body is explicitly expressed by the pattern shifts in the blanket. The less pronounced linear pattern on the woman's dress achieves the same effect for the upper body.

Explore the surface structure of a form by using topographical marks, pattern, or texture. In Figure 5–44, the rapid topographical hatchings create a vivid impression of the turn of rounded forms, as well as the patterns across flat planes.

Exercise 5E

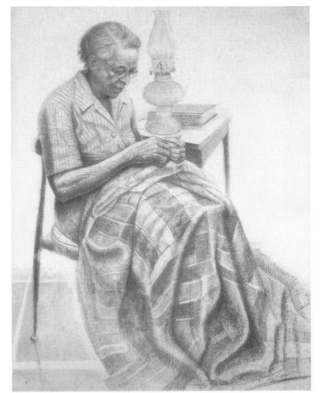

FIGURE 5–43
JOHN BIGGERS
Ma Biggers Quilting, 1964
Conté crayon on paperboard,
39 × 29"

© Estate of John T. Biggers/Licensed by VAGA, New York; Courtesy of Michael Rosenfeld Gallery, LLC, New York

FIGURE 5–44
MARC SPANGENBERG, Kent State University
Student drawing: topographical marks and hatchings to represent forms in space
Graphite on paper, 18 × 24"

Form in Light

The vivid impressions of form we receive through certain lighting effects have preoccupied Western artists for a long time. Consider the following observations recorded by Leonardo da Vinci in his *Trattato della Pittura:* "Very great charm of shadow and light is to be found in the faces of those who sit in doors of dark houses. The eye of the spectator sees that part of the face which is in shadow lost in the darkness of the house, and that part of the face which is lit draws its brilliancy from the splendor of the sky. From this intensification of light and shade the face gains greatly in relief . . . and beauty."

This admiration for light's descriptive and transformative powers persists unabated today. In the drawing by Claudio Bravo (Fig. 6–1), the dramatic use of light and shadow has changed an unremarkable subject into a thing of great

FIGURE 6–1
CLAUDIO BRAVO
Feet, 1983
Charcoal and pencil
on paper, 15 × 15", signed
and dated lower right

loveliness. We are transfixed by the sheer voluptuousness of the form, and also by the quality of light in which it is bathed.

The Directional Nature of Light

In the Bravo drawing, we have a strong impression that the light, diffused as it may be, is nevertheless coming from one dominant direction. If we were to attempt to pinpoint the source of the light within three-dimensional space, we would say that it is located in front, above, and to the left of the subject. We make this calculation by observing the position of the lights and darks on the form and also by observing the angle of the shadow cast by the feet on the floor.

We can locate the light source in Figure 6–2 with just as much certainty. Since the left-hand walls and portions of roofs in this drawing are illuminated, and the shadows are cast in front of the buildings, we can assume that the light source is fairly high and located off to the left and in back of the subject. (By observing the length of the cast shadows, we can even conjecture that the subject is portrayed at midmorning or midafternoon.)

Now, look at this drawing overall and you will see that a definite pattern of light and dark emerges. Most of the planar surfaces that face left, most of the ground plane, and all surfaces parallel to the ground plane (such as the tops of the broken walls) are illuminated. All surfaces roughly parallel to the picture plane and those portions of the walls that are under eaves are in shade.

As a last example, note the direction of light in the drawing by Wayne Thiebaud (Fig. 6–3). In this case, the fairly high light source is located directly to the right of the subject. That it is neither in front nor in back of the subject is clear from the horizontal direction of the cast shadows.

Value Shapes

Value refers to black, white, and the gradations of gray tone between them. Figures 6–2 and 6–3 can be described as drawings that emphasize value over line. Notice that in both of these drawings, the subject's lights and darks have been represented by **value shapes**; that is, each shape in the drawing has been assigned a particular tone that is coordinated with the values of other shapes in the drawing.

Take special note of how the subject in Figure 6–3 has been restricted to shapes of black and white, making it a two-tone drawing. Two-tone drawings are

FIGURE 6–2
VALENTIJN KLOTZ
View of Grave, 1675
Pen and brown and gray ink
and blue watercolor washes,
23.8 × 19.6 cm

FIGURE 6–3
WAYNE THIEBAUD
Pies, 1961
India ink on paper, 19 × 24⅞"
*Collection of The Rose Art Museum,
Brandeis University, Waltham,
Massachusetts; Gift of the Friends of the
Rose Art Museum Acquistion Society.
Art © Wayne Thiebaud/Licensed by VAGA,
New York*

FIGURE 6–4
AVIGDOR ARIKHA
*Samuel Beckett with Glasses on
Forehead*, January 7, 1967
Brush and ink on paper,
10¹⁵⁄₁₆ × 8⁹⁄₁₆"

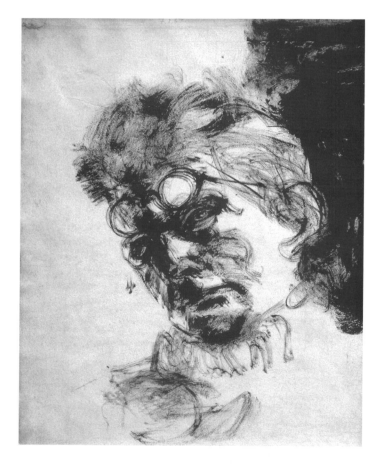

not limited to black and white, however; they can be made by pairing any two values from black, through the intermediate grays, to white.

As we have just seen, the use of value shapes is admirably suited to creating an illusion of light striking flat surfaces. But rounded surfaces can also be implied in a drawing if the value shapes correspond to the way areas of light and dark follow the curve of the form. In the drawing of Samuel Beckett (Fig. 6–4), value has been massed into semi-amorphous shapes to convey an

impression of a three-dimensional head emerging from shadow into warm, brilliant light.

This exercise in value shapes will assist you in expressing a convincing sense of form and light with a minimum of means. Appropriate media include charcoal, brush and ink, black and white gouache or acrylic, and collaged papers.

Before proceeding, remember that when using value to distinguish between two planes that are located at different angles to a light source, you should be careful to carry the tone all the way to the edge of the shape. Compare Figure 6–5a with 6–5b. In 6–5a the boundaries between planes are indicated by lines surrounded by white margins, and as a result the illusion of abutting planes is not so clear as it is in Figure 6–5b.

Drawing 1: This drawing will be done using two tones. In a somewhat darkened room, arrange some brown cardboard cartons so they are illuminated by one strong spotlight. Under this kind of lighting, the shadowed sides of the cartons, their cast shadows, and the darkened surroundings (or "background") will be converted into a single, uniform, dark tonality. The illuminated tops, sides, and ground plane will figure as the light value.

Draw two squares in the margin of your paper. Fill one with the dark tone you see in your subject, the other with the light tone. If white is to be the lightest value and you are using gouache or acrylic, paint the one square white; otherwise leave it the tone of your paper.

Using the squares as your tonal key, draw the subject as a series of light and dark shapes. Since a system of value shapes is the emphasis of this exercise, it is not necessary to make a preparatory line drawing. Remember that adjoining planes identified as all dark or all light should be consolidated into one shape (for an example, refer to Fig. 6–3).

Follow up the two-value drawing with one composed of shapes of three unmodulated values. Working again from a strongly illuminated still life, use a viewfinder to home in on an area of the still life that gives you a good distribution of lights and darks. Using a viewfinder, and also squinting your eyes at the subject, will help you to see these lights and darks as an abstract pattern. If you prefer, you can work with compressed charcoal and white chalk on a gray or brown paper of mid-value.

Drawing 2: In preparation for making a five-value drawing, draw five contiguous squares on the margin of your drawing paper. Shade the squares to achieve even steps of value from light to dark. Note that tones two and four on this value scale will be an average of the middle gray and, respectively, the lightest and darkest values in the end squares.

Make a drawing that depicts the way light falls on a three-dimensional subject using only the five unmodulated values from your scale. Appropriate subjects for this drawing would include a spot-lit still life of light-colored objects against a ground plane of a similar value, or an illuminated human head, your own or someone else's (Fig. 6–6).

Drawing 3: Gently crumple a light brown paper bag until it has the appearance of being made up of a series of planes.

Set the bag on a light gray table or on a piece of light brown butcher paper and illuminate it so that you can see the planes clearly. Draw the bag against the ground taking care to assign a specific value to each plane (Fig. 6–7).

FIGURE 6–5

(a)

(b)

FIGURE 6–6
JEN HARRIS
WAR 1, 2010
Ink on paper, 16 × 14"

FIGURE 6–7
ZENA ALIEVA, University
of Texas at Austin
Student drawing: observing planes
of value in a crumpled paper bag
Charcoal on paper, 22 × 30"

FIGURE 6–8
JORDAN HORN, Savannah College
of Art and Design
Student drawing: combining
modulated and unmodulated
value shapes
Charcoal on paper, 19 × 26"

Drawing 4: *In this drawing you will continue to observe value shapes, but this time you may combine modulated with unmodulated ones. Your subject should consist entirely of light-colored objects and your light source should cast a soft shadow as in Figure 6–8.*

Local Value

Local value refers to the inherent tonality of an object's surface. The surface of an object that is dark in color, such as a desk with a deep walnut finish, will reflect less light than one that is equally illuminated but of a paler color, such as a powder-blue armchair. So a basic attribute of any color is its relative lightness or darkness. Artists who work with traditional black-and-white drawing media analyze the lightness or darkness, or color tone, of objects and record them as value.

When the subject you are drawing includes objects of different colors, you may experience difficulty assigning value to the different parts of your drawing. Artists often overcome this difficulty by squinting at their subjects, concentrating on how the eye, much like the lens mechanism of a camera, admits the relative lights and darks of the colored surfaces they want to draw. This strategy allows

FIGURE 6–9
PABLO PICASSO
Priests at a Seminary
Pen, ink, watercolor, 5³⁄₁₆ × 7"

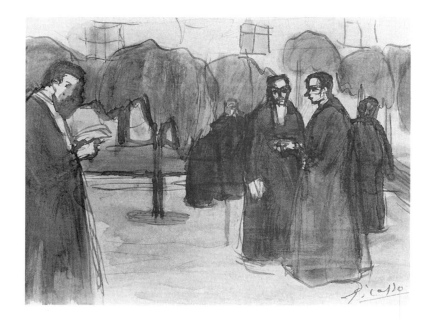

FIGURE 6–10
NORMAN LUNDIN
San Antonio Anatomy Lesson, 1982
Pastel and charcoal, 28 × 44"

them to more readily ignore the colors and identify the local value or inherent tonality of each object's surface free of any variations that result from lighting effects or surface texture.

Local values can be broadly translated into shape areas, as in Figure 6–9. In this early drawing by Picasso, the dark tone of the seminarians' robes contrasts sharply with the paleness of their faces and likewise with the delicate tones of the ground plane and surrounding walls. The middle gray of the trees has a calming and softening effect on this otherwise stark portrayal.

Picasso's decision to limit his tonal palette to the local value of each individual area in Figure 6–9 heightens the work's expressive impact. Frequently, though, artists wish to consider not only the local value of their subject but also the major variations of surface tone caused by light. In this case, the local value can function as a tonal center, or constant, to which artists can relate the variable lights and darks they interpret from an object. To clarify this point, look at Figure 6–10, in which the rectangular shafts of light are each divided into three

carefully measured tones to register respectively the local values of the wall, molding, and blackboard.

Armed with an awareness of local value, you will gradually become more sensitive to the intimate alliance between the essential lightness or darkness of an object and the value variations that appear on its surface. As a consequence, any tendency to represent all light as white and all shadows as black will be moderated by personal observation. In actuality, such extremes of light and dark on a single form are rare under normal lighting conditions. More often you will notice that only objects with a local value of dark gray will approach black in the shadows, and the highlight on such a form will seldom exceed middle gray. Similarly, the local value of an egg simply does not permit a coal-black shadow.

Directional Light and Local Value

In his watercolor, *Houses in Gloucester* (Fig. 6–11), Edward Hopper indicates both a directed source of light and a range of local values. Although any sense of a tonal center in most of the roofs is obliterated by the powerful light of the sun, local values are clearly evident in the shaded portions of the houses. Compare this image with Figure 6–2, in which all the buildings and the ground plane are treated as if they were of identical local value.

When you combine an interest in directed light with the use of local value, it is best, whenever possible, to control the source of illumination. Strong lighting, such as that provided by direct sunlight or the use of a spotlight alone, produces a sharp contrast between lights and darks and thus makes it difficult to see local value (see Fig. 6–12a). An even light, such as found in a room well lit by fluorescent tubes, reveals local value very well, but since such light is nondirectional it does not show the form of an object to advantage. The ideal lighting condition for observing both the local value and the form of an object is one in which the light is directional but not harshly so, such as might be found by a window that does not admit direct sunlight (Fig. 6–12b).

To give the illusion of both directional light and local value, you need to have a command over a range of tones. To acquaint yourself with the tonal spectrum your medium can produce, we suggest that you make a scale of nine

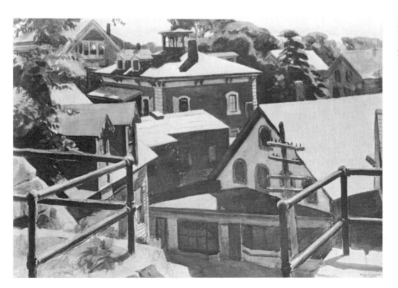

FIGURE 6–11
EDWARD HOPPER
Houses in Gloucester
Watercolor, 13½ × 19½"

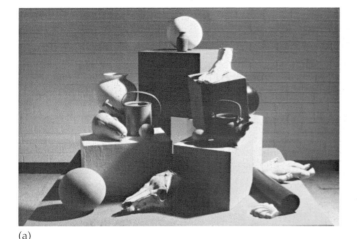

(a)

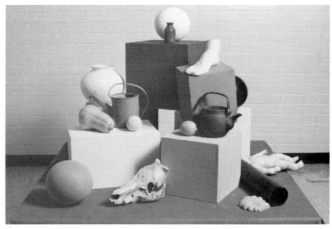

(b)

FIGURE 6–12

separate values. The value scale in Figure 6–13 is particularly useful because the dot of middle gray in the center of each square demonstrates the relative nature of value. The same middle gray that appears as a dark spot in the midst of light-toned squares appears as a pale spot within the context of the darker values.

In making a scale of this kind, we suggest that you start by lightly outlining nine adjoining squares with a circle in the middle of each one. Place the darkest and the lightest tones that you can achieve with your medium on opposite ends of the scale, taking care to leave the circles blank. Then proceed to fill the middle square and the circles with a middle gray. Finally, fill in the remaining squares so that there is an equal jump in tone between them. Remember to blend each individual tone thoroughly, leaving no white margin or black dividing line between the squares.

Exercise 6B *Representing a directed source of light in a drawing will lend a sense of authenticity to the objects you portray. Care in relating the variable tones of an object to a tonal center will give your interpretation of those objects a convincing sense of unity and wholeness and also add optical richness to your drawing overall.*

Drawing 1: This project helps you to apply both of these concepts in drawings of relatively simple, common objects.

Collect some boxes or other angular objects of different local values. You may even wish to paint these boxes black, gray, and white using a cheap brand of house paint. Experiment with both the intensity and the direction of your lighting so that both the local values and the forms of the boxes are seen to advantage. It is also advisable to view these objects against a medium-gray background so as to provide you with a constant reference point when gauging values in your subject.

Choose a white or light-toned paper for this project. In a row of squares along one margin of your paper, indicate the local value of each object in your subject. Now, depict the planes of each object as a value shape, making sure that the tones you put down are within a range of lightness or darkness appropriate to the tonal center, or local value, of that object.

You may want to establish the boundaries of the very lightest shapes first, that is, those you wish to have remain the untouched tone of your paper. Give the rest of the page a light gray tone and then proceed to fill in the very darkest and middle-gray shapes. After these have been drawn, move on to the remaining intermediate tones.

Drawing 2: Here are some ideas for studies in local value that you can do outside the studio setting. Draw a set of buildings under different lighting conditions to experience the effect light can have on your perception of local value. Or do a portrait in value shapes with the aim of

FIGURE 6–13

FIGURE 6–14
DARICE POLO
Theresa, 1948, 2001
Graphite on paper, 18 × 12⅜"

FIGURE 6–15
M. AUSTIN GORUM, Pratt Institute
Student drawing: use of local value to enrich the depiction
of common objects, 3.5 × 4"

*expressing the local value of skin and hair when illuminated by a direct light source (Fig. 6–14).
Another option is to discover the visual presence that local value imparts to objects in the every-
day world, perhaps in an object as mundane as the top of your stove seen by the glare of a kitchen
light (Fig. 6–15).*

Optical Grays

Certain dry media, such as pastel and charcoal, and wet media, such as ink wash,
watercolor, gouache, and acrylic, are commonly used to make solid **actual gray**
tones. Media more suited to a linear approach, such as pen and ink, pencil, felt-tip
marker, and silverpoint, can be used to create **optical gray** tones. Optical grays are
commonly the result of hatched* or "crosshatched" lines, which the eye involun-
tarily blends to produce a tone. **Crosshatching** is a technique that results when
sets of hatched lines intersect one another.

*For a definition of "hatched" lines, see Chapter 5, page 119.

Optical grays can be utilized to achieve the same ends as blended or actual grays. In the drawing by Gaspard Dughet (Fig. 6–16), hatched parallel lines indicate the relative tones of trees and sky. Notice that the hatched lines do not change direction in an attempt to show the topography of the form. Instead, their role is restricted to the depiction of light and dark. In spite of their mechanical look, hatched lines of this sort are well suited to drawing natural subjects. And in contrast to areas of subtly blended tone, the rapid laying in of hatched lines appears to allow depicted forms to breathe.

A robust and gestural use of crosshatched lines to construct shadows can be seen in Figure 6–17. Notice how varying densities of hatched lines help to establish the spatial position of the forms and their gradual emergence from the shadows. This approach to value is an additive one; in other words, the artist began with some selective scribbling and continued to add marks until the form was sufficiently developed.

FIGURE 6–16
GASPARD DUGHET (1615–1675)
Landscape
Red chalk, 10¹³⁄₁₆ × 16¼",
(27.4 × 41.3 cm)
Princeton University Art Museum,
Gift of Miss Margaret Mower for the Elsa
Durand Mower Collection, x1968 1

FIGURE 6–17
HENRY MOORE
(1898–1986)
Women Winding
Wool, 1949
Crayon and watercolor
on paper 13¾× 25"

FIGURE 6–18
CHUCK CLOSE
Phil/Fingerprint II, 1978
Black stamp pad ink fingerprints
and graphite pencil on paper,
Sheet: 30 × 22½" (76.2 × 57.2 cm)
*Whitney Museum of American Art,
New York; Purchased with funds from Peggy
and Richard Danziger 78.55. © Chuck Close,
Courtesy of The Pace Gallery*

An additive approach is particularly evident in Figure 6–18, which show-cases an unorthodox technique for achieving optical grays. In this stamp pad ink drawing by Chuck Close, fingerprints of different intensities have been carefully dabbed onto a grid.

Drawing with scribbled and hatched lines is an excellent way to record your spontaneous impressions of things observed. For this reason, scribbled-tone drawing is an especially useful sketchbook practice, so you will probably have ample recourse to it.

For this exercise, we suggest using a felt-tip or stylus type marker, since they are ideal for fast renderings of objects. Start by making a value scale of nine optical grays (Fig. 6–19). This will help you to gain sufficient control with your marker to begin making drawings of actual objects.

During this exercise you will be taking a path through a complex of buildings, such as you would find on a college campus, and stopping to record the play of light on buildings and vegetation as you go. Your aim will be to complete roughly fifteen small hatched line sketches within three hours, so be prepared to time yourself to spend no more than ten or twelve minutes on each view (Fig. 6–20).

Exercise 6C

Chiaroscuro

Chiaroscuro is an Italian term that basically translates to mean light and dark. In the pictorial arts, chiaroscuro refers more specifically to a gradual transition of values used to achieve the illusion of how light and shadow interact on actual, three-dimensional forms.

However, only certain kinds of light adequately reveal the curvature of a rounded form. A very harsh light, for instance, tends to flatten areas of light and dark into value shapes, as the earliest masters of chiaroscuro knew. Leonardo cautioned against drawing under any lighting conditions that cast strong shadows. In his *Trattato della Pittura* he outlines specific recommendations for illuminating the head of a young woman so that it can be drawn with all its delicacy and charm: the model should be seated in a courtyard with high walls that are painted black, and direct sunlight should be excluded from the space by a roof fashioned of muslin. Whether or not Leonardo ever followed his own set of guidelines, the drawing in Figure 6–21 is certainly evidence of his fascination with the ability of light to model form.

FIGURE 6–19

(a)

(b)

(c)

(d)

FIGURE 6–20
Masa Aoe, University
of Arizona, School of Architecture
Student drawing: cross-hatched
line to achieve optical grays
Pigma micron pen on paper,
7 × 10"

FIGURE 6–21
Leonardo da Vinci
The Head of a Madonna,
c. 1484–1486

Impractical as Leonardo's advice may be, the general point it makes is sound: A very strong light source must be avoided when the intention is to concentrate on the three-dimensionality of a subject. But, so too must the situation be avoided in which the subject is illuminated entirely by ambient light.

Ambient light is the opposite of a unidirectional light source since it appears to come from all directions. The familiar white-walled institutional room, lit with banks of fluorescent tubing, is drenched with ambient light. Although in some circumstances daylight can also be defined as an all-enveloping ambient light, the daylight that comes into a studio with north-facing windows is traditionally favored by people who draw. This is because it is sufficiently directional to reveal form yet not strong enough to cast harsh shadows.

Let us imagine that you are situated in a studio with north light and that the back of your left shoulder is pointed toward the window. The light source is therefore behind you, above you, and to the left. In front of you is a light gray sphere softly illumined by light coming in the window and by reflected light from the light gray tabletop.

The gradations of light that you would see on the sphere can be separated for convenience sake into five separate zones. A sixth zone is the sphere's cast shadow. These zones, illustrated in Figure 6–22, are as follows:

1. The **highlight**, or brightest area of illumination. The highlight appears on that part of the surface most perpendicular to the light source. If the surface is a highly reflective material, such as glass, the shape of the light source will be mirrored on the form's surface at the point of the highlight. If the surface of the sphere is very matte (dull, or light-absorbing, as is velvet) you may see no highlight at all. In Figure 6–22, the surface of the form may be assumed to be semimatte.

2. The **quartertone,** or next brightest area. On a semimatte object, the highlight is blended well into the quartertone.

FIGURE 6–22

Highlight

Quartertone

Halftone

Basetone

Reflected light

Cast shadow

3. The **halftone**, which is located on that part of the surface that is parallel to the rays of light.

4. The **basetone**, or that part of the surface that is turned away from the rays of light and is therefore the darkest tone.

5. **Reflected light**, or the light bounced off a nearby surface. This light is relatively weak and will be observed on the shadowed side of the form just inside its outer contour.

6. The **cast shadow**, which is thrown by the form onto an adjacent surface in a direction away from the light source. Although there are rules of linear perspective governing the use of cast shadows, you would do best to rely on your own visual judgment to record the shapes of these shadows.

A similar organization of tones can be found in curved forms other than true spheres, as can be seen in the still-life drawing by Martha Alf (Fig. 6–23).

Exercise 6D

Set up a subject of a uniform color, such as a ball painted a flat light gray or a substantial piece of drapery (Fig. 6–24). Establish a light source a little behind you and off to one side.

Using compressed charcoal or black conté crayon, do a chiaroscuro drawing of the subject, taking care to include all five areas of tone and the cast shadow. Use a piece of wadded newsprint or a store-bought paper stump to blend the areas of tone, thus achieving smooth transitions between them.

Avoid exaggerating the size and brightness of the highlight and reflected light. You will need to blend the edges of these areas into the surrounding tones; if you do not, they will have the illusion of pushing forward from the volume's surface.

CHIAROSCURO AND TOPOGRAPHICAL MARKS

One of the techniques traditionally favored to render form combines an observation of the play of light and shadow with a judicious use of topographical marks. This technique requires that the lines or marks used to create optical grays also follow the turn of the form's surface. A finely wrought example of this can be

FIGURE 6–23
MARTHA ALF
Still Life #6, 1967
Charcoal on bond paper,
8½ × 24½"

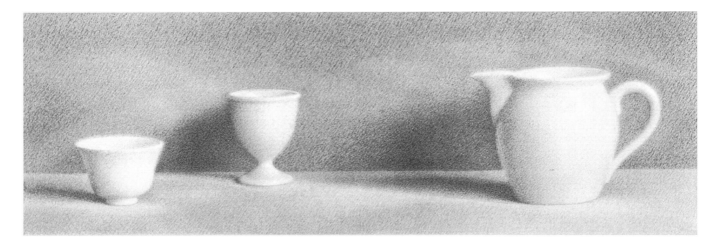

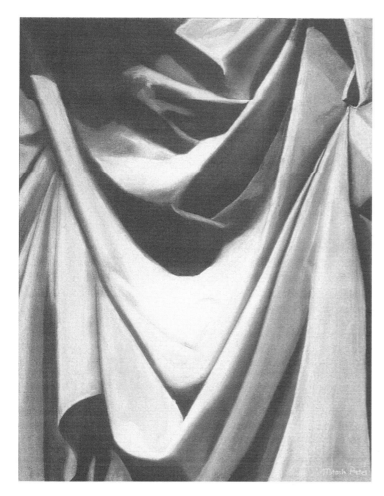

FIGURE 6–24
MITOSH PATEL, Oklahoma State
University
Student drawing: drapery
study using chiaroscuro
Black and white conté, 18 × 24"

FIGURE 6–25
MATTHIAS GRUNEWALD
An Elderly Woman
with Clasped Hands
Black chalk, 377 × 236 mm

seen in Figure 6–25, in which lines of various sorts follow the turning surfaces of anatomical form and costume, while at the same time indicating a play of subdued light.

By analyzing the topography of a form simultaneously with recording the way in which light falls upon its surface, one can achieve a more convincing sculptural effect than would result either from the use of optical grays created by hatched lines or by the use of topographical lines alone. This technique, after all, combines the knowledge of form that can be gained through the tactile senses with knowledge that is gained through our observation of light and shadow. And when employed in a highly controlled way, this technique is unsurpassed for its capacity to model forms of the greatest complexity and subtlety, as we have seen in Figure 6–1.

FIGURE 6–26
Michelangelo
Studies for the *Libyan Sybil*
Red chalk, 11⅜ × 8⁷⁄₁₆"

CHIAROSCURO AND LOCAL VALUE

From the High Renaissance to the early nineteenth century, chiaroscuro was considered virtually indispensable to the art of drawing. A premium was placed upon the modeling of form in the sculptural sense, as may be seen in Michelangelo's drawing of the Libyan Sybil (Fig. 6–26). In the nineteenth century, however, the Renaissance tradition of the picture plane as a window onto infinite space was replaced with a new concern for the flat working surface used by the pictorial artist. As a result of this concentration on the flatness of the picture plane, shape became a more primary means of expression than the traditional illusion of sculptural form. And with an emphasis on shape arose an increased preoccupation with local value.

By the end of the nineteenth century, artists had become adept at using local value shapes to arrive at striking compositions. Furthermore, they found that by controlling the figure–ground relationship of local values, they could achieve a graphic illusion of space, as we saw in the Picasso drawing (Fig. 6–9).

Artists frequently elect to concentrate on either the chiaroscuro modeling of a subject or its local value. This may be demonstrated by comparing the Degas study of drapery (Fig. 6–27) with the drawing of a Spanish dancer by Henri (Fig. 6–28). The drapery study lacks a sense of local value; whether the cloth portrayed is of the palest rose or the deepest purple we do not know. But since Degas' concern was to develop the intricacies of this draped garment in a sculptural manner, the tone of the actual color is of no account. In the *Spanish Dancer*, however, Henri found the play of relative local values essential to the portrayal of his colorful subject. We get a strong sense of boldly rouged lips and cheeks, dark hair, and fabric gaily splashed with a floral motif. But note that there is very little sense of chiaroscuro in this drawing.

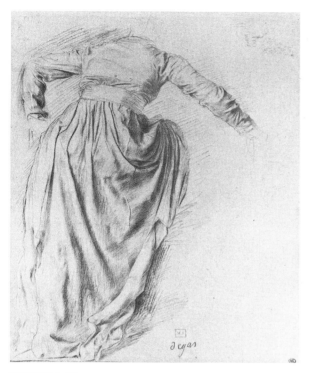

FIGURE 6–27
EDGAR DEGAS
*Study for Semiramis: Standing
woman viewed from the back*
Lead pencil, 35.9 × 23 cm

FIGURE 6–28
ROBERT HENRI
Spanish Dancer
Watercolor, pencil, 10½ × 8"

That artists have often chosen to concentrate on either a chiaroscuro modeling of form or local value does not rule out that the two can be successfully combined in one drawing, as we see in Figure 6–29. To represent the play of light and shadow on his subject, Pearlstein employs the systematic changes of value identifiable with chiaroscuro technique. But instead of blending the tones, he records them as a sequence of value shapes that are carefully contoured to the form. The profusion of these lighting effects is always, however, kept within the boundaries of a tonal "home base," or local value. The representation of sculptural volume in this drawing is heightened by the contrasting use of unmodulated values, as in the patterned rug.

When you wish to balance chiaroscuro and local value be aware that a strong light source that produces very dark shadows will diminish the sense of your subjects' local values. You will also want to avoid placing too much emphasis on highlights and reflected lights as doing so will give an unintended shiny appearance to your subject.

A related issue concerns the belief that value richness in a drawing is always dependent on the use of a full range of tones, including the high contrast of black and white. This is far from true, since many fine drawings in the history of art are composed of a limited series of closely related values that establish a dominant mood, or **tonal key**.

FIGURE 6–29
PHILIP PEARLSTEIN
Male and Female Mirrored, 1985
Conté crayon on paper, 32 × 40"

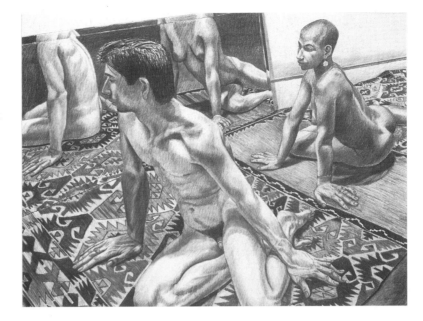

FIGURE 6–30
PHILLIP CHEN
Untitled, 1976
Lithograph, 15 × 22"

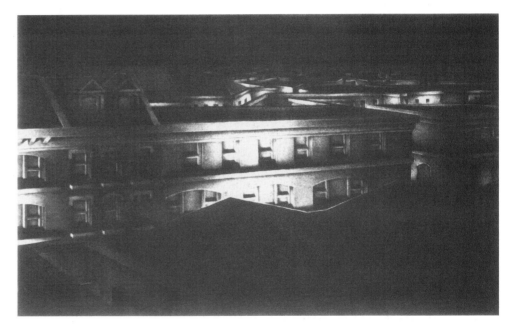

Tonal keys can be high (ranging from white to middle gray), middle (tones within the middle range of the value scale), and low (the dark half of the scale). **Tonal key** refers to the *overall* choices and effect of a coordinated group of values, so it would not preclude, for example, the use of dark accents in an otherwise high-key drawing.

Establishing a tonal key can be a means to both unifying the value schema of a drawing and expressing a distinctive condition of light and mood, as can be seen in Figures 6–30 (a low tonal key), 6–31 (a middle tonal key), and 6–32 (a high tonal key). Artists sometimes transpose the actual values of their subject into another key, making sure to adjust each tonal area proportionately.

In summation, you can employ chiaroscuro without sacrificing the tonal identity of your subject as long as the range of tones used to model a form is

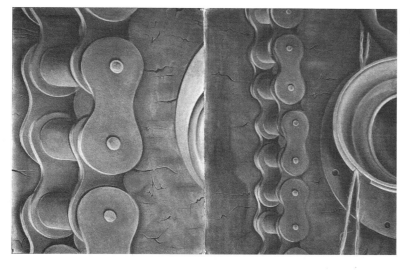

FIGURE 6–31
JOHN ROCKWELL, University
of Wisconsin, Whitewater
Student drawing: organization
of value to establish a mid-range
tonal key

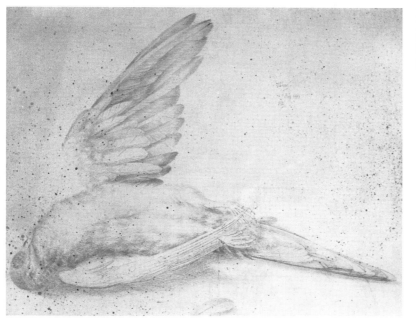

FIGURE 6–32
JOHN WILDE
Objecta Naturlica Divini, 1949
Silverpoint and ink on gessoed
paper

responsive to that form's local value. Figure 6–33 demonstrates how chiaroscuro used within the confines of three different tonal keys—high, middle, and low—can give the impression of forms of distinct local values.

CHIAROSCURO AND TEXTURE

The texture of an object can be drawn using chiaroscuro technique if you consider the various protrusions and indentations of the surface as form in the miniature. One example is the exposed grain of weathered wood, which, when held at the correct angle to the light, reveals itself as a pattern of shallow hills and valleys. An unusual application of this concept is found in Figure 6–34, in which an area of ocean has been conceived entirely in terms of chiaroscuro and texture.

As Figure 6–34 clearly shows, texture is best revealed by raking light, that is, a light that is directed from the side to throw textural details into visual relief. Therefore, you will find that texture is most apparent in the areas of half-tone where the rays of light are most parallel to the surface of a form. This can be

FIGURE 6–33

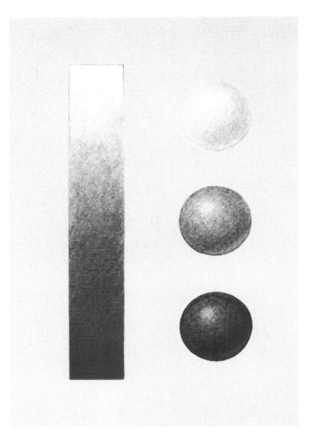

FIGURE 6–34
Vija Celmins
Ocean Image, 1970
Graphite and acrylic spray,
14⅛ × 18⅞"

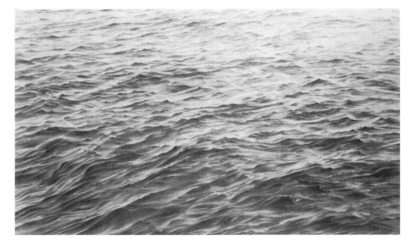

seen in the Claudio Bravo drawing, Figure 6–35, in which the wrinkled and pitted surface of each lemon is most visible where the form starts to turn away from the light. In the more illuminated areas of the surface, where the angle of the rays is most direct, the texture is saturated with light. In the darker areas of the form, the texture is lost in shadow.

Texture includes the idea of the ultra-smooth as well as the very rough. When a surface is so smooth that it is shiny, the normal guidelines of chiaroscuro do not apply. In such cases, the surface reflects values from the surrounding environment, and frequently very light and very dark tones appear next to each other. An example of this can be seen in the reflective surface of the pot in the Currier drawing (Fig. 6–36).

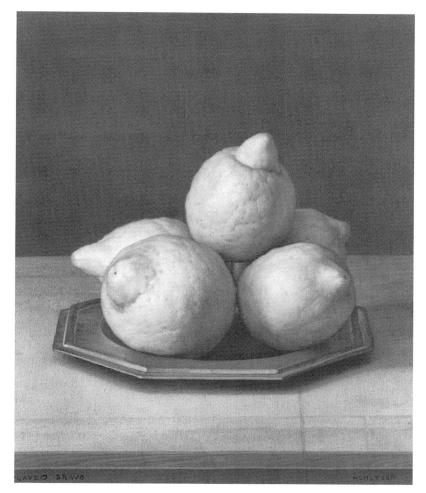

FIGURE 6–35
CLAUDIO BRAVO
Lemons, 1982
Drawing on paper, 15¾ × 13⁵⁄₁₆"

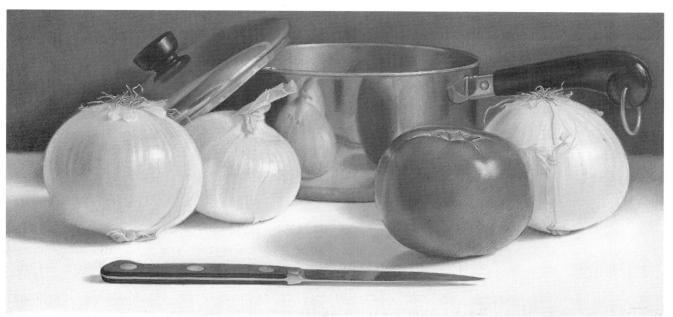

FIGURE 6–36
MARY ANN CURRIER
Onions and Tomato, 1984
Oil pastel on museum
board, 26½ × 56"

Texture need not receive the literal interpretation seen in the last three illustrations. Instead, it can be approximated by a more spontaneous system of marks, as in the Arneson self-portrait, Figure 6–37. Notice that the light and dark marks in this drawing are graded so as to show the general turn of the form.

FIGURE 6–37
ROBERT ARNESON
Eye of the Beholder, 1982
Acrylic, oil pastel,
alkyd on paper, 52 × 42"

*Art © Estate of Robert Arneson/Licensed
by VAGA, New York; Image courtesy
of George Adams Gallery, New York*

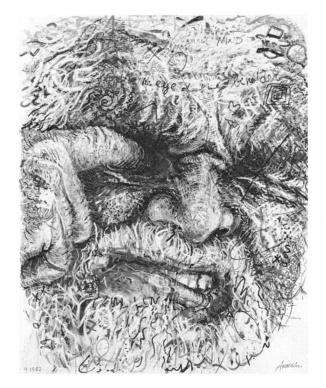

The Interaction of Drawing and Design

In previous chapters, we established the concept of the flat picture plane. This chapter enlarges on that discussion and in the process confirms that responses to two-dimensional organization are integral to the practice of expressive drawing, representational or otherwise.

Drawing and Design: A Natural Union

Design, on some level, plays a part in our everyday existence. But much of the order in our lives is taken for granted, from the simple matter of organizing daily routines to managing the more complex forces of, let us say, career and home life into a state of dynamic equilibrium.

Indeed, design is such a natural part of our consciousness that when we witness something that is superbly organized—as, for instance, the consummate execution of a double play in baseball—we recognize immediately how wonderfully all the parts had to fit together for that to happen. We are thrilled, and it feels good to witness something so well realized, perhaps because the order in our own lives seldom reaches that pitch of resolution.

In drawing, as in all the arts, design is just as natural and ever-present. In fact, you cannot draw *without* designing. Science revealed decades ago that visual perception itself is an automatic process of selecting and making patterns. This means that when we look at things our eyes and mind begin immediately organizing visual differences and similarities so that we might create order out of potential chaos.

So, when you draw to represent your subject, you are simultaneously recording sensations of perceived order. By this we don't mean to imply that you will necessarily create well-designed drawings from the outset of your drawing practice, but only that there is no mystery connected with the fundamentals of design; those fundamentals, like our shared impulse to create order, are simply a part of common experience.

Principles of Design

When transferred to the art-making process, the fundamental means for achieving visual order are generally referred to as **principles of design**. They are given names such as *unity* and *variety*, *contrast*, *emphasis*, *balance*, *movement*, *repetition* and *rhythm*, and *economy*. Principles of design are used by artists to organize the so-called **visual elements** (lines, tones, shapes, textures, and colors) into a unified drawing.

Distinguishing these design phenomena by name may give the impression that they can be set apart from one another and given fixed definitions. On the contrary, they are frequently inseparable and seemingly unlimited in their interactions. Thus, the descriptions below must, of necessity, be neither final nor precise. These summaries are offered only as a set of guidelines to reinforce what you will quite naturally discover on your own.

UNITY AND VARIETY

Imagine, if you will, a country with a population so diverse that it suffers from internal dissension. Its leaders, recognizing that such discord makes the nation vulnerable, look for ways to encourage unity, or a state of oneness, so that the nation's people may stand consolidated against external aggression.

The process of drawing is in many ways the same. A blank sheet of drawing paper, before you put a mark on it, is a totality. Make a mark and you have interrupted its unity of surface and thereby created tension. Adding more marks increases the potential for variety, or difference, while also causing areas of potential agreement, or similarity, to emerge. Your goal when drawing is to find ways to harmonize the conflict of varied forces by building on those areas of agreement so that a sense of unity may be restored.

Thus, we may say that the major polarities in a work of art are unity and variety. Unity underlies a work's impact as a complete event; variety is the agent that enlivens a work and sustains interest. In this regard, look at Figures 7–1 and 7–2. Both are complete visual statements, and yet each in its own way has sufficient variety to leaven the experience. In *Short Schedule* (Fig. 7–1), the repetition of similar nail groupings creates a regular pattern of beats across much of the page. This pattern is relieved by subtle variations of direction within each nail group, and by the contrast of a surprisingly empty, or quiet, zone in the lower left quadrant. In comparison, the multiple images in Figure 7–2 differ more distinctly in their tonal and textural combinations, while a loosely constructed grid imposes unity.

FIGURE 7–1
JAMES ROSENQUIST
Short Schedule, 1972
Pencil, charcoal, and
pastel, 30 × 40"
*Art © James Rosenquist/Licensed by VAGA,
New York*

FIGURE 7–2
R. B. Kitaj
Untitled: Cover of the Times Literary Supplement, c. 1963
Pencil and pasted paper,
15 × 10¾"

CONTRAST

When aspects of variety in a drawing are emphatic, contrast is the result. Contrast may refer to pronounced differences in, for example, scale, lights and darks, shape, handling of media, and activity (busy versus quiet).

In the drawing by Lee Bontecou (Fig. 7–3), look at the startling tonal contrasts and also how rounded masses are poised against larger stretches of flat, unbroken shape. As often happens when contrasts are this extreme, the areas in conflict

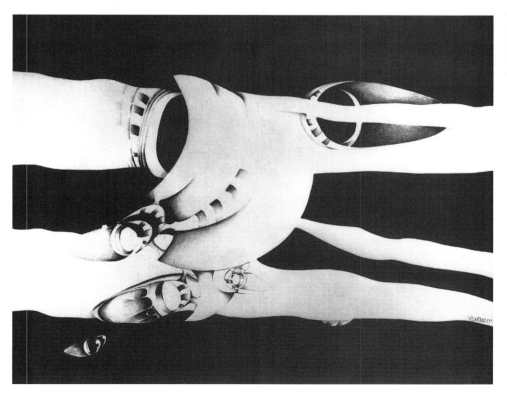

FIGURE 7–3
Lee Bontecou
Untitled, 1967
Pencil, ink on paper,
20 × 26"

FIGURE 7–4
CHARLES SHEELER (1883–1965)
Interior, Bucks County Barn, 1932
Crayon on paper, 19⁹⁄₁₆ × 23"
(49.7 × 58.4 cm)
*Whitney Museum of American Art,
New York; purchase 33.78*

animate each other. They form a relationship based on an attraction of opposites that intensifies their respective differences and helps to bind the drawing together.

EMPHASIS

Levels of emphasis in a drawing are achieved through aesthetic handling (giving certain areas more contrast or a prominent texture, for example) or through the unusual placement or scale of selected lines, tones, or shapes. In Figure 7–4, the silhouetted carriage acts as a focal point due to its stark value contrast, placement (just off-center), the eye-catching slot-like shape of light, and the relative visual calm surrounding the canopy. Emphasis in this area is reinforced by the series of squares that frame the carriage; the rhythms of their subtly varying axes help move the eye from the center of interest to the drawing's overall compositional architecture.

Without emphasis, the visual clues needed to establish the artist's expressive priorities would be absent. Emphasis assists viewer perception by calling attention to significant parts of a drawing. And by placing the elements in dominant and subordinate roles, emphasis lends a hierarchical structure to a drawing, thereby advancing its unity and expressive clarity.

BALANCE

Balance refers to a sense of equilibrium among all parts of a drawing. Typically, drawings are organized on the basis of either symmetrical or asymmetrical balance. The term **symmetrical balance** applies to an image that is divided into virtually mirrorlike halves. Perfect symmetry imparts a formal bearing and is therefore usually reserved for works that are emblematic in character (Fig. 7–5). Many artists who wish to reap the unity that symmetry provides but avoid the ceremonious quality often attached to perfect symmetry employ instead what is sometimes referred to as *near*, or **approximate, symmetry** (Fig. 7–6).

Ordinarily, though, your working drawings will exhibit a diversity of image characteristics—that is, different shapes, tones, textures, sizes, directions, and so forth—unevenly distributed across the picture plane. In this case you will want to use "asymmetrical balance." **Asymmetrical balance** entails adjusting the "visual

FIGURE 7–5
CHARLES STIVEN
Do Opposites Attract?
Charcoal and conté pencil
on paper, 48 × 72"

FIGURE 7–6
ROBERT LONGO
Untitled (desk and chair
in study room, 1938), 2000
Graphite and charcoal on
mounted paper, 68 × 93"

weights" of what you draw (**visual weight** refers to how much an area attracts the eye) to bring these contrasting forces of your drawing into a state of equilibrium. For example, avoid clustering large, complex events on one side of your page without establishing areas on the other side that, although dissimilar in their visual impact, serve as a counterbalance. Look, for example, at the carefully constructed asymmetry in the Wyeth (Fig. 7–7). In this drawing the dark bedpost divides the drawing into two unequal parts: a vertical rectangle on the right and a square on the left.

The artist took a calculated risk in breaking up the image with such a strong and off-center vertical. But note that the vertical of the bedpost can also be regarded as a fulcrum for two cantilevered weights swung to the left and right sides of the drawing and organized into a large "V". On the right side is the visually heavy weight of the scrunched up bedspread; the visually lighter and more distant focal point of the detailed basket is on the left. We respond to the placement of these unequal weights instinctively, just as a smaller child on a seesaw will move farther out from the center in order to find balance with the heavier child on the other end.

FIGURE 7–7
ANDREW WYETH
The Bed, Study for Chambered Nautilus, 1956
Pencil on paper

So, Wyeth carefully adjusted the visual pull of both gestures, using a longer, spatial trajectory on the left to compensate for the shorter, diagonal mass on the right. As a result, a compelling dynamic balance is achieved which restores unity to an otherwise unstable image and imparts visual drama to ordinary subject matter.

MOVEMENT

When selected lines, tones, and shapes are given emphasis in a drawing, they will often imply direction. These separate directions should be organized into a pattern of movement to fluidly guide the viewer's eye across the entire two-dimensional space of the drawing.

Look at Figure 7–8. Although there is a central focal point in this drawing, the artist has not allowed our eyes to remain idle. We are swept around the surface

FIGURE 7–8
GIOVANNI BATTISTA PIRANESI
Capriccio
Red chalk, over black chalk, on paper, 3½ × 5⁷⁄₁₆"

by a series of prominent, gestural curves and opposing diagonals, which are given momentum by changing line weights and clusters of shaded, smaller shapes.

REPETITION AND RHYTHM

Artists often repeat similar shapes, lines, tones, textures, and movements to create organizational relationships in their drawings. Repeated elements do not have to reproduce each other exactly, nor must they always appear in an altogether obvious manner. In Figure 7–9, for example, the figure X on the horizon (representing a windmill) is echoed by a larger X in the foreground that is embedded in the landscape, as is made evident in Figure 7–10. This subtle use of pictorial repetition helps to unify both the two-dimensional and the illusory three-dimensional space of the drawing.

When a visual element, such as a line, shape, or unit of texture, is repeated often enough to make it a major unifying feature in a drawing, it creates what is referred to as a **motif**. In this regard, note the elliptical forms that populate Figure 7–11 in the guises of anatomical features, still-life objects, a light fixture, and a half mirror, the

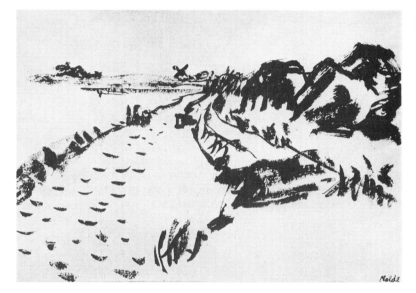

FIGURE 7–9
EMIL NOLDE
Landscape with Windmill, 1909
Brush and black printer's ink on tan paper, 17 1/12 × 23 1/4"

FIGURE 7–10

arcing shape of which is completed inside the figure. If a particular unit of a drawing is repeated extensively, a marked pattern will result. When a drawing is largely constituted of such a pattern, sufficient variation should occur to avoid visual boredom. In Figure 7–12, two strong motifs create contrasting patterns that enliven the surface of the drawing.

Rhythm is based on the measured repetition of features in a drawing. The more these related elements are stressed, especially if the accents and visual pace

FIGURE 7–11
Luiz Jimenez
Abuela, 1997
Lithograph, edition 13/100,
48 × 35½"

FIGURE 7–12
Jack Beal (American, born 1931)
Fat Landscape, 1967
Charcoal with stamping on ivory laid paper, 501 × 650 mm
Restricted gift of Mrs. Irving Forman, 1968.42, The Art Institute of Chicago. Photo courtesy of George Adams Gallery, New York

(or tempo) are varied, the more pronounced the rhythm will be in a work of art. Look, for example, at Figure 7–13, in which both the similar movements of the tree trunks and the intervals of negative space between them are charged with an alternation of stronger and weaker accents.

Rhythm can also be used to invest an otherwise uniform pattern with a sense of pulse. In René Magritte's *The Thought Which Sees* (Fig. 7–14), the delicate tonal changes in the marks create a unified surface that optically vibrates. This work is also a prime example of how organizational properties in a drawing can extend meaning: The meter of the finely woven pattern of marks recalls the hypnotic rhythms of the depicted waves and rolling clouds.

ECONOMY

From time to time, you may find that a drawing you are working on is too complicated and as a result appears disorganized. In that case, it will be necessary for you to do a reasoned analysis of your work, perhaps in conjunction with one or more problem-solving sketches. Start by asking yourself in what ways can the smaller parts of your drawing be consolidated? Locate and strengthen design ideas that are latent in your drawing with the aim of integrating competing or indecisive smaller sections into larger, more clearly defined passages. Sample solutions might include establishing a unifying local value for each major zone in the drawing; clarifying an understated or inconsistent pattern or texture; heightening similarities of shape, scale, focus, rhythm, repetition.

Although one of the strategies may be to reduce the level of activity in an area in order to create a contrasting "quiet" zone in your drawing, economy in a work of art is not necessarily dependent upon reducing the number of visual incidents. It is, instead, a matter of reorganizing a work's constituent parts, no matter how many, into a more easily perceived system of figure–ground relationships. Economy results when a simple pattern or structure is seen to bind visual complexity so that the whole is greater than the sum of its parts. With this in mind, look at Fig. 7–15. At first, the incredible complexity of small shapes,

FIGURE 7–13
BILL RICHARDS
Fern Swamp, 1974
Graphite on paper, 17 × 21½"

FIGURE 7–14
RENÉ MAGRITTE
The Thought Which Sees, 1965
Graphite, 15¾ × 11¾"

FIGURE 7–15
J. Marlene Mueller
Frenzy, 2008
Charcoal, 32 × 44"

lines and value changes in this drawing may appear overwhelming, much as a real-life conflagration on this scale would be. But as we continue to scan the image, we start to sort out the economizing measures the artist used to organize the surface design and spatial illusion of this drawing. Most importantly, observe how the images of the fire and the consumed wooden structure have been given distinct and consistent identities of pattern and value. This strategy, of consolidating very complex parts into larger, simpler zones, has enabled the artist to establish decisive spatial and figure–ground relationships between these two key image areas.

Exercise 7A *Here are three simple exercises that will provide countless hours of challenging drawing in your sketchbook.*

Drawing 1: Choose a subject that clearly exhibits a particular design principle. A landscape, for example, may be perceived as having asymmetrical balance, and ivy growing on a wall may demonstrate the concept of pattern. Carefully observe and draw your subject, paying special attention to its particular design implications and how they may be extended. Refer to the drawing of a piano (Fig. 7–16), in which the contrast between large and small parts is emphasized.

Drawing 2: Choose a common object as the source of a motif for your drawing. Repeat the object, or selected parts of it, across your paper. Provide some variety by, for instance, turning the object over to depict its other side or overlapping some of the images. Figure 7–17 wittily layers the circulating motifs of plastic cutlery and scalloped paper plates in visual counterpoint to a series of marching cups.

 Alternatively, you may wish to draw your objects in different visual guises, that is, change their scale, clarity, positive–negative status, and so forth. Or perhaps as the drawing proceeds, you may wish to place more emphasis on certain areas to establish a center of interest and also to develop paths of movement to guide the eye through your drawing.

Drawing 3: The goal of this drawing is to combine two or more design ideas without sacrificing either unity or variety. In Figure 7–18, the generally globular shape of the vegetables constitutes a unifying motif, a unity that is strengthened by the near-symmetrical arrangement. But note how the linear stalks of the beet top provide a strong contrast to the relatively broad, gleaming sides of the eggplant.

FIGURE 7–16
CHEREEN TANNER, Arizona
State University
Student drawing: contrasting size
relationships as an organizing
device
Charcoal, 18 × 24"

FIGURE 7–17
SPIRO KOULOURIS, Central
Connecticut State University
Student drawing: motifs
developed from repeated images
of cutlery and plates
Charcoal on paper, 18 × 24"

FIGURE 7–18
Marcia Smartt, Middle
Tennessee State University
Student drawing: still life
combining motif, contrast,
and repetition of forms
Charcoal, 28 × 22"

Gesture Drawing as a Means to Design

In previous chapters, gesture drawing was presented as the primary way for artists to grasp the essential visual character of a space or an object.* But a gesture drawing may also serve as the design foundation, or "rough," for the more sustained development of a particular image.

Often artists will make separate sketches, dividing their pages into several formats to test, in a sort of gestural "shorthand," how a subject may best be laid out in preparation for a sustained work (Fig. 7–19).

But just as frequently, marks from gestural explorations serve as the under-pinning for a work in progress and so are not apparent in the finished product. The gestural spirit of search and discovery remains embedded, however, in the naturalness with which the subject has been represented.

*See Chapter 1, "Gesture Drawing as a Means of Capturing Space," and Chapter 5, "Gesture as a Means of Exploring Form." Additionally, "Gesture Drawing as a Means to Interpret the Figure" appears in Chapter 8.

FIGURE 7–19
MAX BECKMANN
Study for the Night
Pen and ink

A particularly illuminating example of this may be found in Figure 7–20. In this drawing, Giacometti, the twentieth-century Swiss artist, has penetrated below the surface detail of a section of a fifteenth-century painting by Hubert and Jan van Eyck (Fig. 7–21) to expose the work's latent gestural energy and structural conviction.

The Giacometti is thrilling to look at not only because it is a beautiful drawing in its own right but also because it functions as a sort of x-ray, interpreting for the onlooker what takes place inside another work of art. This latter point is especially significant for us, since it suggests that artists may use gesture drawing as a tool to diagnose the basic state of their *own* works in progress. Let us suppose, for example, that after a drawing is well under way you decide that parts of your image are lacking in structure or that the overall design is in some way deficient. In response, you might very well make gestural studies on separate sheets of paper so as to analyze these shortcomings prior to resolving them in the actual work.

Giacometti's interpretive drawing has another far-reaching implication for the drawing student. You will notice that he deliberately made a format border to enclose the excerpt of the Ghent altarpiece he chose to draw. His awareness of the rectangular shape within which to conduct his search suggests that gestural activity may be intimately linked with the design conception of a drawing.

FIGURE 7–20
ALBERTO GIACOMETTI
Landscape
Pen on paper

FIGURE 7–21
HUBERT AND JAN VAN EYCK
The Adoration of the Mystic
Lamb, detail of *The Ghent
Altarpiece*, front right-hand
panels, 1432
Tempera and oil on wood

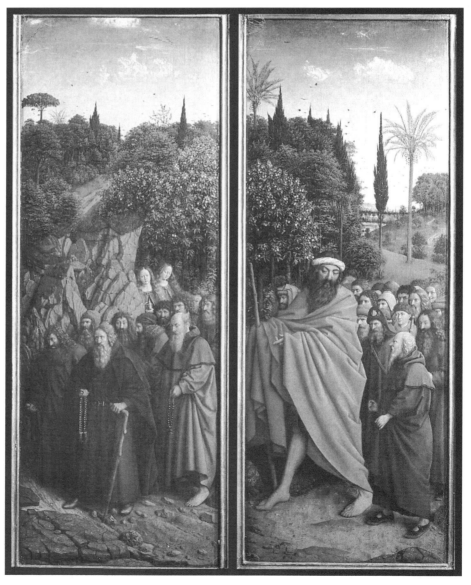

In fact, we may say that design in a drawing is often initiated when gestural responses to a subject are laid out and scaled to the limits of the drawing's format. Barlach's gestural study (Fig. 7–22) has admirably taken into account the overall proportions and rudimentary structural properties of this running figure. But what interests us most here is the way in which the figure's extension into space coincides with the paper's edge. This is significant because, while Barlach took visual possession of the man's image, he simultaneously took physical possession of his drawing surface.

This simultaneous seizing of the gesture of the subject along with the total engagement of the picture's surface is typical of gesture drawing at its best. In the heat of the moment, the artist's own eye and arm generalize the expressive attitudes and organization of parts that are characteristic of the subject. At the same time, the artist is intuitively aware of how the placement and directional energies of the emerging image relate to the rectangular page on which it is drawn. While in the act of drawing, the edges of the drawing constitute the boundaries of the artist's visually created world, so the artist feels the necessity of making the image within those bounds as absolutely real and immediate as possible. Consequently, we are often excited when looking at a gesture drawing, at seeing so much energy packed into a small, flat space. This principle applies even to the drawing of abstract images, as may be seen in the commanding gestural study by Elizabeth Murray (Fig. 7–23).

Beginners often start with single objects to get the feel of gesture drawing and its design implications (Fig. 7–24). But the gestural approach is equally appropriate for subjects made up of multiple objects, such as still lifes, interiors (Fig. 7–25), and landscapes (Fig. 7–26). Drawing multiple objects challenges the artist to empathize with the unique gestural expression of each part of a subject. And as individual gestures are realized, the artist must be alert to correspondences that emerge between areas, since they will suggest larger gestural patterns, which may in turn point to options for organizing the drawing overall.

Look, for example, at *The Farm* (Fig. 7–27) by John Bennett. Each area has its own kind of gestural shorthand, producing a work that is fresh and altogether unstudied in expression. But, as an outgrowth of its spontaneity, the trailing lines from each major division of the page create a zigzagging pattern that binds together the spatial illusion and surface design of this drawing.

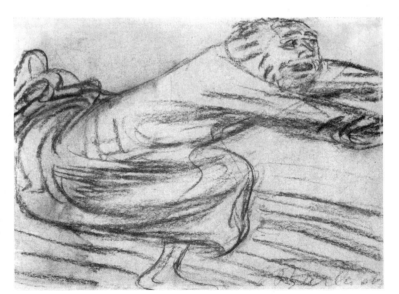

FIGURE 7–22
ERNST BARLACH
Running Man, 1918
Charcoal on white drawing paper,
22.8 × 30 cm

FIGURE 7–23
Elizabeth Murray
Untitled, 1984
Charcoal with rubber
eraser on paper, 44 × 30"

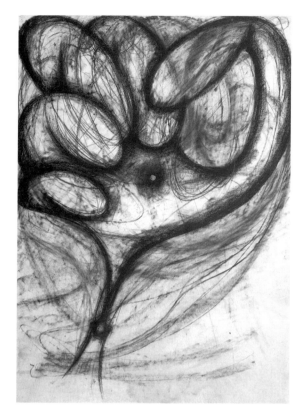

FIGURE 7–24
Crystal Bray, Arizona
State University
Student drawing: gesture
drawing of a single object
Charcoal, 18 × 24"

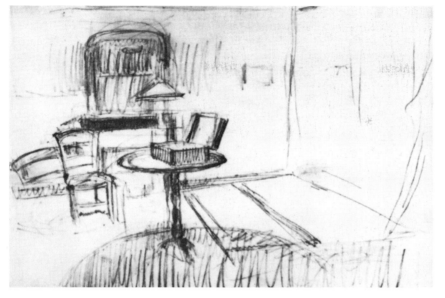

FIGURE 7–25
EDGAR DEGAS
Study for Interior, c.a. 1868
Pencil

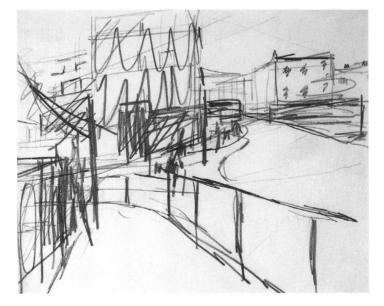

FIGURE 7–26
FRANK AUERBACH
*Study for Mornington
Crescent,* 1967
Pencil, 9⅞ × 11¾"

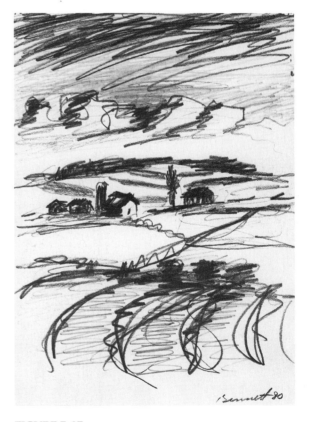

FIGURE 7–27
JOHN BENNETT
The Farm, 1981
Pencil, 9 × 6"

It is interesting to see how the drawing by Gaspar van Wittel (Fig. 7–28) retains a similar gestural freshness. In this work, the slashing marks and abruptly brushed areas of wash summarize the major spatial planes. At the same time, they describe the edges of a mountain range, cuts in the landscape, and the underside of a mass of vegetation that advances toward the picture plane. But much as with Bennett's drawing, these same marks are also the agents of an inventive design strategy in which positive and negative zones are melded into a cohesive unit.

To clarify this last point, compare Figure 7–28 with Figure 7–29. Note that van Wittel divided his page into three major areas, and also see how he grouped

FIGURE 7–28
GASPAR VAN WITTEL
View of Tivoli, 1700–1710
Pen and brown ink, 35.8 × 37.3 cm

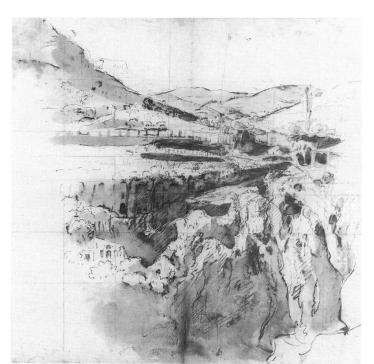

FIGURE 7–29

the dominant dark masses into a tilted, rectangular shape that rests on the bottom edge of the drawing, poised, it would seem, to move into spectator space.

These two projects will urge you toward a more gestural conception in your work.

Exercise 7B

Drawing 1: Using an interior as your subject, choose a viewpoint that offers a spatial movement sufficiently dynamic to establish a strong gestural design, as in Figure 7–30. Taking a broad medium, such as lecturer's chalk or a good-sized brush charged with ink or paint, summarize that movement to take possession of the entire format, thereby unifying the totality of the image. Within that larger gesture, develop secondary movements and design relationships based on different qualities of contrast.

Drawing 2: This time draw from an observed or photographically-derived subject, gesturally recording its major axes and spatial movements. Be sure to draw the image large enough so that your gestural marks are also responsive to the two-dimensional area of your paper.

Finish your drawing, developing its design implications but without losing the spontaneous character of your initial gesture drawing (Fig. 7–31).

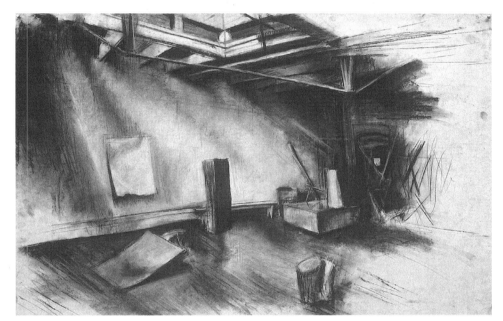

FIGURE 7–30
Student drawing: gesture drawing used as a means to design

FIGURE 7–31
Susan Hlaudy, Kent State University
Student drawing: sustained gesture
Graphite on paper, 18 × 24"

8

Drawing the Human Figure

Why Draw the Figure?

A summary look at the history of Western art since the Renaissance reveals striking changes in the depiction of the human figure. While representations of the human form from the fifteenth through most of the nineteenth century tended to be highly naturalistic, treatment of the figure became suddenly much more abstract in the first half of the twentieth century. You can verify this for yourself by comparing the early Renaissance painting of the dead Christ by Mantegna (Fig. 3–2a) with the Henry Moore drawing of women winding wool (Fig. 6–17).

Even more radically, as twentieth-century Modernism progressed, not only the human likeness, but imagery of any sort, became endangered. With the advent of so-called Postmodernism* late in the twentieth century, interest in the figure was revived but that interest was, and remains, just one stream of activity among innumerable aesthetic practices today. More recently, the necessity for firsthand study of the body has been thrown into question by the availability of software that furnishes options other than freehand drawing for representing the figure.

You may find it curious that in spite of the move away from figurative concerns by modern and contemporary artists, the study of the figure in university art departments and art schools has continued. Why, you might ask, is an academic tradition started in the Renaissance still relevant today?

For students who continue to be interested in the human body as a subject, drawing remains the best route to an understanding of human form. Practice at observational drawing will eventually invest your figurative images with a sense of authenticity, whether or not you choose to take advantage of advanced technologies. But even for those students who have no particular interest in figurative imagery, working from a life model accrues benefits that cannot be obtained any other way. Most pointedly, insights gained from rigorous figure drawing equip the artist with a profound grasp of the world of natural form. As a result, lessons learned about the form and structure of complex organic subject matter will be useful to you across a range of diverse imagery, figurative and non-figurative alike.

Body Identification

The human body is a subject unparalleled in its scope for empathy. Your strong identification with your own body makes it possible for you to wince if you see another person hit a finger with a hammer, or to feel a sense of relief in your own

*For a discussion of Modernist and Postmodernist art, see Chapter 14.

shoulders when you see someone set down a heavy suitcase. That same natural empathic capacity can be put to valuable use when it comes to drawing the human figure. Our approach throughout this chapter is founded upon the concept that, as an artist, your identification with your own body is key to understanding and expressing the figurative subject. By referring you to the experience of your own body, it is our intention that you will learn the basics of figure drawing "from the inside out."

In keeping with this emphasis on the influence of internal structure on exterior appearance, we urge you to take a few minutes to become acquainted with some of the most evident characteristics of human form. Figures 8–1, 8–2, and 8–3 will serve as visual guides. Using your own body as a primary reference for understanding anatomy will increase your sense of "body identification." By this we mean that you will become more attuned to deep-seated associations that will help you to identify with the life model you are drawing.

To begin, assume a "stand at attention" posture, looking straight ahead, shoulders back, arms at your side, spine slightly arched, knees straight but not locked, and with feet slightly apart. Now, using your head as a starting point, begin an orderly tour down your body to the bottom of your feet, pausing to size things up at five key stations.

1. *The head, neck, and backbone.* Place the heels of both hands over your eyes and rotate your palms outward so that your spread fingers wrap lightly around your head. With the fingertips of your forefingers and middle fingers extended toward the back of your head, and the little fingers lying across your forehead, note that the front of your skull is narrower than the rounded

FIGURE 8–1
Bernhardus Siegfried Albinus
Tabulae Sceleti et Musculorum
Corpus Humani
London, Knapton, 1749 Tab I

FIGURE 8–2
Bernhardus Siegfried Albinus
Tabulae Sceleti et Musculorum
Corpus Humani
London, Knapton, 1749 Tab III

FIGURE 8–3
Bernhardus Siegfried Albinus
Tabulae Sceleti et Musculorum
Corpus Humani
London, Knapton, 1749 Tab II

volume of the cranium in back. Run your fingers back along the cranium to the base of the skull. Tipping your head forward, continue moving the fingers of one hand down the back of your neck until you find a bony protrusion. This prominent bump is one of the cervical (or neck) vertebrae and provides evidence of a deep structure inside your body: the spinal column, which unites the skull, rib cage, and pelvis. Note the natural curvature of the spinal vertebrae in our illustration (Fig. 8–2), then bend and twist your torso to experience the flexibility of your own backbone.

2. *The collarbones and shoulders.* Touch the pit of your neck at the base of your throat. On either side of this point is a symmetrical bony system, often referred to as the shoulder girdle, which consists of the collarbones and shoulder blades. Since the axis of this girdle is perpendicular to the spinal column, it represents a major intersection of your body. The shoulder joint is one of the most flexible joints in the human body. If you extend both arms and swing them in windmill fashion, you should get a good idea of the unique range of motion available to this ball and socket joint. As you do so, lightly grasp one shoulder joint with the opposite hand so that you can feel the changing relationships of the collarbone and shoulder blade as your arm bone rolls in its socket.

3. *The rib cage.* Remaining at attention, bend your arms at right angles toward your body and locate two pronounced sharp points at the bottom of your rib cage; they are on each side of the frontal plane of your torso, just above your stomach. Using both hands, trace inward from both points to outline the upside down V of your thoracic arch. Next, spread your fingers and feel the rib cage's curvature around the sides and down to the front of your body. This tactile searching out is meant to impress upon you the volume of the rib cage and its pivotal role in shaping the voluptuous three-dimensional form of your upper body.

4. *The pelvis.* The intersection of the spinal column and the hipbones is another skeletal landmark. Using an architectural analogy, one might think of the bones of the hip as a transfer beam, or lintel, helping to distribute the single-load weight from the upper body across the pelvis and down the two posts of the thighbones. Carefully balancing on one foot, gently rotate your opposite thigh and you will feel that the fluid motion is similar to what you experienced when moving your arm in its shoulder socket. However, if you attempt to swing your leg in a wide circle, as you did your arms, you will discover that the mobility of this joint is more limited than that of the shoulder joint.

Before we move to the next station, change your posture by shifting your weight to one leg. Notice that your shoulders and hips, parallel a moment ago, are now at opposite angles. Lean the other way and these angles reverse. What has happened is this: In the static, at-attention pose, your body's major masses were aligned to effect a relatively simple balance. When you shifted your weight, your stance became asymmetrical, and in order to maintain your balance you had to counteract the tilt of your pelvis with an equivalent opposing swing of your chest and shoulders. This asymmetrical stance, with shoulders and hips in a contrary relationship, is referred to as a *contrapposto* gesture. Not only visually graceful, but revealing of the numerous cause-and-effect relationships inherent in weight shift, the *contrapposto* stance has been a feature of classic figurative form since the early Classical period of Greek art.

5. *The legs and feet.* Stand again with your weight equally distributed on both feet. Tensing your thigh muscles, feel the compactness of the musculature that forms these pillars (interestingly, the muscles of the upper leg are sometimes referred to as *antigravitational*). Balancing on one foot again, test the hinge joint at the knee of your opposite leg, which permits only backward mobility. Finally, try to perceive a line of tension that runs from your hip joints, through your thighs and down the backs of your calves to the anchoring force of your heels. These downward forces are resolved in the end by the displacement of your weight forward as both feet hug the ground plane. (See Fig. 0–4 for a visual expression of these forces inside the lower leg.)

The sensory excursion you just completed was meant to accomplish two things: to imprint upon you a firsthand impression of the longitudinal and latitudinal wholeness of your body, and to initiate an elementary working knowledge of major parts of human anatomy. The next step is to look at the relative sizes and organization of those parts, or what is commonly called proportion.

Proportion

Rules of proportion have been developed by different cultures since antiquity. The drawing by Leonardo in Chapter 3, "Shape, Proportion, and Layout," (Fig. 3–1) applies the classical canon of the Greeks as recorded by Vitruvius. Figure 8–4 is a contemporary example of the use of the classical system of human proportions. Wholesale application of a code of idealized proportions, however, is a matter of artistic choice. Other options include a naturalistic approach, which emphasizes individual bodily idiosyncrasies (Fig. 8–5) or an exaggeration of figurative form for expressive purposes (Fig. 12–11). Nowadays, it is uncommon for artists to correct a life drawing by using a strict, conceptualized canon of proportions. Instead, adjustments in such a drawing are based on further visual observation and analysis, measuring the sizes and angling the orientations of specific bodily regions. Still, awareness of selected guidelines for part-to-whole relationships of the human body can establish a comparative norm from which you can analyze more complex proportional

FIGURE 8–4
ELLEN STEINNON, University
of Wisconsin, Whitewater
Charcoal on paper, 46 × 38"

FIGURE 8–5
MYNKE BUSKENS
Number One, 1998
Pencil, graphite, eraser
on paper, 150 × 200 cm

events. As diagrammed in Figure 8–6, common benchmarks of proportion are the following:

1. Using the head as a unit of measurement, the typical human figure is seven and one-half heads tall.

2. Subdivided into halves, the midpoint of the figure occurs at the hips just above the pubic triangle.

3. Subdivided into fourths, the length from the bottom of the foot to the middle of the knee equals the distance from the knee to the midline at the hips. The upper body is bisected at the nipples.

4. With arms held straight at the sides, extended fingers reach almost to the middle of the thigh.

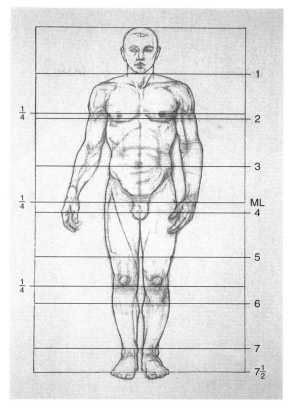

FIGURE 8–6

Since human bodies are not uniform, this set of proportionate divisions should be understood only as a rough guide. Besides, such divisions are of limited use once the figure deviates from a symmetrical, standing position. Yet, with poses of short duration, when there is no time to be persnickety about proportion, these conventions can act as a convenient shorthand to lay out the relative dimensions of a figure.

Gesture Drawing as a Means to Interpret the Figure

The power of a gesture drawing is rooted in the artist's empathy for a subject. For this reason we strongly recommend that, prior to beginning a gesture drawing, you take the model's pose yourself. Concentrate on what the pose feels like. Where is your body under tension? Where is it relaxed? What is the spatial relationship of your head, your torso, and each of your limbs? In addressing these questions you will gain a physical understanding of the pose as you are sorting it out visually and conceptually.

To maintain your sense of bodily involvement and freedom while drawing, we suggest that you assume an active posture by standing at an easel or kneeling over your paper in a hovering position. If possible, use paper no smaller than 18 × 24" so that you may employ the full kinetic sweep of your arm to echo the gestures of the model. In general, we also suggest that you use comparatively large drawing instruments such as sticks of charcoal, lecturer's chalk or graphite, or a carpenter's pencil sharpened to a flat edge rather than a point. Grasp your tools not as if you were writing, but as you would a conductor's baton. In fact, when making gesture drawings, we advise you to be two-fisted in

your attack: Hold your drawing tool in one hand; in the other hand have at the ready an eraser or chamois. Be prepared to smear or soften marks and lines as necessary with your fingers or the sides of either hand.

Start by drawing the figurative image large on the page. Beginning with the head, record the major axial sweep of the pose by swiftly traversing, like an electrical current, through the body to the feet (Fig. 8–7). Encompass the entire figure in your drawing; cropping its image will stymie your ability to express the sequence of anatomical linkages that unify the body. Make sure to indicate the relative placement of head and feet early on in your drawing. In most standing poses the head will be centered above the feet if the model's weight is on both legs, and if the model's weight is primarily on one leg, the head will be located above the weight-bearing ankle. Next, locate the secondary and tertiary axes, and record them with sweeping gestures. (To assist you in analyzing the angles in a pose, look for vertical lines in the architectural environment against which to compare the major axes of the model.)

FIGURE 8–7
Colin Kilian, Pratt Institute
Student drawing: gesture drawing
of the figure

If you work quickly, you will have time to adjust the image. Do not be concerned about errant marks, for they will serve as valuable reference points against which you can make corrections. And, evidence of corrections will invest your drawing with the excitement that went into making it by revealing the physical energy and thought processes involved in gesture drawing. As you record movement in the figure with flowing gestures, vary the dynamics of your marks and lines to suggest "hot spots" in the pose (pressure points due to stretching, compression, or weight-bearing duties). You may wish to express the magnetism of these events in the body through mass gesture or by scribbling a coiled line (Fig. 8–8).

As you proceed, avoid excessive outlining. During short poses, an emphasis on outlining is inefficient: The model will likely change position before you have recorded much of the figure. More importantly, if you devote all your attention to drawing the outer contours you will overlook the fundamental structural and thematic aspects of the pose that inevitably occur inside the outer contours of the body. There is nothing wrong with indicating selective outer contours in a gesture drawing, so long as they are responsive to internal events of the body. So, where bony protrusions or bodily twists drive the energy to the outer contour, register them there; but whenever a force goes across a part of the body, follow that route. The simple rule of thumb is, **Earn your edges!**

Exercise 8A

We have just walked you through a basic approach to figurative gesture drawing. It is one that can be applied to poses as short as thirty seconds or as long as five minutes in duration (Fig. 8–9).

The following exercises are variations on conventional gesture drawing.

FIGURE 8–8
Reginald Marsh (1898–1954)
(Nude Male Figures)
and Sketch for Prometheus, n.d.
Graphite pencil on paper, Sheet: 12 × 9" (30.5 × 22.9 cm)
Whitney Museum of American Art, New York; Felicia Meyer Marsh Bequest 80.31.27.
© Estate of Reginald Marsh/Art Students League, New York/Artists Rights Society
(ARS), New York

FIGURE 8–9
Roni Callahan, Kent State University
Student drawing: sustained
gesture drawing of the figure
Charcoal, 24 × 18"

Drawing 1: *This exercise, called the "strobe-light" method is based on the assumption that conceptually retrieving information you have seen and felt will help to accelerate your knowledge of the figure. First, assume the pose the model has taken and hold it for enough time to experience major axial movements, weight distribution, and the spatial points of the appendages (about twenty to thirty seconds). Now, close your eyes and do a one-minute blind gesture drawing using your visual and sensory memory banks. When the minute is up, stop drawing and open your eyes. Take thirty seconds to compare what you have drawn with further observation of the model. Have you depicted the spatial gestures of the pose by steering the eye through an illusion of depth using different weights, speeds, and clarity of marks? Have you circled across the essential volumes to give those parts of your image a more tactile sensation? The next step is to plan what needs to be done to improve the structure and expression of your drawing. Following that, place your drawing material on the section where you will begin, and repeat the blind gesture for another minute. For the final step, select a portion of the body you feel is crucial to pulling the drawing together. Develop that section with your eyes open to complete the drawing (Fig. 8–10).*

Drawing 2: *A more dramatic method for sensitizing yourself to essentials is to collaborate with a peer on gesture drawings from a life model, using the following arrangement: First, both members of the team should take the pose for twenty seconds. Then, standing (or sitting if necessary) side by side, one person (drawer one) will hold the drawing instrument; the second person (drawer two) will firmly grasp the operative wrist of drawer one. Drawer one then begins to work with drawer two holding onto drawer one's wrist. At the first sign that the drawing is proceeding incorrectly, it is drawer two's responsibility to maneuver drawer one's hand toward a different course of action. Physical give-and-take should be accompanied by comments from both partners as they cooperate in summing up the pose. Complete a two-minute gesture drawing using this method (Fig. 8–11). Switch roles and repeat.*

FIGURE 8–10
Jennifer Wong,
University of Cincinnati
Student drawing: strobe-light
gesture drawing
Graphite stick, 18 × 24"

FIGURE 8–11
Brent Lashley and Rodiney
Gustke, University of Cincinnati
Student drawing: collaborative
gesture drawing
Charcoal on paper, 18 × 24"

Anatomy in More Depth

There are 206 bones and over 600 muscles in the human body. Since relatively few have names that pop up in daily conversation, the prospect of learning them can be intimidating. Fortunately, you do not have to be an anatomist to successfully depict the human body, and ultimately, you alone will have to determine the degree of anatomical knowledge you need to achieve your goals.

It could be argued that students who have mastered the basics of drawing should be able to represent any observed object, the figure included. And it is true that skilled use of form analysis based on outward appearances will enable an artist to draw the figure in proportion and to accurately angle the major axial directions in a life-model pose. Representing the human body only on the basis of external features, however, may be considered a flawed approach, since most bodily structure is subsurface. Failure to account for interior factors that play a major role in what is observed can result in figure drawings that bog down in a welter of disconnected, superficial detail. For this reason, we recommend that you attain at least a rudimentary understanding of human anatomy. Figures 8–12 and 8–13 are general references for the discussion that follows.

BASIC SKELETAL STRUCTURE

The skeleton is divided into two structural components: The axial skeleton, consisting of skull, vertebral column and rib cage; and the appendicular skeleton, consisting of the shoulder and pelvic girdles and the upper and lower limbs.

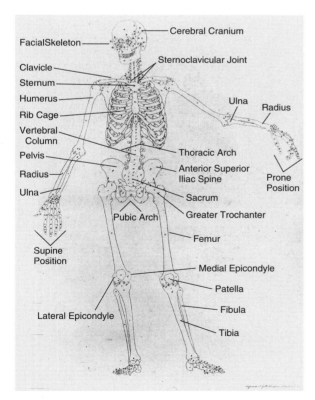

FIGURE 8–12
BERNHARDUS SIEGFRIED ALBINUS
Tabulae Sceleti et Musculorum
Corpus Humani
London, Knapton, 1749 Tab I
(line rendering of Figure 8–1)

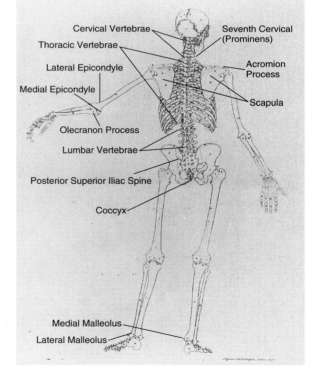

FIGURE 8–13
BERNHARDUS SIEGFRIED ALBINUS
Tabulae Sceleti et Musculorum
Corpus Humani
London, Knapton, 1749 Tab II
(line rendering of Figure 8–3)

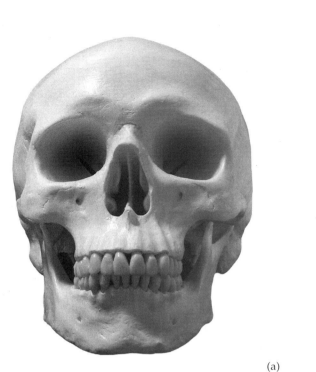

(a)

(b)

FIGURE 8–14

(c)

The Skull The skull is the bony foundation of the head (see anatomical illustrations, Figs. 8–14a, b, and c). It consists of two main sections: the cerebral cranium and the facial skeleton. Be aware that the credibility of your figure drawings will be undermined to some extent if you omit the cranial portion of the skull. A simple summary of the skull can be achieved by using two intersecting ovals, foreshortened as appropriate, to represent the facial and cranial masses (Figs. 8–15a and b).

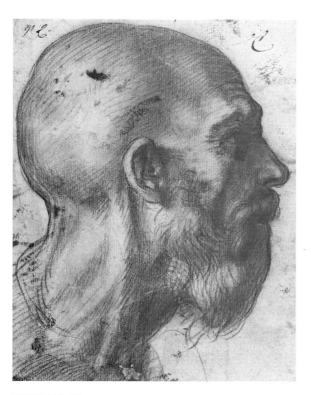

FIGURE 8–15a
ANDREA DEL SARTO
Profile of a man's head,
Louvre, Paris, France
Red chalk

FIGURE 8–15b
Diagram of 8–15a: Constructing
the skull using intersecting ellipses
to indicate the facial skeleton and
cranium

A close look at the skull will reveal the overall three-dimensional form of the head and help you to understand the relationship of the face to the cranium. That the human face is widest across the cheekbones at the zygomatic arch is something easily observed in the frontal view of the skull (Fig. 8–14a). Looking at the skull from above (Fig. 8–14b), you will see that the face constitutes the narrowest part of the head's mass, a fact that may surprise you.

A view from the side (Fig. 8–14c) shows the extent to which the face wraps around the front of the skull. Although the joint of the jawbone (mandible) is set about halfway back from the front of the face, the back molars are less than a third of the way back and the eye sockets are forward of that. Compare Figure 8–15a with the side view of the skull (Fig. 8–14c) and note that the frontal bone of the forehead is set back from the ridge of the brow. Be especially aware of the relationship of the back of the skull to various facial features (the base of the cranium in back, for instance, is located on the same horizontal plane as the base of the nose in front).

Figure 8–16 provides a rough guide to the proportions of the human face. The eyes are located halfway between the top of the cranium (not including the hair) and the bottom of the chin. Measuring from the top of the forehead at the hairline (before the skull starts to recede), horizontal divisions in thirds fall at the eyebrows and the top of the ears, the bottom of the nose and ears, and the lowermost portion of the chin. The center of the closed mouth is one-third the distance from the bottom of the nose to the bottom of the chin. (Observe that the straight lines that horizontally divide the frontal view of the face change to curves when the head is turned to a three-quarter view, as in Figure 0–6.)

FIGURE 8–16

Exercise 8B *Drawing 1: Working either from a real skull, a plastic casting, or from anatomical illustrations, make a sheet of studies of the skull from a number of different angles. Be sure to begin each study gesturally, scribbling out the longitudinal and latitudinal sweep of the skull, followed by an analysis of its major planar structure (Fig. 8–17).*

Drawing 2: Draw a portrait head seen from an unusual angle. Studying the model for bony landmarks and using the knowledge you just gained from working directly from the skull, lay in a drawing of the skull within the portrait. You will, as it were, be trying to draw with x-ray vision (Fig. 8–18).

Drawing 3: Draw a portrait representing several views of your model's head, bearing in mind the general masses of the skull (Fig. 8–19).

The Vertebral Column The *vertebral column* is also known as the *backbone*, the *spinal column*, or simply the *spine*. Made of stacked units, the vertebral column is rigid enough to provide stable support for the head and thorax, yet flexible enough to allow the trunk to bend and rotate, most notably at the waist. The flexible portion of the spine consists of twenty-four vertebrae, which are arranged from top

FIGURE 8–17

FIGURE 8–18
MINDY CARSON,
University of Cincinnati
Student drawing: drawing the
skull within a portrait
Graphite and charcoal, 18 × 24"

FIGURE 8–19
AIDAN SCHAPERA, University
of Cincinnati
Student drawing: portrait from
three viewpoints of the skull
Charcoal on Paper, 25½ × 37"

to bottom into the cervical, thoracic, and lumbar regions of the column. The lower end of the spine is made up of five fused sacral vertebrae and four partially fused vertebrae that form the coccyx. One of the chief visual hallmarks of the vertebral column is its sinuous gesture, achieved by four reversing curves of varied lengths (Fig. 8–2). The weight-bearing role of the vertebral column is more easily understood by studying a frontal view (Fig. 8–1); note that the vertebrae become progressively heavier farther down the spine as they need to support greater weight.

The backbone connects head, rib cage, and pelvis—the three major masses that communicate a good deal of the figure's gesture. It is therefore essential that you have a mental image of the backbone in order to determine the distribution of these major masses in relation to any given pose. Your ability to form this image will be hampered, however, by the fact that the backbone is buried deep in the body and consequently offers few surface clues to its physical characteristics.

The spurs (or projecting parts) of these vertebrae represent some of the few outer guideposts to the vertebral column (Fig. 8–20). On a spare figure, they can be observed as a bumpy ridge along the midline groove of the back; often these spurs are thrown into relief on a figure bending forward. The spur of the seventh cervical vertebrae (*prominens*) is most noticeable. Located at the lower limit of the back of the neck, the prominens establishes the point at which the axes of the neck and shoulders meet.

The Rib Cage　　The rib cage, as its name implies, is an open-framework enclosure within the *thorax*, or chest cavity (Figs. 8–21, 8–22, and 8–23). Shaped like an oval flattened at the lower end, the rib cage consists of twelve pairs of ribs. Joined at the back of the chest wall to the spinal column, the ribs wrap around the side of the body at a downward angle. At the point where the ribs curve upward toward the breastbone (sternum), ten of them have their bony composition replaced by bands of cartilage.

The symmetrical, outward curves of the rib cage conclude at the *thoracic arch*, a conspicuous structural landmark on the front of the body. If you take a deep breath or raise your arms, mimicking the gesture in Figure 8–24, the thoracic arch will be more noticeable. At the same time, locate your breastbone, which sits

FIGURE 8–20
Martha Mayer Erlebacher
Cindy Seated, 1993
Graphite on paper, 19½ × 14"

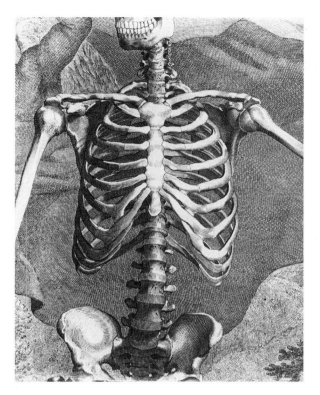

FIGURE 8–21
BERNHARDUS SIEGFRIED ALBINUS
Tabulae Sceleti et Musculorum
Corpus Humani
London, Knapton, 1749 Tab I (detail)

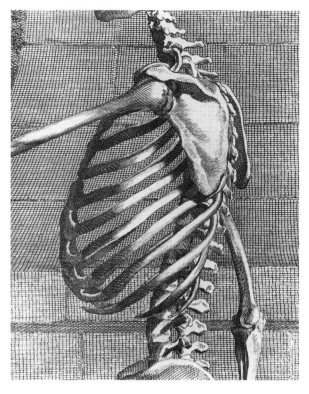

FIGURE 8–22
BERNHARDUS SIEGFRIED ALBINUS
Tabulae Sceleti et Musculorum
Corpus Humani
London, Knapton, 1749 Tab III (detail)

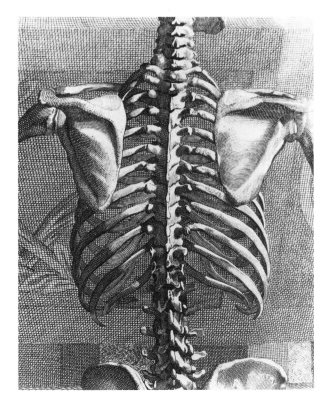

FIGURE 8–23
BERNHARDUS SIEGFRIED ALBINUS
Tabulae Sceleti et Musculorum
Corpus Humani
London, Knapton, 1749 Tab II
(detail)

on the vertical dividing line extending from the top of the thoracic arch to the pit of the neck. In Figure 8–21 note that as a result of the downward curve of the upper ribs, the base of the neck in back is higher than the pit of the neck in front. In Figure 8–22 observe that the rib cage is flatter in back, allowing us to lie on our backs without rolling over.

Exercise 8C　　*Drawing 1: When drawing the rib cage, more important than a count of ribs is that you obtain a strong impression of its three-dimensional form. Making studies of the rib cage from three different viewpoints (front, side, back) will assist your grasp of its structural gestalt (see Figs. 8–21, 8–22, and 8–23). Begin each drawing with a gestural shape summary of the rib cage (Fig. 8–25). Convert its form into a cubic volume in perspective if that will make its overall planar organization easier to understand. Notice the stepped expansion of the cage as you progress down its vertical axis and how it bulges most prominently at the eighth rib. To capture its shell-like curvature, be aware not only of its positive shapes but also of the oval void the rib cage encircles. (You might imagine yourself at a potter's wheel forming the interior of a wide-mouthed clay vessel with your hands.) To help steer the eye around the form of the ribcage in your drawing, blur portions of it and vary the line weights according to spatial position (Fig. 8–26).*

Drawing 2: When you feel confident, repeat the three drawings from memory. Before you draw, rotate in your mind's eye the full volume of the rib cage as if you were turning a virtual reality form on a computer screen. Start drawing the ribs at their junction with the spine where the rib cage is comparatively flat, and then circle its full horizontal and vertical circumferences.

The Shoulder Girdle　　The shoulder girdle is a symmetrical structure that fits over the rib cage. It is comprised of paired collarbones (*clavicles*) and shoulder blades (*scapulas*). This set of fragile bones, with its only attachment to the ribcage at the sternum, forms a nearly closed loop around the axis of the shoulders.

Parts of the shoulder girdle are evident on the surface. While the clavicles can appear as near horizontals from a straight-on view (Fig. 8–21), when viewed from above or from the side it is possible to see the way they wrap around the top of the rib-cage to join with the scapulas (Figs. 8–27 and 8–38). Another landmark on the

FIGURE 8–24
FRENCH SCHOOL
Kneeling Man Bound to a Tree,
c. 1685
Red chalk heightened with white on gray-brown laid paper, 19¹⁵⁄₁₆ × 12"

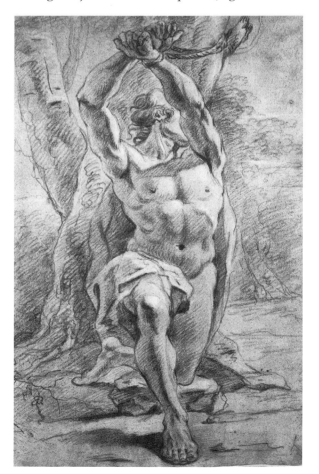

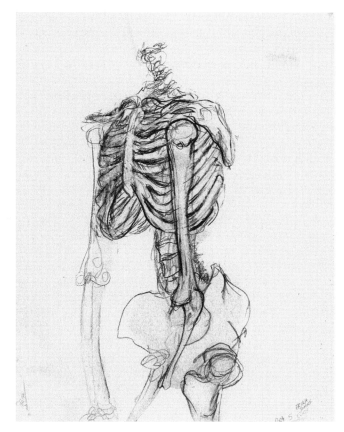

FIGURE 8–25
ERIKA JOHNS, University of Cincinnati
Student drawing: gestural
study of the rib cage
Charcoal, 18 × 24"

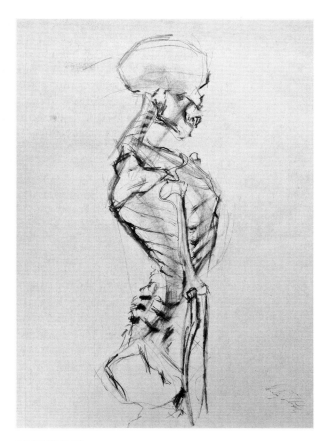

FIGURE 8–26
RODINEY GUSTKE, University of Cincinnati
Student drawing: gestural
study of the rib cage
Charcoal, 18 × 24"

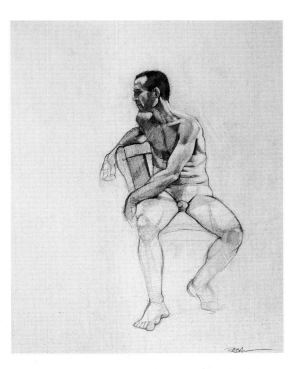

FIGURE 8–27
ROB ANDERSON
Charcoal, 18 × 24"

front of the body is the pair of small bumps made by the heads of the collarbones where they meet the breastbone to form the *sternoclavicular joint* at the pit of the neck. (These bumps are more evident when the shoulders are pushed slightly back as in Figure 8–39.) On thinner persons particularly, the inner edges of the shoulder blades will be evident even when the arms hang loosely at the sides. When the shoulders are tensed, the triangular shape of the shoulder blades will be more noticeable (Figs. 8–20 and 8–28). Other bony landmarks include the top ridge of the shoulder blade and the bump at the outer end of that ridge (*acromion process*) where the shoulder blade meets the collarbone to form the cap of the shoulder (Figs. 8–27, 6–26, and 9–3).

The mobility of the shoulder girdle and the variety of shapes it assumes in response to arm motions will challenge your powers of observation. So long as the elbows remain below shoulder level, the shoulder girdle may be seen to square the upper torso. When drawing the figure with arms down, think of the pair of shoulders as forming the ends of an oblong box perpendicular to the spinal column. This box can be rotated independently of the rib cage around the axis of the spinal column. When the shoulders are pushed back, the shoulder blades are thrown into relief and almost meet (Fig. 8–28), and on the front of the body the collarbones hug the rounded armature of the rib cage. Hunching the shoulders forward causes the shoulder blades to glide apart while at the same time pushing the collarbones forward so that they become more pronounced, as can be seen in the Rubens drawing of a man raising himself (Fig. 8–29).

Compare the Rubens with the Michelangelo study for the Libyan Sybil (Fig. 6–26) and note the striking difference in the appearance of the shoulder and upper back caused by different arm positions. Lifting an arm high and across the body modifies the shape of the trunk by rotating the shoulder blades upward and over toward the side of the rib cage. A clear demonstration of varied shoulder-blade formations may be seen in Figure 8–30.

Upper Limbs The upper limbs are divided into two segments: the arm and the forearm. The arm bone, or *humerus*, is longer, thicker, and heavier than the two bones of the forearm, the *ulna* and the *radius*. The ball-like head of the humerus sits in the shallow socket of the shoulder blade, forming the shoulder joint. The

FIGURE 8–28
MICHELANGELO
*Study of Man Rising
from Tomb*
11½ × 9¼"

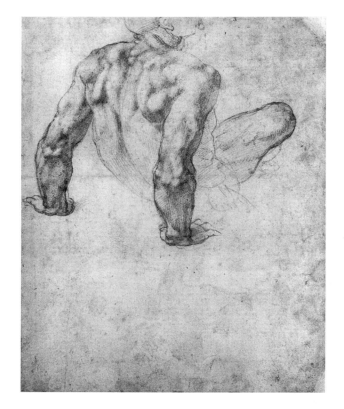

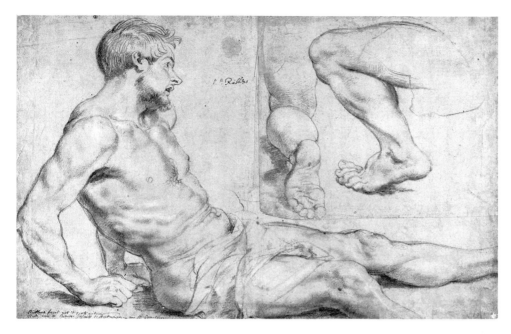

FIGURE 8–29
PETER PAUL RUBENS
Nude Man Study of Leg
Black chalk, 8³⁄₁₆ × 11⅛"

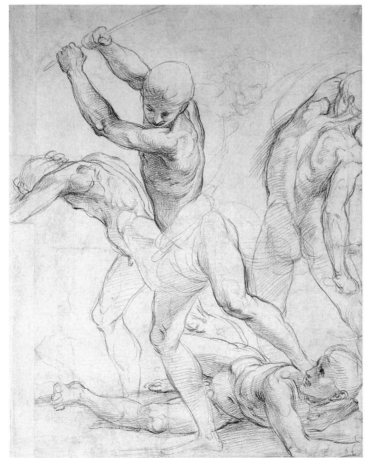

FIGURE 8–30
RAPHAEL
A Combat of Nude Men
Red chalk over preliminary
37.91 × 28.1 cm

FIGURE 8–31
Raphael
Aneas and Anchises
Albertina, Wien

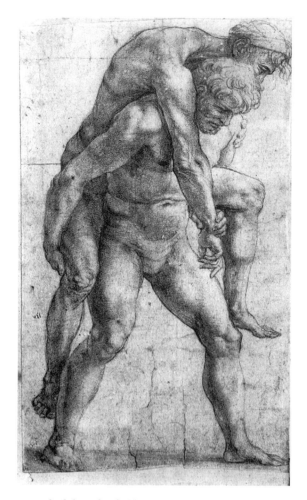

rounded head of the humerus can occasionally be seen, as when, for example, the pressure of body weight leaning on an upper limb pushes its mass out to the surface (Figs. 1–11 and 8–29). At its bottom end, the humerus unites with the ulna and the radius to construct the elbow.

Two separate movements occur at the elbow. The hinge joint that enables the forearm to bend up and down on the humerus is the result of a concave surface on the head of the ulna swinging on a spool-like form at the base of the humerus. For drawing purposes, note that when the forearm is extended, the tip of the elbow (formed by a projection on the ulna called the *olecranon process*) is visible from side and back views (Fig. 8–31). When the forearm is bent, the tip of the elbow becomes an even more pronounced point; this bony point, together with projections on either side of the humerus (medial and lateral *epicondyles*), form a distinctive inverted triangle at the back of the elbow (Fig. 8–28).

The second movement that occurs at the elbow is the rotation of the forearm, by which the hand is turned either palm up (the *supine position*) or palm down (the *prone position*). These are common movements that occur, for instance, when you use a screwdriver or turn a doorknob. To accomplish this movement of the forearm, the radius rotates on its axis, in a notch of the ulna, and crosses over the ulna to turn the wrist a half revolution, as can be seen in the left forearm of the skeleton in Figure 8–1. Notice that this rotary motion can be performed simultaneously with the bending of your forearm.

Be aware of surface landmarks in conjunction with the position of the forearm. When the hand is turned palm-side up, the radius and ulna are parallel, and you will observe the relative flatness of the forearm. When you rotate your hand

to the prone position, the radius crosses over the ulna, and you will see that the forearm appears more rounded and bulky. With your forearm in the prone position, notice the prominent bump of the ulna's *styloid process* on the little finger side of the wrist.

The Pelvis The *pelvis* is a ringlike mass, scooped out at the center, similar to a shallow basin. Among the components of the skeletal system, the pelvis varies most in form according to gender. Overall, the male pelvis may be summarized as a more acute triangle than its female counterpart. The female pelvis is broader and shallower. (This explains the typically wider hips on a female figure.)

Understanding the structure of the pelvis and the angle it assumes in any given pose is essential to the success of your drawing. Be aware of the forward or backward slant of the pelvis when a figure bends, and also the tipping of the hips when a figure shifts its weight to one leg. Such awareness is crucial to visualizing the axial directions at a figure's midpoint and the structural and expressive implications this orientation has for the rest of the body.

But how do we go about seeing the angle of the pelvis? Covered by layers of tissue, surface sightings of pelvic structure are limited. Fortunately, two sets of points provide us some clues. Seen on the front (Figs. 8–12 and 8–32a) or sides of the figure, the forward-most projections, or crests, of the *anterior superior iliac spines* make their appearance as bumps near the top of both hips. These two bumps are most conspicuous when the body is lying down. On the back of the body (Figs. 8–13 and 8–32b), the two crests of the *posterior superior iliac spines* appear as two dimples flanking the base of the vertebral column. These two depressions can be seen as the upper points of the *sacral triangle* at the base of the spine (Fig. 8–33). The triangle is completed at the origin of the cleft of the buttocks by a slight depression caused by the lowest vertebrae of the sacrum. (Because the female sacrum is wider, the dimples on a woman's body are farther apart, making the shape of the sacral triangle broader on the female.) When analyzing the axes of a pose seen from the front, a line drawn (or imagined) through the anterior superior iliac crests will help you assess the angle of the pelvis. Correspondingly, when drawing the figure from the back, a line through the pair of dimples at the top of the sacral triangle will assist you in determining this angle.

FIGURE 8–32
JACQUES GEMELIN
Nouveau recueil d'ostéologie et de myologie . . . Part II
Toulouse, Declassan, 1779

(a) Front view of pelvis showing the anterior superior iliac spines and the pubic arch

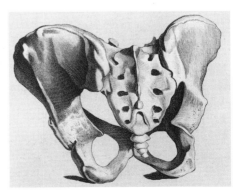

(b) Back view of pelvis showing the posterior superior iliac spines and the sacrum

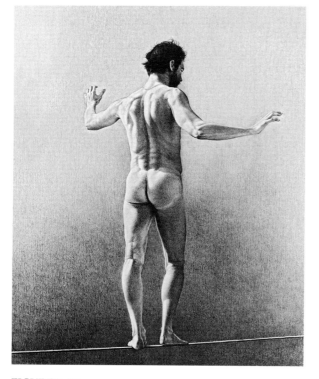

FIGURE 8–33
JAMES VALERIO
Tightrope Walker, 1981
Pencil on paper, 29 × 24"

FIGURE 8–34
ERIKA JOHNS, University of Cincinnati
Student drawing: gestural study of the pelvis
Charcoal, 18 × 24"

Exercise 8D *Because an understanding of the structure and role of the pelvis is so pivotal to your understand-ing of the figure, we recommend that you make studies of the pelvis to commit to memory its overall shape from several viewpoints (see Figs. 8–32a, b). Begin each study with a gestural summation of the pelvis. With sweeping gestures, draw the two, symmetrical, earlike lobes of the pelvis, from the flared upper segments, down and around to the pubic arch (see Figs. 8–12 and 8–13). Use diagram-matic lines and atmospheric perspective to steer around the oval space of the pelvic cavity (Fig. 8–34).*

The Lower Limbs The lower limbs are divided into two sections: the thigh, which extends from the hip joint to the knee; and the portion from the knee to the ankle, which is referred to as the leg.* The thighbone, or *femur*, is the largest and strongest bone in the human body. At its upper end, the rounded head of the femur sits deep in a pelvic hollow, forming a ball and socket joint of sufficient stability to accommodate the weight-bearing function of the hips.

Between the head and shaft of the femur is an extended neck that cantilevers out from the pelvis and ends in the *greater trochanter*. When visualizing the skeletal arrangement of a model's hips in a drawing, be sure to draw the greater trochanter of each femur as jutting downward and outward from the pelvis rather than hang-ing straight down from each side of the hips (see Fig. 8–1). Note too that in a nor-mal standing position, the femurs angle inward from the greater trochanters down to the knees. On individuals with thin hips the greater trochanter may appear as a barely visible protrusion located below the gluteus medius, and on those with more body fat it may show up as a depression. In contrapposto poses the great trochanter may appear as a slight bulge on the outthrust hip answered by a depression on the other side (Fig. 5–36). In Michelangelo's study (fig. 8–35) the greater trochanter is marked by a small depression just in front of the larger depression of the buttock.

*While the word "leg" in everyday usage refers to the lower limb from the hip to the ankle, we use the word in reference to the section between the knee and the ankle in keeping with current anatomical terminology.

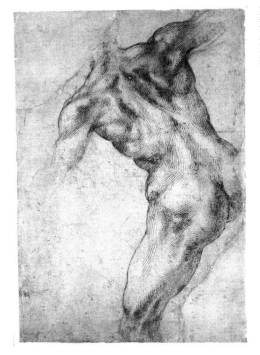

FIGURE 8–35
MICHELANGELO
Nude Male Torso
Pen, brown ink, black chalk,
262 × 173 cm

The greater trochanters are valuable structural landmarks because locating them will help you establish both the widest point of the hips and the midpoint of the figure along its vertical axis.

At its lower end, the femur joins the head of the *tibia*, one of the two long bones of the leg, to form the hinge-like knee joint. Bony projections (*epicondyles*) on the inner and outer sides of the base of the femur are visible landmarks at the knee. (Their presence is more obvious on the leg bent at a right angle, as can be seen in Figures 8–29 and 8–31). Also at the base of the femur, on its front side, is a shallow cavity. When the leg is extended (straight), the flat, triangular kneecap (*patella*) sits in this cavity and is visibly pronounced at the joint of the thigh and the leg. When the leg is flexed (bent), the kneecap becomes less prominent as it moves along the length of that cavity and nestles into the deeper groove on the underside of the femur.

The tibia, located on the inside of the leg, is the heavier of the two leg bones. The thin and conspicuous frontal plane of the shin (or tibial shaft), seen from a frontal or three-quarter view, provides a linear guide for drawing. It runs from the knee to the inner ankle, as may be seen on the left leg of the slumped body in Figure 9–27. The other long bone of the leg, the fibula, is the slender bone on the outside of the leg. The expansion at the lower end of the fibula may be observed as the outside ankle bone, properly called the *lateral malleolus*. Just above this protrusion you may also observe a bit of the shaft of the fibula, which will appear as a short vertical line. Seen from front or back views, the outside ankle bone appears lower on the axis of the ankle joint than its counterpart on the inside of the ankle (the *medial malleolus* of the tibia), as can be seen on the left leg in Figure 8–33.

BASIC MUSCULAR SYSTEM

Although there are three different kinds of muscles in the human body, we will focus on skeletal muscle, the most abundant muscle mass in the body. Attached to the body's skeletal armature, these muscles contour the form of the human figure and furnish its capability for movement.

Muscles, elastic tissues arrayed symmetrically throughout the body, cross over the joints wherever two bones meet. During contraction a muscle shortens, thus pulling one bone toward the other. The end of the muscle that attaches to the stationary

bone in any movement is its point of origin; the attachment on the bone moved by the muscle is its insertion. The number of muscles encountered in figure drawing far exceeds the limits of this chapter to describe. Perhaps the most practical way to become conversant with the superficial muscles of the human body is to pore over anatomical illustrations (such as Figs. 8–36 and 8–37,) in combination with many clocked hours drawing from life. In the next section, we present twenty-two muscles we consider to be most useful to artists beginning a study of human anatomy.

The Twenty-Two Muscles You Need to Know *The Neck* The paired *sterno-cleidomastoids* are the most prominent of all muscles on the front and the sides of the neck. At their upper ends, both sternocleidomastoids insert behind the ear (Fig. 8–15a), and at their lower ends, they divide on both sides of the neck into two strap-like segments (Fig. 5–4). Seen from a front view, the more prominent of these segments attaches to the breastbone; together these two segments define the familiar V-shaped indention of the pit of the neck (Figs. 8–38 and 8–39). The other two segments attach to the inside face of the collarbone; they are often visible when the head is turned to one side, as in Figure 8–38 (note the triangular hollow between the divided straps of the muscle on the side of the model's neck). The function of the sternocleidomastoid is to move the head. Contracting one of these muscles will pull the head to that side. If the two muscles contract together they flex the neck, causing the head to nod forward and down.

The Torso The two principal muscles occupying the front of the torso are the *pectoralis major* and the *rectus abdominis*. The large pectoralis major forms the upper

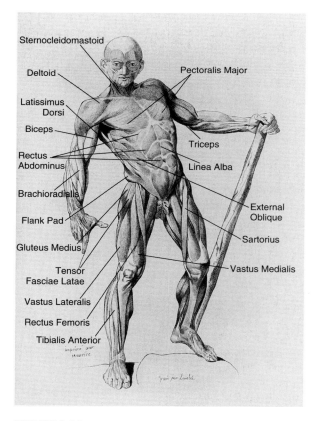

FIGURE 8–36
JACQUES GEMELIN
Nouveau recueil d'ostéologie et de myologie . . . Part II
Toulouse, Declassan, 1779

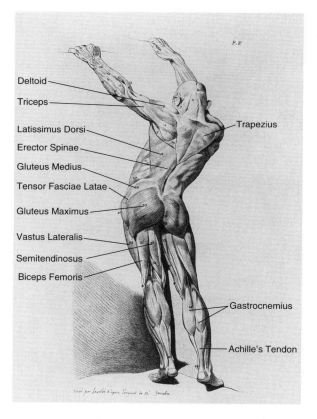

FIGURE 8–37
JACQUES GEMELIN
Nouveau recueil d'ostéologie et de myologie . . . Part II
Toulouse, Declassan, 1779

FIGURE 8–38
DANIEL LUDWIG
Figure on Stool, 2000
Charcoal on paper, 40 × 26"

FIGURE 8–39
STEVEN ASSAEL
Male Figure Study, 1989

chest and the front wall of the armpit. In the male, the wedge shapes of the paired muscles give the chest its characteristic windshield-like sweep (Fig. 8–39). In the female, the breasts cover the lower and much of the outer borders of the muscle. This muscle moves the arm forward, down, and toward the center line of the body.

The *rectus abdominis*, a long flat band of muscle situated on either side of the body's midline, forms the central plane of the abdomen. Its chief function is bending the upper body forward, as when doing a sit-up. This muscle is divided into eight segments, four on each side of the midline of the torso. On muscular individuals, the upper six make a distinctive pattern (clearly visible in the image of the crucified Christ and the male nude on the left, in Figure 5–3). A more valuable drawing landmark is the *linea alba* ("white line"), since it may be seen on the average human figure. A shallow channel of connective tissue, it runs along the midline of the body from the breastbone to the navel. The linea alba is conspicuous on the male torso in Figure 8–39; note also the partial description of the rectus abdominus in this illustration.

The *external oblique* is a thin muscle that slants downward and forward from the sides of the rib cage to form a border with the rectus abdominus (Figs. 8–24 and 8–31). At the hips, the external oblique contributes slightly to what are sometimes referred to as "flank pads" (Fig. 8–24). These pads are predominantly a buildup of fatty tissue, although on very thin individuals the slight bulge of the external oblique may be seen. Nonetheless, these pads just below the waist are

useful structural guideposts when sketching a shape summary of the figure. In conjunction with the groove of the groin, the raised masses of the flank pads lend the lower boundary of the abdomen its gently curving, quarter-moon termination, particularly in the male figure (Figs. 8–24 and 8–39). Connecting the sides of the lower eight ribs to the anterior (front) crest of the pelvis, the external oblique, when contracting only on one side, twists the trunk on top of the hips. When the external obliques on both sides of the body contract, they compress the abdomen and fold the trunk forward.

One muscle that is physically prominent on the surface of the trunk from any viewpoint is the *deltoid* (Figs. 5–4, 8–36, and 8–37). A cushion-like mass, the deltoid may be described as a three-sided pad that significantly determines the form of the shoulder. The chief action of the deltoid is to move the arm away from the body, up to shoulder height.

The three large muscle masses layered on the back of the torso are the *trapezius, latissimus dorsi*, and *erector spinae*. The flat sheets of the trapezius (uppermost of the three) and latissimus dorsi constitute most of the superficial muscle coverage of the back, from the base of the skull to the sacrum. The erector spinae is subsurface.

The kite-shaped trapezius moves the shoulders back, up, and down; bends the neck from side to side; and pulls the head back as well as turns it. The vertical axis of this muscle coincides with the seam of the spine. Viewed from the back, the top of the trapezius shapes the nape of the neck, and its flared wings establish the line of the shoulders (Fig. 8–40). In front, the trapezius joins with the

FIGURE 8–40
STEVEN ASSAEL
Male Back, 2000
Pen and ink, chalk over acrylic
wash on paper, 13⅞ × 9"

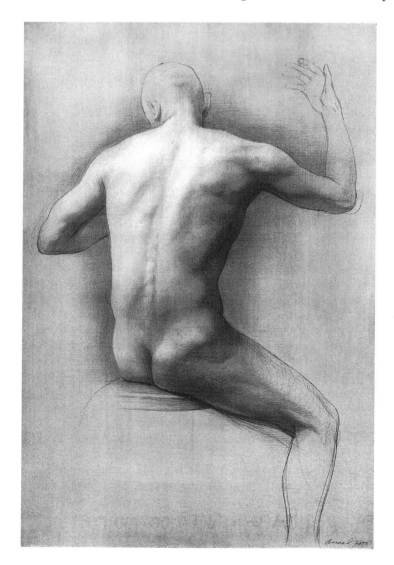

outer third of the collarbone, forming the visually explicit triangular masses that define the edge of the shoulders from the neck to the shoulder cap (Fig. 8–39). Viewed from above, the neck appears to be firmly embedded in the diamond-shaped space framed by the collarbones and the fleshy wedges of the trapezius (Fig. 8–38).

Shoulder actions alter the appearance of the trapezius. When the shoulders are pulled forward so as to stretch this superficial muscle across the rib cage, its lower, V-shaped contour may be seen, as on the model's right side in Figure 8–20. When the shoulders are pushed backward, the trapezius bunches into fleshy heaps on both sides of the spine in the thoracic region (Figs. 8–28 and 8–33); note that in the Michelangelo, the lower, V-shaped portion of the muscle is sketched in.

Although the large latissimus dorsi covers half the back of the human torso, it appears as an explicit surface landmark only on the front or side of the body. When the arm is extended (particularly if there is some exertion) or when it is raised, the latissimus dorsi is conspicuous as the convex mass forming much of the back wall of the armpit. It gradually becomes more slender before curving backward just above the waist (Figs. 8–24 and 8–29). This muscle functions mainly to extend the arm, pulling it backward and into the body. For drawing purposes, the latissimus dorsi represents a transitional bridge between the arm and the torso of the human figure.

Situated on both sides of the indented seam of the spine are several separate muscles, grouped under the umbrella term *erector spinae*. As the name implies, their chief function is to stabilize the torso. Although they are deep muscles, they nonetheless provide an important clue to the location of the vertebral column. A surface effect of the erector spinae may be seen in the mound-like masses that appear on both sides of the spine in the lower back (Figs. 8–33 and 8–35).

The Hips Three superficial muscles that largely form the hips are the *gluteus maximus*, the *tensor fasciae latae* (or tensor muscle), and the *gluteus medius*.

The large, powerful muscle that defines the mass of the buttocks is the gluteus maximus. It straightens the thigh and raises the trunk (as when you get up from a seated position). Most of the gluteus is visible on the surface of the figure. A useful structural guidepost when drawing is the indentation on either side of the buttocks located just behind the greater trochanter, as is shown in Figures 5–36 and 8–35.

The tensor fasciae latae, situated on the forward plane of a figure's side, is a small, scoop-shaped muscle running diagonally downward and backward. Its chief actions are to bend the thigh and rotate it inward. When the thigh is bent the tensor is most visible, appearing as a thick knob at the juncture of hip and thigh. In Figure 8–35 the tensor can be seen just to the fore of the depression caused by the greater trochanter.

The gluteus medius, which moves the thigh outward, sits between the tensor and gluteus maximus muscles, squarely on the side of the body and at a slant similar to the tensor. Observable from directly front or back views as the bulge above the shallow indention of the greater trochanter (the tensor is the swell just below), the gluteus medius is thrown into high relief when tensed (Fig. 8–35).

The Thigh The muscles playing a prominent role on the surface of the thigh are grouped by function and location. Quadriceps that straighten the leg at the knee and bend the thigh at the hip are located on the front or side of the thigh; hamstrings that bend the leg at the knee joint and extend the thigh at the hip are located on the back of the thigh.

The quadricep muscle group comprises more than half the muscle mass of the thigh. Proceeding from the outside of the thigh, this group of four muscles includes the *vastus lateralis*, the *rectus femoris*, the *vastus intermedius* (a deep muscle located under the *rectus femoris* which is not a visible landmark), and the *vastus medialis*.

The vastus lateralis contours most of the outer thigh from a few inches above the knee all the way up to the tensor muscle at the hip. From the front, there is often a small crease or dimple in the surface terrain above the knee, where the lateralis muscle changes to a tendon, as may be seen on the left thigh of the female nude in Figure 8–41. From a front view, the vastus medialis sits on the inside of the top plane of the thigh, where its characteristic teardrop shape swells from just above the knee to about midthigh, as on the left thigh (on our right) of the central warrior in Fig. 8–30. From a side view, this muscle fleshes out the inner thigh just above the knee joint, as on the right thigh of the male warrior just mentioned in Figure 8–30.

The rectus femoris is positioned between the vastus lateralis and the vastus medialis. Seen from the front or side, this convex muscle lends the top of the thigh its characteristic sloping curvature downward to the knee, as in the study in the upper right of Figure 8–29. Originating at the anterior inferior iliac spine and ultimately tying into the tibia, the rectus femoris is a two-joint muscle, with the dual function of flexing the thigh at the hip and extending the leg at the knee.

One additional muscle that is visible on the front and inside of the thigh is the *sartorius*. Belt-like in form, and the longest muscle in the body, it takes a diagonal route from the outside of the pelvis down to the inner surface of the leg. Multifunctional, the sartorius strongly flexes the thigh at the hip joint, helps to rotate the thigh and pull it away from the body and assists in flexing the leg at the knee. Its upper boundary at the pelvis visibly emerges when tensed, for instance, when a model turns his or her leg and foot inward or sits cross-legged. In the left leg of the central staff-wielding figure in the Raphael (Fig. 8–30), a break in plane running from the hip to the inside of the knee indicates the presence of the sartorius.

The two hamstring muscles that flesh out the back of the thigh are the *semitendinosus* and the *biceps femoris*, both of which extend from the hip to the leg. On the back of the thigh the two muscles are most often seen as a unified mass (Fig. 8–33). When the knee is bent, the edges of both muscles are easily detected

FIGURE 8–41
WILLIAM BECKMAN
Scale Study for Woman and Man, 1988
Charcoal and crayon
on gessoed paper, 90 × 71¼"
Arkansas Arts Center Foundation Purchase: 1988. AAC Coll. 88.43. Courtesy Forum Gallery, New York, Los Angeles. All Rights Reserved.

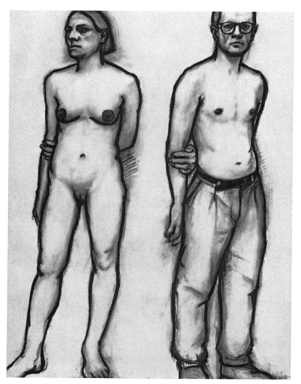

(the semitendinosus is the most apparent). At the back of the knee the muscles separate, with the semitendinosus veering to the inside of the thigh and the biceps femoris passing to the outside. Their separation causes the distinctive depression at the back of the knee. In Figure 8-40 the tendon of the biceps femoris is clearly visible as it passes from the thigh to its attachment to the head of the fibula. When the knee is straightened, the hollow is replaced by a mass of fatty tissue, as may be seen in Figure 8–33.

The Leg The two major muscles of the leg flex the ankle and toes. Seen from the front, the *tibialis anterior* is situated along the outer edge of the shin bone. When the leg is seen from the side, this muscle defines its front contour. The tibialis anterior flexes the foot upward; note that when the foot is bent in this manner, the tibialis swells prominently. About midway down the leg, the tibialis switches to tendon. As it descends from that point, the tibialis jogs toward the inside of the leg, where, at its lower end, it crosses the ankle and attaches to the bottom of the foot. The route of this long tendon may be observed when the leg is tensed, as in Figure 8–24.

The form of the back of the leg is dominated by the plump mass of the calf muscle, or *gastrocnemius*. The chief action of this muscle is to flex the foot downward. It is divided into roughly two halves, with the longer inside portion dropped lower on the leg. At the middle of the leg, the gastrocnemius binds with the achilles tendon, a strong tapering band that is most visible just above the ankle and down to its attachment on the heel bone. The junction of the gastrocnemius with the achilles tendon is pronounced when the calf is stressed; look for the reversed V-shaped notch that signals where the sheet of tendon and bulk of muscle fiber meet, as in Figure 8–33.

The Arm Movements of the forearm are governed by two large muscle masses of the arm, the *biceps* and *triceps*. The biceps flexes and supinates the forearm, and the triceps extends it.

The *biceps* is located on the front of the arm, but slightly off center toward the inside edge. Attached at its upper end to the shoulder blade, the muscle shifts to tendon at its lower end, where it curves over the elbow to join with the radius. Tense your biceps, and its tendon will be evident to sight and touch on the inside of the hollow on the front of the elbow.

The *triceps* constitutes virtually the entire body of muscle on the back of the arm. The mound of the triceps is especially apparent when the upper limb is torqued toward the body, as in the right arm of the man being carried in Fig. 8–31. When the arm is tensed, look as well for the inverted V-shape where the surface of the back of the arm dips slightly from a convex muscle mass to a flatter tendinous plane. This landmark is apparent in the right arm of the male nude in Figure 8–28.

The Forearm With one exception, no muscles of the forearm emerge as major surface landmarks. Instead, it is the thirteen superficial forearm muscles that interest us for drawing purposes. These can be categorized as the flexors (which bend the hand forward) and extensors (which straighten the hand and fingers). The flexors are located for the most part on the front of the forearm, and the extensors are on the back. In Figure 8–42 note the broad, rounded plain of the extensors on the back of the forearm bounded by a shadowed groove along their inside (right) edge. This groove represents the bony landmark of the ulna which divides the extensor group from the flexor group on the little finger side of the forearm.

The *brachioradialis* is the one surface landmark muscle in the forearm as it marks the boundary between the flexors and the extensors. Located on the thumb side of the forearm (when the hand is supine) the brachioradialis is attached to the humerus a couple of inches above the elbow and to the lateral surface of the radius. Visible as an asymmetrical fleshy bulge just below the elbow

FIGURE 8–42
EMIL ROBINSON
Compression, 2010
Colored pencil on paper, 22 × 15"

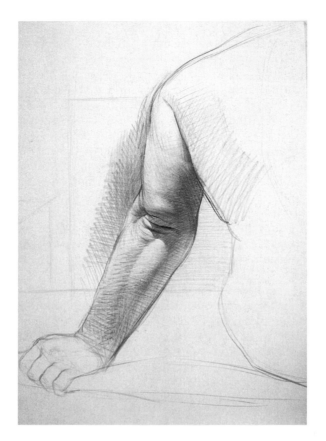

(Fig. 8-43), this muscle bends the forearm at the elbow. Look again at Figure 8–42 and note the prominent wedge shape of the *brachioradialis* on the lateral side of the forearm spanning above and below the elbow joint.

The Importance of Gesture Drawing in Longer Poses

The role of gesture drawing in developing completed figurative imagery is commonly misunderstood by beginning life-drawing students as an activity confined to the first part of a life-drawing session. In fact, gesture drawing may also be regarded as a critical foundation for more finished figure drawings.

Sustaining the general-to-specific process demanded by gesture drawing will assist you in avoiding common pitfalls associated with working from longer poses. The failure to progressively analyze major-to-minor information often results in "finished" drawings in which the figure is axially incorrect, woefully out of proportion, or lacking in the unity, grace, and vitality of the living form. Figurative images of any style that grow from a gestural conception will more successfully convey the natural rhythms of the human body and the life force they express. What you want to avoid once a figure drawing is finished is the realization that despite all the attention you gave to subtleties of sculptural modeling, the image appears lifeless or wooden.

We recommend that you begin an extended drawing by investigating the pose from several viewpoints. Find at least two angles that strike you as spatially dynamic. Remembering to first take the pose yourself, do a two-minute gesture drawing from each location. Once you are ready to commit to a specific view of the model,

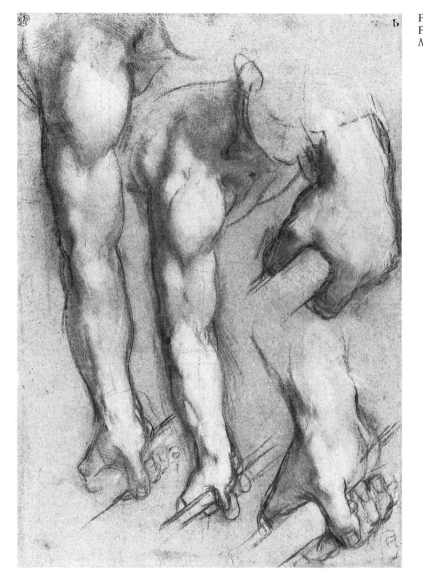

FIGURE 8–43
FEDERICO BAROCCI
Martyrdom of San Vitale

rough out the figure large on your format, maintaining the same gestural energy you have used for shorter poses. (You will want to work with a forgiving medium, such as vine charcoal or soft graphite stick so that later on the record of your early explorations can be minimized or even expunged.) Use curvilinear lines to respond to supple parts of the body. Use straight lines and angles to mark major axial divisions at the shoulders, rib cage, pelvis, and knees. You might also use straight lines to indicate where the feet contact the floor or where sightings of the bony skeleton occur.

As the image of the figure begins to take shape, you will need to respond more specifically to the structure and expression of the pose. Considerations of the body as a field of related events (not separate parts), basic anatomical insights, and your sympathetic memory from having taken the pose, will help foster your sense of the linkage between surface appearance and the action expressed by the model. In our student example (Fig. 8–44), note the interplay of forces. The greatest pressure in the pose is where the heel of the model's left hand is pushed against her outswung hip to stabilize the twisting of her upper torso. Not coincidentally, that physical pressure point is also the visual focal point of the drawing toward which lines of force in the spine, the shadowed left arm, compressed buttocks, and braced right leg converge.

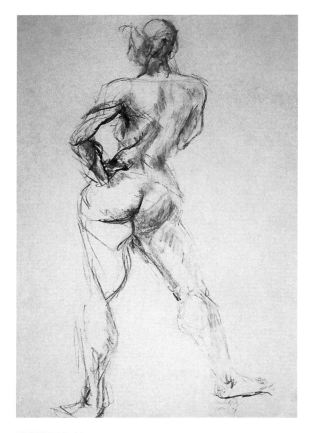

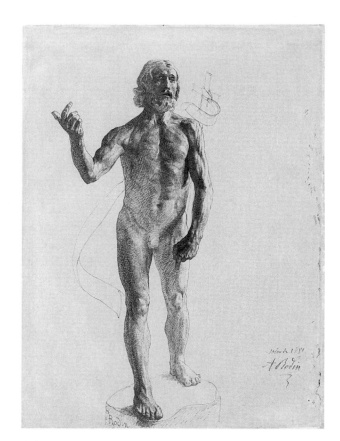

FIGURE 8–44
EMILY KELLY, University of Cincinnati
Student drawing:
sustained-gesture study

FIGURE 8–45
AUGUSTE RODIN
St. John the Baptist
Black ink with touches of graphite
on light tan wove paper,
32.8 × 23.9 cm

Identifying the gestural continuity of key, active zones in a pose will prove invaluable in organizing the visual priorities of your drawing. Rodin's image of St. John the Baptist (Fig. 8–45) is a stunning example of a drawing united by a hierarchy of actions. While the scissorlike movement of the striding legs may be identified as the figure's primary gesture, a moment's study will reveal two sets of second-tier gestures that circuit through the figure. The first of these two gestural loops may be discerned in the forward part of the body. Note the energy passing down the left arm, arcing out the pointing forefinger to the toe of the right foot, up the right leg and through the shoulder girdle, to start the loop again at the left shoulder. Trace the second loop by starting at the left sternocleidomastoid, traversing the pectorals through the right flexed arm and out the forefinger, then jumping through the head and back down to the left sternocleidomastoid. These looped gestures seem to recycle the energy within the figure.

The clear organization of sequenced gestures in Rodin's figure of St. John has its roots in the artist's profound understanding of anatomical mechanics. By cultivating an awareness of the interrelation of human form and anatomical function, you too can become more discriminating about what information to include from a pose and the order of importance you give that information. It will naturally follow that a more selective process will coax you away from a practice of uniformly recording details in your drawing.* You will be preoccupied instead with levels of **form definition** as you develop an image of the human body, from refined "detailed" passages to areas that are more generally depicted, as in the

*For more discussion on the issue of detail in a drawing see Chapter 10, "The Form of Expression."

Rodin. Grappling in this way with a more thoughtful, directed conception will invest your figure drawings with increased authority and personal expression.

Fleshing Out Your Drawing

Once you have drawn the model's gesture, start fleshing out your drawing by blocking in major masses, beginning with the chest and hips. Use cross-contour lines to map important surface features of the pose (Fig. 8–46). You may find it easier at first to simplify large forms of the body into circular and elliptical shapes (Fig. 8–47). A variation on this approach is found in Figure 8–48. Here, the body is gesturally divided into sections that are suggested by plane breaks along the figure's outer contour. If you prefer, represent the torso seen from front or back as a rectangular volume (Fig. 5–33). Smaller parts, such as the chest or buttocks, may be drawn as cubes; and you can translate legs and arms into faceted cylinders. Masses that have their long axis turned at an angle away from the picture plane have to be conceived in perspective. Whether the anatomical forms you are drawing are foreshortened or not, indicate major plane changes (located generally in line with the longitudinal axes of forms) and block in major areas of shadow.

When drawing foreshortened areas, remember that the actual dimension of any part of the body is apparent to the eye only from an unforeshortened viewpoint. Consequently, you will want to draw what you see, not what you think should be there. This is particularly important in cases of extreme foreshortening, as when you are seated in front of a reclining model and all the normally recognizable parts of the body appear distorted. To analyze the relative lengths of different parts of a foreshortened figure, first draw key latitudinal cross contours that

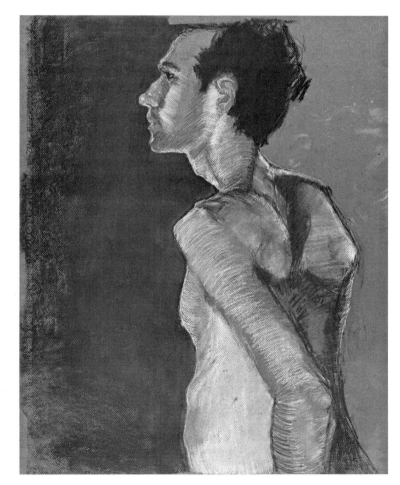

FIGURE 8–46
ERIKA JOHNS, University of Cincinnati
Student drawing: using cross-contour to flesh-out a figurative volume
Charcoal and pastel, 25½ × 19½"

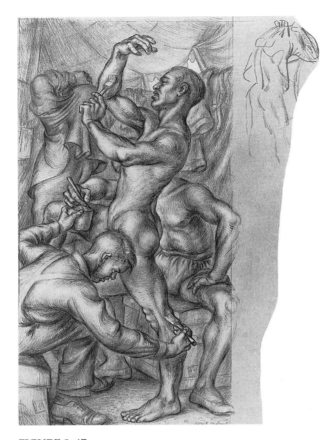

FIGURE 8–47
PAUL CADMUS (American,
1904–1999)
Gilding the Acrobat, 1930
Pen, ink, and white chalk
on paper, 15⅜ × 9¾"

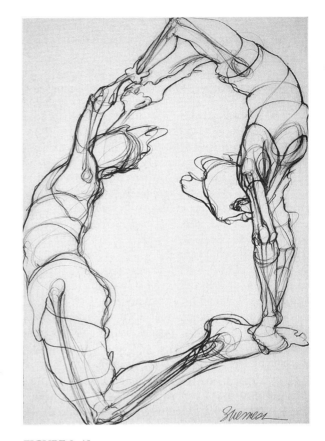

FIGURE 8–48
LORRAINE SHEMESH
Lasso

divide the foreshortened form into segments. Then carefully measure the relative
lengths of those segments. Compare Figures 8–49a and b, and you will see an im-
plied series of arcs crossing the body at major plane breaks that help organize the
figure into progressively diminishing segments. Utilizing visual references out-
side the figure, in addition to part-to-part internal measuring, can also be invalu-
able in gauging proportions under conditions of extreme foreshortening.

Once the main masses of the body are spatially oriented, search out the
principal surface planes. This is key to lending the illusion of volume to figurative
forms. Using planar analysis, change complex curves into facets following the
gestural cross-contour lines that you made earlier. Be selective about the number
of planes you include (Fig. 8–50) so as to avoid fussiness that obscures the larger
structural relationships of a pose. As you use planar analysis to solidify the bulk
of the figure, take into account the inherent geometry of its curves. The ability to
discern *angularity in curvature* will help you to effectively represent the body's
underlying structure.

In seeking to express the roundness of human form, be cautious in your use
of line. Given the liberties that long poses offer, students will often spend large
amounts of time drawing the outer contours of the body, since it is the overall
shape that makes the figurative image recognizable as a nameable thing. Keep in
mind, however, that when you draw outer contours, you are actually represent-
ing planes that are turning away from view. Flat outlines tend to compromise rec-
ognition of the body's volume by seeming to push the edges of a figurative image
forward and emptying the body in between. That is a difficult phenomenon for

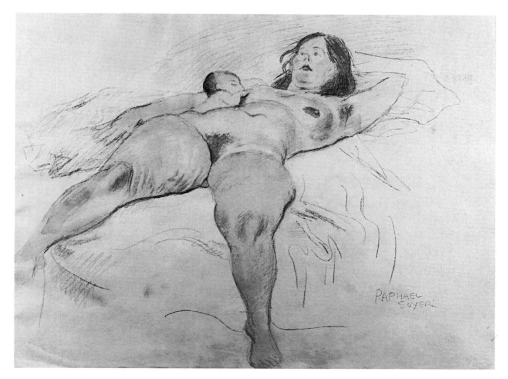

FIGURE 8–49a
RAPHAEL SOYER
Mother and Infant, 1967
Watercolor and graphite
on paper, 15¼ × 20"
Whitney Museum of American Art, New York; Gift of Bella and Sol Fishko (76.25). © Estate of Raphael Soyer, courtesy of Forum Gallery, New York

FIGURE 8–49b

beginners to overcome. In order for an outer contour to succeed as a descriptive element, it must carry powerful implications of the body's overall convexity. A persuasive example in that regard is Figure 8–41. This drawing employs contour lines of subtly varying weights, plus an angularity that firmly acknowledges the

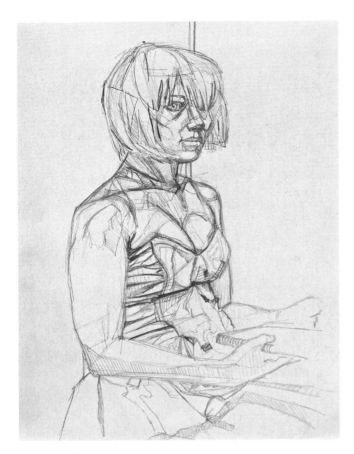

FIGURE 8–50
MARY SCHARTMAN, University of Cincinnati
Student drawing: planar
study of figure in sketchbook
Graphite, 11 × 8½"

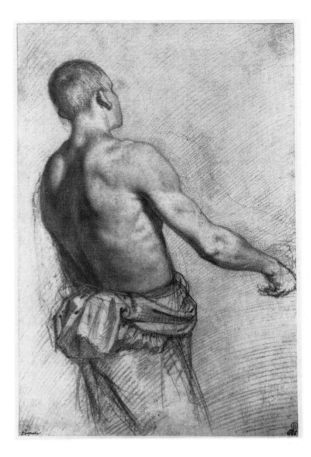

FIGURE 8–51
JACOPO DA EMPOLI
Young Man Seen from the Back,
IV, 172
Red chalk, 16 × 10½"

geometry of curved planes, all of which convince us that the shape of the outer contour is completely a consequence of interior form.

Figure 8–41 also includes blushes of tone to support the contour work in creating the illusions of roundness and of receding planes. Value, used structurally, is an important resource in figure drawing. Tone may be built up optically through hatching to infer volume, light, and surface movement, as in Figure 8–30. It may also be modulated to express the play of light and shadow over the three-dimensional forms of the figure, as in Figure 8–51, where the effects of chiaroscuro persuade us of the massive bulk of the back.

Exercise 8E

Drawing 1: *Do a sustained gesture drawing of a model from an extremely foreshortened angle. Analyze the orientation of figurative forms on a measured, part-to-part basis, using a series of elliptical shapes (Fig. 8–52).*

Drawing 2: *Again drawing a model from a foreshortened view, add value to convey a strong sense of atmospheric perspective to support the linear analysis of severe recession (Fig. 8–53).*

Drawing 3: *Using the side of a stick medium, build the figure out of decisive value shapes. Create edges through abutting planes of light and dark (Fig. 8–54).*

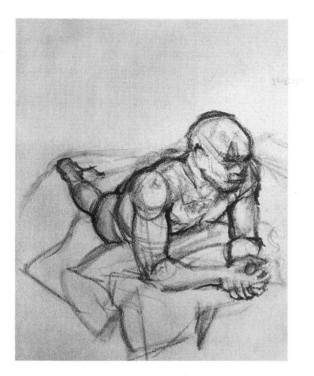

FIGURE 8–52
MICHAEL COLBERT, University
of Cincinnati
Student drawing:
foreshortened figure study

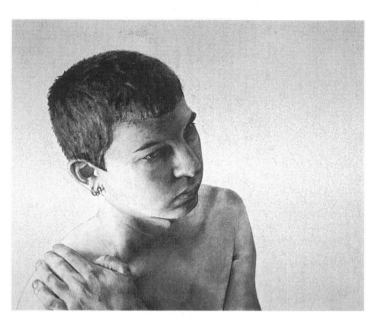

FIGURE 8–53
BRANDON RAYGO, University
of Wisconsin, Whitewater
Student drawing: foreshortened
figure drawing with value
Charcoal, 22 × 26"

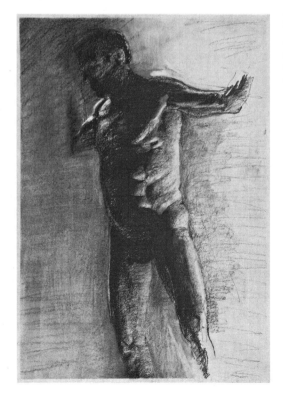

FIGURE 8–54
DAN O'CONNOR, University
of Cincinnati
Student drawing: figure study
using value shapes
Conté on paper, 18 × 12"

Drawing Hands and Feet

Because hands and feet present a variety of small forms, your best initial approach may be to generalize their overall appearance through the use of shape summary and planar analysis. Summarize the foot seen from the side by drawing a triangle (Fig. 8–55a). To soften the geometry, round off the outer contour of the back of the heel so it projects out from the foot. Using a modulated line, suggest the meeting

FIGURE 8–55

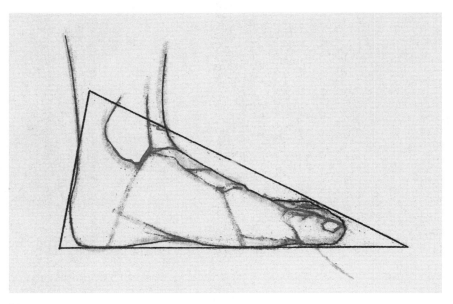

(a)

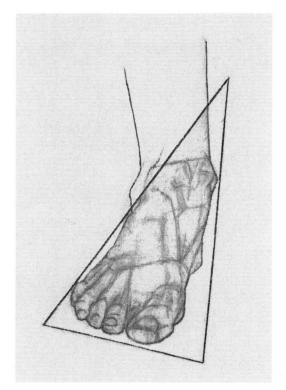

(b)

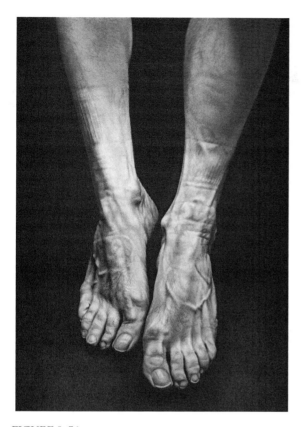

FIGURE 8–56
JAMES VALERIO
Feet, 2000
Pencil on paper, 28⅝ × 25"
© James Valerio. Image courtesy of George
Adams Gallery, New York. Collection of
Kenneth Spitzbard

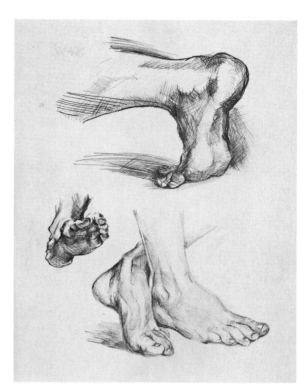

FIGURE 8–57
BRENT LASHLEY, University of Cincinnati
Student drawing: sketchbook
studies of feet
Graphite, 8½ × 11"

of the foot with the ground plane. Observe that the outside of the foot hugs the ground more evenly than the inside, where the curvature of the arch of the instep is more pronounced. A triangle may be used to summarize the foot from many viewpoints, as in Figures 6–1 and 8–56, including a foreshortened view front or back (Fig. 8–55b). You can verify this by using a mirror to make sketchbook studies of your feet in different positions (Fig. 8–57).

Turning to the hand, observe that with fingers extended and closed, both palm and back views may be summarized as an oval shape. To establish the proportions of the back of the hand, draw three crosswise arcs through the knuckles to connect the fingers. (The thumb and big toe each have two bones and the other four of our fingers and toes each have three bones; when flexed, each bone occupies a separate plane.) Begin the series of arcs with one that curves across the knuckles and divides the hand in half. Observe that from this back view the middle finger is approximately one-half the length of the hand. The next two arcs should increase slightly in degree, and the segments should be progressively shorter. Draw the thumb with simple, parallel curves. Held snugly against the hand, the thumb's rounded tip should reach almost to the midpoint of the index finger.

FIGURE 8–58
KAITLYN FITZ, University
of Cincinnati
Student drawing: gestural studies
of the hand
Charcoal, 18 × 24"

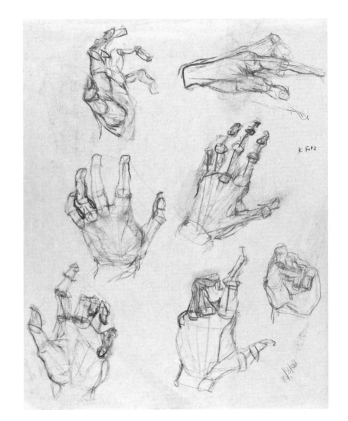

To draw the palm side of the hand, repeat the oval-shaped summary and the arcs at the joints. In contrast to the back view, however, note that the finger segments appear more evenly divided on the palm side, and correspondingly, that the middle finger from this view measures less than one-half the length of the hand. This apparent structural discrepancy is due to the crease of skin folds and webbing of fatty tissue at the juncture of palm and fingers, which conceal one-half of the first bony joints of the fingers. (Conversely, on the back of the hand, the presence of the knuckles seems to increase the length of the fingers.) Generalize the palm of the hand as a circle, and block in the muscles at the base of the thumb and along the heel of the small finger (you may wish to add a few topographic marks to account for the shallow depression in the middle of the palm).

Once the fingers are flexed and assume gestures in different directions, the hand becomes quite challenging to draw. Regardless of viewpoint, however, summarizing the fingers first as a simple mass will help you consolidate their form. Drawing arcs across the hand that connect each set of knuckles will help you see the totality of the hand's structure and gesture. It will also assist you in organizing the fingers into planar sections, beginning with the largest facets. Figure 8–58 provides a visual summary of gestural approaches to drawing the hand.

The Figure as Narrative

The narrative potential of figurative art has its basis in both the story-telling aspects of the figure as subject, and in the expressive values of the compositional design of a figurative image.

To enhance the subject (or thematic) narrative in your drawing you may wish to emphasize selected signs and symbols such as gender, age, body type, hair style, and dress. All of these carry connotations, some of which may be universally understood while others will be interpreted variously by different cultures. You may also choose to augment these associations by placing a figure in a specific

setting, by having a figure perform a specific action, or by depicting several figures interacting with one another.

The aesthetic choices you make during the drawing process constitute the second broad category of narrative possibilities at your disposal. These range from your selection of media, format, and two-dimensional layout, to how you handle the visual elements (such as lines, values, and shapes), to your orchestration of design relationships. All of these "process decisions" contribute to the final appearance or overall compositional form of your drawing. In fact, just as the three-dimensional human body you draw has form (volume and structure) so does your drawing have a physical form, except in this case you are responsible for the structural integrity of your image. And, much as your handling of subject matter can point to themes, so the form (or formal) characteristics of your drawing will carry meaning. For example, a drawing in a dark tonal key might appear somber; a symmetrical composition may have ceremonial overtones; or a drawing that retains evidence of its gestural origins will impress as energetic.

So, it is the interplay of *subject matter* (what you draw) and *form* (the way in which you draw it) that determines the *content* of your drawings. That association of subject and form has the power to generate rich layers of meaning, which for purposes of discussion we will refer to as the *formal* (compositional) and *thematic* (subject matter) narratives of an art work. When developing a drawing an artist will typically devote increasing amounts of attention to organizing subject matter into a formal hierarchy of major and minor emphases, much as an author arranges characters and events into main and subordinate plots.*

We will now look at three drawings that demonstrate how compositional form and subject-matter themes can consolidate the expressive power of a figurative image. In Figure 8–45 the formal decisions are crucial to the communication of subject-matter themes. In this work Rodin dispenses with all the subject attributes that traditionally identify St. John the Baptist—the emaciated body; the long, tangled hair and beard; the rough camel-skin tunic; and the lamb. This St. John exudes a lean but muscular good health, his beard is well groomed, and he is obviously a modern man. It is the formal device of his stride that finally identifies this figure as the saint. Rodin, by his own account, conceived of his St. John as the forerunner, the man who went forth to announce the coming of the Christ, so he used the gestural energy of the forward stride to signify this concept.

Drama is concentrated in the upper part of the body where the saint appears to be leaning toward the picture plane. Note especially the shortened muscles in the neck, upper chest, and upper arms, all of which are given more definition and tonal contrast than the rest of the body. The intensity of all that muscular activity alerts us to the ferocious energy of St. John. Moreover, the focus on the upper torso and limbs powerfully conveys a use of body language to express deep emotion while preaching. Finally, note how the artist furthers the thematic narrative through the gesture of the extended index finger, which in religious iconography refers to the act of teaching.

Let us now revisit the Valerio drawing (Fig. 8–56) to consider how a highly naturalistic figurative image can be organized so as to elicit a strong viewer response. Starting with broader compositional concerns, see how the whole image is conceived in terms of two intersecting triangles. The larger inverted triangle that descends from the top of the format follows the outer contours of the calves and converges at the big toes; the smaller triangle is suggested by the outer contours of the two feet. Notice how our attention is directed to the lower half of the page by a combination of ploys, including the intersection of the triangles, the increased focus, and the greater tonal contrast. Having arrived at this area, we find ourselves mesmerized by an abundance of clinical detail pertaining to a part of the body generally covered from sight. We may also perceive a morbid stillness

*Chapter 10, "The Form of Expression," is a more advanced discussion on the relationship between the form of a drawing and the meanings it conveys.

in the image, due largely to the equilibrium of forces in the opposing triangles. All this prompts us to ask, Why are we looking at these feet, and to whom do they belong? Is this person living or dead?

Concentrate on the feet and you will see an unsentimental depiction of small bones, raised veins, and fragile digits, all of which elicit an acute realization of the body's vulnerability. The indented impressions left on the shins by the ribbing of recently removed socks quietly magnifies the realism of the image (making the feet more uncomfortably naked than nude), and complements the drawing's emphasis on the transience of flesh by adding the suggestion of time elapsed. Ultimately, we may conclude that the drawing engages a theme we normally shy away from—our own mortality.

A quick comparison of Valerio's depiction of feet with that by Bravo (Fig. 6–1) confirms our claim that it is *how* rather than *what* you draw that finally determines content. Although in the Bravo we again see only a fragment of the figure, we are not troubled by that; the feet, beautifully bathed in light, suggest ease and fulfillment. They are comfortably nude.

The Rodin and Valerio drawings restrict their imagery to a figure set against an empty ground, and each demonstrates how the functional design peculiar to human anatomy may be translated into a drawing's visual structure. In the Degas (Fig. 8–59), the artist integrates the structural dynamics of a pose with the two dimensional organization of a fully realized spatial setting.

Notice first the near vertical divisions of the picture plane that begin with the edge of the tabletop on the right side of the drawing. That crisp line is repeated by a second implied line that runs from a sliver of drapery in the background, across the high points of the shoulder blade, over the ridge of the deltoid and acromion process on the left shoulder, and down the braced left arm. This is but one example of how Degas related a prominent gestural movement across the image of a figure to a larger design conception.

The formal symbiosis between figurative image and its domestic environment can also be seen in the framing devices Degas used in this work. The most easily observed is the tub itself, which like a giant platter serves the figure up to our gaze. Less obvious is the full-format design strategy that implicates nearly all the subject matter in the drawing. Begin by tracing the almost horizontal line from the groove of the spine between the scapulae, and across the nape of the neck to the base of the skull. Now, let's extend that line to the right and left sides of the picture and see what happens. Moving to the right we follow across a highlight on the back of the ribcage, along the line dividing the dark wall and gray floor to the double curves of pitcher handles. Scan back across this line to the left and you will discover that the shape of the sponge the bather is pressing against

FIGURE 8–59
Edgar Degas
The Tub, 1886
Pastel on cardboard,
60 × 83 cm

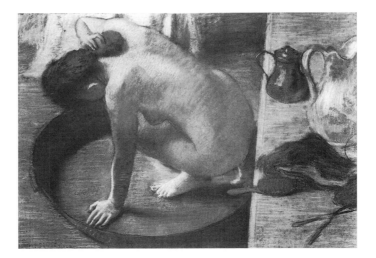

her neck and the outer contours of the front and back of her hair rhyme with the pitcher handles. By this method, Degas has your eye traversing an implied horizontal like a tight rope walker between two buildings.

Next, fix for a moment on the woman's shadowed face and hair and notice how they blend into the dark inner curvature of the basin. Follow that curve around to the illuminated hand and foot, including their long shadows, until you arrive at the stacked belongings on the lower end of the table. That right-angled movement (down the left side of the drawing and across the lower horizontal) in conjunction with the upper horizontal described above, creates a large unifying rectangular shape that echos the proportions of the format. Lastly, note that the multiple thin shapes at the bottom edge of the table (such as a brush handle and the open shears) echo the linearity of the model's fingers and toes—another example of subtle rhymes that create a binding relationship across the drawing's surface.

As a result of the extraordinarily orchestrated visual means Degas employed to maneuver our gaze, the configuration of the model's pose has a choreographed look (this despite the fact that her action is entirely natural and unstudied). Note, for example how he directs us to the formal and thematic focal point of the work: the intersecting horizontal and vertical forces where the sponge comes in contact with the model's skin focuses our attention on the very ordinary task of bathing. At the same time, however, that intense focus, combined with our unusually high vantage point in relation to the subject, makes us very conscious of our own act of looking. And, since the subject and setting are so intimate our implied presence in the scene places us in the disquieting role of voyeur.

Drawing 1: *To formally integrate a figure into an environment, first do a three-minute gesture drawing. Begin by scanning the entire image of figure and field and draw the main axis of the pose, followed by a major axial direction in the space around it. Proceed by finding similarities and contrasts of, for example, shape, direction, and value as you alternate your attention from figure to ground. Keep in mind that angles, intersections, and negative shapes in the model's environment can be used both to measure proportion and to create a design. Make use of linear and atmospheric perspective so as to infuse even this brief study with spatial dynamism (Fig. 8–60).*

Exercise 8F

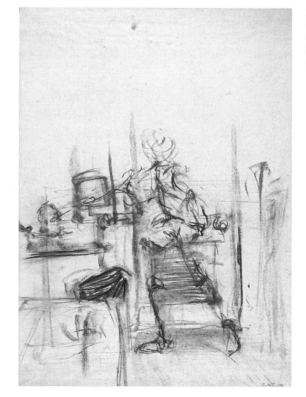

FIGURE 8–60
Carolina Curran, University of Cincinnati
Student drawing: gesture study of figure in an environment

Drawing 2: *If you have difficulty building the figure and its environment simultaneously, try first doing a three-minute gesture drawing of the spatial setting without the figure, sizing up the setting's two-dimensional design potential and three-dimensional organization. Instead of rendering the environment in uniform lines and tones, vary your touch to create different levels of definition as well as to suggest major and minor compositional motives and important spatial relationships. When you do introduce the figure, you may happily find that the relationships you have stressed in the environment function as cues for seeing the structural properties of the figure more quickly and comprehensively. (This alternate exercise can be done in a life-drawing studio simply by ignoring the model for the duration of the initial three-minute study.)*

Drawing 3: *Once you have settled on a viewpoint, do two ten-minute, intermediate, sustained-gesture variations that expand upon the correspondences and contrasts found in the briefer studies. Try to advance two-dimensional relationships between the figure and its environmental field (Fig. 8–61). Organize values into shaped patterns of light and dark, and experiment with line versus mass, making sure to include linear pathways that cross the boundaries of nameable objects. Find rhyming elements in different guises (positive/negative, large/small) to create unifying motifs. You may want to use a viewfinder to help you compose.*

Drawing 4: *Conceive of the two-hour final drawing as a more deeply plumbed variation of your ideas rather than as a large copy of what you achieved at the intermediate step. Continue to refine your selection process, editing to establish levels of form definition. Observe how in Figure 8–62 the lines of the reclining model repeat architectural themes. Note also how the figure has been organized*

FIGURE 8–61
ANDREW CASTO, University of Cincinnati
Student drawings: sustained-gesture figure composition studies

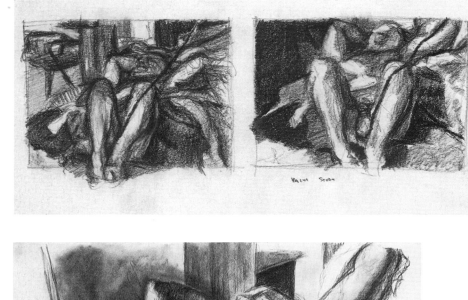

FIGURE 8–62
ANDREW CASTO, University of Cincinnati
Student drawing: final figure composition

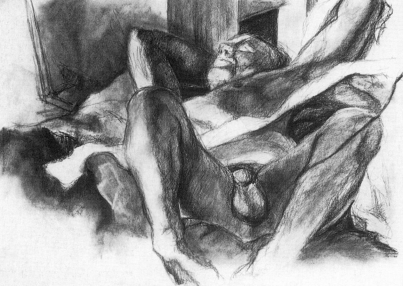

(a)

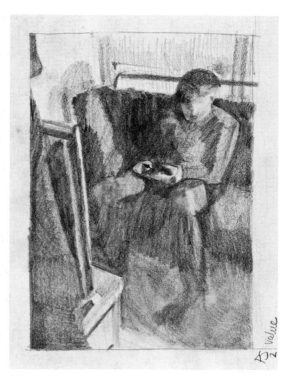

(b)

(c)

FIGURE 8–63
KAITLIN FITZ, University
of Cincinnati
Student drawing: sketchbook
composition studies
Graphite, 6 × 4½ "

triangularly, with the main design tension occurring where the diagonal of the right arm and leg interrupt the opposing diagonal of the sheet.

Drawing 5: *Repeat the steps outlined in Drawing 2, 3, and 4, but this time use a clothed figure as your subject. Once again start with preparatory sketches, as in Figure 8–63a, b, c where a series*

FIGURE 8–64
AIDAN SCHAPERA, University
of Cincinnati
The String
Pastel on paper, 28 × 20"

of studies have been made in a sketchbook: the first image summarizes a layout and elementary design plan (Fig. 8–63a); the second study organizes light, dark, and midtones (Fig. 8–63b); the third is a more developed intermediate step (Fig. 8–63c). Figure 8–64, done by a different student, integrates two clothed figures and a fully developed spatial environment into a finished composition. Observe the different levels of form definition in this drawing. The backyard patio is broadly treated in large, hazy shapes of dark to mid-toned grays. In comparison, areas of the figures are intricately constructed, sharply focussed and theatrically lit. Selecting the upper bodies and hands for higher resolution (or detail) supports and concentrates the thematic narrative of two curious boys unraveling string wrapped around a mysterious package.

Drawing 6: *A variation on the preceding projects is to make a complete compositional statement with a theme of figurative movement, as in Figure 8–65. Here, a moment's lapse is captured using two states of focus. Traces of what just occurred remain visible to the viewer, evoking a sense of passing time and memory.*

FIGURE 8–65
Tess Wrathall, Boise State University
Figure in Motion
Charcoal on paper, 36 × 45"

9

Subject Matter: Sources and Meanings

The preceding chapters of this book were designed to help you to master the basics of drawing. In the midst of learning these fundamentals, you may at times have wondered when you would be able to put your "basic training" aside and begin to make expressive drawings. But in truth, the drawings you have been making all along have been involved, on some level, with self-expression. Maybe you have even noticed that your drawings have consistently exhibited certain visual characteristics that are different from those of your classmates, even when a very specific assignment had to be carried out. Features that distinguish your drawings from those of your peers reflect your particular way of seeing and making visual order and, once recognized, will give you an inkling of your own artistic identity.

From this chapter forward, our emphasis is on expressive issues in drawing. We examine in more depth how self-expression is rooted in *what* you draw and *how* you draw it and also how these two factors combine to affect the thoughts and emotions of a viewer. Or, in art terminology, we are speaking of what are often called the components of an artwork's expression: subject matter, form, and content. As an introduction to these terms, we provide the following definitions:

Subject matter is what artists select to represent in their artwork, such as a landscape, portrait, or imaginary event.

Form is the set of visual relationships that artists create to unify their responses to subject matter.

Content is the sum of meanings that are inferred by a viewer from the subject matter and form of an artwork.

Subject matter and form are indivisible in a work of art. To explore their expressive possibilities in depth, however, we discuss them separately. This chapter is devoted to issues of subject matter. We begin with a focus on traditional themes in art.

Traditional Subject-Matter Areas

There are four major areas of subject matter—the human figure, landscape, still life, and the interior—that may be considered "classic" since they have survived the test of time. That all four categories are still viable today attests to the fact that they are both meaningful enough in themselves to have relevance for contemporary life and general enough to allow unlimited scope for personal expression.

Almost any subject you draw will in some way fall under one of the categories of the human figure, landscape, still life, or the interior. An awareness of the rich heritage of meaning attached to each of these subject-matter areas will help you to consolidate your own emotional and intellectual reactions to any particular subject you choose to draw.

Although the four major subject-matter areas were sometimes accorded separate treatment in Classical (Greek and Roman) art, in the Middle Ages they were for the most part subsumed into narrative works, which were usually religious but occasionally allegorical or historical. When these subjects were not essential to the story illustrated, they often appeared as incidental detail that nonetheless had allegorical content that reflected back on the larger meaning of the narrative.

Starting in the Renaissance, each of these formerly incidental areas began to reemerge as a subject in its own right. And as new symbolic content gathered around them, the set of meanings these subject areas carried from narrative painting evolved over the centuries. What follows is a brief survey of themes found within these four major subject-matter areas.

THE HUMAN FIGURE

The figure as a subject in its own right was the first to reemerge from the narrative art of the early Renaissance. This happened at a time when the philosophy of humanism was initially taking shape. The humanist movement upheld the inherent dignity of the individual with the assertion that one could be ethical and find fulfillment without help or guidance from supernatural powers. The rationalist basis of this philosophy is embodied in the drawings of idealized nudes by Leonardo, and to a lesser degree in the earlier drawings of Michelangelo. This secular bent of humanism made possible a view in which human beings stand heroically alone and responsible for their own destiny. Today, the essential loneliness of the individual is a central theme around which many portrayals of the figure are constructed.

The portraits by Elizabeth Peyton (Fig. 9–1) and Stephen Hale (Fig. 9–2) are contemporary variations on the ideal of physical beauty, as popularized in the

FIGURE 9–1
ELIZABETH PEYTON
Marc (April), 2003
Colored pencil on paper, 8⅝ × 6"

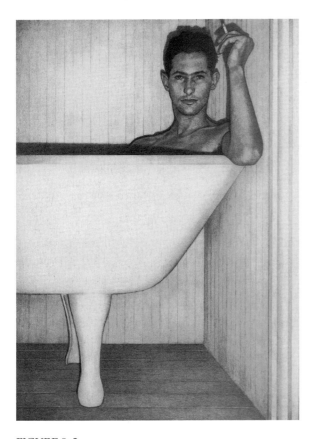

FIGURE 9–2
STEPHEN HALE
Untitled, 1985
Graphite on paper, 40 × 30"

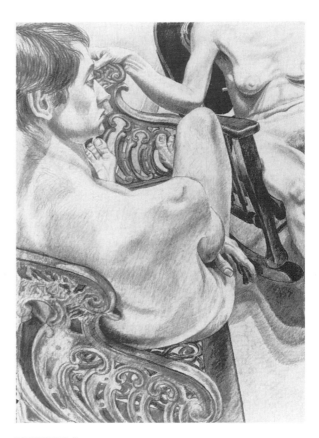

FIGURE 9–3
PHILIP PEARLSTEIN
Male and Female Model with
Cast-Iron Bench and Rocker, 1982
Charcoal, 44 × 30"

mass media. Male pulchritude for Peyton conforms to a fan magazine type; her sitters are androgynous, slender of build with tousled hair, darkened eye sockets and red Cupid's bow lips. By depicting these pretty boys in modest domestic settings, Peyton presents what a fan would really like to believe—that these impossibly beautiful boys are really sensitive, emotionally available individuals who can engage the viewer in conversation. No such intimacy is evident in the Hale. In this drawing the means for idealizing and even glamorizing the figure—the level gaze, the floodlighting that reveals the facial structure and musculature, the single prop, and the shallow space—are all appropriated from the cooler field of fashion photography.

In contrast, the figures in the Pearlstein drawing (Fig. 9–3) are devoid of myths connected with idealized beauty and glamour, making them appear more naked than classically nude. To achieve the existential edge of this image, the artist has directly addressed the corporeality of the human body, a property that has been exaggerated by the way in which the figures fill the picture space.

Realistic portrayals of individuals are often concerned with the issue of social position. When looking at the Goodman drawing of a middle-aged man framed by wrecked vehicles in Figure 9–4, we cannot help but compare the smashed cars to the burly figure behind them. From his haircut and sweatshirt we

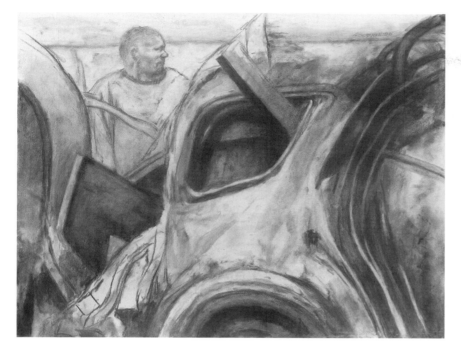

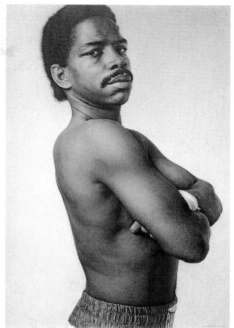

FIGURE 9–4
SIDNEY GOODMAN
The Wreckage, 2007
Charcoal on paper, 23 × 29"

FIGURE 9–5
BILL VUKSANOVICH
Prizefighter II, 2000
Pencil on paper, 29¾ × 44"

might identify him as a member of the working class or lower middle class. Yet, we can also interpret the image as an allegory for the feelings of uselessness and decline that many people will experience at one time or another.

The Vuksanovich drawing of a prizefighter is much more pointed than the Goodman in its reference to class or station (Fig. 9–5). The stance of this professional pugilist is macho, but not aggressive. Rather than confronting the viewer, he is turned sideways and looks out with an expression that seems at first glance to indicate grave personal suffering. But can we be sure that the facial expression does not also register distrust, or even veiled malice? The somewhat unusual close-up viewing angle and use of cropping can cause viewers to be uncomfortably aware that they are looking so intently at the image. This awareness touches upon the Postmodern issue of the "privileged gaze," a concept that lends power to the viewer, who, by virtue of the gaze, exerts supremacy, even implied ownership, over another being. As we look at the work we may doubt the propriety of our gaze, and instead of enjoying it purely on aesthetic grounds, we may start to ask questions relating to race and class exploitation in the sports and entertainment industry.

Unlike the Goodman and Vuksanovich, which both address concerns that transcend the unique individual, the drawing by Alice Neel (Fig. 9–6) is clearly a portrait and one in which the subject was depicted in context with the Zeitgeist, or prevailing spirit of the times. This is an impassioned yet ironic portrayal of the conflict between the subject's image of himself and the way the artist sees him as a member of society at large. His angry and impatient glance and the furtive, admonishing gesture of his forefinger seem to imply that he is some kind of revolutionary. But the artist has played up the dandyish aspect of his hippy's

garb so that he ultimately recalls the politically retrograde seventeenth-century cavalier.

Self-portraits range from idealized or romantic images to ones that are more insightful or even unsparing. In Jerome Witkins' expressionistic drawing (Fig. 9–7) we encounter the familiar portrayal of the artist as an eccentric visionary. In the multilayered self-portrait by Susan Hauptman (Fig. 9–8) the artist playfully portrays herself in a meticulously detailed fancy dress while at the same time depicting her facial features with a hard-bitten realism.

LANDSCAPE

Landscape as a separate subject came into its own in the Low Countries sometime in the sixteenth or seventeenth centuries. The early Dutch landscape artists often found work as cartographers, and assuredly there was a crossover between the disciplines of mapmaking and landscape art at that time. Maps of countries were often decorated with topographic views of major cities, and maps of specific locations often included horizon lines (Fig. 9–9). So in the earliest phase, landscape was often a portrait, so to speak, of a particular place or region.

Looking more closely at Figure 9–9, note that the specific features of the place are portrayed in terms of their use by the region's inhabitants, including soldiers,

FIGURE 9–7
JEROME WITKIN
Self-Portrait with Corrections, 2002
Charcoal on paper, 24 × 18"

FIGURE 9–8
SUSAN HAUPTMAN
Silver Self-Portrait with Dog, 1999
Charcoal, pastel, and aluminum
leaf on paper, 85 × 36½"

farmers, and townspeople. Later this idea was enlarged and became an early romantic concept, that is, a feeling for the "genius" or resident spirit of a place.*

In romantic landscape, human existence was regarded as basically irrelevant. This sense of detachment, combined with the firsthand involvement that artists of this time had with nature as they tried to catch its ever-changing spirit, often resulted in studies of surprising objectivity (Fig. 9–10).

*Romanticism was a full-blown artistic movement in Europe during the first half of the nineteenth century.

FIGURE 9–9
C. V. KITTENSTEYN, after Pieter
Saenredam
The Siege of Haarlem
Etching

FIGURE 9–10
JOHN CONSTABLE
*Study of Clouds above a Wide
Landscape*, 1830

In the work by John Virtue (Fig. 9–11), the ambition to capture the portrait of a place has been achieved by including several views of a particular locale, in this case a hamlet in Lancashire, England. Arranged on a maplike grid, these intimate miniatures may be presumed to be glimpses of a single group of buildings from a series of different vantage points. Taken as a whole, the group evokes a sense of familiarity with place that grew out of the artist's day job as a postal carrier in this area of England.

FIGURE 9–11
JOHN VIRTUE
Landscape No. 32, c. 1985–1986
Ink on paper on hard board
mounted on wood,
50 × 56"

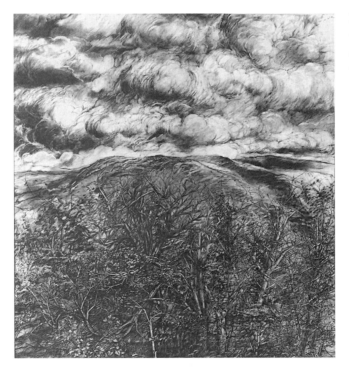

FIGURE 9–12
ARNOLD BITTLEMAN
View of The Green Mountains, 1977
Charcoal heightened with white
conté, 67½ × 60½"

The drawings by Bittleman (Fig. 9–12) and Lees (Fig. 9–13) are concerned primarily with a romantic view of nature, since human landmarks are absent from both works. In the sultry landscape that Bittleman creates, everything appears in closeup. The minutely textured hedges in the foreground forbid entry into the space, while the boiling clouds overhead seem to rush forward. Even the horizon is brought disturbingly close by a series of not-too-distant hills. It is a

FIGURE 9–13
JOHN LEES
Bog, 1986
Ink, watercolor, pencil,
and mixed media/paper,
22½ × 37½"

landscape intimate in its detail, yet one that threatens to ensnare with twigs and smother with demonic clouds.

The image in the Lees drawing, on the other hand, seems more remote. The impenetrable mass of nondescript bushes coalesces into a shape that hovers quietly in the middle of the page. Here is nature at its wildest, with forms that are inexplicable to human understanding.

The drawing by Sean Gallagher (Fig. 9–14) proposes that the relationship between humanity and nature is akin to an uneasy truce. This is no sunlit harbor filled with gallant merchant vessels or leisure craft, but rather an industrial dockland. The great cranes we see silhouetted against a partially overcast sky seem to have fallen into disuse, so the regret we feel at seeing the natural shoreline disturbed by industrial structures is compounded by frustration at the wastefulness of modern commerce. The agitated surface of the water, which grows visually "louder" in the foreground, may effectively stir in us the sublime terror of the unknown. And, by drawing our attention to the receding plane of water, the artist reminds us of the immensity and long duration of nature when compared to the puny strivings of humankind.

The romantic conception of nature as being in a constant state of flux finds its urban counterpart in Figure 9–15. Here, commuters careen over precipitous Bay Area streets under a network of cables transporting invisible electrical impulses. The buildings, like the stunted trees, seem temporary in this cityscape, where yearnings for place and permanence are secondary to the imperatives of rapid transit and telecommunication.

STILL LIFE

Still life became a subject in its own right in the Low Countries at about the same time as the appearance of landscape. The still-life genre, more than landscape or

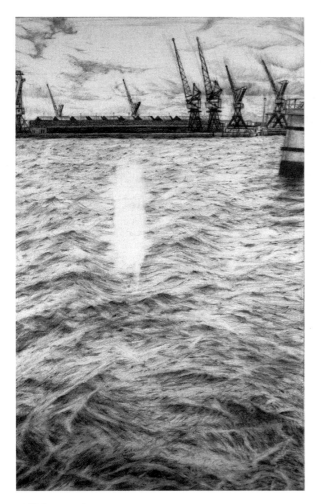

FIGURE 9–14
SEAN P. GALLAGHER
Renewed Presence
Pencil on paper, 22 × 14"

FIGURE 9–15
WAYNE THIEBAUD
Down 18th Street (Potrero Hill), 1974
Charcoal on paper, 22⅜ × 14⅞"
Art © Wayne Thiebaud/Licensed by VAGA,
New York; Photo courtesy of the Allan Stone
Gallery, New York; Photo: Ivan Dalla Tana

the figure, retained a strong allegorical content long after it was removed from the context of religious narrative. Detailed depictions of flowers and insects (Fig. 9–16) were symbolic of the variety and also the impermanence of Creation. Vast piles of food—fruits, vegetables, dead poultry, game, fish, and raw flesh of all kinds—were not only evidence of the wealth and abundance of the bourgeois household but also a resigned recognition of the transience of all life. The moralistic theme of the temporality of all material things finds its culmination in the *Vanitas* still life (Fig. 9–17). (The Latin word *vanitas* literally means "emptiness," but in Medieval times it became associated with the folly of empty pride.)

The vanitas theme is one that has survived to this day in still life. In the drawing by William Wiley (Fig. 9–18), the objects on the left-hand side are the memento mori so commonly found in Dutch vanitas paintings: The apple is a symbol of the mortal result of Original Sin; the dice and chess piece are symbolic of life as a game of chance; the steaming beaker suggests the futile search for the elixir of life; the jewels are symbols of earthly pride; and the knife, skull, and candle all belong to the iconography of human mortality. A framed mirror near the center of the drawing bears the fleeting inscription "What is

FIGURE 9–16
Ambrosius Bosschaert, The Elder
*Large Bouquet in a Gilt-Mounted
Wan-Li Vase*
Oil on panel, 31½ × 21½"

FIGURE 9–17
Herman Steenwijck
Vanitas Painting, c. 1640
*Museum De Lakenhal, Leiden,
The Netherlands*

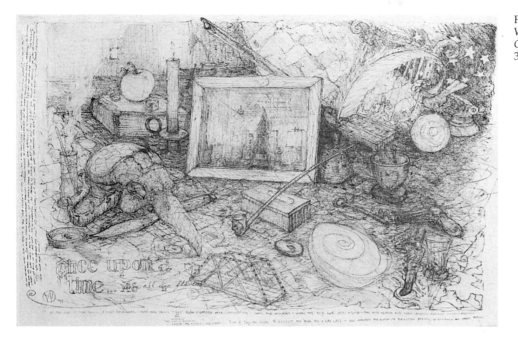

FIGURE 9–18
WILLIAM WILEY
G.A.D., 1980
35½ × 53½"

not a bridge to something else?"—a reference to the passing of all material things. Below it is a long-stemmed pipe common to both Dutch and early American still life. The pipe and tobacco box (tobacco is a New World plant) act as a bridge between the fatalistic iconography of the Old World and the iconography of death by (mis)adventure of the American frontier. The items on the right side of the drawing—the pistol, the key, the pewter cup, the quill, and the American battle standard—are objects common to the already nostalgic trompe l'oeil ("fool the eye") painting of the nineteenth century.

The painstakingly detailed pastel by Massad (Fig. 9–19) is well within the traditions of a trompe l'oeil still life. The believability of this depiction hinges on

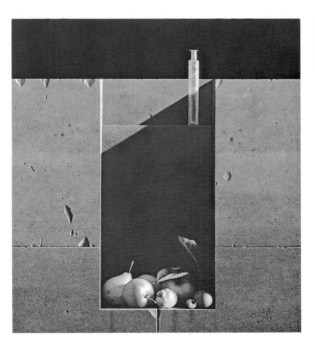

FIGURE 9–19
G. DANIEL MASSAD
Columbarium, 1998
Pastel on paper, 24 × 21½"

FIGURE 9–20
Tom Wesselman
Drawing for Still Life No. 35, 1963
Charcoal, 30 × 48"
Art © Estate of Tom Wesselmann/Licensed by VAGA, New York

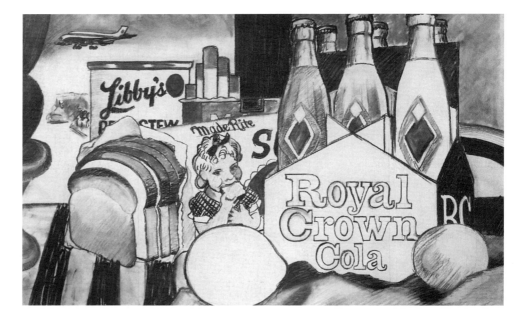

the way in which the beautifully realized expanse of stone runs parallel to the picture plane, thereby eliminating any interruption between spectator space and the pictorial illusion. The artist appears to be playing with the literal meaning of still life (*Nature Morte* in French) by entombing the fruit, plucked from a living tree, in a shallow niche. His intention is underscored by the work's title, which refers to a wall pierced with niches for the commemorative storage of cremated remains. The artist's sense of irony is revealed by the explicit contrast between the rigorous structure of the architectural niche and the lively curves of the fruit. The raking light also plays a major role in the work. It bathes the luscious fruit against the unforgiving stone and reminds us of a time of day (very early morning or early evening) that is particularly fugitive.

Larger-than-life portrayals of food and other consumable items locate the Pop Art movement within the vanitas tradition. The Wesselman drawing (Fig. 9–20) concentrates on the packaged nature of common consumer goods. It even goes so far as to equate the glamour and convenience associated with name-brand foods with the glamour and convenience of jet travel (another packaged experience). The only natural foodstuffs in this drawing are the two lemons, the acerbic juices of which hardly promise the immediate gratification enjoyed by the Sunshine Girl on the bread wrapper. And the cigarettes, the cola, and the highly processed foods are presented as objects of questionable desire. They are not linked overtly to the issue of life and death, as are the poultry, fish, and game of Dutch still life, but they are nonetheless icons of death, first because of their own throwaway identities and second because their consumption may prove more harmful than nourishing.

Glass drinking vessels, such as the overturned wine goblet in the Steenwijck painting or the ominous-looking liquor glass in the Wiley drawing, are common vanitas symbols. Among the characteristics that make them such a fitting symbol of temporality are: They can be drained of their contents; they are fragile; and they are transparent (as are ghosts), with surfaces that reflect an evanescent world in miniature. Janet Fish exploits the theme of reflection in her depiction of glassware (Fig. 9–21). The shapes of the rather sturdy and commonplace restaurant glasses are subdivided into countless shimmering, splinter-like pieces. Just as the forms of the glasses are lost in the myriad reflections, so too are the forms of the

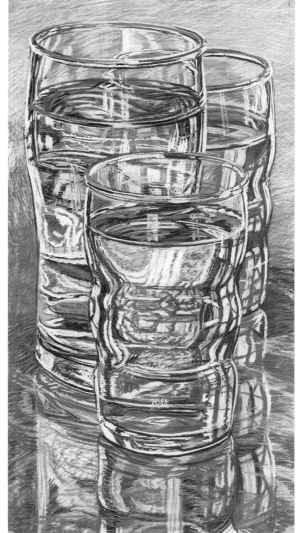

FIGURE 9–21
JANET FISH
Three Restaurant Glasses, 1974
Pastel on paper, 30¼ × 16"
*Collection of the Minnesota Museum of
American Art. Art © Janet Fish/Licensed
by VAGA, New York*

immediate environment distorted almost beyond recognition in the reflections on the glass surfaces. In the end, we get a picture of a world that is insubstantial and fragile.

THE INTERIOR

The domestic interior has long been associated with the contemplative life. In Medieval and Renaissance painting, meticulously rendered interiors appeared in such subjects as St. Jerome in his study or in Annunciation scenes in which the Virgin is usually depicted with a book. In the Romantic era, poets and artists became increasingly preoccupied with exploring the workings of an imagination that could have free rein only in solitude. In literature, the novel delved into the private thoughts of fictitious characters who had the middle-class leisure to reflect on all the petty intrigues of domestic life. Today, the rooms to which a person can go to ruminate, reminisce, or daydream still hold a special significance.

The drawing by Lucas Samaras (Fig. 9–22) is in the tradition of the room as metaphor for the private mind. This interior is devoid of any personal domestic

FIGURE 9–22
Lucas Samaras
Untitled, August 18, 1987
Pastel on paper, 13 × 10"

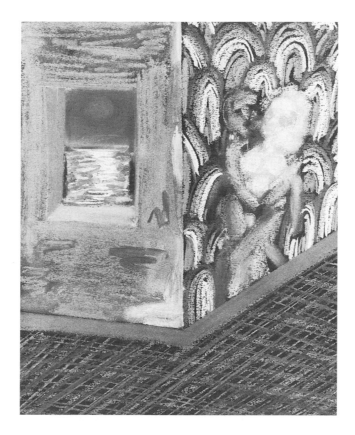

effects, but it is populated by memories or daydreams of amorous trysts that have left their imprint on the walls.

The drawings of empty interiors by Lundin (Fig. 9–23) and López García (Fig. 9–24) are far less confessional. Both may be regarded as images of the mind swept clean. The Lundin drawing shows a section of what appears to be a spacious empty studio. The softly polished floor and the slender shaft of weak sunlight that falls on it exude a meditative calm. In the López García drawing, the

FIGURE 9–23
Norman Lundin
Studio: Light on the Floor
(small version), 1983
Pastel, 14 × 22"

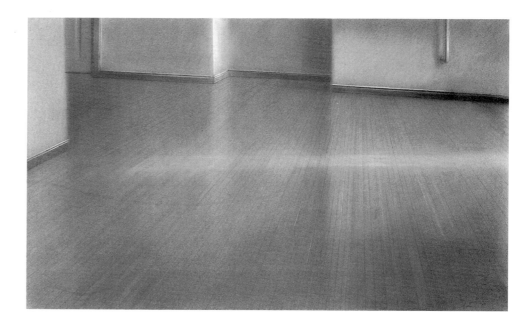

FIGURE 9–24
Antonio López García
Cocina de Tomelloso (The Kitchen in
Tomelloso), 1975–1980
Pencil, 29⅜ × 24"

uncluttered kitchen contains several clues that attest to a life that is more austere
than contemplative. The only relief from the bare, brightly lit surfaces is the stark
geometric pattern on the floor.

The high vantage point in the drawing by Robert Birmelin (Fig. 9–25) is
key to transforming a room into a deep, cave-like space steeped in melancholic

FIGURE 9–25
Robert Birmelin
Two Women on a Sofa, 1963
Watercolor, gouache, ink and
pencil on paper, 24¾ × 24½"

FIGURE 9–26
Hollis Sigler
Crawl Back to Safety, 1982
Cray-Pas on paper, 28½ × 34"

darkness. The angles of the furniture and the arc inscribed on the floor counteract the quickly vanishing perspective lines so that the space appears to pivot around the two figures isolated in their weariness on the couch. The protective darkness that seems about to envelop these figures suggests the slow winding down of daytime energies toward the ultimate refuge of sleep.

The Hollis Sigler drawing, *Crawl Back to Safety* (Fig. 9–26), shows the interior as literally a place of refuge. The inner sanctum of the house or apartment is the bathroom, which in most homes is the only room with a lock on the door. Here a person can be safely alone; and in the revitalizing comfort of the warm bath that is being drawn, one can soak away the grime and tensions accumulated during the day. The discarded clothes on the floor and the neatly set-out bathrobe and slippers promise a cozy retreat from the crazy world still visible through the window.

Subject Matter as a Source of Meaning

That aspect of content that is derived from subject matter in a work of art is generally referred to as **subject-meaning**. Subject-meaning is most often literary in character; that is, it is meaning that is interpreted from the depiction of an event, story, or allegory.

The content that is taken from pictorial subject matter can be loosely categorized as inhabiting either public or private spheres of meaning. Artists interested in tapping content from the public domain often do so to strike a critical nerve in the social conscience of their time. The Daumier, for instance (Fig. 9–27), boldly engages the issue of crimes against humanity, portraying as it does the brutal murders of a household of innocent workers by the French civil guard in 1834.

FIGURE 9–27
HONORÉ DAUMIER
The Murder in the Rue Transnonain,
1834
Lithograph

A more recent and reassuring example of topical content can be found in Red Grooms's *Local 1971* (Fig. 9–28). In this satirical narrative, Grooms's characterizations are not only amusing, they also betray the curiosity we all have about the facts and foibles of humankind.

The harrowing image in Figure 9–29 does not directly engage the public side of life, as it is a record of this artist's intense personal vision. Yet, in its own

FIGURE 9–28
RED GROOMS
Local, 1971
Color litho from "No Gas"
portfolio, 22 × 28"

FIGURE 9–29
Luiz Cruz Azaceta
Self-Portrait: Mechanical Fish, 1984
Oil pastel, colored pencil on
paper, 102 × 45"
© Luiz Cruz Azaceta. Image courtesy of
George Adams Gallery, New York

eccentric way, it bespeaks of modern-day barbarism by inciting in us simulta-
neously the emotions of fear (of death and dismemberment) and compassion (for
a victim).

But subject-based content in a work of art does not have to depend on
spectacle, or subject matter that makes an aggressive appeal to extreme states
of emotion. In the portrait by Mary Joan Waid (Fig. 9–30), for instance, mean-
ing is insinuated gradually. Presented with the most enigmatic of subjects,

FIGURE 9–30
MARY JOAN WAID
Dream Series IX, 1984
Pastel, 29¾ × 41½"

the gaze of another human being, we might be moved to wonder about this woman's particular story or what thoughts lie behind her melancholy glance. Content may also be effectively derived from humble subjects that the artist found personally moving, as in Figure 9–31, which depicts the mundane but beautiful event of sunlight streaming into a room.

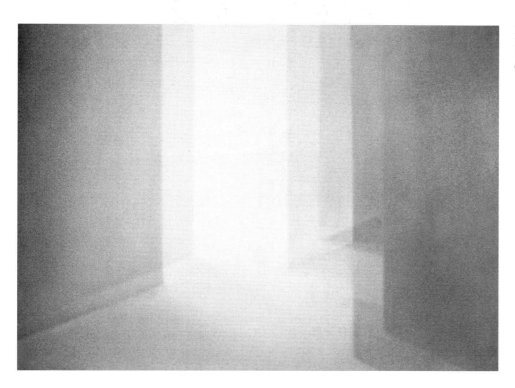

FIGURE 9–31
ELYN ZIMMERMAN
Untitled, 1980–1981
Graphite on mylar, 18 × 24"

Thematic Variations

As a student working in the structured environment of the classroom, you may not always have free rein in your choice of subject matter. But even so, this should not put a damper on the expressive values of your work. One way to inject more personal excitement into your drawings is to cast the subject matter in a new thematic light. For an example of how a potentially banal subject can be charged by a reality existing outside the realm of ordinary studio surroundings, look at the still-life variations by Paul Wonner (Fig. 9–32) and Manny Farber (Fig. 9–33).

Art-historical context provides the guiding impulse for the Wonner drawing. The deep space and suggestion of ever-changing light, plus the flowers, delicate vessels, and comestibles that melt in the mouth all hark back to early Dutch still-life paintings. And lest we should be in any doubt about this allusion to an art-historical precedent, the artist has included the image of a Droste chocolate bar (a Dutch brand).

The dynamics of space, form, and light are minimized in the Farber. Seen from directly above, the unforeshortened matlike shape does not invite us into an illusionistic space but rather stops us short. The only recourse the viewer has is to follow the clockwise movement around the periphery of the square, a movement that recalls the advance of markers on a gameboard. Taken further, this clockwise motion suggests a hidden storyline in which the cheery pieces of confectionery and the enigmatic cork, eyedropper, and cigar play out their dramatic roles.

So in the end, we have two works with basically the same subject matter that nevertheless stir up a very different set of associations. In the Wonner, we are taken up by the Dutch-inspired theme of the temporality of all earthly delights; in the Farber, *we* are the subject of the work, acting as sleuths trying to decipher clues within the narrative.

FIGURE 9–32
PAUL WONNER
Study for Still Life with Cracker Jacks and Candy, 1980
Synthetic polymer paint and pencil on paper, 44½ × 29⅞"

FIGURE 9–33
Manny Farber
Cracker Jack, 1973–1974
Oil on paper, 23¼ × 21¼"

The illustrations in this chapter are meant to indicate the vast storehouse of expressive potential inherent to the four subject-matter categories: human figure, landscape, still life, and interior. It is important that you use this resource as a starting point for your own continuing personal research into subject-matter meanings. Study monuments from art history in depth. An art-historical perspective will help you grasp how classic subject matter has been utilized and adapted over the ages as a basis for countless means of cultural expression. And, to learn more about those works for which you feel an especial affinity, read about the social context in which they were created.

 The following projects are intended to help you begin assembling personal insights into subject-matter themes.

Exercise 9A

Drawing 1: Draw an interior that clearly reflects the way that space functions for you on a daily basis. Do cramped quarters and clutter suggest that you live at a frenetic pace? Or do you regard your home as a series of spaces that allow you to day dream or meditate, as in Figure 9–34?

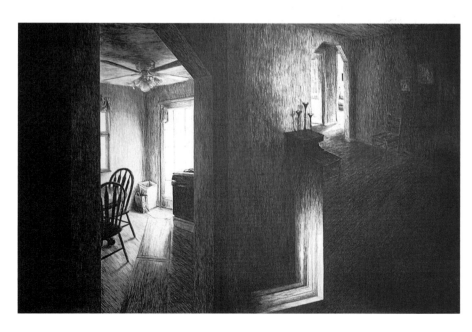

FIGURE 9–34
Jason Butler, University of Cincinnati
To empty myself
Student drawing: meditative interior
Ballpoint pen on paper, 30 × 44"

FIGURE 9–35
Tom Bennett, Arizona State
University
Student drawing: interior with
suggested narrative
Pencil, 18 × 24"

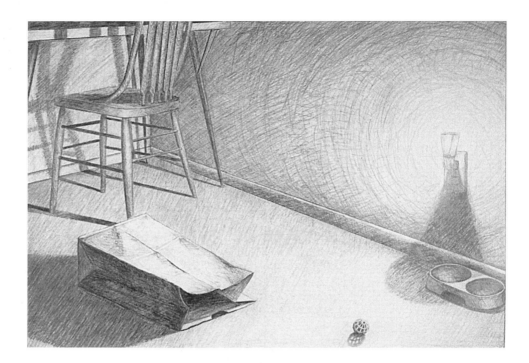

Alternatively, you might look for a narrative within your interior. In Figure 9–35 the pet bowl and toys, along with the spooky cast shadows, make us look around for the absent cat.

Drawing 2: *Draw a diaristic or autobiographical still life using objects that have collected quite naturally, for example, on top of your desk, dresser, or television set. Alternatively, you might select objects thematically related, as in Figure 9–36, which retells some of the complexities of a long auto trip. Figure 9–37 invests some common vanitas symbols—the burning candle, the fading rose, and the fragile wine glasses—with the seeds of a thought-provoking narrative. As viewers, we have no choice but to assume the role of a character who, having imbibed too much, sees this dramatic scene through blurred vision.*

FIGURE 9–36
Jennifer Plourde, Arizona State
University
Student drawing: autobiographical
still life
Charcoal, conté, 22 × 30"

FIGURE 9–37
DANIEL NILSSON, Metropolitan
State College
Jack
Student drawing: still life with
a vanitas theme
Charcoal on paper, 20 × 20"

Drawing 3: *Draw firsthand a portrait of a landscape that for you embodies a sense of genius or romantic spirit, free of the trappings and overtones of human existence (Fig. 9–12). Create strong contrasts of marks and values to express the intense feelings this landscape elicits in you. Another option is to select from a landscape a detail that in miniature arouses those same feelings of awe you would experience when confronted by the scale and power of a vast panorama (Fig. 9–38). You may wish to follow up either of these projects with the opposite conception of an urban-scape that blatantly displays a dominant human presence (Fig. 9–15). Depicting your subject after dark can soften a city's harsh geometry and permit the reemergence of natural mysteries (Fig. 9–39).*

FIGURE 9–38
DAVID LARSON, University
of Montana
Student drawing: landscape detail
enlarged
40 × 40"

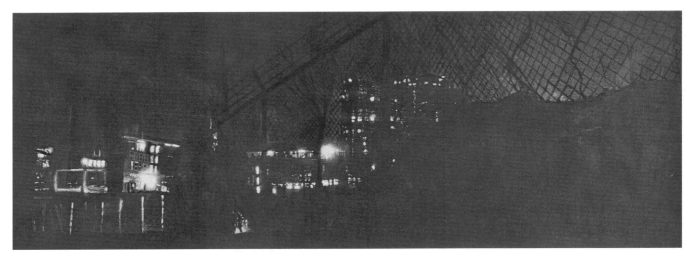

FIGURE 9–39
Claudia Hershner, University
of Cincinnati
Student drawing: urban landscape
at night
Black and white color pencil,
charcoal, white conté on black
paper, 9½ × 25¾"

Drawing 4: Do a portrait of an obliging friend or relative. Include some narrative elements to iden-
tify who they are or how they would like to be perceived. On the other hand, you might wish to do a
self-portrait that explains something about your current life situation (Fig. 9–40).

Exercise 9B

*Alternatively, try using subjects or themes belonging to more than one of the major categories. Such
is the case in Figure 9–41, which may be considered a still life, since it consists of a skeleton and
a draped piece of furniture. But the skeleton's gesture recalls a living figure, insinuating that the
draped desk is more than a mere studio prop. In this context, it suggests something sinister, such as
a shrouded tomb or a piece of furniture stored in a house after the death of its occupant. Or look at
the stowed fire hose in Figure 9–42. Although it may be literally defined as a still-life object, visually
it connotes a threatening human presence.*

FIGURE 9–40
Tiffany Gobler, Kendall College
of Art and Design
Self-Portrait with Guitars
Student drawing: self-portrait
with narrative elements

FIGURE 9–41
SHERILYN HULME, University
of Arizona
Student drawing: still life with
psychological content

FIGURE 9–42
WANDA GAG (1893–1946)
Macy's Stairway, 1941
Lithograph on paper,
Sheet: 11⅞ × 16¹/₁₆"
(30.2 × 40.8 cm) Image:
9⅞ × 12¾" (25.1 × 32.4 cm)

Whitney Museum of American Art, New
York; Purchased with funds from The Lauder
Foundation, Leonard and Evelyn Lauder Fund
96.68.123/Gary W. Harm, deceased, nephew of
Wanda Gag

The Form of Expression

In earlier chapters, we introduced ways to organize the two-dimensional space of a drawing, from the initial layout to the development of a more complex set of design relationships. This chapter enlarges on the topic of pictorial order by linking more fully the artist's orchestration of the visual elements to the creation of expressive *form* in a drawing. Also included is a set of strategies to help you troubleshoot problems of observation and design in your drawings.

The Two Definitions of the Term **Form**

In Chapter 5, we discussed one definition of the term "form" as it is used in art: the three-dimensional properties of objects in the real world. Often, in critiques about a representational work of art this definition will be extended to include how convincingly an artist has depicted the illusion of three-dimensional objects, as in: Does the image of the bowl, tree, or figure successfully convey the volume, weight, and sculptural roundness of the actual objects?

In Chapters 8 and 9, we referred to a second definition of form: the visual relationships artists create to compose their works of art. It is this second meaning of form that we elaborate upon in this chapter. In its fullest definition, this second meaning of form refers to an artwork's total tactile and visual existence. That includes the physical substances from which it is made and the quality of its visual order, or compositional form.

In other words, form is what we literally, physically experience when looking at a work of art. By virtue of its material existence, form distinguishes itself from both subject matter and content since subject matter exists only symbolically, but not actually, in a drawing, and content exists only as an interpretation made by the viewer. Ultimately, then, it is the actuality of an artwork's form that sets it apart as a unique object in its own right, independent of the real-world subject matter it represents.

To further clarify this second meaning of the term *form*, specifically as it refers to compositional form, we shall examine the visual organization of a masterwork.

Studying the Form of a Masterwork

Our stress on the visual reality of form does not mean to imply that the form of a specific artwork can be comprehended at a single glance. On the contrary, the structural composition of a good work of art is often multileveled and will become apparent only after some degree of study.

To illustrate this point, we will analyze Mary Cassatt's painting, *In the Loge*; we will also use one of her studies for this work to provide us with additional insight. Starting with Cassatt's painting (Fig. 10–1), observe that the whole composition can be divided diagonally into two triangular areas: a darker one and a lighter one. The line dividing these two areas functions as a seam running from the upper right down to the lower left (Fig. 10–2). An opposing force, represented by the illuminated, upper-balcony facade, collides with that seam, forming a shallow V-shaped juncture (Fig. 10–2). That juncture is repeated at the bottom of the picture by the hand holding a fan, a repetition that gives both shape and closure to the otherwise unrelieved dark expanse at the work's lower edge. (Turning the picture upside down may help you see the various points we discuss about the underlying structure of the work.)

Now, look more closely at that upper-balcony diagonal, while referring to both Cassatt's pencil study (Fig. 10–3) and our diagram (Fig. 10–4). The broadened end of the light, swath-like shape (which sits just to the right of the center of the picture) that hooks into the darker area of the composition creates a bridge to unify the two large triangular passages. This is an important feature of the work for two reasons. First, because Mary Cassatt took the risk of creates a bold image through strong contrasts of value and direction. And second, because she invented design strategies to integrate those contrasting forces (in this case, the bridging form described above) to create a dynamic equilibrium.

Other notable sources of contrast in this work are small versus large, and busy versus quiet. Specifically, we point to the dark, lower triangular section and how its large and relatively undisturbed surface differs from the upper triangle. This latter area is divided into several subsections, each populated with a variety of small shapes, all of which give the upper triangle a more active presence. Figure 10–5 isolates the looping figure Cassatt used to organize this array of smaller shapes, which include the jacket cuffs on the outer and inner sides of the woman's raised wrist, and her opera glasses.

Next, compare Cassatt's painting to her study and you will see that the artist made some changes in the design, from the rough to the final. She cropped the composition from the top, slicing off a bit of the bonnet and cutting out the top architectural arc. The result is that the figure now commands more area within the composition and the picture's top edge is not weakened by a dished shape. When we look in the painting for the vertical lines included in the study, we find that they have been greatly downplayed. But the two strongest architectural verticals remain. Combined with the near vertical of the woman's forearm, these verticals function to frame the head and bust of the woman, as seen in Figure 10–6. Drawing a horizontal line from the woman's elbow to the right margin of the composition completes a rectangle in the upper right that is of exactly the same proportions as those of the whole composition. This frame within a frame, like the light swath discussed above, helps to focus our attention on the woman's gesture.

In conjunction with the image of the woman, consider the way Cassatt laid out the spatial illusion. We as viewers are seated right next to her, squeezed into the compressed, sculptural foreground plane. If we look straight out into the represented space, however, we get a glimpse of the sweeping curvature of the opera house; looking down, we are plunged dizzyingly into its cavernous depth. Our perception of these different spaces is abrupt and involuntary, and they deposit us directly in the loge, much as Cassatt was when she drew her study.

Now that we have isolated some of the chief form characteristics of *In the Loge*, the next step is to introduce the concept that the expressive character of this artwork is a direct outcome of the form choices Cassatt made when creating it. In other words, in the act of composing *In the Loge* she transformed fairly neutral subject matter into a personal visual statement. So, how do the form choices, outlined above, affect our subject-matter reading in this work? Altogether, the clash of directions and decisive shifts of spatial orientation and illumination create visual high drama. That drama, in turn, provokes an unmistakable undercurrent of implied

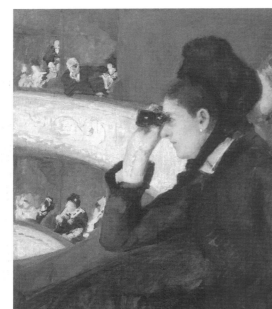

FIGURE 10–1
MARY CASSATT (American 1844–1926)
In the Loge, 1878
Oil on canvas, 32 × 26" (81.28 × 66.04 cm)
Museum of Fine Arts, Boston, The Hayden Collection-Charles Henry
Hayden Fund, 10.35. Photograph © 2011 Museum of Fine Arts, Boston

FIGURE 10–2
Opposing movements in the Cassatt
painting create a V-shaped juncture
that is repeated at the bottom by the
hand holding the fan.

FIGURE 10–3
MARY CASSATT (American
1844–1926)
Drawing for *In the Loge*, 1878
Graphite, 4 × 6" (10.2 × 15.2 cm)
Museum of Fine Arts, Boston, Gift of
Dr. Hans Schaeffer, 55.28. Photograph
© 2011 Museum of Fine Arts, Boston

narrative, urging us to ask: Who is this woman who is so utterly composed at the center of so much pictorial hubbub? What is the psychology of her gaze, as she concentrates undeterred by, for example, the visual pinball of the clustered figures on the upper and lower balconies to her right?

The poignancy of this woman's image is set in motion by Cassatt's keen conjunction of form and subject matter. The layers of design relationships do not give us definitive answers to the mysteries embedded in this woman's image, but they help structure the questions we ask.

FIGURE 10–4
The light-valued, swath-like shape
unifies the two triangular masses
and integrates the opposing
diagonals.

FIGURE 10–5
The loop-like shape organizes
a series of smaller shapes.

FIGURE 10–6
Cassatt's frame-within-a-frame
compositional device focuses
attention on the subject's act of
gazing through binoculars.

The Matter of Pictorial Invention

As mentioned, Cassatt made her study on-site in an opera stall. That she could
recognize the visual-content potential of these disparate real world things—
balcony, wrist, face—is a testimony to her ability to see and invent pictorially.
And we must stress that the act of pictorial invention was critical to the originality
of Mary Cassatt's visual statement in *In the Loge*.

To understand this concept, we refer you once again to the network of
design relationships that are sketched out in Cassatt's study and fully developed
in the painting. That network of relationships, improvised on the raw material of

the observed subject matter, has a verifiable existence in the artwork, but it has no reality outside of that pictorial realm. To clarify this, consider again what we call the "light swath" including the upper balcony in her study (Fig. 10–3) that runs diagonally from top left to slightly past mid-page and includes the woman's hand and face. This is a startling shape, not only because it is the most conspicuous among all shapes in the work, but also because it has no name. Or, to be more precise, it has no name that can be matched with an identifiable thing in the real world. And that is because it amalgamates three different subject-matter symbols: balcony, hand, and face. Test this notion by tracing the shape and showing it to a friend to see if she can identify it. Invent a nonsensical name for it if it will help to drive home the point that artists use their creative imaginations to transform subject-matter information. Thus, the pictorial inventions artists create are freed from the confines of everyday things and the everyday conventions of looking at things. In view of all this, we may make two general observations:

1. That artists, in the process of making their ideas and emotions comprehensible to others, manipulate the visual elements beyond the service of pure description to create new pictorial entities, which for purposes of convenience are often referred to as *pictorial shapes, pictorial lines*, and so on.

2. That the sum of pictorial invention, that is, all the created shapes, linear movements, and orchestrations of value taken together in a particular drawing, constitute that sense of form that we experience in a fine work of art.

To summarize, we have established that the form of a drawing refers to its entire structural character; or to put it simply, form refers to that compositional reality of a drawing that we can apprehend with our eyes.

We have also determined that the form of a drawing has a visual and material identity that is distinct from its subject-matter source in the real world. In fact, we can say that what all artworks have in common, regardless of stylistic, media, or historical differences, is their separateness, or *abstractness*, from reality.

This matter of why the form of any artwork is undeniably abstract, and how this concept can be understood in relation to the common designation of an "abstract style" in art, is the focus of our next topic in this examination of form.

What Is Abstraction Anyway?

When applied to drawing, the term **abstraction**, like the term **form**, has more than one meaning. First of all, a drawn image is separate and distinct from a sensory experience of actual subject matter. In Figure 10–1, for example, no woman is present. What does exist is a visual symbol (or abstracted representation) for a woman that is embodied by a deposit of media on a flat surface.

Second, abstraction refers to a multilayered *process* that is inherent to the making of all visual art. Let us clarify this by simplifying the operation of making a drawing into three steps.

1. Out of the world of experiences, which has been described by the philosopher William James as a "blooming, buzzing confusion," the artist selects something to draw. This method of singling out or generalizing from concrete reality is an *abstracting process.*

2. Thereafter, each choice an artist makes while drawing continues to reflect the abstracting process of the mind. Such early decisions as format orientation, vantage point, plus the character of the initial layout wherein superficial detail is overlooked in favor of summarizing the proportional and gestural essences of forms and spaces are all part of this process.

3. As a drawing's specific form character progresses, its existence as an independent object, governed by its own pictorial order, becomes more distinct. The basis for this abstract wholeness is the essential arrangement and unity of the visual elements. Consideration for the abstract function of the visual elements is a feature of all good drawing, even if the image is a representational one.

To conclude this discussion on the abstracting process, compare the rough sketches in Figure 10–7, both of which are visual first impressions of the same subject. Figure 10–7a represents a literal approach. Each nameable piece of subject matter has been outlined prior to a filling-in of values. This method often results in a final work that is generic in appearance due to the predictable way the subject matter has been handled. In Figure 10–7b, the abstracting process was underway from

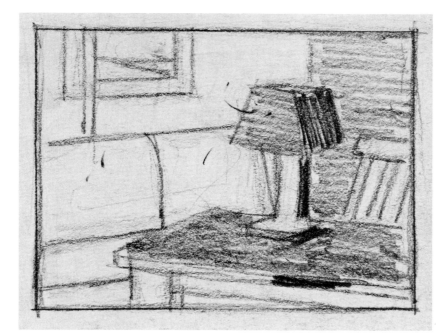

FIGURE 10–7a
A rough sketch of an interior in which the shapes literally correspond to the nameable objects that are depicted.

FIGURE 10–7b
A rough sketch of the same interior in which invented shapes are improvised for compositional purposes, without a loss of spatial illusion or form.

FIGURE 10–8
FRANZ MARC
Sketchbook from the Field, 1915
Pencil, 9.7 × 16 cm

the get-go. Instead of depicting each object one at a time, as in Figure 10–7a, the image field as a whole (the entirety of the positive and negative shapes) was scanned. This enables the artist to see across and through the objects, giving full rein to more creative, form-building improvisations. A dependency on outlines was replaced by a selection of which edges to stress, inside and outside the forms, to discover new patterns of value and shape. As a result, Figure 10–7b contains visual hunches for how the observed subject matter might be transformed, which is one crucial step in the development of a pictorially inventive and original work of art.

The term **abstraction** also refers to certain styles in the history of art. The term *abstract art* gained currency in the early twentieth century when numbers of artists abandoned naturalistic representations of subject matter in favor of formal invention (Fig. 10–8). But abstraction as a means to simplify and stylize an image was not unknown in earlier phases of art, as demonstrated by a page from the *Book of Kells* (Fig. 10–9).

Today, the designation *abstract art* is often used to describe not only quasi-representational imagery but also works of art that are completely devoid of subject matter. More precisely, though, when an image is solely the product of an artist's imagination, and is therefore without reference to an external stimulus (Fig. 10–10), the style of the work is **nonobjective**.

Exercise 10A *We cannot overestimate the benefits of using the drawing process to learn how fine works of art have been constructed. By making penetrating, analytic studies of a masterwork (as opposed to merely copying it), you experience more intimately why certain formal choices were made by the artist, which in turn expands your general understanding about formal organization in pictorial art. Studies of masterworks are also to some extent expressive endeavors, since the formal attributes you find in a work, and the way you represent them, depend on your own subjective values. Using Tasley's Truck (Fig. 10–11), let us review some of the steps you will want to take when making your own analytic drawings.*

FIGURE 10–9
Book of Kells

FIGURE 10–10
HANS HOFMANN
Red Shapes, 1946
Oil on cardboard, 25¾ × 22"

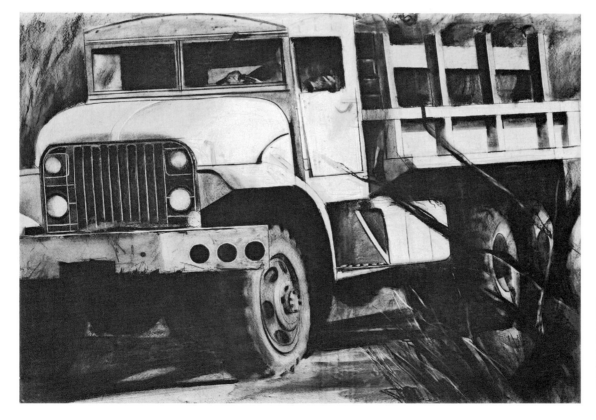

FIGURE 10–11
MATT TASLEY
Truck, 1985
Charcoal on
paper, 60¹⁄₁₆ × 85"
*Arkansas Arts Center
Foundation Collection:
Purchase. 1985.85.040*

FIGURE 10–12
Surface division of the Tasley "Truck" drawing.

FIGURE 10–13
Positive-negative summary of the drawing by Matt Tasley.

1. *Sketch out the fundamental layout, or subdivision, of the work's surface (Fig. 10–12).*

2. *Determine the major positive–negative arrangement (Fig. 10–13).*

3. *Locate repeating shapes, patterns, or textures that build relationships between different areas of the work (Fig. 10–14). In this case, note the integration of round and angular shapes that are varied in size and tonality and are at times fully delineated and at other times only suggested.*

FIGURE 10–14
Analysis of motifs in the "Truck" drawing.

FIGURE 10–15
Linear, gestural pathways that help organize the image in Figure 10–11.

4. *Examine the linear movements and accents that guide the eye (Fig. 10–15). Note the gestural cues that initiate a "secret" elliptical movement circulating the main image, which relieves the severe grid-like architecture of the drawing.*

In summary, when drawing from a masterwork, uncover as many compositional relationships as you can. Part of your goal should be to discover how any one area of a work may have several organizational roles to play. If you are analyzing a work from a book or magazine, placing a sheet of translucent paper over the reproduction will suppress subject-matter detail sufficiently to allow you to concentrate on the work's organizational virtues.

Exercise 10B *For this exercise, you will first do a series of studies from a masterwork (Fig. 10–16). Be sure to select a masterwork that has a developed illusory space and full-page design.*

Now, with the inventions of the masterwork fresh in your mind set out to make your own compositional statement. Choose your subject carefully: one that will be in place long enough should you need to return to it several times; and one that will furnish enough spatial and subject-matter raw material for you to manipulate, with the aim of inventing new form and design relationships.

It is advisable to keep your drawings small for this project, so your sketchbook may be ideal for this purpose. Complete two preparatory studies (Fig. 10–17a is a value study; Fig. 10–17b explores layout and shape invention) before you proceed to the final (Fig. 10–17c).

FIGURE 10–16
TREVOR PONDER, University
of Cincinnati
Student drawing: sketchbook page
of masterwork studies
Pencil on paper, 8½ × 11"

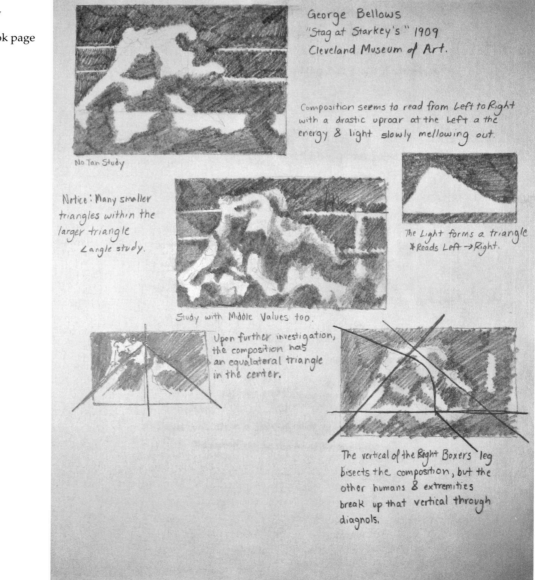

FIGURE 10–17a
AMANDA NURRE, University
of Cincinnati
Student drawing: sketchbook
value study
Pencil on paper, 5 × 5½"

FIGURE 10–17b
AMANDA NURRE, University
of Cincinnati
Student drawing: sketchbook
layout and shape invention study
Pencil on paper, 5 × 5½"

FIGURE 10–17c
AMANDA NURRE, University
of Cincinnati
Student drawing: sketchbook final
Pencil on paper, 5 × 5½"

Many artists prefer simplifying, combining, or distorting aspects of their subject matter to give them more freedom to improvise, with shapes, lines, values, etc., and to invent personally discovered design relationships. Figure 10–18 is one example of creating an abstraction from the physical world. Here, the repetition of circular and linear motifs, together with the gestural attack, has produced a riot of newly minted, bicycle-derived form combinations.

Another abstracting method is to severely crop a portion of your subject, making sure that the part you have chosen has sufficient visual variety (Fig. 10–19). In this work, there is an appealing dichotomy between the seemingly photo-real surfaces and the abstract play with line, value, and pattern.

Exercise 10C

FIGURE 10–18
HEATHER CONVEY, University
of North Carolina at Greensboro
Student drawing: bicycle
abstraction
Charcoal and pastel on
paper, 60 × 83½"

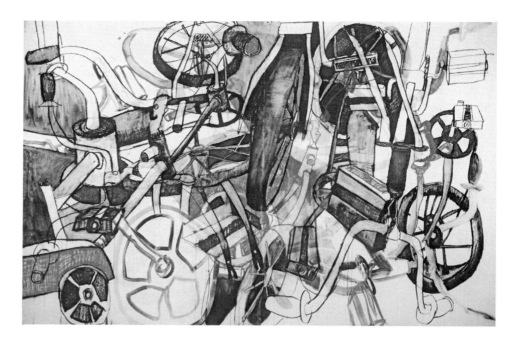

FIGURE 10–19
RYAN KERSH, Savannah College
of Art and Design
Student drawing: abstracting
an image by cropping
Charcoal and pastel dust
on paper, 14 × 14"

The Primacy of Form in the Visual Arts

Form is often considered to be at the heart of the artistic enterprise. One reason
for this belief is that the form of an artwork is its visual reality. In other words,
and as stated earlier, form is what you see in an artwork—its lines, shapes, colors,

and tones, which have been organized in a particular way. This means that in a work of art, the subject matter is inevitably seen through the filter of form. Or, to put it another way, the depiction of subject matter in an artwork (or *what* has been represented) cannot be divorced from its form (or *how* the subject matter has been treated). This is why versions of the same subject by different artists may vary in content so dramatically, as in Figures 10–20 and 10–21.

FIGURE 10–20
JEAN-FRANÇOIS MILLET (French 1814–1875)
The Sower, 1850
Oil on canvas, 40 × 32½"
(101.6 × 82.6 cm)
Museum of Fine Arts, Boston; Gift of Quincy Adams Shaw through Quincy Adams Shaw, Jr. and Mrs. Marian Shaw Haughton 17.1485. Photograph © 2011 Museum of Fine Arts, Boston

FIGURE 10–21
VINCENT VAN GOGH
Sower at Sunset
Reed pen
Vincent van Gogh Foundation/National Museum, Amsterdam, The Netherlands. Stedelijk Museum

Form is what the artist manipulates when giving expression to ideas and emotions, so it may also be regarded as the primary source of content in a work of art. In fact, properties of form are thought so essential to the meanings we take from an artwork that, for many, the terms *form meaning* and *content* are synonymous.

Form as a Source of Meaning

That aspect of content that is derived from the form of an artwork is commonly referred to as **form meaning**. Form meaning is prompted by the visual character of a work of art; so in contrast to the literary character of subject meaning,* the content taken from form, by its very nature, cannot be expressed adequately in words.

The meanings we attribute to form in art have their origin in our experiences and associations from birth with qualities of form in the real world. For example, jagged forms belong to a large class of objects that have the potential to inflict pain and injury, such as teeth, claws, thorns, and knives. Similarly then, jagged lines or shapes in a drawing (Fig. 10–22) may well give rise, at least on the subconscious level, to feelings of anxiety.

In Figure 10–23, Graham Nickson has effectively capitalized on form meanings that are commonly attributed to horizontal, vertical, and diagonal movements. The figurative image in this work echoes our upright human condition in opposition to the flat plane of the landscape. The stability of this relationship is heightened by the way in which the clear and simple intersection of the standing figure and the horizon line repeats the geometry of the format. However, this static harmony is interrupted by the diagonal direction of the outstretched arms; a direction that in everyday life signifies action that is often unpredictable. Note that the diagonal creates a similar effect in Figure 10–24, which is nonobjective in style.

FIGURE 10–22
ED PASCHKE (1939–2004)
His and Hers, 1977
Graphite pencil, yellow fiber-tipped pen and colored pencil on paper, Sheet: 29 × 23¼" (73.7 × 59.1 cm)
© Ed Paschke. Whitney Museum of American Art, New York; Purchased with funds from the Drawing Committee 84.46

*See "Subject Matter as a Source of Meaning" in Chapter 9.

FIGURE 10–23
GRAHAM NICKSON
Bather with Outstretched Arms III, 1983
Acrylic on canvas, 100 × 120"

FIGURE 10–24
JOEL SHAPIRO
Untitled, 1984
Charcoal on paper, 43 × 30¾"
(109.2 × 78.1 cm)
*© 2011 Joel Shapiro/Artists Rights Society
(ARS), New York*

We conclude our discussion of form meaning with three more examples of contemporary drawing. The Alex Katz (Fig. 10–25) is striking due to its simplicity of line, overall paleness of tone, and general lack of strong visual contrast. By minimizing visual differences, the artist sustains a mood of genteel contemplation. Meaning in Figure 10–26 is heightened by masking out, or **cropping**, all but one

FIGURE 10–25
ALEX KATZ (b. 1927)
Thomas, 1975
Pencil, 15 × 21¾"
*Art © Alex Katz/Licensed by VAGA,
New York*

FIGURE 10–26
ROBERT ROHM (b. 1934)
Untitled, 1975
Graphite on paper,
20 × 26¾" (50.8 × 67.9 cm)
*Whitney Museum of American Art,
New York; Gift of Dr. Marilynn
and Ivan C. Karp 75.50*

small section of a wall. This intensifies our recognition of aspects of the subject's form, such as its density and rough physical texture, and the irregular rhythms of the bricks and mortar. From so vivid a depiction of a lively surface, we might interpret an allusion to organic growth and change, perhaps going so far as to sense an inner life within something ordinarily thought of as mute and inanimate.

The structural motif underlying the nonobjective drawing by Eva Hesse (Fig. 10–27) is the grid, which connotes measure, and reason. The disc-like shapes built up with beautifully graded values similarly contribute to a theme of deliberate purpose and control. But taken as a whole, we may see that these delicate tonalities and their subtle variations are also the means to express a very different

FIGURE 10–27
EVA HESSE
Untitled, 1966
Pencil and wash, 11⅞ × 9⅛"

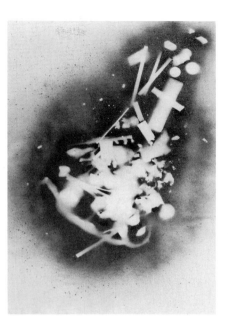

FIGURE 10–28
DAVID SMITH (1906–1965)
Untitled, 1962
Spray paint on paper, 27 × 39⅝"
(68.6 × 100.6 cm)
Whitney Museum of American Art, New York; Purchased
with funds from an anonymous donor 79.40. Art © Estate
of David Smith/Licensed by VAGA, New York

kind of content. Viewed together, the discs begin to pulse or vibrate, resulting in the illusion that the entire field is fluctuating before our eyes. This unpredictably expanding and contracting movement upsets the stability and harmony first observed in the drawing and makes the surface appear to breathe.

In conclusion, form meaning is significant in art because it is based on memories that are innate to virtually all human beings, regardless of their geographic or ethnographic differences. That is to say, people in general are able to find meaning that they cannot express verbally in, for example, contrasts between light and dark, sharp and fuzzy (Fig. 10–28), and so on. Interestingly, Charles Burchfield produced a suite of drawings, "Conventions for Abstract Thoughts," in which he attempted to find visual equivalents for otherwise unrepresentable states of mind (Fig. 10–29).

In comparison, the communication of subject meaning in a narrative-based work of art is dependent upon viewer recognition of a specific temporal event, or at least a viewer's confidence in deciphering signs and symbols imbedded in the work (and, perhaps title). If we respond to the expressive values in Figure 10–30, for example, we may experience feelings of instability due to the tangle of unpredictable forms on the left, versus the relative comfort we take in the architectural solidity on the right. Yet, from the standpoint of subject, or thematic content, we might find the work so open-ended that we are left to wonder, "What does it mean?"

Troubleshooting Your Drawings

This last section of the chapter raises questions you may want to ask when you are evaluating or troubleshooting the form of one of your drawings in progress.

FIGURE 10–29
CHARLES BURCHFIELD
Dangerous Brooding, 1917

FIGURE 10–30
MICHAEL ANANIAN
*Quid Pro Quo, Graduating
with the Art Students*, 1999
Charcoal on paper, 23 × 25"

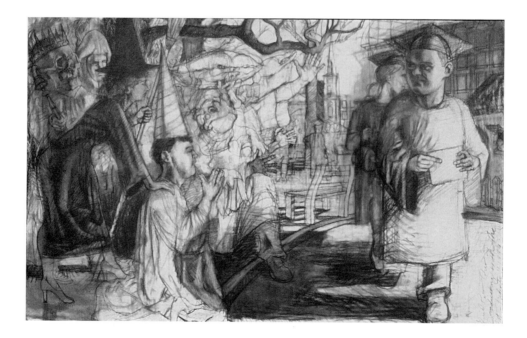

CRITICIZING YOUR DRAWINGS

Almost everyone who takes a drawing class is familiar with the "class critique," during which members of the class comment on each others' work. Class critiques are valuable for many reasons, perhaps the most important of which is that they enable you to distance yourself from your own drawing and see it with a critical, dispassionate eye. However, it is also important that you extend this critical outlook beyond the class critique and apply it during the process of making your drawings.

While a drawing is in progress, you should step back from it periodically to ask critical questions about its development. This is a natural and constructive part of the drawing process. Without this activity, you run the risk of making drawings that are structurally or expressively weak, or both. Also remember that the critical assessments you make about a drawing are always to some extent personal value judgments and are therefore expressive of your subjective life experiences.

Finally, it can be argued that each time you examine the form of one of your drawings (or a work made by another artist), you are feeding your "intuitive bank." In other words, what you put into your consciousness through a deliberate learning process you will in the future be able to tap as if by second nature. This relationship between self-conscious learning and the ability to react unerringly is common to scores of other disciplines: Think of the concentration necessary to first learn the basics of how to bat a baseball, or how countless hours of practice come to fruition in a dazzling musical performance.

Critical Questions to Ask about Your Drawings

Self-reliance is an important attribute for an artist. Artists must take responsibility for assuming the roles of both maker and critic of their own work. And the successful artist may be defined as one who knows what questions to ask.

The criteria employed when studying the form of a drawing in progress usually fall into two categories. On the one hand, you will be assessing how well you have observed and depicted the subject matter. On the other hand, you will need to determine whether the treatment and organization of the visual elements best serve your aesthetic and expressive ends.

The following is a set of questions to assist you with these two categories. Your use of these questions (or any other questions you might ask) should always be considered against the overall objectives you have for your drawing. Moreover, it is advisable to combine the process of asking critical questions with the practice of making diagnostic studies from your drawing. Studies of this sort can often be of invaluable assistance in getting to the crux of a formal problem and in making design alternatives more apparent.

Questions pertaining to observation and depiction:

1. Do areas that you want to read as three-dimensional volumes appear flat? Are they bounded by either an outline or an unmodulated dark tone that has the effect of making them look cut out? Have you neglected to organize the tones according to spatial planes, or are those planes so inconsistently handled that they lack the illusion of spatial volume? Figure 10–31 successfully avoids these pitfalls.

2. Is the spatial illusion consistent? Check to see whether some areas of your drawing "pop," that is, advance ahead of their desired spatial position.

3. Is your depicted light source consistent?

4. Are all objects seen from a consistent eye level? Do the converging lines of your depicted objects conform to a vanishing point (Fig. 10–32)?

5. Are the scale and part-to-part proportional relationships accurate when compared with the actual subject matter?

6. Does each depicted object have tonal integrity (Fig. 10–33)? Or, are the surfaces splintered into too many tones to establish a local value for each object? Have you expressed light with essentially the same tone throughout (a common error is to have the untouched surface of a light-colored paper stand in for all the varying qualities of light in a subject), and have you made all the shadows equally dark?

FIGURE 10–31
CHRISTOPHER SICKELS, Art
Academy of Cincinnati
Student drawing: convincing
spatial planes

FIGURE 10–32
TAYLOR HSIAO, University
of Arizona
Student drawing: effective use
of perspective

Questions pertaining to the organization of the visual elements:

1. Is the format subdivided so that all areas, positive *and* negative, have been given definite or implied shape (Fig. 10–34)? Generally speaking, a layout that divides the page into equal or near equal areas will reduce a drawing's impact, no matter how much attention is given to its imagery.

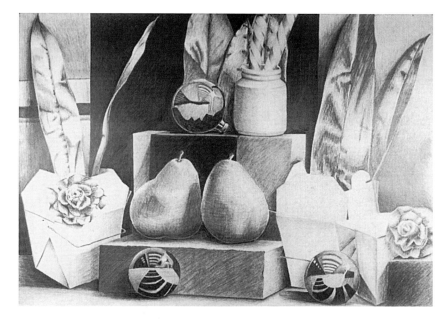

FIGURE 10–33
Noelle Fridrich, Arizona
State University
Student drawing: still-life
objects rendered with tonal
integrity
Pencil, 22 × 30"

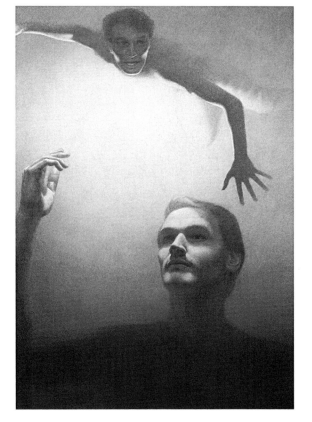

FIGURE 10–34
David Andrews, University of Wisconsin, Whitewater
Student drawing: bold positive and negative layout

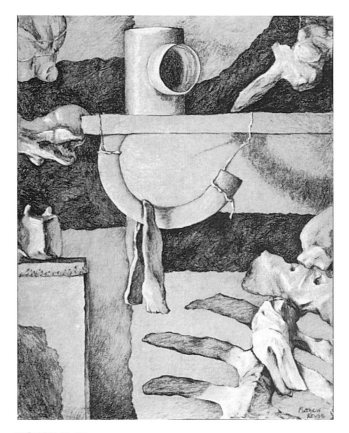

FIGURE 10–35
Matthew Kruse, Arizona State University
Student drawing: guiding the viewer's eye across the surface
Charcoal, 18 × 24"

2. Are there enough variations among the visual elements to create tension?

3. Have the visual elements been orchestrated sufficiently to create unifying relation-
ships? Is there a cohesive pattern of emphasis and de-emphasis that leads the eye
at varying speeds across the surface and through the illusion of space (Fig. 10–35)?

FIGURE 10–36
JULIE McCREEDY, Boise State
University
Student drawing: still life
employing a variety of expressive
and descriptive marks and lines
Charcoal and pastel on paper,
37 × 49"

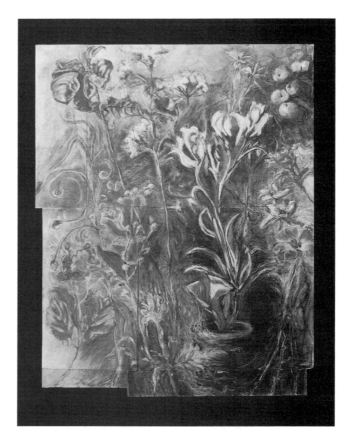

4. Is the value range sufficient to furnish your drawing with a dynamic tonal character (as opposed to a sameness among values that may cause visual boredom)?

5. Do the marks and lines function in expressive as well as descriptive roles (Fig. 10–36)?

6. Finally, where is your drawing going? Does it register clearly your aesthetic and expressive intent? Or has your intent become muddled because, for example, you've concentrated too heavily on the detail of a few areas? Moreover, does your drawing contain visual clues that, if developed, could lead to unexpected richness in form and content? For example, could you intensify the mood of your drawing by consolidating the values into a lower or higher tonal key, or could you tighten its design by stressing a particular motif that was formerly not apparent to you in either the actual subject matter or your drawing?

COMMON ARTISTIC BLOCKS AND THEIR SOLUTIONS

At times when you are drawing, a problem may arise that you cannot seem to solve. As a result, you may feel frustrated and even suffer a loss of confidence. Being stymied by a drawing in this way is one example of a syndrome often referred to as an **artistic block**. Artistic blocks of one kind or another are common to the experience of most artists, beginners and professionals alike. Some typical artistic blocks and some possible solutions for them are as follows:

1. *You can't get an idea.* Ideas for drawing are everywhere. You may find expressive potential in the most modest of circumstances—your unmade bed, the dishes collected on a countertop, the visual diversity that has accumulated in

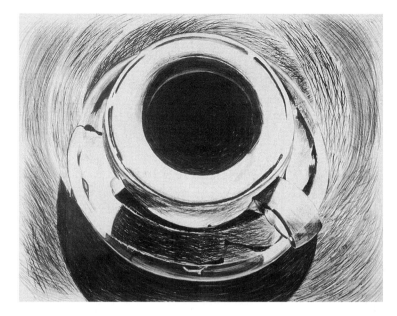

FIGURE 10–37
IRVIN TEPPER (American 1943)
Third Cup of Coffee, 1983
Charcoal and oil pastel,
43¾ × 51½" (111.13 × 130.81 cm)
Arkansas Arts Center Foundation Collection:
Purchase. 1984.043

a closet, or an otherwise inconspicuous coffee cup seen from an unusual point of view (Fig. 10–37). With domestic or otherwise mundane subject matter, try working at unconventional hours and see if those settings you normally take for granted do not take on a wealth of mystery and narrative (Fig. 10–38).

2. *You have an idea but don't know how to get it down.* Try a two-pronged attack for this one. First, to inspire yourself, find examples by other artists who have dealt with a similar idea. Second, since many of the problems will work themselves out in the act of drawing, break the ice and start to draw.

3. *A problem arises in a drawing and you can't figure out how to correct it.* First, try shifting your perception by turning the drawing upside down or looking at it from a distance (or both). If that doesn't work, put the drawing aside for a few days, even a week, and go on to another. When you return to the earlier drawing you will probably find that your "mental distance" from the work enables you to more clearly diagnose and act on its deficiencies.

4. *You like one area of your drawing and don't want to change it.* Trying to adapt a drawing overall to fit one area that you don't want to lose usually results in a fragmented image and an artistic block. To restore healthy forward movement in your process, it will be necessary to manipulate or change the blueprint of that part of the drawing. Once you start to see ways to integrate that area into the drawing as a whole, the preciousness attached to it will subside, and you will be prepared even to completely reconceive the area if necessary.

The Issue of Detail

In the introduction to this book there is a section titled "Seeing Versus Naming" (pg. 13) which stresses a *visual*, as opposed to a *verbal*, approach to understanding the subject matter you draw. A natural outcome of this working method is a realization that *there is no detail in a successful drawing.*

The word "detail" in general refers to nonessentials. In drawing, it usually refers to the laboriously worked layers of specific information that viewers inspect up close. The problem is, once you approach a drawing from the standpoint of adding detail, where do you stop? How many hours do you spend and when are you finished—when exhaustion finally overtakes you? Attention to detail for its own sake can also

FIGURE 10–38
Tom Bennett, Arizona
State University
Student drawing: mundane
subject at night
Charcoal, 18 × 24"

imply that you actually believe that you can duplicate reality. But think about. Were it even possible to capture reality in a drawing, why bother? Viewers can simply look at the real thing. And, from a formal standpoint, focusing your attention predominantly on detail usually results in a deadening similarity of treatment throughout an image.

The alternative to being bogged down with mindless attention to detail is to concentrate on the abstract nature of the drawing process. Engaging the drawing process from that perspective inevitably reaffirms that making a drawing means to be selective about *what* you include in your drawing and *how* you include it.

So, the operative word is *choice*. But the choices you make must be guided by the needs of the drawing, which is a real thing in its own right although it bears your stamp of creation. How powerful that stamp is depends upon the quality of those choices you make. (Choices which, in turn, depend upon the clarity and astuteness of the questions you ask, as discussed earlier in this section.)

Thus, we want to promote a process in which you are aware of how each part of a drawing contributes to the compositional and expressive whole. Your awareness of these things at any given point in the working process may be intuitive or analytic; most artists arrive at a personally judicious balance of these two spheres of knowledge. So, the alternative to part-to-part detail is to make choices that will set your entire work in motion from the first mark to the last. Instead of thinking about detail, think about levels of form definition in the drawing. Where will you choose to increase definition (or resolution or emphasis) and where will you decrease it, and at what rates of difference, and for what design effect?

This is not a matter of semantics. It is a state of mind, a visual-seeing state of mind, the absence or presence of which will have serious repercussions for the drawings (or artworks in general) that you make.

Visualizations: Drawing upon Your Imagination

Have you ever had a mental image be so persistent that you felt the only way to put it out of your mind was to draw, paint, or sculpt it? This is a common experience among artists and is perhaps one of the things that best differentiates us from other people; we are driven to give outward form to the images that persist in our mind's eye. For some artists, a single memory or obsession may serve as their primary subject matter for many years. Such was the case for H. C. Westermann (Fig. 11–1) for whom the horrors encounterd while in service on a battleship during World War II could only be purged by repeatedly drawing crucial scenes from memory.

Even artists driven by concerns that are more public in nature delve deeply into their private store of imagery in order to express a moral or political stance. Consider the fantastical scene by Brueghel in Figure 11–2, in which bizarre creatures performing inexplicable antics serve as allegories of various types of church corruption. In our own day, artists moralizing on current social or political issues

FIGURE 11–1
H. C. WESTERMANN
USS Enterprise, c. 1958
Ink on paper
Art © Lester Beall, Jr. Trust/Licensed by VAGA, New York

FIGURE 11–2
PIETER BRUEGHEL, the Elder
Temptation of St. Anthony, 1556
Pen and black ink on brownish
paper, 216 × 326 mm

FIGURE 11–3
SUE COE
*Scientists Find a Cure for
Empathy*, 1997
Graphite, gouache,
and watercolor, 53½ × 52½"
*© 1997 Sue Coe. Courtesy of Galerie
St. Etienne, New York*

continue the satirical tradition, mixing a dark, bitter humor with their messages and using exaggerated and sometimes fantastic form (Fig. 11–3).

We live in a culture distinguished by a constant bombardment of mass media images. While the imagery produced by the advertising industry is often undeniably clever, we generally perceive it as shallow and lacking the meaning we hunger for. So, the role of the artist today includes recharging the vast pool of imagery around us with images that are at once personal and recognizable as pertaining to a more universal human condition (Fig. 11–4).

Representations that are based on imagined or recalled material are commonly referred to as **visualized images**. Visualized images can range from the

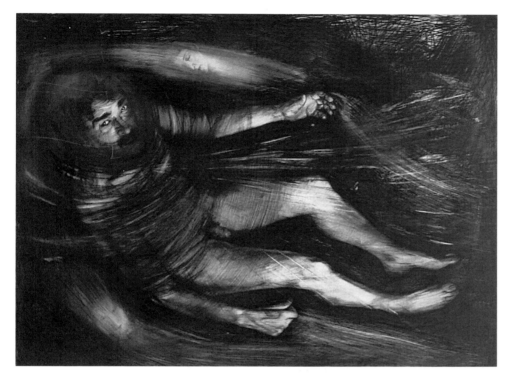

FIGURE 11–4
MADDEN HARKNESS
Untitled, 1988
Mixed media on vellum, 47 × 36"

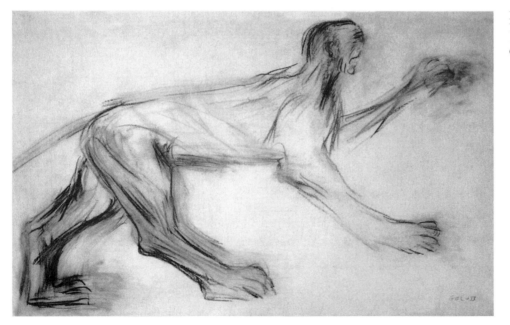

FIGURE 11–5
LEON GOLUB
Untitled (Sphinx), 1963
Conté on vellum, 23¾ × 39"

humble sketch someone makes prior to buying lumber for a bookcase to such
bizarre artistic conceptions as Figure 11–2. And in complexity and degree of
finish, envisioned images can span the gamut from the gestural drawing of a
sphinx by Leon Golub (Fig. 11–5) to the much more elaborately detailed draw-
ings by Brueghel (Fig. 11–2) and Coe (Fig. 11–3).

Visualizing an Idea

Getting ideas efficiently down on paper and in a way that communicates them clearly can be vital for an artist who is conceiving a visualized image. In Figure 11–6, for example, the Swiss sculptor Jean Tinguely has made a series of spirited studies of a machine propelled by waterpower. Notice the casual look of these studies, the rapid strokes, and fervid written notations. The artist, we assume, was particularly concerned with getting down a series of ideas as quickly as possible before he lost his train of thought. All of the images in the Tinguely are drawn in profile view (the view described in the design fields as the *side elevation*). There is no attempt at illusionistic depth here, as the drawing's purpose was to record information.

In a more finished drawing, made perhaps to communicate specifications to a fabricator, Buckminster Fuller also resorted to a side elevation, but in this case he has provided a cutaway view allowing us to see the inner workings of his visionary vehicle (Fig. 11–7). The sculptor Robert Stackhouse, on the other hand, is primarily concerned with the spatial disposition of his frail wooden structures, so linear perspective is well suited to the development of his concepts (Fig. 11–8).

Creative brainstorming is equally a feature of the commercial art and entertainment worlds. Alfred Hitchcock, a filmmaker long admired for the way in which he composed his frames, habitually planned his takes in storyboard form (Fig. 11–9). Although the images shown here are hastily sketched, the individual frames are well composed, and the series communicates a sense of narrative urgency.

FIGURE 11–6
Jean Tinguely
Fontein, 1968
65 × 50 cm

FIGURE 11–7
BUCKMINSTER FULLER
Dymaxion Transport, 1934
Ink on silk, 30 × 63½"

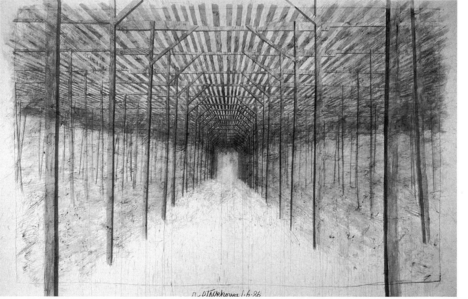

FIGURE 11–8
ROBERT STACKHOUSE
*Inside a Passage
Structure*, 1986
Watercolor, charcoal,
and graphite on paper,
89½ × 120"
*Arkansas Arts Center Foundation
Collection: Purchased with a gift
from Virginia Bailey. 1987.024.001*

FIGURE 11–9
Storyboard image
from *The Birds*

FIGURE 11–10
ROBERT SMITHSON
Entropic Landscape, 1970
Pencil on paper, 19 × 24"
Art © Estate of Robert Smithson/Licensed by VAGA, New York

Drawing can also assist in giving form to more broadly philosophical or even literary ideas. In casting about for images that would serve as a model for his ideas of entropy, the earthworks artist Robert Smithson generated fantastic landscapes (Fig. 11–10). Victor Hugo's drawing of the legendary Eddystone lighthouse (Fig. 11–11) is another example of visualized-image drawing in service of an idea. Written descriptions and historic etchings describing this wildly excessive structure had intrigued the famous French novelist. Piecing what information he could gather into this drawing was actually a preparatory step to his writing long descriptive passages in one of his novels about a similar but fictitious lighthouse.

Practical Advice for Drawing Visualized Images

Usually when drawing from the real world, we choose subjects that are stationary and clearly defined by actual light and shade. This allows us to measure the success of our depiction against the concrete objects and spaces before us. When drawing things in motion (such as a pacing zoo animal or people milling about in a public terminal), we are forced to retrieve and generalize information from a continually changing subject. But even in these circumstances, we still may test, to some degree, what we've made against what we see.

Drawing from images we visualize is another matter altogether. In this case, we do not have the luxury of directly comparing our effort with the source material. And in order to rough out and develop what we have imagined, we must try to capture what is often a fleeting and vaguely formed mental picture, the particulars of which may seem to disappear in translation. This is why drawing invented forms and spaces, especially when they are complex, can be a challenge for any artist. But in spite of the demands, the execution of visualized imagery should

FIGURE 11–11
VICTOR HUGO
The Lighthouse of Eddystone
Pen and brown ink wash,
890 × 470 mm

not be beyond the capability of anyone who has a command of fundamental drawing skills.

Drawing images from your mind depends first of all on a utilization of the basic facts of seeing as gained from drawing real things. This is because even the process of drawing the structural properties of objects you can literally see is usually organized around an internalized image or gestalt. In other words, each surface change recorded from an actual subject in a drawing is measured against what this gestalt feels like in the mind's eye.

So how, you may well ask, does one go about plugging into the half-formed picture in one's mind? Probably the best advice we can give is not to be afraid but to go ahead and start making thumbnail sketches—lots of them. Don't be critical, but keep improvising from one thumbnail sketch to another. Try drawing your imagined subject from different vantage points or in different positions, as in Daniel Quintero's *Sketches of Pepele* (Fig. 11–12). Following this procedure, you will find that you are gaining greater understanding of your subject and are becoming more confident of its form with each drawing. Let the image evolve at the same time as you are drawing it, as if it were revolving in space. Eventually you should find an image that seems true to your expressive purpose.

Once you have an image roughed out in thumbnail scale, try developing it by applying many of the same techniques you would use in perceptual drawing, keeping focused at all times on the three-dimensional gestalt of your imagined subject. No matter what approach you employ (e.g., cross-contour lines, mass gesture, planar analysis), you will in effect be "sculpting" or discovering the structural specifics of your visualized subject as you draw it. Look again at

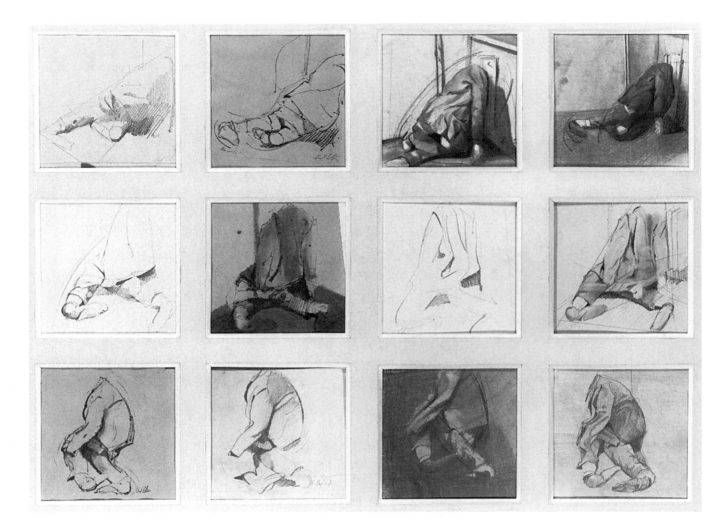

FIGURE 11–12
DANIEL QUINTERO
Sketches of Pepele, 1974–1975
12 drawings on paper,
each 4¾ × 4¾"

the Golub sphinx (Fig. 11–5) and note the slashing topographical marks that indicate the tactile surfaces of its powerful and quivering hindquarters. In the antiwar image, Figure 11–13, a body's form and heft is suggested by the longitudinal folds in the bag that enwraps it, and by the cross contour of the twine that binds it.

Thus, many of the factors you have to consider when recording your impressions of actual space and form can be used as building blocks to guide the emergence of something recalled or imagined. The most important of these factors are:

1. The vantage point from which to draw what you have envisioned.

2. The gestural essence of visualized forms, which includes their overall proportions.

3. The spatial relationships of imagined objects. Note how spatial clarity has been imparted to the envisioned scene in the Ananian drawing (Fig. 11–14) by the use of relative scale, overlapping, foreshortening, and even a suggestion of sun angle.

4. The surface structure of imagined forms, which includes an understanding of their major planes and topography (see Figs. 11–5, 11–13, and 11–14).

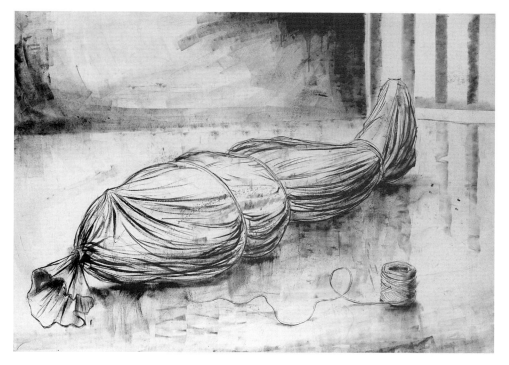

FIGURE 11–13
DAVID FOX
Cell
Etching ink on paper, 38 × 50"

FIGURE 11–14
MICHAEL ANANIAN
Quid pro quo—Vagrant, 1999
Charcoal on paper, 38 × 25"

FIGURE 11–15
CHARLES WHITE (1918–1979)
Preacher, 1952
Pen and black ink, and graphite
pencil on board, Sheet:
22 ¹³⁄₁₆ × 29¹⁵⁄₁₆ × ³⁄₁₆"
(57.9 × 76 × 0.5 cm)
Collection: Whitney Museum of American Art, New York; purchase 52.25. © 1952 The Charles White Archives

Another thing to bear in mind when drawing a visualized image is the positioning of its form in relation to the picture plane. When drawing from life, it is a good practice to select the view of your subject that best reveals its spatial character (unless flatness is a specific aim of your work). As mentioned earlier, recording visualized ideas in an unforeshortened view may be the most efficient method in the initial stage of conception. But imagined forms often appear more impressive and more natural if they engage space fully by confronting the picture plane (Fig. 11–15). If you find that you are not able to overcome the difficulty of drawing your visualized subject in a foreshortened view, try fashioning a small three-dimensional model of it from clay or cardboard. Look at your model from a number of angles to find the view that is most expressive of what you wish to communicate.

Before we conclude this section, it is important to point out that the two extremes of drawing from life and drawing from your imagination can be mutually beneficial. Rigorous scrutiny of things seen through the act of drawing can help you realize envisioned images by increasing the reserve of forms that you have committed to memory. And the exercise of your powers of conceptualization during the practice of visualized-image drawing will make you more adept at rapidly grasping the essential gestural and structural qualities of the real subjects you draw.

Freeing Up Your Imagination

So far in this chapter we have discussed ways in which to draw images you already have in mind. Now let's suppose you have the desire or need to come up with original images, but your brain is simply not volunteering any mental pictures. To compound the problem, when looking at the work of others, you may surmise that the images have poured out spontaneously, making you feel in comparison as though your imagination has completely dried up.

While some artists, such as Cuevas (Fig. 11–16), create invented imagery of the highest order in a seemingly effortless manner, most of us have to prod or

FIGURE 11–16
JOSE LUIS CUEVAS
Sheet of Sketches, 1954–1959
Pen and blue and black ink with
brush and colored washes
on pink laid paper with
red fibers, 479 × 335 mm

FIGURE 11–17
HUMBERTO ACQUINO
From the Inside, 1978
Watercolor and tempera, with pen
and black, brown, and blue ink,
heightened with gum varnish, on
white wove paper, 316 × 131 mm

"crank up" our imaginations before visualized images of merit begin to emerge. Fortunately, there are some fairly universal ways to free up the imagination.

To begin with, since you'll always be using aspects of the real world to kindle your creative thoughts (no one can get outside of nature), we recommend that you get into the habit of playing uninhibitedly with what you see in your daily life. Personify a group of parked cars, making them good or evil characters, or imagine that for a change, a fire hydrant soaks a dog with a stream of water. Picture looking out your window only to see an amorphous mass of throbbing protoplasm in the backyard (Fig. 11–17). Imagine changing the proportions or scale of some object, or perhaps distorting it in some significant way. In this regard, look at Figure 11–18, a self-portrait in which the ceramic artist Robert Arneson kneads his head as if it were a great lump of clay, with a result that is both humorous and gruesome. Yet another approach is to concoct composite images in your imagination that could never occur under normal circumstances, as in John Wilde's *Portrait of Emily Egret* (Fig. 11–19).

FIGURE 11–18
ROBERT ARNESON
Wedging the Head, 1988
Mixed media on paper,
48 × 31¾"
*Art © Estate of Robert Arneson/Licensed by
VAGA, New York; Image courtesy of George
Adams Gallery, New York. Collection of
Kenneth Spitzbard*

FIGURE 11–19
JOHN WILDE
*Lady Bird Series #9—Portrait
of Emily Egret*, 1982
Silverpoint on paper,
8 × 10¼" (sight)
*Arkansas Arts Center Foundation Collection:
Purchase, Tabriz Fund. 1983.024.002*

Uninhibited play with media can be another springboard for visualized images. Experimenting with unfamiliar media will introduce the element of chance to your work and may give you ideas for future directions. Joshua Neustein, for example, used magnetic attraction to organize patterns of iron filings (Fig. 11–20). Similarly, Lucas Samaras sacrificed some artistic control when he transformed his Polaroid SX-70 self-portrait by manipulating the photo emulsion as the image was developing (Fig. 11–21). Taking rubbings of surfaces to obtain textures or transferring images of current events from the popular press can be a catalyst for new drawing adventures. Or you might overlay onto the ground of your drawing found materials, such as menus, posters, or sheet music.

FIGURE 11–20
JOSHUA NEUSTEIN
Full Metal Magnetic
Magnetic strips and iron filings on paper, 24 × 30"

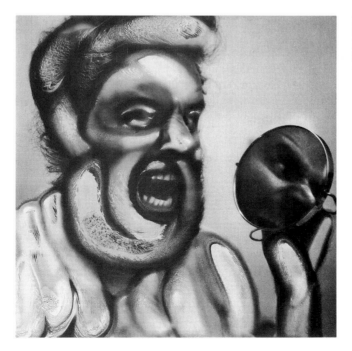

FIGURE 11–21
LUCAS SAMARAS
Photo Transformation, 1973
SX70 Polaroid, 3 × 3"

FIGURE 11–22
JACKSON POLLOCK
Sheet of Studies, 1941
Pencil and charcoal
pencil on paper, 11 × 14"

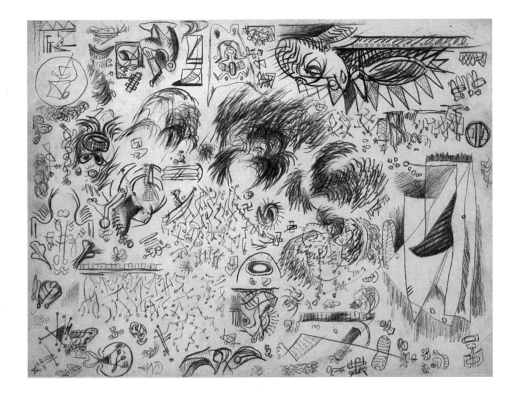

Perhaps the best-known way to spontaneously generate visualized imagery is to doodle. Doodles are usually thought of as idle scribbling that helps to pass the time or vent nervous energy. Artistic approaches to the doodle vary.

Some artists practice a more elevated form of doodling called *automatic drawing* in order to stimulate an outpouring of intuitive imagery. Typically, artists who practice automatic drawing neither consciously plan ahead nor pause while drawing to redirect their course. For some artists, automatic drawing is the sole means by which they create their imagery. This is especially true for artists like Jackson Pollock, who credit the unconscious as the source for their art. Interestingly, Pollock's astonishing ability to channel his subconscious feelings onto paper is confirmed by the fact that his psychoanalyst used many of his innumerable sheets of studies as a therapeutic aid for him (Fig. 11–22). Other artists develop their doodling into refined images, as in Figure 11–23, which appears to have been arrived at through an accretion of doodled passages, most of which seem to refer to an invented vegetable kingdom.

Categories of the Visualized Image

This chapter has taken a straightforward look at the topic of visualized imagery. With our commonsense approach, we have endeavored to reassure you that the basic building blocks for representing observed form and space provide the underpinning for even the most complex of visualized images. In making the working process more comprehensible, however, we run the risk of implying that visualized-image drawing is formula bound and mechanical.

Nothing could be further from the truth. On the highest level, the creative drawing act is a magical and unpredictable process that resists analysis and rigid formulas. Nowhere is this more evident than with the creation of envisioned images, which are conceived from scratch, so to speak, using the resources of the

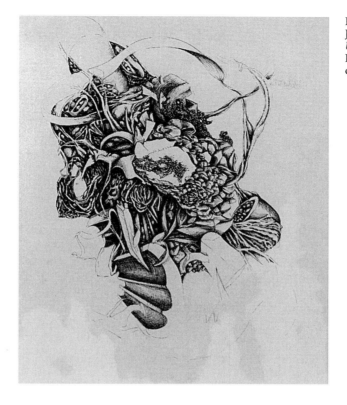

FIGURE 11–23
JONATHAN BOROFSKY
Untitled at 2,784,770, n.d.
Ink and charcoal pencil
on paper, 11 × 14"

artist's imagination. The practical insights in this chapter are meant to empower you in discovering your own creative resources; it is our hope that the reproductions of old and new master drawings in this chapter will communicate the depth of innovation and expressive impact commonly associated with drawings of visualized imagery.

To reinforce our theme that inspiration can be taken from studying the visualizations of other artists, the last part of this chapter categorizes and briefly examines a select group of drawings by modern artists working with visualized imagery. The categories are arbitrary; they are used purely to lend temporary structure to the seemingly endless array of envisioned images in pictorial art. We encourage you to combine these categories or even invent new ones.

IMAGES BASED ON MEMORY

The artist's memory is perhaps the most common source for visualized images. Some artists rely heavily on the remembrance of things past for their subject matter and may take great pains to reconstruct the memory pictures that inspire them. For example, they might do a substantial amount of photo research to augment their powers of recall, visit sites that are similar to the one imagined, or make studio models of a remembered scene to retrieve structural detail and lend their work an air of authenticity.

For the most part, however, artists do not intentionally plan to take advantage of the opportunities their active memories may provide. Instead, they react intuitively to overtones in a developing work that trigger their memory of, let us say, the peculiar physiognomy of someone glimpsed in a bus, the striking pattern of shadow shapes under restaurant tables, or even an unusual pairing of colors. The contributions of things impulsively remembered and acted on can greatly enrich a drawing or any work of art.

But whether you are consciously mapping out the visual coordinates of an event that has haunted you for years or simply responding to spontaneous

FIGURE 11–24
HYMAN BLOOM
Landscape #14, 1963
Charcoal, 41½ × 35"

recollections of a more fragmentary sort, it is important that you trust your memory and go wherever its unfolding narrative takes you. This is not to imply, however, that the images you draw must be rigorously controlled by your memory. The drawings you make will have their own momentum; what you recall should be considered a basic script, or scenario, to get at deeper meanings. The woodland scene by Hyman Bloom (Fig. 11–24) nicely illustrates the relationship between memory and visualization. At first glance we may react to this scene as if it were drawn directly from life, but a closer look reveals that the forms depicted here do not conform to what can be literally seen. The branch-like forms are more expressive and beautifully composed than anything you would actually encounter in nature. This is a forest fantasy that could only have been drawn by an artist who has an extensive background in drawing both from observed reality and memory.

The eerie scene by Charles Stiven (Fig. 11–25), clearly a visualized image, is composed of elements simple enough to be drawn from memory. Even the use of light, which imbues the strange scene with much of its believability and mystery, is something that, once learned, can be practiced without depending upon observed source material. Notice that while many envisioned images are rather sketchy in their particulars, the forms here are crisp, even pristine, a quality that only adds to the surreal effect.

Another contemporary narrative artist, Sandow Birk (Fig. 11–26), seamlessly combines material from diverse sources with images drawn from memory. His anachronistic scenes often show contemporary disasters composed in the heroic manner of Romantic history painting. Note that, although his forms are

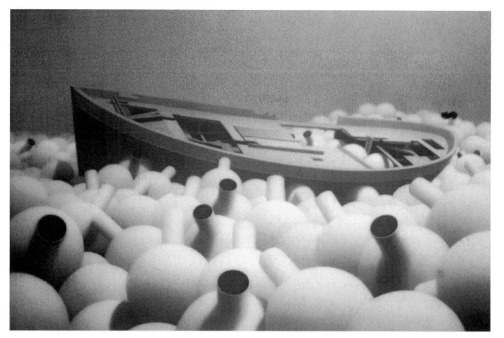

FIGURE 11–25
CHARLES STIVEN
Still Life with Septic Tanks
Charcoal and conté pencil, 34 × 46"

FIGURE 11–26
SANDOW BIRK
Arriving Too Late at the Great Battle of LA, 1998
Ink and pencil on paper, 17 × 19"

sketchy and generalized, he does not skimp on the use of shadow or deep space. Comparing this image of devastation and waste to that of Stiven (Fig. 11–25) will give you an idea of the enormous scope of visualized images based on the depiction of real objects.

TRANSFORMATIONS

In everyday life, transformation refers to a change in the outward form or appearance of a thing. There are two basic states of transformation. One is the alteration of something as we know it—think of a densely forested tract of land altered by a fire. Transformation may also mean a more complete and essential change, as in the metamorphosis of a caterpillar into a butterfly.

For artists who transform reality to make an envisioned image, the same two orders of change apply. At their best, transformed images seem to be the result of artistic alchemy. And as is the case with actual living matter, the central feature of artistic transformation is a sense of process or movement from one phase to the next, which is either apparent or felt.

The transformed self-portraits by Lucas Samaras (Fig. 11–21) and Charles Littler (Fig. 11–27) are striking examples of how an altered exterior can act as an extension of the psychological self. Both of these drawings exhibit a mastery of form improvisation that, in view of the subject matter, can be considered to have resulted in images of grotesque abnormality. But the intent of both artists was to communicate certain interior feelings more forcefully than would be possible with an objective rendering. And how different is the expression in these two works: The snarling visage of Samaras is diabolical; the Littler is marked by gentility and repose in the presence of change.

The startling imagery in Figure 11–28 depicts the metamorphosis of beggars into dogs. These mutational forms are modern parallels of the human–animal hybrids that abound in the mythologies of ancient peoples. But in spite

FIGURE 11–27
CHARLES LITTLER
Self Portrait, 1977–1985
Charcoal, 36 × 30"

FIGURE 11–28
RICO LEBRUN
*Three-Penny Novel—Beggars
into Dogs*
Ink on paper, 40⅞ × 30¹¹⁄₁₆"

of their fantastic bearing, these images seize and hold our attention because they seem structurally plausible and because their swift tracer-like lines express energy and the passage of time. Note as well that these transfigured beings embody a timeless social theme: the fate suffered by those who are cast out by society.

Transformations of the human form can have a particularly intense emotional impact on us because our identification with the subject is so immediate and profound. And yet one of the reasons artists are a vital cultural resource is that their transformative powers often shift and refresh our perceptions of the most commonplace things in our environment. Look, for example, at the drawing by Max Ernst (Fig. 11–29). By the seemingly simple strategy of applying the texture of wood grain to a leaf, Ernst short-circuits what is often an important clue in recognizing an object—its distinctive surface quality—and makes us consciously reconsider what we normally take for granted.

INVENTIONS

The dividing line between visualized-image inventions and transformations is thin and at times impossible to pinpoint. But for our purposes, it seems necessary to differentiate between those images in which a change in the appearance of something known is the critical element and those that are generated by the ambition to graphically portray things that either cannot be seen or that never existed.

Visualized-image inventions are speculative adventures, inspired by a window onto another world. Some illuminate visions of fantastic subject matter such as futuristic landscapes or miraculous plants and animals. André Masson, for instance, populated his Caribbean Landscape (Fig. 11–30) with skeletons of as-yet-undiscovered vertebrates. In the large drawing (Fig. 11–31), which is itself part of a multi-panel work, Clive King depicts a field of carnivorous-looking plants. These sharp-toothed specimens refer to the discord that broke out amongst the polyglot workforce who built the legendary Tower of Babel, as well as to political and sectarian violence in contemporary Iraq.

FIGURE 11–29
Max Ernst
Histoire Naturelle, 1926
Lithograph, 15$\frac{15}{16}$ × 10$\frac{1}{2}$"

FIGURE 11–30
André Masson
Caribbean Landscape, 1941
Pen and ink, 20$\frac{5}{8}$ × 16$\frac{1}{8}$"

FIGURE 11–31
CLIVE KING
Tower of Babel – Undertow
Left Panel, 2006
Graphite on paper, 80 × 80"

FIGURE 11–32
EMILIO J. RENART
Bio Chemica C, 1966
Brush, pen and ink, 30 × 44⅛"

Other invented images are of such baffling composites that they defy strict subject-matter classification. For example, *Bio Chemica C* (Fig. 11–32), by Renart, synthesizes plant, animal, and human associations. Its overall form suggests a cushion plant (complete with thorns) or the fleshy pads on the underside of a dog's paws. The mass of bristles is reminiscent of a hedgehog's coat, and the center hints at parts of the human anatomy. Altogether, this organic mongrel both attracts with its erotic overtones and repulses with its unpleasant surface and mysterious origins.

FIGURE 11–33
TODD SILER
Cerebreactor Drawing: Tokamak,
1980
Mixed media and acetate
on rice paper, 24 × 35"

Yet another type of invented image makes visually explicit those natural forces and dimensions that are otherwise invisible. Todd Siler's drawing (Fig. 11–33), for instance, may be understood as a metaphor for the unobservable processes of the human mind. It combines visual and verbal excerpts from a real, neurological text with diagrams of an apparatus apparently designed to initiate a chain reaction within the cerebral cortex and release enormous amounts of energy in the form of human thought.

Exercise 11A *Visualized-image drawing should be practiced frequently as a complement to drawing from observation. Drawing from your imagination sharpens your ability to conceptualize and heightens your powers to express yourself pictorially.*

Drawing 1: Choose as your subject a couple of kitchen utensils. In your drawing, animate those objects while at the same time providing some kind of spatial environment for them. The example in Figure 11–34 is of particular interest for its dual spatial system. While the graters slide in and out of the format in a direction parallel to the picture plane, the eggbeaters plow every which way through the three-dimensional matrix of marks. Notice how the foreshortening of the eggbeaters activates the space and makes for an unsettling image.

Drawing 2: This time, attempt an illusion of depth by drawing a very large form, such as a huge animal or piece of fantasy architecture, in some kind of environmental medium. (Imagine a world at the bottom of the ocean or a mist-filled atmosphere in which things closest to the eye are clear and things further away are obscured by the medium.) Figure 11–35 shows an imaginary cathedral illuminated at the base with the upper spires disappearing into the depths of the night sky.

Exercise 11B *The projects that follow urge you to express subjective responses by transforming subject matter of your choice.*

Drawing 1: The goal here is to transform the appearance of your subject, stopping short of a metamorphic change. To do this, you can choose to improvise on its form and structure (Figs. 11–21 and 11–27). Alternatively, you could transfer onto its surface an inappropriate texture (Fig. 11–29), or recompose it using an accumulation of other objects (Fig. 11–36).

Drawing 2: Choose an ordinary object that, by virtue of some visual characteristic, suggests another unrelated object. In a set of drawings, clearly describe the metamorphosis of the first object into the second (Fig. 11–37).

FIGURE 11–34
JEN PAGNINI, Arizona State
University
Student drawing: eggbeaters
and graters in a matrix of marks
Graphite and eraser, 18 × 24"

FIGURE 11–35
AMY GLOBUS
Student drawing: imaginary
cathedral at night

FIGURE 11–36
MARK LICARI
Untitled (Shark), 2001
Ink on paper, 72 × 141"

FIGURE 11–37
JIM SHAW
Dream Object (I was looking
at drawings of successful
businessmen which became
increasingly distorted and
became a pornographic hedge . . .)
19 drawings each 14 × 11"
Long drawing 14 × 81"
Framed 15.25 × 82"
Ink, prismacolor pencil on paper

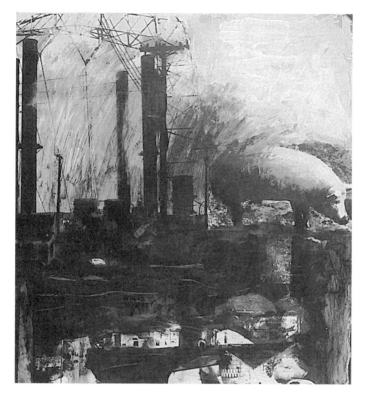

FIGURE 11–38
CHRISTINE KARKOW, University
of Montana
Student drawing: envisioned
image using collaged material on
sheet rock, 15 × 20"

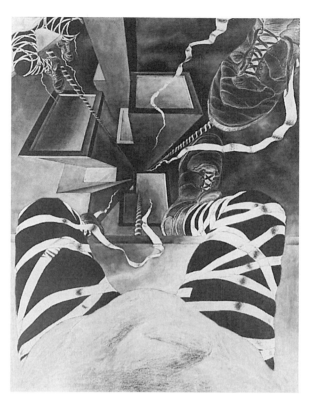

FIGURE 11–39
CHRISTOPHER ARNESON, University
of Wisconsin at Whitewater
Student drawing: envisioned
image using cross-contour

Drawing 3: *Make an envisioned image by combining collaged material with drawn images to pro-*
duce a unified work. To free yourself from old habits and expectations, you might wish to incorporate
nontraditional materials, as in Figure 11–38, in which sheet rock was used as a drawing surface.

Drawing 4: *Draw more complex environments, with or without figures. The subjects for these*
drawings may be images you have seen in your dreams (Fig. 11–37), images that come as a result of
reflecting on a passage in a novel or a poem, or even images that pop into your head while listening
to music. When drawing more ambitious subject matter from your imagination, it may be helpful to
rely on drawing devices with which you are already familiar, such as linear perspective (Fig. 11–8)
or cross contour (Fig. 11–39).

12

Using Color in Drawing

Color is one of the most powerful visual elements that artists have at their disposal. If you take a moment to thumb through the color plates included in this chapter you will note that in some works color was used to record observed appearances with great fidelity while in other works it was used subjectively in order to give greater impact to the works' expressive content. Color affects us involuntarily—and we take it personally. Color harmonies, or the associations they waken, can cheer us up or darken our mood. We may even notice our pulses quicken in the presence of some colors, while the clash or intensity of other color combinations may make us avert our glance.

The pervasive use of full-blown color in drawing is a modern phenomenon. Before the advent of modern art in the mid-nineteenth century, color drawings were infrequent; most drawn images either celebrated the use of line or were conceived on the basis of a **grisaille**, an arrangement of varied steps of gray values. Interestingly, in seventeenth-century France, a commonly held opinion identified drawing with reason and color with emotion. The gradual emergence of color drawing as we know it today is the result of many influences that have occurred during the Modern epoch. What follows is a brief and less-than-exhaustive summary of some of those contributing factors.

In one sense, technology set the stage for uniting color with drawing. By 1856, the first synthetic aniline dyes had been manufactured, producing an array of colors previously unavailable to artists. The new dyestuffs also impacted the clothing industry. The availability of more vibrant, high-key color apparel, coupled with the introduction of the more brilliant kerosene and gas lamps, conspicuously changed the artist's environment.

The proliferation of new colors coincided with studies about the nature of color. From approximately 1850 until the turn of the century, numerous theories and principles of color organization were pioneered by prominent theoreticians and leading painters of the day, including Eugene Delacroix, Georges Seurat, and artists belonging to the schools of the French Impressionists and Neo-Impressionists. Their efforts were augmented by several scientific treatises on the relationship between color and the behavior of light, published during the same period.

The revival of printmaking in Europe during the last quarter of the nineteenth century, inspired in part by brightly colored Japanese prints, was an important stimulus for the use of color in the graphic arts. This is especially true of lithography as practiced by Toulouse-Lautrec, Edouard Vuillard, and Pierre Bonnard, who by the end of the century were achieving color effects in lithography not possible

in painting. Lithography is the printmaking medium most akin to drawing, and the success of the color lithographs by the above artists was probably in large part responsible for the new interest in color drawing in the twentieth century.

The twentieth century was characterized by exuberant explorations of polychromatic images in all the visual arts. Gifted colorists like Matisse and Josef Albers, and artists in various art movements, from the Fauves during the first decade of the century to the color field painters in the 1960s, based the form and content of their work on the interaction of color. But as the century progressed, the continuing advances of technology plus the emergent mass media were the most vital sources of color awareness among the general populace.

Today we are immersed in dazzling color images. Not as in touch as our ancestors with the colors of our natural environment, we nonetheless are saturated daily by literally thousands of artificially generated colors through print and electronic media, home and office decor, packaging, industrial design, and fashion. Entering the classroom or studio from this kaleidoscopic profusion of color, it is no wonder that the professional artist and student alike often gravitate toward full-spectrum color in drawing.

The purpose of this chapter is to inspire you to discover your own color aesthetic, while providing you sufficient introduction to the fundamentals of color so that you have a solid basis for experimentation. Before we proceed, there are two points to keep in mind: First, color is relative. Similar to the interrelationships of value in a drawing, our perception of a color is influenced, to a greater or lesser extent, by the other colors around it. Second, there are no "bad" colors. Any color can be used successfully, depending on your ability to create effective harmonious relationships between that color and others within the same artwork.

Basic Color Theory and Terminology

The three basic properties of color are hue, value, and intensity. We discuss all three in relation to the diagrams in Figure 12–1.

HUE

Hue refers to the common names used to distinguish colors, such as red, green, and yellow-orange. Mixing one color with another changes its hue. For example, blue added to red in gradually increasing amounts changes the hue of red to red-purple, then to purple, and finally to blue-purple.

The term **chromatic** is sometimes used to refer to the property of hue, or color. The opposite, **achromatic**, means without hue and refers to the so-called **neutrals:** black, white, and gray.* At times, artists selectively introduce hue into an otherwise black-and-white image to add another dimension of visual interest or meaning, as in Figure 12–2.†

Figure 12–1a arranges the twelve major hues into a color wheel. These twelve hues can be grouped into different categories of color relationships that are useful to the artist. The **primary colors**, red, yellow, and blue, cannot be made by mixing other colors.** When mixed in pairs or in admixtures of all three, the primaries are the source for all other hues on the color wheel. The **secondary colors**, orange, green, and purple, are each the result of mixing two primaries; for example, yellow and blue create green. The remaining six **tertiary colors** are

*For a discussion on "browns," see page 298.
†For more discussion of this work, see "Color Economy" (p. 304).
**We are discussing color mixing in terms of the mixture of pigments traditionally used by painters. In contrast, printers' inks use a primary palette of cyan, magenta, and yellow. Colored light is a mixture of red, green, and blue.

obtained by combining a primary and a secondary color: Mixing yellow with green produces the tertiary yellow-green, and so on.

The farther apart colors are from one another on the color wheel, the more their relationship is based on hue contrast. Hues that are directly opposite one another represent the strongest hue contrast and are called **complementary colors**. The three basic pairs of complements are red and green, blue and orange, and yellow and purple.

The closer colors are to one another, the more they exhibit hue concord. Hues that are adjacent to one another on the color wheel represent the strongest hue similarity and are called **analogous colors**. One set of analogous colors is red, red-orange, orange, and yellow-orange.

VALUE

Value refers to the lightness or darkness of a color when compared with a gray scale (black, white, and the steps of gray between). Look at the pure colors displayed in the color wheel and try to determine their relative values. To help you get started, observe that yellow is the lightest hue (closest to white on a gray scale), red and green are approximately middle gray, and purple is the darkest (closest to black). Squinting may help you to see the value differences more readily.

The value of a color can be lightened by adding white to produce a range of **tints** or darkened by adding black to produce a range of **shades**. Adding white or black to a color will not change its hue: Pink, created by adding white to red, is a light-red hue; maroon, achieved by adding black to red, is a dark-red hue (Fig. 12–1b). But mixing a hue with either of these neutrals will diminish its purity to some extent, depending on the proportions of the admixture. (The purity of a color is discussed in more detail in the next section.) Creating tints and shades of a color is useful, for example, for depicting the dramatic play of light and shadow on form (Fig. 12–3). (For a related discussion, see the use of monochromatic color under "Color Schemes" on page 298.)

A color can be lightened or darkened, without being neutralized, by mixing it with a second pure color that is analogous and lighter or darker in value, as needed. Mixing two pure, analogous colors, however, will produce a hue change (the steps in Figure 12–1c move from yellow through yellow-green and green to blue-green and blue). In contrast to the use of tints and shades, adjusting color value in this manner has the advantage of creating colors that express a greater sensation of color light across a form, not only in the most illuminated passages but also in the deepest shadows.

INTENSITY

The term **intensity** refers to the saturation, or purity of a color. The purest colors, sometimes referred to as *parent colors*, are represented on the color wheel.

Students often experience difficulty at first in distinguishing between the concepts of color intensity and color value. Keep in mind that the parent hues vary in their values (blue-purple is darker than red, yellow-green is lighter than red-orange), but all parent hues are equally intense. The idea that hues on the color wheel are the same intensity may initially confuse you since yellow can appear more intense than purple. That distinction is a matter of perception and subjective interpretation. (We associate yellow with bright light and activity while purple may suggest cool shadows and rest.)

From a perceptual standpoint, the reason that dark, transparent pigments appear almost black when a glob of paint is squeezed out of a tube is that light is trapped in the paint film. If you apply a thin layer of such paint to a white support, light can bounce off the particles of pigment and the intensity of the color becomes evident. Some practitioners will add a small amount of white to a dark

color in an effort to make it more intense. Although adding white to dark, transparent colors will perceptually brighten them (thalo blue looks almost electric when modified in this way), this practice actually decreases the intensity of a dark pigment by converting the pure color into a tint.

Two concepts sometimes associated with intensity are color brilliance and luminosity. **Brilliance** refers to the *quality* of light that is reflected from a color pigment, as distinguished from value, which designates the *quantity* of light reflected. To test this difference, place a swatch of pure yellow paint next to a light gray of the same value and observe how the yellow appears much brighter. (In a black and white photograph, the swatches would appear identical.) In making judgments about color intensity and brilliance, bear in mind that while the most brilliant colors are always fully saturated, not all fully saturated colors possess brilliance (consider once again our earlier comparison of the parent hues of yellow and purple). Note that you will alter both the brilliance (vividness) and the intensity (purity) of any single color by mixing it with white, black, or another color.

Luminosity refers to applied uses of color to achieve certain visual effects, rather than to basic color theory. The word luminosity may be used to describe the illusion of light emanating from *inside* a color area, as in the large central shape of the drawing by Margaret Lanterman (Fig. 12–4). The effect of a mysterious emission of light from this area is achieved by surrounding its cool light yellows and greens with a series of warm colors and darker values. Also observe how the delicately modulated colors in the luminous area create the sensation of a translucent gaseous medium in contrast to the opaque and comparatively heavy masses that circle it. To help you grasp this concept, compare the luminous color light coming from within the major form in Figure 12–4 with Figure 12–5, where the objects are bathed by an external light source.

The concepts of hue, value, and intensity cross over when an artist mixes chromatic grays. The term **chromatic gray** refers to a gray created by adding hue to a neutral or by mixing complements to achieve a neutralized color. Achromatic grays are uncommon in nature; chromatic grays are not. Line up a series of small stones in daylight and you will probably be surprised by the number of color grays you see. There are several ways to make a chromatic gray. Mixing a hue with an achromatic gray of a different value will neutralize the intensity of the hue and change its value. Mixing a hue with an achromatic gray of the same value will diminish the intensity of the hue without altering its value. Chromatic grays obtained by mixing a hue pigment with an achromatic gray are generally flat and dull in appearance and are, for example, excellent for depicting the opacity of surface and weight of solid forms.

Chromatic grays of a different order can be achieved by mixing two complementary colors. When made with complements, chromatic grays appear as though they are permeated with light because they are coloristically richer than grays arrived at by mixing achromatic neutrals with color. As Figure 12–1d illustrates, when complements are mixed they generally result in neutralized color tones. However, if the mixture is carefully adjusted, a chromatic gray will result, as demonstrated in the middle box of our example, where a slate gray appears. (The richness of a chromatic gray will be more apparent if a small amount of white is added, as in our illustration, but that will further neutralize the color intensity.) The hue and value of the gray that results depend on which of the two complements was used in the larger amount.

In Figure 12–6, color grays are obtained by using what is often called optical color. **Optical color** refers to the eye's tendency to mix small strokes of color that are placed side by side or overlapped. For example, adjacent strokes of red and yellow in a drawing will be perceived as orange from a normal viewing distance. Note, however, that complements applied this way will cancel each other's intensity as they blend in the eye to produce vibrant chromatic grays. In Figure 12–6, red, orange, blue, and yellow were applied in a dense tangle of strokes, dabs, and

dragged lines, with the addition of white, to produce neutralized complementary relationships of red-purple with yellow and yellow-green, and blue passages flecked with orange.

Using dark-valued complements can also result in a dark hue which may be a suitable replacement for black. When using water color or acrylic paint, for example, you can mix a "chromatic black" from alizarin crimson and viridian. Since both alizarin and viridian are transparent, it is possible to dilute the mixture to obtain a range of lively grays. If you want to express the quality of warm light and cool shadows, you can do so by adding a very small amount of alizarin to the lighter values and more viridian to your darker ones.

A variation on the subject of neutrals is the family of browns. One method for making browns is to use ochres, siennas, or umbers and add primaries to alter their color tone. Browns may be achieved also by mixing the three primaries or certain combinations of secondaries (green and orange) or tertiaries (yellow green and red violet). Once again, the side of the spectrum to which the brown leans depends upon how you tweak the balance of colors. One final note about browns. Some color theories describe this family of colors as "muddy" and therefore unappealing. We do not share that position, believing instead that brown neutrals have no less the capacity than any other colors to enrich a chromatic statement, depending upon the overall palette of a work (Fig. 12–7).

Color Schemes

The term **color scheme** refers to a relationship among selected colors that play a major role in the organization of a work of art. A color scheme also establishes a principal color harmony or color key in an artwork and in so doing is an important carrier of content. Two or more color schemes can coexist in a work, usually in a dominant–subordinate relationship.

The inventory of color schemes is large, but five in particular can be considered fundamental, since they are used most often, either individually or in combination, and they form the basis from which more personal color schemes can be improvised. They are the monochromatic, triadic, analogous, complementary, and discordant color schemes.

A **monochromatic color scheme** is limited to the value and intensity variations of one hue. A monochromatic work can be achieved by adding white and black to a hue, as in Figure 12–3, in which the monochromatic color scheme is effectively used to create the illusion of three-dimensional form and space. A second means for producing a monochromatic color scheme is to dilute a hue pigment to various strengths, as in Figure 12–8. Here, the monochromatic red ground, extremely harmonious and consistent in its visual dynamic, establishes a subdued backdrop for the smaller, more intricately colored image.

Triadic color schemes are based on three hues that are equidistant from one another on the color wheel. There are three categories of triadic relationships: the primary triad (red, yellow, blue); the secondary triad (orange, green, purple); and two sets of tertiary triads (red-purple, blue-green, yellow-orange; and yellow-green, red-orange, blue-purple). The primary triad, due to its elemental potency, is the most common in fine works of art (Fig. 12–9), and also in mass-media advertising. The secondary and tertiary triads tend to produce more subtle relationships. One reason for this is that in contradistinction to the primary triad, which consists of hues that are unique and basic, each of the hues in the secondary and tertiary schemes shares a color with the two other hues of the triad. For example, in the secondary triad, orange shares yellow with green and red with purple; in one of the tertiary triads, red-purple shares red with yellow-orange and blue with blue-green.

So although each of the triads is based on contrasting hues that can enliven a drawing, the colors that constitute the secondary and tertiary triads have built-in

bridges that shorten the intervals of difference. Artists frequently capitalize on the unifying potential of secondary and tertiary triads, as in Figure 12–10, in which the pervasive purple note in sky, pavement, and shadows, is answered by a green swath and a luminous orange building facade, to complete a secondary triad.

Analogous color schemes involve several hues (usually three) that are adjacent on the color wheel. Figure 12-11 uses orange, red-orange, and red to express an almost claustrophobic intimacy that heats up the tension in a farcical female/male relationship. Analogous schemes create harmonious relationships because of the short intervals between neighboring hues on the color wheel and also because one common color links the sequence of colors (red is the common color in Figure 12-11). Figure 12-12 employs two analogous series which are contiguous on the color wheel and have yellow as the dominant center. The major scheme is established by green, yellow-green, and yellow; it is joined by subtle passages of yellow-orange, orange, and red-orange.

Complementary color schemes employ hues that are directly across, or opposite, from one another on the color wheel. For example, red/green, orange/blue, and yellow-green/red-purple are all pairs of complementary colors.

A complementary color scheme can be built around one pair of complements, or pairs of complements can be used in combination. In the watercolor and colored-pencil drawing by Lostutter (Fig. 12–13), three pairs of complementary hues are used: red-orange/blue-green, red-purple/yellow-green, and yellow-orange/blue-purple. A variation on the complementary color scheme may be achieved by employing three hues in a "split-complementary" relationship. Split complements are obtained by using a hue in combination with the colors on either side of its true complement. In Figure 12–14, for example, the intense yellow shapes in the center and on the right of the drawing are contrasted with blue-purple and red-purple areas.

A **discordant** color scheme is based on hues that do not easily resolve into a harmonious relationship. Artists will make unconventional color choices (using colors that normally would not be thought to go together) to enliven the expressive potency of their work. There are no absolute rules for creating discordant color schemes, but generally speaking, a combination of hues that are far apart on the color wheel (except complements) will achieve discord, as in Figure 12-11 where the dissonant relationship between the dominant red-orange and purple serves to jangle the nerves of the viewer. Also, an already discordant relationship can be heightened by equalizing the values of the colors or by reversing their natural value order.

The content embodied in a discordant combination of colors is valued by artists who wish to create visual equivalents for extraordinary phenomena, as in Figure 12-15. Here, a red-orange cloud formation screams across the top of the image. Its explosive impact is due in part to the scale and velocity of its diagonal sweep, especially in contrast to the more predictable horizontal bands that occupy the remaining two-thirds of the drawing. But it is the discordant interaction of colors that intensifies this otherwise straightforward depiction of a landscape into an extreme statement. Specifically, it is the clash between the dominant red-orange and the areas of purple and acidic yellow-green that set this depiction on edge. And since each of these hues is saturated, the perceptual agitation they stir up is unrelieved until our eye lands on the relative calm of the blue-gray interval at the bottom.

More gentle discord can still arouse unsettling feelings. In Figure 12–16, the reversed tonal order of the light purple strokes to the left of the figure in relationship to the darker greens of the ground, together with the passages of yellow interspersed among areas of blue-green, are visually unpleasant (the viewer may feel subtle waves of queasiness). In the final analysis, the color discord in this drawing is inseparable from the content associations it evokes: the self-absorbed, anguished characterization of the figure and its stale, sickly aura of decadence.

Using Color to Represent Space and Form

A spatial dynamic is inherent in the perception of color. In the world around us, color is light, and light reveals the dimensions of space and form. It is up to the artist to control the interactive energies of color pigments to convincingly depict the volume of individual forms and the impression of depth. This section concentrates on four concepts that are basic to representing space and form with color: local color, warm and cool color, color value, and the optical phenomenon of push–pull.

LOCAL COLOR

Local color refers to what is generally understood to be the actual color of an object's surface, free of variable, or unnatural, lighting conditions. The yellow of a lemon, the blue of a swimming pool, the fluorescent orange of a Frisbee are all examples of simple local color.* Local color, as the readily identifiable color characteristic of an object, provides a conceptualized home base for more complex local-color explorations.

Complex local color refers to the natural range of hues of some objects that, seen under normal light, constitutes the overall impression of a dominant local color. In Figure 12–17, for example, many of the green peppers include several hues of green and blue-green with subtle patches of yellows, and reds, and oranges. (The peppers that are half green and half red represent a variation on this idea in that they do not possess a dominant local color. A red-and-white-checkered tablecloth and a plaid shirt are two more examples of objects with more than one local color.)

An allied concept is perceived color. **Perceived color** refers to observed modifications in the local color of an object because of changes of illumination or the influence of colors reflected from surrounding objects. Dramatic changes in the color of objects can occur, for example, at twilight, under artificial illumination, or during volatile atmospheric conditions, such as stormy weather. Figure 12–18 records the darkened colors of crops, grasses, and earth under an overcast sky. In Figure 12–19, we see on the apple a combination of complex local color (the oranges, greens, and yellow-greens on the illuminated side) and perceived color (the bronze-green mixture on the shadowed side, the result of reflected color). And in Figure 12–17 observe the varied muted colors that make up the shadowed planes of the cardboard box and paper bag. Should we consider these subtle hue variations complex local color that has resulted from stains and dampness? Or are they perceptions of color reflected from neighboring surfaces? Or, are they a combination of the two, but exaggerated for compositional purposes?

So on the one hand, the problem posed for the artist is to render sufficiently well the rich colors that appear on an object so that its image in the drawing rings with authenticity. On the other hand, there should not be such a profusion of hues describing an object that the integrity of the local color is compromised. Furthermore, the colors selected to describe an object should serve the needs of the illusion of three-dimensional form *and* the design motives of the work.

WARM AND COOL COLOR

In addition to the qualities of hue, value, and intensity, colors are perceived to have temperature. Colors are usually classified as either "warm" or "cool." Dividing the color wheel in half provides an easy means for general identification: In our color wheel (Fig. 12–1a), the top half is occupied by the **warm colors**

*For a discussion about a similar concept in black-and-white drawing, see "Local Value" in Chapter 6, "Form in Light."

yellow, yellow-orange, orange, red-orange, red, and red-purple; the bottom half by the **cool colors** yellow-green, green, blue-green, blue, blue-purple, purple. This division should serve as a reference point, not a formula. Warm blues and cool yellows are common phenomena in works of art, and color interaction can cause the temperature of any hue to change, or appear to change, depending on its color context. A yellow-green, for instance, will look cool when surrounded by reds, oranges, and warm browns but will seem to be downright hot in the context of gray-blues and blue-violets.

We instinctively identify temperature differences among hues; as an example, consider how quickly we distinguish between cold fronts expressed in blue and warm fronts expressed in red, orange, or yellow on a weather map. Based on deep-seated sensory experiences, we associate the warmer colors of the spectrum with sunlight, fire, or the stove burner that was too hot to touch. Conversely, on a hot day, who is not tempted to wade into a stream or lake rippling with blue and green reflections or to collapse on a carpet of cool, green grass?

Generally, warm colors appear to advance and cool colors to recede. In Figure 12–20, the hue of the paneled sides of the overpass grades from warm browns on the right to pale greens and blues as it curves back around in the distance. But this general rule does not mean that we should not depict blue, green, or purple objects in the foreground of our drawings, since the illusory advance or retreat of any color depends on its intensity and value in relation to the surrounding colors as well as on the spatial structure of the image as a whole (note how close to the picture plane the blue arch appears in the upper left of Fig. 12–21). All things being equal, however, if two objects, identical except that one is orange and the other green, are placed at an equal distance from an observer, the orange object will seem to be closer.

What this general rule also refers to is the effect of atmospheric perspective.* Atmospheric perspective has two effects on our perception of color. First, because the wavelengths of warmer colors have less energy than those of cool colors, the light rays of warm colors are absorbed more quickly by particulate matter in the atmosphere. This is why objects perceived at a great distance appear to have a blue cast. Second, the farther objects are away from us, the more the atmosphere disperses the rays of colored light reflected from them. As a result, the color intensity, brilliance, and contrast of all objects, regardless of whether they are warm or cool in hue, are reduced as we perceive them at increasing spatial depth, as can be seen in Figure 12–22.

COLOR VALUE

When using color to create the illusion of three-dimensional volume and weight, apply the same rules of atmospheric perspective discussed above, although on a smaller scale. Keep in mind, however, that convincing depictions of form are much more dependent on adjustments of color value and intensity than on hue selection. And do not underestimate the power of monochromatic images or the use of a reduced number of hues to express mass and form. The fine-tuning of value relationships prompted by a limited palette not only can sensitize you to a structural use of color but it can also help you to consolidate an array of local color in a complex subject.

Figure 12–5 exhibits an effective use of color value to represent the illusion of three-dimensional form. Particularly effective is the way chromatic grays render the play of light and shadow on the yellow-green material under the sewing needle. The shadowed left side changes from a neutralized yellow-green to a

*A fundamental definition of "atmospheric perspective" appears in Chapter 1, "The Three-Dimensional Space of a Drawing"

warm color gray with the admixture of red-purple (complement of yellow-green) to a cooler blue-gray as the cloth recedes. Note as well the cooler-color light in the shadow under the cloth, the very subtle shifts of color neutrals along the background plane, and the strategic use of flecks of saturated color at various pitches of brilliance (yellow to orange to red) that resemble jewels sparkling out from under encrusted surfaces.

Figure 12–20 is an example of how to control color values for the purposes of depicting planar forms and organizing a spatial illusion. Stark tonal contrasts, derived from the works' photographic source material, emphasize the geometry of the crisscrossing overpasses, while subtler gradations of color value register the progressive effects of atmospheric perspective on the two lines of trees, one in the middle ground and the second in the distance. Squint your eyes to reduce your perception of hue contrast, and the orchestration of color values employed to represent form and space will be more evident. Turn the reproduction upside down and squint, and you will also see that the work's design unity is based upon systems of large abstract shapes of similar value.

PUSH–PULL

Up to this point, we have focused on the use of color to represent space and form in image-based drawings. Colors by themselves, however, have dynamic energies that can create a sensation of space that is free of both subject-matter connotations and the traditional methods for achieving three-dimensional illusion (perspective, chiaroscuro modeling, etc.). Spatial tension created purely on the basis of color interaction is often referred to as **push–pull**.

Push–pull can be loosely described as shifting relations among colors that appear to attract or tug on one another as if magnetized, with one color seeming to pull forward and another to push back. This refers to a manipulation of color that creates an "optical space" that, remarkably, appears to exist within the flat picture plane. Optical space is not a space that we understand rationally; it is a space that we react to as the result of involuntary perceptual responses to color. In other words, optical space is perceived by a viewer due to actual (physiological) sensory experience. This is in contrast to the representation of three-dimensional depth in a two-dimensional work, which is a constructed illusion.

Controlling the push–pull dynamic depends on many coloristic factors. The intensity, value, and temperature of an individual color must be considered relative to other important influences on the creation of color space, such as texture, placement, and the shape and area of a color (intense warm colors generally appear to expand, intense cool colors to contract).

Typically, artists achieve push–pull energy by working with relatively pure areas of color in a shallow or flat space. In the Heizer drawing (Fig. 12-23), a black and white photograph of a foreshortened box on a pebble-strewn ground represents a traditional illusion of tactile space (one you feel you could walk through). A series of intense color splashes and gestural scrawls creates a second spatial arrangement based on push–pull. In this optical space, a sequence of color planes dance in back, on and in front of the drawing's picture plane. For example, observe the progression from the green in the upper left, which appears to be well behind the transparent picture plane, to the large blue shape on the right side of the black box which seems to have been sprayed on the back of the picture plane, to the runny white splotch at the bottom that apparently has clotted on the front of the work, while the scribbled yellow lines right of center give the impression of having lifted off the surface to float in spectator space.

In Figure 12-7, the artist, Robert Colescott, clearly does not want to breach the picture plane of his drawing. The three sculptural figures are organized into a closely-stepped series of overlaps, forming an impenetrable mass that hugs the

picture plane and defines the edges of its lower half. By contrast, the two images in the upper corners are weightless sketches drawn over loosely-brushed grounds that float to the surface. Pushing and pulling are the saturated colors. Observe particularly the blue in the center ballooning up against the warm browns that march along the margins; and the diagonal, cross tension between the cerise smear in the upper left and the yellow-green shirt below it.

Color and Design

Color should be wedded to design from the early stages of a drawing's conception. In a successful work, it is impossible to separate the contributions of color from the organizational relationships that constitute an image; but when color is added as an afterthought, the result is often as disjointed as a colorized photo.

Although the remainder of this section focuses on design concepts already introduced in Chapter 7, "The Interaction of Drawing and Design," our purpose here is to clarify the mutuality of color and the two-dimensional organization of a drawing.

UNITY AND VARIETY

Since color increases the potential for variety in an artwork, it is important to find patterns of coloristic similarity to unify an image. For this reason, many artists find that preparatory studies are particularly crucial when working in color. Figure 12–24 shows three steps in a student's process of laying out a color drawing. After the initial blue pencil sketch was completed, two color variations were made to test approaches to orchestrating the drawing's color and design. In the first color variation, a series of analogous reds, yellows, and oranges organizes most of the major planes of the image, with cooler blues and greens used judiciously as contrasting accents to guide the eye and open up the spatial illusion. The second variation reorganizes the pictorial shape formations in conjunction with a general muting and cooling of the color scheme. Note how the triangular deployment of yellow-orange shapes in this variation unifies the entire composition.

VISUAL EMPHASIS

A powerful way to create or strengthen visual emphasis in a work of art is to use simultaneous contrast. **Simultaneous contrast** refers to the enhancement of contrast that occurs between two different colors that are placed together. Color contrasts are created by differences of hue, value, intensity, brilliance, and temperature. The artist may opt for different degrees of simultaneous contrast. For example, a grayed red-purple appears relatively intense against a neutral gray ground, but it seems more charged against a chromatic gray ground that has a yellow-green cast. On the other hand, that same mixture appears less intense if surrounded by a saturated red-purple.

Look at Figure 12–21 to observe how complementary hues produce the most striking effects of simultaneous contrast. When two complements are unequal in saturation, the hue of the lower intensity color will seem strengthened, as can be seen in the centrally placed recumbent figure which appears decidedly greener than it would in a context of less color opposition. When high-intensity complements of equal, or nearly equal, value are used, the pair of colors will appear to vibrate, as can be seen with the smaller, blue archlike shape against the red-orange

ground. Remember that complementary contrast depends on at least one of the pair of colors occupying an area in the artwork that is comparatively large. As mentioned earlier (in conjunction with Fig. 12–6), small adjacent shapes or strokes of complements will neutralize each other.

Figure 12–14 is a good example of how diverse gestural energies and color ideas in a drawing can be ordered into a hierarchy of visual emphases based on color contrast. Observe first the larger framework of similarities consisting of a geometry of facades and flattened cubicles colored with a series of generally close-valued, darkish hues.

The large blue-purple facade with its bright-yellow doorway is the main focal point of the image. The near-complementary contrast of these two colors, heightened by their differing quantities and stark contrast in value and color brilliance, creates a nucleus around which the smaller, congested areas circle and group. The larger yellow rectangle to the right moves us out of the center and adjacent to the red-purple square that completes the split-complementary relationship (yellow to red-purple and blue-purple). All three yellow shapes create an area of emphasis at strategic points in the drawing. Notice also the secondary network of accents that enliven the surface, which is based on relatively subtle changes in value, hue, and saturation (the lime green rectangle in the lower left, situated against a ground that slips from orange to pink, is especially rich).

COLOR ECONOMY

Related to visual emphasis is the economic use of color in a drawing to achieve dramatic expressive or aesthetic effects. Refer back to the drawing by Itatani (Fig. 12–2) and note how the introduction of muted red-orange charges the emotional relationships among a group of figures that, by virtue of their almost stereotypical heroic bodies and achromatic depiction, might otherwise seem distant from each other and from the viewer. Color economy can also contribute to formal clarity, as in the Currier drawing (Fig. 12–19). Notice here how expanses of cream and light-yellow contrast with the subtle handling of gradually more saturated hues (climaxing in the intense yellow-green of the apple). These differences are united at diagonally opposed corners by russet triangles that, like wedges, hold everything in place.

BALANCE AND MOVEMENT

The quantity and quality differences among colors, and the way in which they are consolidated or divided, affect our perception of balance and movement in a drawing. In Figure 12–25, the cool and warm colors of the central image area are massed into two large planes that are roughly equivalent in size, and the image is nearly symmetrical on either side of its central, vertical axis. Color interaction is based on a bold use of saturated complements which clearly convey the impression of "completing" each other.* In terms of movement, the color contrasts among the shapes along the border create an almost hypnotic series of irregular beats. In the lower half of the main image, the movement is more regular, sustained by the comparatively subtle hue contrast of the muted-green tree trunks against the pink sky; the graduated progression of analogous colors across the landscape; and the evenly spaced value contrasts represented by holes in the ground, mounds of dirt, and saplings to be planted. And note that when you arrive at the illuminated center of the drawing, the resting place of

*The notion of complements completing one another is based on physiological fact. Staring at any intense hue tires the eye, and to compensate, the eye perceives in that intense color the flicker of the color's complement. Also, less intense or neutral colors adjacent to an area of intense hues will appear to have the cast of that color's complement.

the lamp cannot be viewed without a peripheral awareness of the color "noise" on the edges. This is a canny color movement strategy used by the artist to express the gulf between yearning for inward calm amid the insistence of outward distractions.

Discussion of two asymmetrical images is in order. Figure 12–21 demonstrates how small proportions of contrasting colors have the power to attract our attention and thereby offset other types of visual weight in a drawing. In Figure 12–26, two counterbalancing forces are evident. From a form standpoint, the initial impact of the pieces of fruit in the upper left is absorbed, or harmonized, within a triangular configuration consisting of a pair of flowers on the right and globs of yellow and white paint at the lower left. The gestural sweep from one form couplet to another is stabilized by a color system based on repetition of hue, intensity, and value. (Do not miss the white halo around the peach that serves as the apex of that triangular configuration.) Additionally, observe how the delicate balance in the work depends upon adjusted proportions of saturated hues in relation to contrasts of value. (The rounded passages of neutral orange-browns, including the peach pit, are arranged in another triangular formation.)

Color and Expression

The potential of color in art to evoke associations and express feelings, from the most powerful of emotions to the most delicate of aesthetic insights, is incalculable. Correspondingly, since color perception is grounded primarily in the deep structures of personal experience, each artist will capitalize on color's expressive potential in a different way.

Color used to expressive ends is not the domain of a particular artistic style. It would be a mistake to conclude that the expressive values of a highly representational, or naturalistic, artwork are necessarily any less rich than those of a more blatantly expressionistic image.

Having said that, it is important to note that throughout the twentieth century to the present day, the visual arts in Western society have been characterized by the coexistence of two fundamental streams of color conception: One stream continues the Renaissance practice of descriptive color based on references to nature; the second stream has liberated color from its purely descriptive role, broadening the artistic inventory of expressive response. The remainder of this section focuses on the latter, that is, the more overt manipulation of color for subjective purposes. We begin with a definition of subjective color.

Subjective color refers to arbitrary color choices made by the artist to convey emotional or imaginative responses to a subject, or to compose with color in a more intuitive or expressive manner. Note that the use of the word *arbitrary* in this context is not meant to imply superficial motives for deciding on an arrangement of colors. Instead, it suggests deeply felt impulses or convictions about color that are not dependent upon references to the natural world.

In the drawing by Adolf Wolffli (Fig. 12–27), subjective color is used to promote the design and to serve decorative rather than spatial purposes. The evenly applied, pleasing colors have an ornamental splendor. The intense hues coincide with active shape zones and are balanced against the gray areas of rest to enhance sensations of order and harmony. Note the motif of brilliant yellow accents that march clockwise around the central swirl of black, brown, and purple shapes, imbuing the image with an air of ceremonial formality.

Heightened or exaggerated color can strengthen our emotional identification with a subject. The color in Dan Leary's self-portrait (Fig. 12–28), for example, expresses a radiance that transcends realism. Certainly, the facial expression together with the vulnerable gesture of the head and neck contribute to the

poignancy of this image. But it is the scalding intensity of the color that is paramount in creating an immediate emotional impact; we cannot help but attribute our own subjective feelings to such an acute state of mind.

The central role of color in setting the mood of Leary's work is instructive. In general, color can stimulate a wide range of psychological and associative responses, consciously or unconsciously. It is not uncommon, for example, for a viewer to associate certain colors and properties of colors with specific feelings (warm colors get our attention and can inspire a robust, aggressive, or hopeful outlook; cool colors are more withdrawn, suggesting a serene, reserved, or melancholy disposition—"I've got the blues"). Associations can also be made with sensory experiences (red is often equated with a sweet taste and things hot to the touch, green with outdoorsy smells, and orange with brassy sounds).* Particular hues may also trigger symbolic associations with abstract concepts: For instance, we are culturally conditioned to associate yellow with treachery or cowardice and purple with royalty; we may even have a red-letter day because of our green thumb!

The symbolic connections the mind makes with a particular color can be contradictory (red can mean sanctity or sin). Interestingly, the color green is most frequently associated with nature, and by extension it symbolizes the positive concepts of life and growth. Given that, how effective and startling is the negative representation of this hue in Figure 12–29? Here, a muddy green symbolizes natural growth as a blight of mildew covering the walls and metal shelving in a bathroom.

Returning to the Leary drawing, observe that the face is an island of intense oranges a color that often symbolizes irradiation, surrounded by dark values that connote brooding or introspection. Roche Rabell's self-portrait (Fig. 12–6) reverses the order of events seen in the Leary. Here, it is the flamboyant color of the hair that acts as an emotional catalyst. Looking as if it has just ignited, with curls of flame licking the edges of the face, this badge of an assumed persona might summon responses of fear, amazement, or even irreverence, but it is not easily ignored. The claylike grays of the face, which substitute a fanciful color system for naturalistic local color, express a cool, deathly pallor. This complexion, by suggesting inertia and depersonalization, is the perfect foil for the animated, intimidating stare of the eyes, the only clue to the true personality behind the disguise.

Although there may be a level of shared response to color within a society, the attribution of meaning to colors is highly variable among individuals and across cultures. For this reason, it makes sense for you as an aspiring colorist to periodically analyze for content your own color preferences, as gleaned from your personal work and from masterpieces that strike you as particularly effective in their use of color. The reactions that color in an artwork provokes from an audience are, like all visually-conveyed content, impossible to predict. What is important is that the subjective color choices an artist makes possess the *authenticity* to move viewers toward responses that are similarly strong, if not identical in kind, to the artist's expressive intentions.

*Having a subjective sensation accompany an actual sensory experience, such as hearing a sound in response to seeing a color, is known as **"synesthesia,"** a phenomenon explored by many, particularly nonobjective, artists during the twentieth century.

FIGURE 12–1
12–1(a) Twelve-Step Color Wheel,
12–1(b) Tint/Shade Scale,
12–1(c) Color Value Scale,
12–1(d) Complementary
Color Scale (middle gray heightened with white)

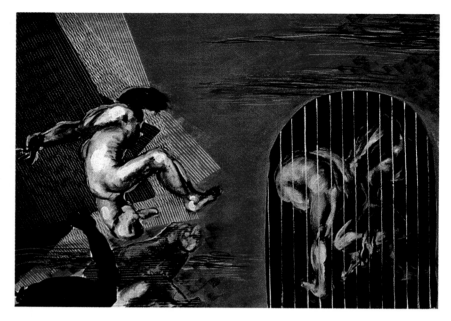

FIGURE 12–2
MICHIKO ITATANI
Untitled, 1991
Mixed media on paper,
22 × 30"

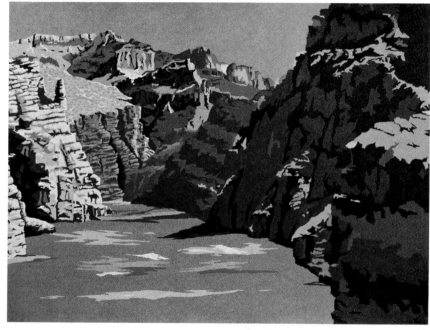

FIGURE 12–3
TIM JOYNER, University of Montana
Student drawing: monochromatic
color

FIGURE 12–4
MARGARET LANTERMAN
Chair for Don Juan, 1983
Pastel on paper, 26 × 36"

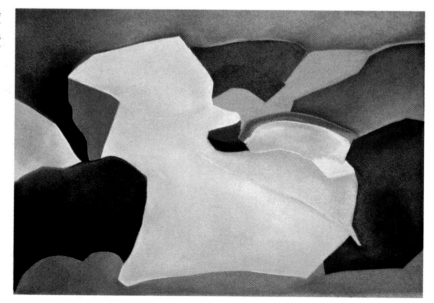

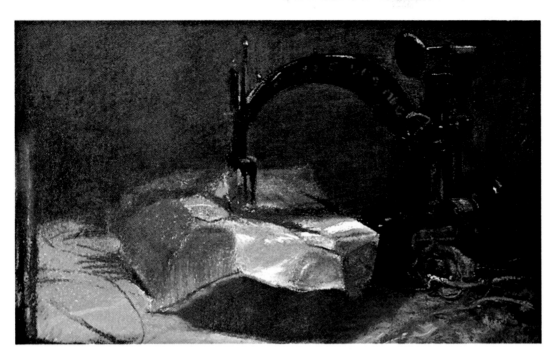

FIGURE 12–5
JIM BUTLER, Middlebury
College
Sewing Machine, 1986
Pastel on paper, 12 × 16"

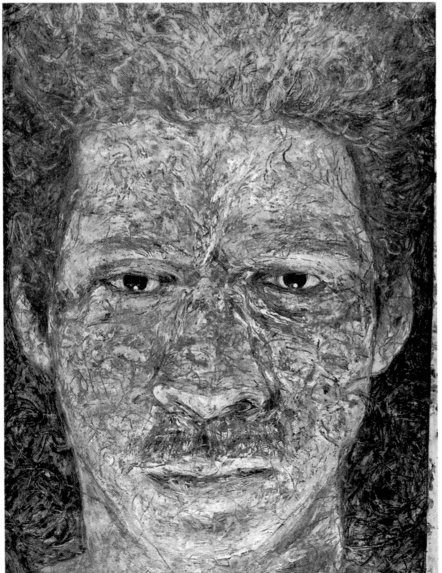

FIGURE 12–6
ARNALDO ROCHE RABELL
We Have to Disguise, 1986
Oil on canvas, 84 × 60"

© *Arnaldo Roche Rabell. Image
courtesy of George Adams Gallery,
New York*

FIGURE 12–7
ROBERT COLESCOTT
A Letter Home, 1991
Artist's proof, acrylic on
paper, 40½ × 26"

FIGURE 12–8
ED SHAY
Myth, 1991
Watercolor, 35¼ × 29¼"

FIGURE 12–9
CASEY CRISENBERRY,
Savannah College of Art and Design
Student drawing: charcoal and pastel pencils
on paper, 30 × 40"

310

FIGURE 12–10
Kim Cadmus Owens
USADAS, 2009
Charcoal and acrylic on paper,
24 × 36"

FIGURE 12–11
Jim Nutt
Really!? (thump thump!), 1986
Color pencil, 14 × 16"

FIGURE 12–12
Jan Gregory, University
of Arizona
Student drawing: analogous color

311

FIGURE 12–19
MARY ANN CURRIER
Apple Bronzino, 1993

FIGURE 12–24
JAN GREGORY, University of Arizona
Student drawing: preparatory
color studies

FIGURE 12–25
HOLLIS SIGLER
*She Is Hoping She Can Make Up
for Lost Time*, 1990
Oil pastel with painted frame,
33½ × 28½"

316

FIGURE 12–26
WILL MENTOR
Water Management, 1995
Mixed media on bookpage,
11¾ × 8¾"

FIGURE 12–27
ADOLF WÖLFLI
Untitled, c. 1920
Color pencil on paper, 12¾ × 20"

317

FIGURE 12–28
DAN LEARY
Self-Portrait XXIII
Pastel and powdered pigment
on paper, 22½× 17½"

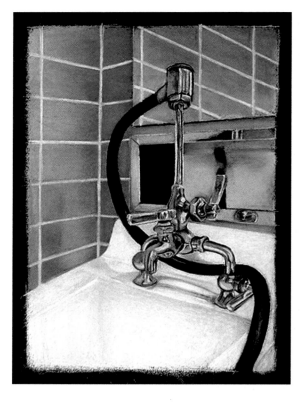

FIGURE 12–29
JAMIE KEMP, Eastern Illinois University
Student drawing: pastel on paper
20 × 30"

13

Portfolio of Student Drawings

This chapter is devoted to student drawings that were selected from eight university art departments and schools of art around the United States. Most of the drawings were made by advanced undergraduates. The portfolio as a whole represents diverse media, imagery, and stylistic orientation. Self-reliance and a strong commitment to making an original, personal statement in visual art is what links them.

Each drawing embodies a sustained effort in which the student artist grappled with resolving sophisticated depictions of space and form organized into an expressive compositional unit. These drawings were not made to satisfy preordained goals of a classroom assignment. They are evidence of independent aspirations pursued with conviction.

The goal of Chapter 13 is to document a handful of images that may serve to set a standard of quality and creative thought as you embark on ambitious drawings of your own. It is our hope that through a review of this work you will gain a clear and refreshed perspective on what you may achieve, even at an early stage in your artistic studies.

To structure this discussion, we have organized the drawings into five categories. Three of the categories are identified by subject matter: Portrait and Self-Portrait; Visualized Images; Unusual Subject Matter. The two remaining topics are designated either on the basis of format: Graphic Novels and Comics; or medium: Computer-Generated Images.

Portrait and Self-Portrait

The topic of this first section centers on one word that has spawned much controversy since the early 1980s: *self*. The very existence of human self has been seriously questioned, even denied, by intelligentsia within certain quarters of the humanities and social sciences. Notwithstanding that debate, how convincingly can one actually portray self, that most elusive of human characteristics? The following drawings approach this critical feature of the human condition from several, equally legitimate, contemporary perspectives.

We begin with a self-portrait titled *No Shame* (Fig. 13–1), which assertively lays claim to the existence of a unique self. Attention to facial features is minimized in this work. The typical use in portraiture of the eyes as a "window on the soul" has been replaced by an expanse of bodily surface upon which a politics of identity is mapped out. Instead of a face-to-face spiritual or psychological encounter, this work asks its audience to interpret tattooed text and symbols for clues to the artist's distinct character.

The area of the body that is depicted, and its placement in the spatial illusion, are both crucial to the drawing's expression. The framework of the shoulder girdle

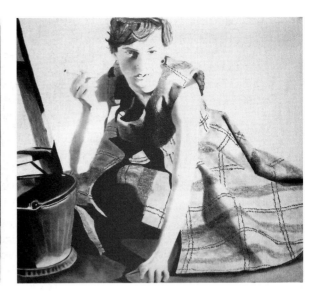

FIGURE 13–1
ERIC BARTL
No Shame
Charcoal, 20 × 30"
Courtesy of the artist, photo credit Jaclyn Yanahan, Instructor: Anne Coddington, Eastern Illinois University

FIGURE 13–2
BRITTANY DEAL
Untitled
Charcoal/Strathmore roll paper, 36 × 36"
Courtesy of the artist, Instructor: Mary Frisbee Johnson, University of Northern Iowa

and rib cage gives this section of the torso a boxlike construction. In this context we may go as far as to say that the drawing's focus is the exterior "housing" of the self, and that upon its walls the branding of that self is inscribed. The main symbol depicted in this drawing is the heart and wings emblazoned on the chest. This sign refers to the trust the artist has in himself, and underscores an expression of self worth.

The sweep of the foreshortened upper torso as it angles into space, plus the full-frame occupancy of the image, emphasize a grandness of scale. Add to this the dramatic film-noir lighting, and the drawing's overall visual syntax may be interpreted as an attempt to clothe its subject in myth—a myth of heroic individualism, embodied in a figure that stoically takes control of its fate with "no shame." Just as evident, however, are visual signs that coax this solemn myth into the realm of spectacle. In this interpretation, a personal conviction has been condensed for public consumption into a motto that might just as easily be displayed on a billboard or amidst the graffitied sides of industrial properties.

Figure 13–2 represents an instructive conceptual contrast to the expression of a unified self in *No Shame*.

The backstory of this drawing is enlightening. The dress worn by the artist was borrowed from a gay peer, who constructed it from stiff upholstery fabric. This unexpected choice of clothing material suggests that it was chosen as a sign of mainstream culture's attempts to mute alternative voices, thus dehumanizing them and diminishing their presence to the status of furniture.

The conspicuous texture and unwieldy presence of the dress is hard to deny. Together with the female figure's boyish haircut, the dress serves as a threshold for the artist to pictorially enter the persona of another as a strategy to highlight present-day questions about gender identity.

Yet another conceptual layer exists in this drawing, supported by other aspects of the constructed mise-en-scène. We refer to the artist's weaving of contradictory signs to personally test the social minefield that is a woman's role in contemporary Western society. On one side of the equation, the female figure's posture is submissive, and she is surrounded by the trappings of "women's work." Countervailing signs include the cigarette, a vintage symbol of women's liberation; the self-reliant gaze that challenges the notion of female passivity; and, from a formal standpoint,

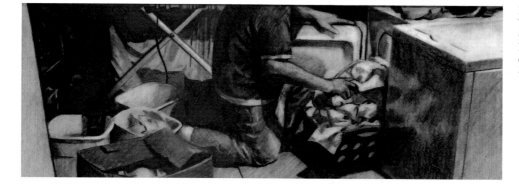

FIGURE 13–3
TIM PARSLEY
Clean
Ebony pencil/Mylar, 3.5 × 9.5"
Courtesy of the artist, Instructor: Denise Burge, University of Cincinnati

the dominant triangular shape of the figure that further underscores the intimidating strength of the female protagonist in this life-sized drawing.

In the final analysis, this image of a young woman in a staged pose is a self-conscious acknowledgement that gender construction is not fixed. And correspondingly, that an engagement with this unstable social phenomenon, always in a "state of becoming," is itself an anxious process. Not so with the next image, *Clean* (Fig. 13–3), which expresses a comparatively peaceful state of self-abnegation.

The head of the figure in this drawing is more decisively cropped than in Figure 13–1, and as a result the common visual metaphor for the ego has been excised. Emphasis is shifted instead to the workaday actions the figure performs.

As viewers of the drawing, we are intimate witnesses to its common theme: the simple task of retrieving white clothes from a laundry dryer. We also associate with the image because of formal decisions made by the artist: its spatial compression, forward and backward, which heightens the immediacy of our contact; and the elongated "panoramic" window of the format which magnifies the ordinariness of the scene and, in so doing, universalizes it.

A clue to yet another expressive dimension of this drawing is the conspicuous "X" immediately to the left of the figure, which represents the legs of an ironing board. Follow the diagonal of the front leg of this ironing board down from the top of the drawing to where it bumps into the figure. Travel around the figure's hips and you will see that the diagonal resumes on the thigh and continues along a shadowed plane of the laundry basket to the lower edge of the drawing. This "X" formation, with its extended lower right stem, recalls a leaning cross. A powerful Christian symbol, the cross points to a cleansing of sins, an absolution that is in agreement with ancient Jewish and Muslim rituals of purification. In this context, doing white laundry carries the connotation of being "washed as pure as snow." When this metaphor is considered in combination with the reverent kneeling posture of the figure, a deeper, unifying theme emerges.

By implication, this drawing proposes that mundane, repetitive rituals in the artist's life, such as vacuuming, washing dishes, and retrieving laundry from a dryer, may over time have the cumulative effect of instilling a state of grace similar to that of spiritual transformation. Ultimately, this drawing aspires to reconcile two poles of human existence: the secular and the divine. Its narrative is played out on a stage of modest proportions with a script that is as unpretentious as it is accessible.

The first three images in this chapter ranged in content from a strong pronouncement of self, to an attempt to accommodate fluctuating definitions of self, to the sublimation of self in the service of humble tasks. The next drawing suspends questions of personal self to ask if it is as difficult to grasp and communicate the nature of someone else as it is to know ourselves.

Among the first visual qualities you may notice in this portrait titled *Night-light* (Fig. 13–4) are the contrasts, particularly the rich play of light and shadow, but also the oppositions of geometric and organic form. Both sets of contrasts have been grouped into large, simple patterns to heighten their impact. Second, the style

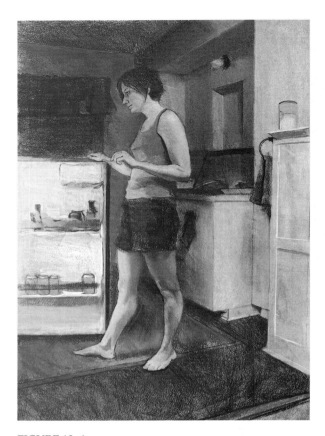

FIGURE 13–4
AIDAN SCHAPERA
Nightlight
Charcoal/paper, 41 × 29"
Courtesy of the artist, Instructors: Tarrence Corbin, Wayne Enstice,
University of Cincinnati

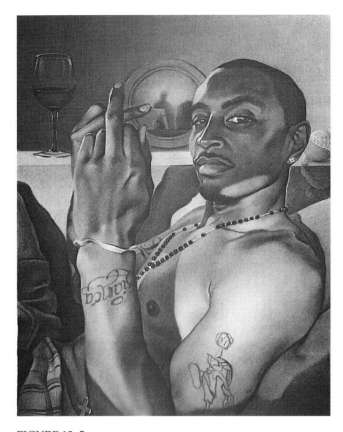

FIGURE 13–5
PAUL LOEHLE
King
Pastel/paper, 40 × 31"
Courtesy of the artist, Instructor: Kimberly Burleigh, University of Cincinnati

of the drawing is far from a clinical, photo-real rendering of an anonymous figure. On the contrary, the stylistic handling of this drawing gives us the comfortable sense that we know something about the person portrayed. How is this achieved? One answer is the insistent hand-built texture of the drawing's surface. The resulting "mediumistic atmosphere," which verges on a particulate-matter haze, serves to implicate us in the process. It is as if the drawing were under construction even as we look at it, thereby making the presence of the artist so palpable that we cannot help but experience the subject through his eyes. And what he sees is a visage that is soft and radiant. A Romanticist aura predominates in this work, drawing us in to furnish an intimate look at a small slice of this subject's life.

The rough, informal technique is in concert with the nonchalant air captured in the subject's demeanor. Her clothing, bodily gesture, and frozen instant of meditative focus all make us psychologically sympathetic. In this respect, the refrigerator light may be understood as a metaphor for a momentary illumination of this young woman's interior self.

King (Fig. 13–5) destabilizes conventional expectations of portrait and self-portrait, a tactic that is apparent in the research methods this artist uses in preparation for making a drawing. He began by conducting a random online search of Facebook profiles from which he chose a portrait photo. His criteria for selecting this particular image as source material included its potential to be formally manipulated and its display of a demonstrative personality. Next, he chose old master artworks that contained imagery that would expand on themes he found latent in the digital photograph. By choosing the tactile medium of pastel and a realistic style, both of which demand a lengthy and laborious working method, the artist

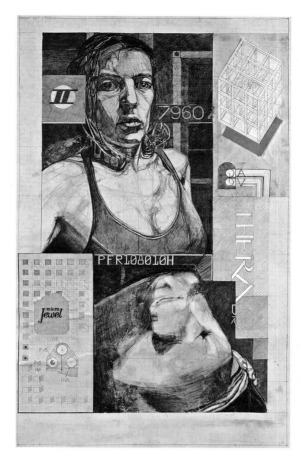

FIGURE 13–6
MARY SCHARTMAN
Micro Jewel
Graphite/gouache, tracing paper/
paper, 34 × 22¼"
*Courtesy of the artist, Instructor: Wayne
Enstice, University of Cincinnati*

invested the instantaneous and immaterial digital image with the aura of a timeless, physical presence.

The image reproduced in this work depicts a male subject who displays a defiant glare, demeaning gestures, tattoos, and hip-hop bling bling to announce his larger-than-life pretense. Behind the subject, the artist has planted props that mimic icons of status and comfort from Northern Renaissance paintings, including a framed, circular image which, with its vaguely reflective surface, recalls the mirror in Jan van Eyck's *Arnolfini Portrait*.

In general, it is the clash of the mundane cyber world and the rarified domain of high art that animates the thematic conception of his drawings. On the one hand, realist painting of the fifteenth and sixteenth centuries was considered magical in its ability to mimic natural appearances. These masterworks defined for their contemporary audience what was "real," and they have endured by virtue of their profound visual form. Facebook images, on the other hand, are screen glimpses of the artificial posing as the real, a "real" that is as superficial as it is disposable.

In the final analysis, this drawing's sophisticated formal handling, and the art–historical allusions it contains, trigger associations with traditions that run deep in our culture. Nevertheless, the fabricated personality that holds dominion in this work blocks any attempt by the viewer to engage an authentic self; indeed, any concept of self in the cyber world has the rapid obsolescence of consumer culture as a whole. Thus, we may say that the artist's overall aim in creating this uneasy alliance is to challenge us to find our personal synthesis of competing value systems that define contemporary existence.

The counterfeit world of the poseur and the skin-deep elegance of *King* are in stark contrast to the profound depth of existential reality expressed in Figure 13–6. The artist was diagnosed at age fourteen with "long Q-T syndrome," a dangerous

arrhythmia that caused her heart's electrical system to malfunction and her heart to stop beating.

The medical solution was to implant two devices to control her heart function: a pacemaker in her upper chest, and an internal cardiac defibrillator in her abdomen, just above the navel. In the drawing, both are apparent as subcutaneous bulges that alter the contours of her body. Circulating the composition are schematic renderings, logos, and labels that are references to these precision instruments keeping her alive. Their clean lines and flat shapes stand out in contrast to the awkward, corporeal presence of the self-portrait. But cosmetic issues pale next to the physical discomfort she experiences daily. These miniature machines are uncomfortable for her to bear physically, and they are uncomfortably truthful about her frailty. As a result, she distrusts her own body.

The bodily dislocation she feels is keenly expressed in the fragmented format of this drawing. Her uncertain tether to the world is shrewdly communicated by the daring imbalance of the diagonal axis that functions as the pictorial spine beneath the sculptural form of her body. The impossible-to-resolve asymmetrical weight distribution in the work is a visual correlative for the chronic affliction she cannot escape in real life.

The angular depiction of the face in this self-portrait vividly indicates the psychical fissures the artist endures. A close inspection reveals the parched mouth, strands of hair in coiled disarray at the shoulders, and the eyes, one in a fear-frozen stare and the other wandering as if in search of release.

Visualized Images

Visualized imagery refers to imagined ideas and subjects that otherwise would not be available for us to see. So, for someone (artist or viewer) who feels limited by the trappings of everyday visual reality, immersion in an envisioned world can be a profound outlet for personal content. Visualized images can also be, for example, a means to make pointed social commentary, or they may be agents of surprise and amusement.

Figures 13–7 and 13–8 are restrained in their imaginative flights. Images in both retain a fidelity to natural appearances, but they are excerpted from their natural contexts and recombined to express new content. The reconfiguration of reality in *Kelly* (Fig. 13–7) is a means to simultaneously make a portrait of an autistic child and to convey her serene mental state.

The easily distinguished subject matter on the right side of the drawing is a young female working on a puzzle. But that is only one, and the most obvious, level of interpretation. Putting puzzles together enables autistic children to meet adult-world expectations of completing a task. Correlatively, families of autistic children often feel that the life of their son or daughter is a puzzle; that their children literally progress "piece by piece."

FIGURE 13–7
SARAH HESS
Kelly
Charcoal and pastel on paper,
30 × 76¼"
Courtesy of the artist, Instructor: Wayne Enstice, University of Cincinnati

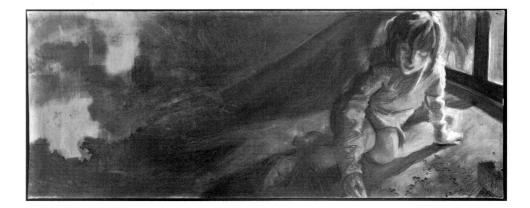

FIGURE 13–8
SHANE MILLER
Order and Chaos
Charcoal, 66 × 30"
Courtesy of the artist, Instructor: Janice Pittsley, Arizona State University

This drawing was an outcome of the artist working for several months with the depicted youngster, Kelly. At first, the artist found it a challenge to overlook the superficial characteristics of the child's autism, such as her screaming, crying and self-injurious hand movements. These stress responses, symptomatic of Kelly's discomfort around new people and crowds, masked her cognitive ability.

Eventually, the process of puzzle solving proved an entry to the child's reality, a reality that the artist felt was analogous to an infinitely layered puzzle. The visualized image of this drawing, then, may be seen as gently didactic in its advocacy for the special "genius" and unfamiliar "normality" of the drawing's subject.

Formally, the drawing employs several design strategies to advance its subject-matter theme. First of all, the long, horizontal format conjures the cinematic screen of the mind upon which the child's almost compulsive involvement with doing puzzles is played out. Next, notice that the child's image is sequestered in a corner, the confines of which might recall either a meditative space or a harsh, institutionalized detention. Further analysis of the right side of the image uncovers a pictorial invention that reinforces the aura of private concentration expressed by the child. We refer to the closed loop that travels from the child's leading hand, up the gesture of her extended arm, across the skull on the directional patterns of the hair, back to the window framing, and down to a shadow under an abbreviated still life that directs our eye back to the hand. On the left side of the drawing there is a second, rhyming ellipse, within which layers of the unfinished puzzle are depicted, as processed in the child's mind.

Also worth pointing out is the contrast between the repeating diagonals on the right, suggestive of the dynamic of a cogitating mind, and the more regularized shapes on the left which, by repeating the stable vertical and horizontal junctures of the format shape, evoke a sense of reasoned analysis. A filmic dissolve acts as a transition between the two.

Figure 13–8 is titled *Order and Chaos*. It is based on the aftermath of the massive earthquake in Haiti, which occurred on January 12, 2010. Offered as a warning, the artist's purpose was to question the human impulse to impose order on nature, the folly of which is never so glaring as in the wake of natural disasters of this magnitude.

The top panel of this triptych focuses on head shots of a staunch Haitian couple who are threatened by a whirl of telecommunications debris and tentacles of dislodged, heavily trafficked roadways. This random tangle suggests the extreme disorientation suffered by survivors. Any sense of linear time and the security that goes with it is dashed. In this new, uncertain temporal context, unprecedented chaos can deflate the affected population's confidence that order can ever be restored. And systems that trumpet human accomplishment, including feats of engineering, can seem irreparably damaged. Another primal fear, acrophobia, is invoked by the form choice of a dizzying vantage point from which we see additional stretches of highway and cloverleaf exchanges.

The midsection of the drawing differs from the other two panels because it depicts a single image rather than multiple points of view. There are signs of hope in this space: the calm sky, radiating light, and a bird gliding undisturbed on an updraft. A foreboding chord is struck, however, in the saturated black band that recalls funereal bunting.

An analysis of the form narrative in the drawing as a whole underlines the artist's skepticism about the viability of human control over nature. We begin with the stacking of the three formats, which is unsteady due to several factors. First, constructionally sound right-angle geometry in the work is subverted in the upper and lower portions by layers of disruptive diagonals. The top section is most conspicuous in this regard; the density of visual confusion it exhibits makes the composition top heavy, threatening to topple the overall structure. Moreover, the diagonals at top and bottom give the impression that they course beneath the middle panel, applying pressure to pop that section out.

Structural integrity is also undercut by the bridge pillars depicted at the bottom. Visually, this series of thick verticals is used to anchor the dynamic energies in the drawing. Figuratively, they are meant to suggest strength and reliability. Interesting, then, to see that the artist has achieved the opposite effect: by obscuring and softening their form, he has made the pillars appear vulnerable.

A final form choice that helps defeat the triptych's structural unity is the treatment of the black band that was mentioned previously in its symbolic capacity. Note how the abrupt value shift along its bottom edge makes this juncture spatially ambiguous. As a result the entire structure is threatened with collapse at this point, and with it, by implication, the sustainability of current concepts about the relation of twenty-first century humans to their natural environment.

Ground Swell (Fig. 13–9) is similar to the previous work in its gloomy premise that the world on its current course will end in destruction. It differs from Figure 13–10 in its depiction of hybrid imagery.

The artist's travels are key sources for the drawing. These include a visit to the city of Pompeii, devastated in AD 79 by volcanic eruption, where she saw plaster casts of victims frozen in their futile attempts to flee, as well as time spent in Utah's Moab Desert surrounded by eroding land forms. Two streams of pre-WWI German Expressionism were important artistic influences, including Ludwig Meidner's apocalyptic visions and Franz Marc's devotion to mysticism in nature.

Improvised imagery in this work is based upon two divergent subject-matter sources: the human figure and desert geology. The implied narrative concentrates on a procession of disconsolate souls, part human and part mineral, struggling to

FIGURE 13–9
AMANDA NURRE
Ground Swell
Charcoal, chalk pastel on
Stonehenge paper stained with tea
and coffee, 49 × 25"
*Courtesy of the artist, Instructors: Wayne
Enstice, Jim Williams, University of
Cincinnati*

free themselves from a decayed environment. They emerge from what resembles a
fossilized birth canal. The landscape they march through is parched and forbidding,
and dominated by oppressive stalactite and stalagmite formations. As the exodus
proceeds, the characters shed much of their inorganic outer layer. The two sub-
jects closest to the picture plane are all but denuded, exposing their fleshy skin.
The mien of the female figure gives us a riveting glimpse of the bleak psychologi-
cal state suffered by the group as a whole.

The work's form emphasizes content carried by shape, value, and rhythm.
Prominent shapes in the drawing are sharp and flinty, creating an inhospitable
environment for vulnerable, fleshy creatures. Patterns of more generalized shapes
knit sluggish, hobbled rhythms that offer a visual soundtrack for the solemn dis-
position of the work. Values occupy a predominantly light- to mid-tone range,
supporting the sensation of a bleached and desiccated setting. The major excep-
tion is on the right side of the image. Here, the increased contrast, including the
hopeful effect of an irradiant light source, is keenly coordinated with the climax
of the drawing's story line.

Figures 13–10 and 13–11 are more determinedly surrealist than previous
images in this section, as they explore dream or netherworld fantasies.

FIGURE 13–10
EMILY BRUNNER
Emergence
Graphite, 20 × 22"
*Courtesy of the artist, Instructor: Don Kelley,
University of Cincinnati*

FIGURE 13–11
NICHOLAS DISIMILE
The Secret Rite of Skullcrushing
Graphite, collage, coffee
on paper, 22 × 30"
Courtesy of the artist, Instructors: Wayne Enstice, Jim Williams, University of Cincinnati

Emergence (Fig. 13–10) was inspired by Surrealist artists Leonora Carrington, Leonor Fini, and Frieda Kahlo. The artist used techniques of frottage, including rubbings of a tree root at a local cemetery, and automatic drawing to initiate imagery for this work. The major theme is transformation, and the associated forces of creation and destruction. This allegorical conception is expressed through layers of symbolism adapted from Neopagan traditions.

Within contemporary Neopaganism the old woman, or crone, holds the key to mysteries of death and dying. The focal point of this drawing is a triangular formation that represents the hands of a crone holding up a black egg cracked to reveal a skeleton. This disturbing visual paradox, the gestation of death in the vessel of birth, points to alchemical processes of regeneration. The gesture of the paired hands supports this interpretation, as it recalls elevation by a supplicant of a consecrated host, symbolizing rebirth. The organization of values complements this narrative event, with the bright, rich white decisively poised against mid-tones and black.

The envisioned setting for this ominous, feminine spirit is an inner dreamscape. The dark pool represents the unconscious. Inhabiting the surrounding terrain are an owl-headed deer and a deer-headed owl. Their reversed hybridity extends the climate of paradox in this netherworld "reality."

The form of the work befits a chthonic scene. The slow, short marks that construct the majority of the passages lend an indolent character to the drawing. The texture of the surface is arid, recalling the dryness one experiences when sleeping open mouthed. Subtle chiaroscuro slowly turns each of the horizontal striated masses as they gradually descend with the pull of gravity. The rhythm of patterned surfaces is languid; even the interspersed motif of circular shapes is more hypnotic than playful. These visual characteristics create a somnolent mood, making the entrance of the hands all the more startling. Their eruption from the pond is like an unwelcome sign of the id on the surface of the ego.

Among the drawings in this section, Figure 13–11 possesses the most nihilistic outlook. The extent to which the imagistic conception of this work subjugates rational interpretation in favor of the visceral relates it to the darker side of surrealism.

This drawing's statement does not take direct aim at social or political conditions. Its purpose, instead, is to disclose in evocative terms a dimension of human experience which, however secretive, is proliferating. Simply put, the work refers

to the multitude of escapist avenues that earmark contemporary society and are used as outlets for aggression, fears of dying, and a despair that life is meaningless.

Inspiration for this artist's work has diversified sources within recent populist culture, including horror comics such as *Creepy* and *Goreshriek*, the science-fiction magazine *Heavy Metal*, punk music and its subculture, and the filmmaker, and so-called "Godfather of Gore," Lucio Fulci. Its iconography draws upon autobiographical and anthropological signs. The Roman Catholic sacrament of Holy Communion, during which believers consume the body of God, is invoked by a grisly narrative in which two protagonists dismember a third. Adjacent is a collaged image of three miniature figures kneeling in a ritualized presentation of a body.

Probing a bit deeper, note the masks worn by the two perpetrators at center stage. One is the commonly recognized Jack O'Lantern. The dark bag worn by the character on the right may not betray its origin so easily, but it is reminiscent of the black pillowcase worn by the infamous Zodiac killer.

Additional subject-matter cues include the hag-like figure behind the killers, inspired by a rubber "Monster in My Pocket" toy that the artist prized as a child; and the deer head, which points not only to taxidermy but also to cross-cultural myths that identify horned creatures as the embodiment of Satan. The ghostly apparition in the foreground, cautioning the viewer to be quiet, is perhaps the drawing's most provocative icon. It is based on a photograph of the famous occultist Aleister Crowley, dressed in the ceremonial garb of the Hermetic Order of the Golden Dawn.

Formally, the fragmented organization of this image is congruent with the wrenching subject matter. Indeed, the narrative vignettes are so disjunctive that pictorial structure may initially appear to be highly informal, even "accidental." But that is hardly the case.

The major design components in the drawing are an asymmetrical balance; a horizontal organization based on an "X," at the center of which is the focal point of the dark figure; vertical geometric divisions of the surface, including the large, quasi-triangular shape defined by converging lines that frame the stagelike space and its macabre goings-on; and the coarse texture that is emotionally abrasive as it conjures walls of dangerous back alleys or abandoned tenements.

The artist's powers of invention were also exercised by the theatrical values of this drawing. In addition to depicting and composing, the work demanded ambitious preparatory research and the assumption of a directorial role with respect to matters of location, costume, lighting, and character development.

Escapism is also the theme of Figure 13–12, but in contrast to the previous image it is grounded to a greater degree in autobiography. It is important to note that Figure 13–12, titled *Floating*, is one of two images in this chapter by the same artist (see Fig. 13–28 for the second example). Together, they represent two crucial steps in the artist's perception of daydreaming, beginning with his personal investment in waking fantasies.

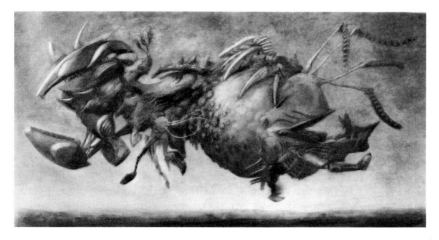

FIGURE 13–12
DAVID NASH
Floating
Graphite, pencil/vellum, 18 × 32"
Courtesy of the artist, Instructor: Wayne Enstice, University of Cincinnati

The relevant plot lines from the artist's personal life are not uncommon: child of a single parent attending a new school, having difficulty making friends, feeling like a social misfit, and prompted by it all to escape through daydreaming to a more comfortable place. *Floating* is not the image of a recalled daydream. Instead, it is an attempt by the artist to envision the emotional confusion of that period in his youth that led him to a dependency on daydreaming.

The floating mass in this drawing has no direct reference in nature, but its barbell segments allude to two broad classifications of things: mechanical and organic. Overall, it recalls a bizarre Zeppelin airship; if we fancy a story line, we may imagine it to be on a reconnaissance mission.

It has no front or rear end, so by way of orientation we shall say that the right side seems to combine a buffoonish whale physiognomy (including a series of projections that may be distant cousins of "fishing poles" found on the head of a real-life angler fish), with the fibrous look of a tuber recently yanked from the ground. While the right side is benign and magical, its left side is more alien, machinelike, and threatening. The net result of these incongruous, truly polar-opposite ends, is that the creature is inscrutable.

Formally, the use of graphite on vellum gives the drawing its smoky appearance, rather like a hallucination caused by too much particulate matter in the eye. The fine-toothed vellum surface enabled the artist to achieve rich, chiaroscuro transitions, which, together with the scale of the image, promotes the illusion of a sculptural immensity impossibly hovering in midair.

But perhaps the slyest formal decision was to equalize the design patterns of the image. The absence of visual hierarchies forestalls any directional energy from taking precedence. This is in keeping with the artist's conceptual intent to efface from our experience of the drawing any sense of the passage of time. The sum effect of the drawing, then, is akin to the stasis of consciousness that is commonly called daydreaming. After looking at the drawing for a time, we may feel disoriented and be moved to utter; "How long has my mind been wandering?"

Unusual Subject Matter

Traditionally, art students in their introductory years have a fairly steady diet of drawing from still lifes, with occasional attention paid to the human figure, landscapes, and interiors. These are four timeless categories of subject matter (a thorough discussion of which appears in Chapter 9). Nevertheless, many artists, itching to enrich their form vocabulary, occasionally veer from the beaten track to investigate comparatively unusual subject-matter domains.

Unusual in this context does not refer to imagery that springs from the imagination. Instead, we invoke conventional wisdom that "truth is stranger than fiction," and feature in this section subjects that are actual things in the world. These things may not inspire a critical mass of attention, but in the eyes of individual artists they merit attention.

In this collection of drawings, subject matter that deviates from the norm may be grouped into two categories: phenomena that were viewed with dispassionate fascination, and subjects that provoked some degree of personal identification. Figures 13–13, 13–14, and 13–15 fit the first category.

The intent of Figure 13–13, *Blue Print*, which depicts a songbird nest, is to celebrate the elegant aesthetic of natural objects. The realist drawing of the nest—its illusion of volume, weight, and tactile presence against the spare ground—gives the image tremendous visual panache: The nest appears to jump off the page.

The irregular conical shape of the nest gives its form a subtle gesture. The tilt of the nest, and its off-center placement, initiate movement to the left, a dynamic all the more effective because it is implied. (Note the arrow-shaped leaf on the lower right side of the nest, which visually puns this directional tug.)

Despite its hint of gestural motion, the actual speed of the nest's form is slow. This is due to the density and sharp focus of its texture, which sets up a

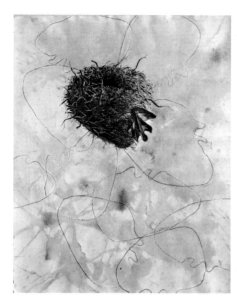

FIGURE 13–13
NATHAN BRANDON
Blue Print
Dirt, water, charcoal, conté, pastel
on paper, 22 × 30"
*Courtesy of the artist, Instructor: Dale Leys, Murray State
University*

FIGURE 13–14
AMANDA NURRE
ENT Study
Pencil on paper, 6 × 10"
*Courtesy of the artist, Instructor: Wayne Enstice,
University of Cincinnati*

striking contrast with the graceful dance of tracery around the nest. These cal-
ligraphic curves serve a design function in the work by lightly enclosing a series
of shapes that repeat the outer contour of the nest. More intriguing, however, is
the role these curvilinear patterns play in suggesting the illusion of atmospheric
space, which is in delightful counterpoint to the artist's use of real dirt to assert
the flat expanse of the picture plane.

Figure 13–14 represents a dance of a different kind. It consolidates informa-
tion from a series of photographs taken in a surgical theatre during an ENT (ear-
nose-throat) procedure. Pictured on the left is a surgeon holding a bulb syringe,
and on the right, a surgical assistant.

This drawing is a prime example of how the process of abstraction can en-
rich the expressive values of an image. Sufficient recognizable exotica of the med-
ical profession give us subject-matter footing; nonetheless, the drawing's overall
theme does not depend on an identification of objects, but, instead, upon the con-
tent carried by formal relationships.

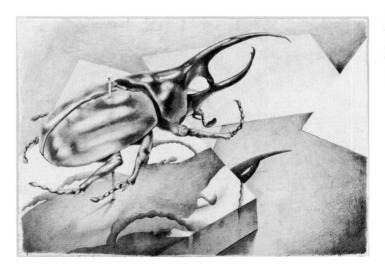

FIGURE 13–15
TREVOR PONDER
Hercules
Graphite, 20 × 28¼"
*Courtesy of the artist, Instructor:
Wayne Enstice, University of Cincinnati*

Look, for example, at the asymmetrical balance. It throws the focal point of the image off-center, immediately activating the design. This focal point is located at the shadowed pocket just left of center, between the two hands of the surgeon. Fanning out from this pocket are three bold diagonals; altogether, the image gestalt of this area recalls a wheel hub with radiating spokes. This series of diagonals extend sufficiently to achieve a sensation of equilibrium in the drawing, but note as well the way they are arrayed in measured, counterclockwise steps. A prime interpretation of these formal choices is of synchronized motion, rotating compactly and with purpose.

Next, scan the lights and darks blinking across the surface of the drawing. They are organized into unpredictable patterns that are the result of emphases, or the lack of them, on inner and outer contours in places you would least expect. Both of these visual characteristics are the result of keen form improvisation. They help to unify the picture plane and imbue the image with the content of a nimble syncopation, a brisk but controlled dynamic.

In the final analysis, the distillation of objective reality into succinct design motifs in this work more effectively communicates the efficient choreography of a professional surgical team than would an objective rendering of the events.

Hercules (Fig. 13–15) converts close observation of an unusual subject into a drawing with sublime overtones.

Due to its fearsome appearance, the Hercules beetle is made to order for childhood fantasy. This drawing dramatizes that sense of youthful wonder. In large part, this is because the compositional form of the drawing is a natural outcome of the design of its subject.

The adult male Hercules beetle is among the largest beetles (seven inches long and the weight of a hamster). Pound for pound, they are the strongest animals on earth. The artist employed several visual methods to indicate this insect's robust stature. They include the beetle's scale, its streamlined contour and slick, hard carapace, and our bird's-eye vantage point. Taken together, these characteristics effectively exaggerate the Hercules' perceived militancy (actually, it is harmless to humans).

Although the Hercules beetle is not a good flier, it is surprisingly fast on the ground. In this image, two parallel diagonals, which span much of the drawing's surface, allude to its speed. The movement of the top diagonal is swift, and the climax of our ride is on the daggerlike horns. The trip along the creature's shadow is a bit more tentative due to interruptions by small incidents, and it ends with the conspicuous plane break where the pincher shape of the horns is echoed.

Instead of flying off the page on the diagonals, the rhyming arcs of the pincer-like horns and the pocket of space they enclose gently apply the brakes. The curve of the upper horn sets our eye on an elliptical journey over a series of flat shapes, including the pieces of paper on the right and the illuminated front corner of the specimen box. The gesture of the insect's four hindmost legs complete the ellipse and encourage the eye to once again follow the same path over and around the beetle's elegantly curved form.

Now, observe how the elliptical movement in the composition has its counterpoint in the insect's main curvaceous volumes. Those curves are repeated in a linear fashion by the beetle's segmented legs. These flexible modules, along with the hinged articulation that moves the horns, are faultlessly designed. Thus, the Hercules beetle is a model of precise engineering in a disagreeable form. This imbues it with an intimidating majesty, a thrilling presence that rivals the attraction of classical beauty. The artist's calling is to find visual equivalents for this awe-inspiring mystery, not by copying nature but by composing in a manner parallel to it.

A variation on the theme of attraction and repulsion is found in *Teeth* (Fig. 13–16), which has its origins in autobiographical sources.

Generally speaking, the mouth may be considered to be in the "public domain." Aside from its powers of oral communication, the form of the mouth assumes a variety of silent, expressive guises, from smile to grimace.

FIGURE 13–16
KAITLIN FITZ
Teeth
Oil washes and pencil,
8¾ × 12"
Courtesy of the artist, Instructor: Wayne Enstice, University of Cincinnati

Daily sightings of the mouth (ours or anyone else's), however, do not usually include retraction of the lips to expose a panorama of teeth and gums. Such a display might well prompt a strong reaction, from embarrassed amusement to mortification or disgust. In this sense, then, the interior of our mouths may be considered a not-much-discussed "private part."

The personal backstory for *Teeth* is shared by many who have endured a prolonged dental history. Surgeries, extractions, and unsightly (not to mention uncomfortable) orthodontic hardware are common medical as well as cosmetic correctives. The associated psychological tolls are not so conclusively overcome.

The photographic source for this work was a medical illustration of postreconstructive oral surgery. The artist chose it as a way to confront painful memories, chronic anxieties about dental visits, and a lingering obsession with vanity. The goal was to find aesthetic virtues in the image in order to transcend the morbid fascination it held for her. She wanted to close the psychological gap between the public amenity of a pleasing smile, and the private distress behind it.

The artist's visual conception successfully expresses her conflicting emotions. On one side of the equation, the blatancy of the image is undeniable, as the moist sheet of gum tissue that may repulse us stretches across the picture plane. On the other hand, the tonal washes that describe the gums are admirably controlled, conveying a delicate beauty. But, their translucency also recalls blood coursing underneath, which may remind us of our mortality. Correspondingly, the sensitivity of this lining to, let us say, hypodermic needles may cause us to wince. The glistening texture on these gums is perhaps their most gross attribute. Saliva harbors a veritable jungle of microbes, a fact that justifies the commonly held opinion that the mouth is the dirtiest part of the body.

The observational fidelity in the rendering of the teeth, including the soft record of light, is also accomplished. Nonetheless, their awkward fit and ungainly pattern are unpleasant to contemplate. Ultimately, the refined sensibility operating in this work is competing with visual mnemonic cues that are comparably repugnant. And these conflicting messages, packed into an image that is both mundane and startling, serve as an expressive parallel to one important thread in this artist's personal story.

The source for *Fence* (Fig. 13–17) is the artist's upbringing on a family farm. She has worked with sheep much of her life, having learned the basics of animal husbandry at age eight. The thematic orientation of this drawing grew out of the artist's disillusionment with what she considers unnatural farming practices.

FIGURE 13–17
AMY THOMPSON
The Fence
Graphite, 22 × 30"
*Courtesy of the artist, Instructor:
Darice Polo, Kent State University*

Working with such an exaggeratedly domestic and dependent animal, one that had lost most of its instincts for survival, was no longer appealing to her.

Formal organization is the principal means by which expressive values are communicated in this drawing. Page layout is divided in half diagonally with subject-matter information unexpectedly limited to the left side of the drawing. The impact of the chute shape is abrupt. Its recession into illusory depth is fast; its rise up the drawing's surface is steep. As a result of these design ideas, the composition has an almost brutal suddenness. On the heels of this first impression are overtones of violence—the images of sheep are compressed laterally (as if they had been shoved against the left side of the format) and squeezed vertically. The severity of the implied narrative is softened only by the gentle, repeating arcs along the length of the diagonal incline, and also by the endearing faces of the sheep.

But feelings of sympathy are undercut by the predominantly materialist presentation of these animals. Our high vantage point leaves no doubt about how tightly packed the sheep are, standing so close that they have no option except to move forward. Compare this claustrophobic density to the open space on the right side of the drawing and observe the intense light expressed by that expanse of untouched paper. This harsh light flattens the form of the sheep bodies, drains them of their corporeality, and suggests that these jostling animals are numbed with fear.

Despite the eventual fate of the pictured sheep (in this case they were merely corralled to be shorn), this drawing, as alluded to previously, is not sentimental. On the contrary, its expressive intent is to provoke a sobering comparison between the passivity of these creatures and the willing acquiescence of people in urban areas to be "herded like sheep" into overcrowded conveyances (buses and subways) only to arrive at demeaning and impersonal workplaces. The drawing's visual analog for this condition throws into critical question the compliance of animals and humans alike when submitting to unnatural circumstances, making them complicit in the bleakness of their own destiny.

Figures 13–18 and 13–19 straddle the two preceding categories of unusual subject matter. In both cases the artists made drawings to reimagine their fascination

FIGURE 13–18
BRANDON STENZEL
Natural vs. Commercial
Charcoal, conté on paper, 44 × 60"
Courtesy of the artist, Instructor: Susan Messer, University of Wisconsin at Whitewater

with aspects of the natural world, and, as a dividend of the process, each expanded his philosophic frame of reference.

The theme of *Natural versus Commercial* (Fig. 13–18) is marine conservation. The objects depicted in this drawing are laid out on a "flatbed" picture plane, or a horizontal surface that recalls a desk or table top rather than a window. Built into this formal ploy is the high vantage point, which positions the viewer to "read" the diagrammatic contents of the drawing. The information-based character of the composition is reinforced by the diptych format. On the left side of the drawing's book-like two-page layout, we see the image of a second book opened to a food-chain map. On the right is a shark-jaw poster—yet another reference to the printed page.

In general, subject-matter depictions in this work point to the artist's interrelated interests in aquatic systems and the sport of fishing. The crucial sign, however, is the seahorse skeleton, which functions as both a visual and a conceptual focal point.

Seahorses, low on the food chain and essentially defenseless, are an endangered species due to the massive harvesting of them for their use in Chinese herbology. The almost fetish-like rendering of this animal, therefore, has an ironic cast since it is being hunted to the verge of extinction due to its purported healing power.

The iconographical narrative of this work is, in an understated way, an environmental admonition. The inferences that may be taken from its equally subtle visual form are appropriately morbid. Relevant visual characteristics include the overall grey pallor of the image; the multiple uses of threatening, sharp shapes that represent spines, arrowheads, hooks and teeth; and the dry, chalky surface, reminiscent of cretaceous fossilized deposits under much of our seas.

Figure 13–19, "Inflationary Transition" addresses the subject of mutually opposed states of existence. To convey this theme, the artist chose to represent

FIGURE 13–19
M. THOMAS SWARTZ
Inflationary Transition
Sumi ink and graphite on arches and painted wall, 7 × 21'
Courtesy of the artist, Instructor: Darice Polo, Kent State University

dichotomies from two different disciplines. The fundamental descriptive dualities of wave-particle and micro-macro from the science of physics are reflected in this drawing through decisive aesthetic contrasts, including the use of dissimilar media and styles.

Concepts of wave-particle and the micro-macro cosmos are influential theoretical constructs that attempt to describe conditions of energy and matter at the "Big Bang," or genesis of the universe. Material characteristics of the drawing serve as visual analogs to these theoretical constructs. The scale of the work is one example. Unusually ambitious for a drawing, its size speaks to the magnitude of the "Big Bang." Other literal characteristics of the work include the format itself, which is composed of three separate panels. Media used for the left and right sections are misted sumi ink, discharged with a common spray bottle on a paper support. The paper was soaked more heavily with ink on the inside portions of both side panels; a gradual lessening of spray toward the outer edges achieved the dramatic tonal gradient. The physical transition of this gradient is intended as a visual metaphor for the conceptual transition of particles from energy to matter.

It is important to observe that a gestural style was used to visualize that transition. Imagistic events along the gradient include the reticulated pattern in the center; the blurred state of the lines that make up this pattern is a result of the "second gesture" of the medium (that is, the capillary spread of the ink on the wet surface). This phenomenon expresses the condition of particles as energy. The nodules at the ends, the result of more controlled spurts of mist, are visualizations of particles condensing into matter.

The central panel was drawn directly on the wall using graphite pencil. It is conceived in an explicitly contrasting mechanical style. Built up from intersections of diagonal lines that create the optical sensation of differing values, this perceptual approach is distinct from the material application of tonal media on the side panels. The illusory pulsing of this grid superstructure is meant to imply frequency waves organized into sheets of energy.

Macro-micro cosmos refers to infinite big-little progressions with macro, or cosmic, scale referring to earth, solar system, Milky Way, etc.; and micro, or atomic scale, referring to things such as humans, cellular structures, molecules, etc. The commanding geometric figure in the center panel is an intended visual parallel for a cosmically-scaled progression; brilliant, cold light at its core gives the impression of outward expansion. The mirrored side panels are windows on a drastically different, atomically-scaled world that is intimate and organic; a warm luminescence invites the eye within.

This drawing's exaggerated differences in media and style, and its scale, are meant to visually approximate universal mysteries that constitute and dwarf human existence. For the artist, acknowledgement of these ominous yet elegant forces, these sublime cosmological dichotomies, has been a source of spiritual enlightenment and a path to philosophical harmony.

Comics and Graphic Novels

The difference between comics and the graphic novel is a subject open to debate. Some consider graphic novels to be a long-form derivation of comics. Others distinguish between them on the basis of, for example, age demographics (comics are for young audiences; mature themes are common to graphic novels), and physical description (including differences of length, binding, and shelf life). Regardless, one characteristic that unites comics and graphic novels is the sequential format. That is, unless cartoons are mentioned because yet another perspective organizes comics and graphic novels under the general heading of the cartoon, including animated (sequential) and single framed.

FIGURE 13–20
BRENT LASHLEY
Global Slaughter
Water color
and ink/paper, 7 × 8"
*Courtesy of the artist, Instructor:
Wayne Enstice, University of Cincinnati*

Skirting around this debate, what we propose is that each of these genres within the art of drawing has proven an effective means of telling a story. Another generalization we can make is that comics and graphic novels are identical to any other art form in their inclusive embrace of subject matter, style, and expressive potential. Most drawings in this section are based on firsthand autobiographical accounts. That personal slant of the imagery, in conjunction with original story lines, finely-tuned character development and well-written texts relates these works more closely to literature-based fine art than to such populist idioms as talking animals, super heroes, anime, and manga.

Figure 13–20 is a prime example of a single-frame cartoon. Titled *Global Slaughter*, it is a potent blend of populist imagery, graphic sophistication, and trenchant social commentary.

Source material for this work is readily identifiable since it is appropriated from corporate trademarks that are ubiquitous in our contemporary sign-littered landscape. In this drawing, ostensibly benign cultural icons have mutated into and become a villainous figure wielding a machete in a parody of slasher films. This sensationalistic imagery denotes, and unmistakably denounces, Western consumerism run amok across the globe, with particular reference to mechanized food production and the associated atrocities of animal cruelty.

This work is not literature-based. The source of its raw, expressive power resides chiefly in its acute formal organization in which slasher figure and slaughtered cow have been coalesced into a large, arcing abstract figure. The simple gestalt of this invented figure takes possession of the page, and, in conjunction with the process splatters, gives the total image a billboard-like immediacy.

Each of these formal strategies is used in the advertising world to ascribe persuasive meaning to a line of product. Even the informal sketch technique is derivative of Madison Avenue illustrative styles that are used to disarm consumers for optimal reception of a commercial message. Here, the artist commandeers these strategies for use as subversive weapons in a work that courts a level of controversy normally reserved for caustic political cartoons.

FIGURE 13–21
Jason Butler
The Morning White
Graphite on paper, 11 × 17"
Courtesy of the artist, Instructor: Carol Tyler,
University of Cincinnati

Figure 13–21, *The Morning White,* is the second page of a three-part book illustration that is based on the following poem written by the artist:

> *you are*
> *the morning*
> *white*
> *in my throat*
> *a great equalizer*
> *you make*
> *a washed out photograph*
> *of everything*
> *the reason*
> *for my squinting*
> *and the comforter*
> *over my head*

The image was drawn in pencil, unlike the traditional inked comic. This was done, in part, to capture visually the meaning expressed in the poetic image, "a washed out photograph." The silvery warmth of the pencil tones and their tactile surfaces, however, also impart the image with a sense of intimacy that would not be obtainable using a more cut-and-dried graphic approach.

The familiarity we feel when looking at this drawing exploits the "third-person" omniscience that is inherent to the comic-book format. We have privileged access to this character's private morning ritual, so much so that we might feel a bit awkward, given his informal gestures and relative state of undress. The passage of time is evoked not only by the movements and activities that are portrayed in this work, but also by the storyline breaks between panels. Those gaps encourage the viewer's imagination to supply connective tissue for the narrative sequence. Formally, the panels are linked by such ploys as reverse camera angles in the top frames, and repeating figurative gestures that quietly set the overall design in motion.

Figure 13–22 is similar to the preceding image in that it too was motivated by a text outside the work (although in this case the copy is recreated within the image). But, whereas the plainspoken naturalism of *The Morning White* kept our attention on

FIGURE 13–22
ILA KRIEGH
Letter to ILA . . .
Pen and ink, 11 × 17"
Courtesy of the artist, Instructor: Ken O'Connell, University of Oregon

FIGURE 13–23
ADAM M. LESH
The Middle of Nowhere
Pen and ink with digital shading/digital text, 9 × 12"
Courtesy of the artist, Instructor: Ken O'Connell, University of Oregon

the rhythm of an ordinary morning, the informed, child-like style of *Letter to Ila . . .* (Fig. 13–22) plunks us on the threshold of fantasy even before we sample the script.

Based on an actual letter sent to the artist, the illustrations lay out the dream-like episodes and landscapes that flickered across the screen of the author's mind while composing it.

To this end, observe how compositional choices in this drawing erect a parallel between the phases of the letter writer's process and the arc of the narrative. Take, for example, the square shapes in the upper left and lower right. They are prominent visual weights in the drawing that help stabilize the overall design. In these diagonally opposed squares we see the letter writer at the beginning and end of the story line.

Compare the relative calm of those squared corners with the remainder of the drawing which is roughly organized into a large diagonal passage that travels from upper right to lower left. The visual ruckus of this area, which coincides thematically with the middle of the plot, is where the writer's subconscious whimsy is illustrated.

Figures 13–23 and 13–24 are firsthand accounts of real-life events. Although both of these comics have an absorbing narrative with a similar theme—an episode of ill-fated travel—their respective visual translations are emphatically different.

The Middle of Nowhere (Fig. 13–23) chronicles a week during which the artist, his wife and cat were stranded in a taiga, or subarctic forest, in Yukon Territory while moving from Alaska to Oregon. The narrative sequence was conceived as a single-page format. Nevertheless, the sensation of forward movement in the final cell, carried by the image of a foreshortened car, suggests that the story continues.

The formal attitude of this work is austere, befitting the desperate circumstances. Only visual staples are used, without embellishment. They include the

FIGURE 13–24
MARIANA YOUNG
Round Trip Milwaukee
Pen and ink, paper, 8½ × 11"
(individual page)
*Courtesy of the artist, Instructor: Carol Tyler,
University of Cincinnati*

news-tagged sans serif type; the flat line and mechanical value structure with basic black, white and half-tone screen; and the purposely bland representational style.

As a result of these decisions, the visual form narrative of *The Middle of Nowhere* expresses, in its own right, composure and resolve, as if it were an excerpt from an expeditionary log. What a contrast to the giddily emotive quality of Figure 13–24.

Compare these images for yourself. Observe the unbroken surfaces in Figure 13–23, and how its uncomplicated layout verges on a bare-bones arrangement of large, positive–negative cutout shapes. Figure 13–24 has a far busier surface, with its unpredictable texture of atomized shapes and complex layering of figure–ground.

These and other differences can be accounted for with one simple premise: each story line demanded a particular visual style to express the content of its subject-matter narrative. Another way of saying this is that the qualities of form in both images are what drive, and determine the success of, their thematic content.

In order to take our comparison a few more steps, we need to establish the plotline for Figure 13–24. Titled *Round Trip Milwaukee*, the narrative concerns a bus trip from West Virginia to Milwaukee for romance. The literary climax, developed over twenty-four pages, is that both the trip and the romance end disastrously. The two pages reproduced here represent that point in the story where the protagonist first meets the romantic interest.

Understanding the dissimilarities in subject matter between Figures 13–23 and 13–24 gives us more perspective on their pronounced visual discrepancies. *The Middle of Nowhere* is a concise, self-possessed record of the Yukon saga. As viewers, we observe from a distance the formidable circumstances that have befallen this couple and their feline companion.

Contrarily, we are personally captured by the playful abandon in Figure 13–24, as if it were an effusive, personal letter to the viewer. Its homespun aura is advanced by the repetition of decorative, stitched-like patterning; and the cursive handwriting contained in a proliferation of speech bubbles injects the work with a conversational tone. Add to these personalized features the appealing, hatched-line sparkle and comical figuration and it is clear why *Round Trip to Milwaukee* is so endearing. Mesmerized visually, we are drawn into the work to sympathize with the intricate psychological shadings of the central character's romantic adventure.

FIGURE 13–25
JASON BUTCHER
Surgery #6
Digital drawing
(dimensions variable)
Courtesy of the artist, Instructor: Charles Woodman, University of Cincinnati

Computer-Generated Images

The computer is today among the most popular artistic media. Its attraction is twofold. First, it is a matter of context. The virtual world and its associated mass media imagery, has defined cultural reality for recent generations of art students. As a consequence, the computer and its peripherals are as indispensable as a #2 pencil and paper were for their parents.

The computer medium is chameleonlike, a second reason for its popularity. There is seemingly no visual event that computer-simulation software cannot duplicate; no style or mediumistic guise it cannot mimic. (Our examples in this section raise the question, "What does a computer-generated image *look* like?") The overlap of computer screen and visual culture furnishes artists the option to collage endless extant resources from public domains. More recently, increased use of graphic tablets has vitalized the computer's function as an extension of the hand. Today's student artist can seamlessly make the transition from immersion in a wired culture to the fine art of drawing in cyberspace.

Figure 13–25 is a stand-alone computer drawing that was derived from a three-minute animation. The animation was created with 2D software, including a graphics tablet. The drawing, *Surgery #6*, was composed by stacking and editing multiple, consecutive frames.

The title of the animation is *Self-Discovery through Medication and Surgery.* As the title implies, the theme is a perception of self as both a symptom and an indictment of a contemporary, overindulgent and overmedicated society. The drawing's particular focus is on two issues commonly tied to a classification of behavior-controlling drugs referred to as psychostimulants: the leniency with which such drugs are prescribed; and the habitual abuse of them for recreational purposes.

The chilling scenario of this image—pills surgically inserted into the circulatory system—is advanced by its formal construction. The fundamental layout of the image is key to its expressive content. The "X" formed by the two major diagonals, respectively inclined on the vertical and horizontal, establish a basic visual conflict.

The vertical movement is dominant; it interrupts the horizontal, and the stronger contrast of its dark values commands our attention. Continue to look at that vertical as an abstract formation (without identifying the subject matter), and you will experience a sense of tautness that stretches across the height of the image area. This is in marked contrast to the relaxed, even limp, curvature of the horizontal movement.

These significantly different visual gestures elicit equally different emotional responses. It is at this primary level where the agreement between form and subject-matter narratives sets the tone for the work, conveying together the opposition of control and helplessness. It is no coincidence, then, that the disturbing focal point of this drawing is located where these dissonant states intersect.

Perhaps most notable, however, is the overall style of the drawing, which nods to medical illustrations that might be found in, for instance, vintage Red

FIGURE 13–26
LINDSAY NEHLS
Mud Drawing
Digital drawing (dimensions variable)
Courtesy of the artist, Independent Work,
University of Cincinnati

FIGURE 13–27
LISA TOMPKINS
Cake
Digital animation (dimensions variable)
Courtesy of the artist, Instructor: Denise Burge, University of Cincinnati

Cross First-Aid manuals. In this context, such an anonymous veneer adds an uncomfortable twist to the image, and may also be said to exploit the cliché of computer dehumanization.

Figures 13–26 and 13–27 are also computer-generated images that stand as complete visual statements, and both are based on dream imagery. *Mud Drawing* (Fig. 13–26) is a double self-portrait that the artist drew on a graphics tablet immediately upon waking. Diary-like in form, it includes a brief written entry and an incidental aside about the dream.

Subconscious visions have been for some time a principal impetus for this artist's work. She embraces dreams as a prolific image source; and when she shifts gears from being an artist and assumes the role of analyst, she finds that dream imagery offers provocative insights to her everyday existence.

Aspects of her research have included common dream themes and associated phases of sleep. Although many dream types are universal, personal variations on a theme are shaped by each individual's unique circumstances. The artist's real-life situation, contemporary with the vision illustrated in *Mud Dream*, can enlighten our attempt to understand the subject-matter signs and formal organization of the drawing.

Leaving a busy American metropolis for an extended stay with relatives in a quiet town overseas had unexpected ramifications for her. As she did not speak the language of the local inhabitants, she was generally frustrated in her attempts to communicate and was particularly dismayed by the lack of meaningful contact with her peers.

That frustration and loneliness surfaced dramatically in her dreams during this period, of which "Mud Drawing" is an example. Generally speaking, this drawing records a variation on the phenomenon of sleep paralysis, a phase of intense dreaming that is combined with muscular immobility. In this image, the frightening sensation of sinking inexorably down into a mud-like substance is accompanied by the inability to move or scream for help. The self-portrait on the left signifies this terror at its most extreme, the irrationality of her nightmare heightened by the frenzied chaos of line.

The larger self-portrait signals an explicit turn in the dream sequence, complemented by an equivalent adjustment in the form of the work. This area, roughly one half of the drawing's surface, is grimly quiet. Indications of space on the left have been abandoned, and with them the explosion of frantic energy. Movement on the right-hand side has been reduced to the illusion of mud

gradually encroaching on the woman's neck; the mutual contours of these two zones (mud and neck) are interlocked in a slow positive–negative alternation.

The woman's facial expression confirms that she has given up all resistance. We see an attitude of resignation, relieved slightly by the petitioning gesture of the upturned head. Despite the absence in dreams of beginnings and ends, the gripping scale and immediacy of the transfixed figure commands our attention in a manner that recalls a cinematic swan song.

The portability of the graphics tablet enables this artist to document the most vivid memories of a dream before they start to fade. The abbreviated sketchy style is attributable to the urgency of this recording process; it also has the salutary effect of recreating the dynamism of the dream. The flat, graphic character of the drawing should perhaps be expected from someone so attuned to her personal psychic patterns, as it demonstrates the influence of mass media and interactive imagery that bombard her.

Cake, Figure 13–27, is excerpted from a three-minute animated dream sequence. Multiple techniques were wedded in the evolution of this work.

First, the artist created an elementary version of drawn, stop animation. Working directly on her studio wall with charcoal and paint, she produced a long succession of images that were digitally photographed then erased. Each of these recorded images (over 1,000) was loaded into a computer and compiled to give the illusion of movement. Actual materials installed on the studio wall were also recorded during this process—in our example, note the scraps of wood draped with yarn in the lower right-hand corner. Additional layers of imagery were added using Photoshop drawings (the large hand and tea-bag tag) and live action imagery, both of which were dropped into the digitized, hand-drawn series.

The goal of this animation was to embody and attempt to reconcile anxieties the artist harbored about attending art school. On the one hand, she was eager to excel and be acknowledged within her school community as a credible emerging artist. Clashing with this drive to be accepted in her discipline was the artist's nagging doubt about the purpose, indeed relevance, of Fine Arts in today's world. She aspired to make a difference, but questioned whether art is the best instrument for her to effect important change.

Graphic correlatives for these contradictory emotional states abound in this single-frame drawing. Most psychologically revealing is the rickety structure upon which the artist's image is perched. The upset caused by the asymmetry of this vertical is compounded by the use of visual imminence as a design strategy: The tea cup is ready to tumble, and with it we expect to see the unceremonious dumping of its nestled inhabitant.

The formal instability of this main image area, in conjunction with the subject-matter signs, puts a finer point on the artist's content ambitions. Tea cups and tea point to comfort. In this context, both signs are meant to be visual metaphors for the "safe" route taken by the artist: matriculation, or baptism, as an art major in an institutionalized setting. Questioning the status quo might be risky, however. The large hand holding the string, an unmistakable signifier of authority, is controlling but reassuring.

The visual character of this image is provocative. Aside from the precarious balance of its design and the abrupt changes in technique, there are also explicit stylistic shifts, from the amorphous gestural formations on the right to the cartoonish drawing on the left. The questions this image asks are no less unsettling.

Waiting for a Response (Fig. 13–28) is a digital print of an image produced in Photoshop. It is thematically related to a drawing entitled *Floating* (Fig. 13–12) in the "Envisioned Image" section of this chapter. Both images were made by the same artist on the subject of daydreaming. But, whereas the origin of *Floating* is intensely personal, and may, on that account, be regarded as an emotional totem, Figure 13–28, *Waiting for a Response*, is dispassionate in tone. Taking a critical perspective, the artist created this work to impugn the excesses of daydreaming and the related widespread abuses today of virtual realities as mechanisms for escape.

FIGURE 13–28
DAVID NASH
Waiting for a Response
Digital drawing (dimensions
variable)
*Courtesy of the artist, Instructors: Wayne
Enstice, Denise Burge, University of
Cincinnati*

The image in this drawing was inspired by actual events. As a youngster, the artist had a shape-shifting friend who kept him company on the school bus. This seemingly harmless fantasy, along with other pleasant imaginings, stunted his socialization. As he matured, he witnessed friends who developed a pathological need for immersion in a self-created, alternative reality.

Figure 13–28 is similar to *Floating* in that it contains an envisioned creature. In all other respects the two images differ. Instead of the thematic inertia of *Floating*, we are presented here with a telling fragment of an implied linear narrative. To underscore the universality of the theme, the depicted setting is a generic slice of everyday reality. We can readily identify the central character on the basis of his clothing and weary posture as someone who is homeless and out of a job.

Grim reality shifts emphatically into fantasy in the lower half of the drawing. Both the creature and the pinwheel are projections of the man's reveries, which he indulges to relieve his despair. The image at this point gathers suspense. Will the man shake off the daydream, or accept the gift he clutches as a talisman and choose to remain under its spell?

Formally, the split between the two halves of the drawing (and the separation of the two realities) is greatly enhanced by the amassed visual weight in the lower section. As a consequence, the bottom half has a tremendous sensation of gravity (a property absent in *Floating*), which threatens to drag the main character farther down, literally and figuratively. Observe as well how the directional forces in this image assist in heightening the dramatic impact of the story line. We refer first to the powerful collision between the diagonal moving down from the upper right (along the edge where the sidewalk meets the grass) and the repeated diagonals that oppose it, represented by the axes of the man and the creature. The compositional focal point of the drawing is located at this intersection, and it neatly coincides with the narrative climax that takes place in the exchange of glances as the creature awaits a response.

Figures 13–29a, b, c are stills from an untitled, two-minute animated HD video. To construct the work, the artist first took digital photographs of himself along with selected objects in his immediate environment. The video imagery, based on those photographic references, was drawn with a graphics tablet, masked, reassembled with compositing software, and articulated to create the character rigs.

(a)

FIGURE 13–29
CLINT WOODS
Untitled
Digital drawing
(dimensions variable)
Courtesy of the artist, Instructor: Wayne Enstice, University of Cincinnati

(b)

(c)

Conceptually, this work may be summed up as "art about art." More specifically, it homes in on the art-making process as relentlessly self-regenerative: art generated by an artist in an endless chain with neither beginning nor end. Throughout the animation, this repetitive cycle is visualized most prominently by the recurring bearded male figure, a dead ringer for the artist.

In the first panel (Fig. 13–29a), one cloned version of the artist draws a portrait of his counterpart. In subsequent frames the drawing itself will become animate, adding yet another generation of progeny. The outstretched arms and hands of the second character in this first panel encircle a cluster of crystalline forms that are meant to signify the materials, the "stuff", the artist uses to create; and in the context of this animation, the art of creation is closely associated with alchemy. These inorganic structures are massaged (Fig. 13–29b) and, as the animation proceeds, they are transmuted from their elemental state into a fresh line of fabricated central characters.

The third panel (Fig. 13–29c) intimates a psychological dimension. We see the artist, in one of his duplicate incarnations, kneeling on a bed of the aforementioned crystalline raw material; he is studying the portrait drawing that was conceived in the first panel. How are we to interpret this image? It would appear to express a mixture of concentration and humility (perhaps even self-doubt—"am I good enough to be an artist?"). Thus, the emphasis on process over product is accompanied in this work by an the implication that the artist has a compulsive need to reinvent himself, making his image, his creative rituals, and his art not only redundant but synonymous. The visual presentation of this obsessive aesthetic has embedded in it, however, a dry, offbeat humor, and as a natural outgrowth the gnawing question is raised as to whether or not any attempt to invent new realities is an absurd ambition.

The controlled neutrality of the drawing is the chief source of quiet levity in the animation, and it agrees with the enigmatic character of the work's theme. Indeed, the bland, illustrative style is as indistinguishable as are the characters, one from another. Equally judicious was the choice of computer-generated animation, as its real-time definition reinforces the expression of a continuous present caught in a closed circle.

Portfolio of
Contemporary Drawings

We have written this chapter with two purposes in mind. First, to collect a representative sampling of drawings that, on a purely visual level, will give you a feel for contemporary art. Second, to use those drawings to introduce you to some of the major aesthetic and philosophical drivers behind the complex art of our time. Images have been grouped generally according to medium and issues of content.

Historical Background

It was not so long ago that the terms "contemporary art" and "modern art" were used almost interchangeably. That is no longer the case. Nowadays the modern art period is generally considered to have ended some time in the 1960s or 1970s, when the Postmodern period is said to have begun. Whether or not the Postmodern movement drew to a close along with the second millennium is an issue that art historians and theorists continue to debate.

MODERN ART

Modern art is not a *style* with a recognizable set of formal and subject-matter characteristics. Looking back at earlier periods in art history we can find numerous periods during which a particular culture produced art of a given style—think of the three thousand year reign of the ancient Egyptian style, the distinct styles of Archaic and Classical Greece, Early Italian Renaissance, High Gothic, Rococo, and so forth. To a person with a basic knowledge of art history, all of those period descriptions will call forth images of art with an identifiable look. Given the stylistic diversity of modern art, we might more appropriately regard the term "Modern Art" as simply describing art produced in a *period* of about one hundred years' duration, from about 1860 to 1960.

This is not to say that the various streams of modern art were unrelated or had nothing in common. In fact from the 1870s through the first decade of the twentieth century modern art can be seen to follow one major trajectory: the gradual elimination of real-world representation in favor of ever-increasing abstraction. But in the years just prior to, and more noticeably after, the First World War, we see a schism in modern art practice. One major stream, "Modernist Art," was a movement that unlike "modern art" *can* be considered a style, for it was dedicated exclusively to a unified set of formal concerns. The other "modern" stream consisted of a variety of styles and movements—e.g., Futurism, Metaphysical Art,

Dada, Surrealism—that retained subject-matter references even in the midst of formal innovation.

Modern art inherited many attitudes from Romanticism. Primary amongst them was the Romantic artist's faith in individual subjective experience as an antidote to materialist culture. The more formalist or "modernist" faction delved deeply into subjective experience in the quest for a universally understood language of color and form that could express deep spiritual truths. The other strain of modern artist was captivated by dreams and other manifestations of the unconscious mind.

Modern artists also inherited the Romantic view of the artist as a frequently misunderstood prophet struggling to produce art that challenged, and sometimes offended, the staid expectations of the bourgeoisie. Enlightenment concepts of progress found their Romantic and Modern counterparts in the notion of the avant garde.

Enlightenment ideas of Utopia were also kept alive by the Modernist faction. Many modernist artists believed that the expressive power of significant form responded to a shared inner necessity, and that art that communicated this shared necessity could actually help people to live better lives and by extension create a better society. This Utopian view was not necessarily shared by the other modern faction (including Dadaists and Surrealists), who were more skeptical by nature, and whose art often addressed the absurdity of materialistic societies that could send their youth to be slaughtered in the Great War.

POST-MODERNISM

In the decade following World War II, the modernist faction, now based in New York, became more entrenched in its formalist concerns. Modernist, or formalist, artists strove to maintain the "purity" of their artwork. This meant creating an art that, with its insistence on form, transcended the corruptions of everyday narratives from personal or social spheres and resisted middle class hankerings for illustrative kitsch.

But in the early 1960s, modern art, and particularly the linear progressive juggernaut of aesthetic modernism, hit a wall. Narrow modernist definitions of ambitious art were shattered by the impact, inaugurating our age of cultural heterogeneity. This art world repudiation of dominant values was not an isolated phenomenon; it reflected broad paradigm shifts in society at large.

Vociferous elements in Western societies during this period began a process of questioning the precepts of modern life that continues today. In America, the Civil Rights movement was the first in a wave of movements that successfully challenged the status quo. Other underrepresented groups followed in an effort to procure rights for all and to raise consciousness on a variety of issues. Sympathy for "The Establishment" began to erode, especially with respect to the Military/Industrial Complex and its partnership with the engine of capitalism. Aesthetic modernism, tethered to a belief in progress and innovation, and by now in its own establishment phase, was branded as cold-war corporate art.

Pop Art was the first serious challenge to aesthetic modernism, and in its wake previously strict divisions between "high" and "low" art became blurred. By synthesizing imagery from consumer and popular culture with many of the formal ploys of modernist painting—large-scale, liberal use of color and flattened pictorial space—Pop artists were doing something truly subversive. They were reintroducing imagery, and kitsch imagery at that, while at the same time liberating the recognizably Modernist formal devices from grandiose references to the sublime. Many of today's critics recognize Pop artists as the first Postmodernists.

The battlefield was enlarged in the early 1970s, due in part to the sudden entry of feminists into the art world. Under fire from this new group were formerly sacrosanct anchors of the modernist sensibility, including concepts of genius and originality and the narrow canon of taste developed by a white male–dominated field of art critics and curators. In short, grand narratives of modern art were branded as either outdated or elitist. Over succeeding decades, various minority or otherwise underrepresented groups continued to storm the modernist barricades. Art produced under the umbrella term "multiculturalism" sought legitimacy for forms and subject matter previously thought to be beyond the pale of serious art.

With so many pressing issues that needed to be addressed, it followed that the emphasis on form, so dear to modernists, was displaced by subject matter as the source for ambitious art. Adopting photo-mediated techniques from mass media and recontextualizing everyday objects were common Postmodernist strategies used to question consumer society in particular, and the distribution of wealth and power in general. Performance, installation and electronic art, all forms that engage real time, real space, and real-world politics, were dominant streams of artistic activity as the twentieth century lapsed into the twenty-first.

Since the early 1970s, the definition of what it means to be an artist has undergone similar disruption. Dispensing with the romantic image of the artist as a tortured outsider possessed of virtuosic skills, Postmodernists have offered a new model of the artist as a contemporary figure stripped of myth. Consistent with their theory that the "real" is indeterminate, Postmodernist artists do not copy reality; nor do they transform ordinary materials to create the extraordinary: a unique object bearing the stamp of individuality. Postmodernist artists, spurning assumptions of individual self, act only to synthesize ideas and visual systems that already exist in the culture.

MODERNISM/POSTMODERNISM—WHAT'S IN A NAME?

Much of the cultural dialectic of our times is devoted to the question of whether the societal phenomenon dubbed as Postmodernism actually exists. Opponents of this theory, and its implied cultural dislocation, sum up recent events as symptomatic of the continuing evolution (some would say "excesses") of modern art and Modernism.

In vogue as well is the proposition that a Postmodern period did occur (concentrated over the decades 1970–2000), but is now all but defunct. In some respects, recent art-world signs bear this out, as formal concerns and artistic innovation appear once again to be on the ascendant. The critic and curator Nicholas Bourriard has given the label "altermodern" (alternative modern) to one of the post Postmodern movements. Although artists labeled altermodern are diverse in their approach to form and subject matter, much of their work is in response to the contemporary forces of globalization and digital interconnectivity. In studying the drawings we reproduce in this chapter, look for both the fragmentation of image held together by fluid, open-ended composition and the recurrence of certain themes such as travel through time and space, hybridization of culture and identity, and a heightened concern for global well-being.

Whether we are entering a new art historical period or not, the positions that Modernist and Postmodernists take in regard to a variety of aesthetic and philosophical issues still profoundly influence attitudes toward art and art making. To help you decipher the ideological underpinnings of the drawings in this chapter we pose a series of key questions with answers from Modernist and Postmodernist points of view. As you review these contrasting statements, see if you tend to agree more with one group or the other. And while reading the chapter, be sensitive to any resonance a particular drawing might have with your own aesthetic sensibility or value system. You may find that these questions, combined

with looking at high-quality works by contemporary professionals, will help you clarify your own position in relation to today's broad cultural movements.

Truth: Are there inviolable, absolute truths, or is truth relative?

Modernist artists search for universal truths that are communicated through significant form. For the Modernist, significant form embodies inner truths that can be interpreted across boundaries of time and culture.

Postmodernists deny fixed truths, viewing notions of truth as shifting constructions in variable cultural contexts.

Self: Do you possess a unified subjective self with a personal stamp?

For Modernists the unique self is the well-spring of true artistic creativity; the modern subjective self, however, can experience excruciating feelings of alienation.

Postmodernists claim the self to be a fiction created by language. In their view, mass media depictions have encouraged us to imagine ourselves playing so many roles that our concept of self is hopelessly fragmented.

Originality/Genius: Are originality and genius critical for the production of true art?

Modernists affirm the conventions of originality and genius and tie them to the concept of the individual.

According to Postmodernists, genius is a mythological construct that must be dismantled along with the myth of the individual. For the Postmodernist originality is trumped by the conviction that all ideas are extant in the culture, which inevitably leads to appropriation, not innovation.

Quality: Is quality in art a definable phenomenon, and one that is important to sustain?

For modernists the issue of quality is crucial and definable, and based on innovation within the strict limits of a medium's inherent characteristics; for the formalist, the earnest pursuit of pure form might even be considered a value comparable to moral virtue and strength.

The impure, eclectic approach of Postmodernism precludes any consensual agreement on standards of quality. Judgments of artistic value, however, can be applied to Postmodernist artworks, but these are generally made relative to the merit of the artist's intentions and the degree to which the art work fulfills those intentions, rather than in relation to an aesthetic canon.

The Autonomous Art Object: Should the art object be able to stand on its own?

The Modernist artwork is considered to be self sufficient, transcendent, and replete with form-based meaning. In Modernist terms, a "work" of art is a singular creation, made by one author.

In Postmodernist art meaning is contingent upon multiple voices within a broad cultural discourse, and visual information is often couched in an expository format. For these reasons, Postmodernist art is referred to as a "text."

Realism and Reality

Mimesis, or the imitation of visually perceived things and their environment, is perennially fascinating. Indeed, since Paleolithic times the degree of realism in art has waxed and waned; it was mostly at a low ebb, for instance, for about nine hundred years between the last decades of the Roman Empire through the early Gothic period. But the repeated resurgence of realistic art styles suggests that they answer to some fundamental human need to replicate important things from the world around us.

FIGURE 14–3
CRAIG MCPHERSON
Clairton from the Hill, 2006
Graphite on paper,
36⁶/₁₀ × 28⁹/₁₀"

FIGURE 14–4
KIM CADMUS OWENS
Infra Structure, 2005
Charcoal and chalk on paper, 24 × 36"

result in a constant cycle of building and demolition. Sometimes we will experience a sense of dislocation when we arrive at a place that we think we know or remember, only to find our memories of the place do not jibe with what we actually see.

This work is from a series of paintings and drawings that feature vertical striations of the sort that appear on the monitor of a computer as it is starting to crash (as a result of memory loss). The artist is fascinated by those moments at which digital technology is interrupted by static, hiccup-like pauses and other varieties of visual noise, moments that most of us would regard with frustration. She claims her interests lie less in the visual qualities of these disruptions, and more in the capacity they have to make us aware of distinctions between the digital world and the corporeal one.

In this image the vertical stripes impede our view of a bridge in the process of collapse, enabling us to draw parallels between the phenomena of digital decay and the decay associated with nature and man-made structures. In both cases a crash may be signaled. Ironically, the vertical stripes, by reminding us of the picture plane, actually increase the sense of depth in the depicted scene, restoring in our minds the scale and spatial extension of the collapsing bridge.

Abstraction

The impulse to make abstract and nonobjective art was never entirely stymied by Postmodernism's challenge to the aesthetic viability and social relevance of Modernism. There is no doubt that important, established artists have continued to make recognizably Modernist works throughout the Postmodern reign. In this chapter, however, we represent artists who, while influenced by Postmodern theory and practice, have nonetheless found a renewed pictorially visceral approach to making art. What we are seeing in these works may be defined as a hybrid form of abstract art. A hybrid in which such Modernist values as formalist improvisation and media experimentation have been restored, albeit chastened by the content imperatives of Postmodernism.

Probir Gupta's work (Fig. 14–5) is a prime example of the fusion of abstract form invention with a socially conscious narrative. Imagery in *Desert Scrap* is drawn

FIGURE 14–5
PROBIR GUPTA
His Master Voice II, 2008
Watercolour, acrylic, ironoxides and charcoal
on paper, 189 × 160 cm

FIGURE 14–6
ROLAND FLEXNER
Untitled, 2009
Sumi ink on paper, 5½ × 7"

from Gupta's experience as a social activist. Growing up in Calcutta at a time when the radical Naxalite movement was using terrorist tactics to promulgate a Maoist-style revolution, the artist developed a profound dislike of violence as a means to social change. After schooling in Paris, he returned to India where he continued to paint and to advocate for people displaced by a relentless program of slum clearance. The wholesale destruction of shanty towns not only dispossessed the impoverished population of its meager shelters, but in some horrific instances bulldozers cleared shacks with their inhabitants still in them, with deadly consequences.

Note in this drawing how bone-like shapes and valve-like objects comprise the center image, which seems put together by forces of compaction, suggesting the inhuman power of a bulldozer or other crushing device. Pale, wraithlike, free-moving objects, also recalling human bones, ply the periphery of the picture space, suggesting dispersion of the wounded and dispossessed.

One might ask why an artist would use abstract rather than an illustrational or text-based style to register social concerns. Ironically, an answer to that question might be found in Postmodernist contentions that media representations of disaster, natural or human caused, have desensitized us to the suffering of our fellow human beings. Gupta's artistic strategy is not to hit the viewer over the head with a blatant and realistic image. His work requires the viewer to access content through the contemplation of expressive form; in so doing he guides the viewer to approach content slowly from a subjective state of mind.

When looking at Roland Flexner's sumi ink drawing (Fig. 14–6) we find it difficult to separate our awareness of the medium from our contemplation of the dramatic netherworld we see pictured.

This drawing was created by using a variation on the traditional Japanese sumi technique called "suminagashi." Related to other marbleizing techniques, this decorative art involves floating ink on the surface of a tub of water or diluted gelatin, drawing into the floating ink with a piece of bamboo, and then dipping paper into the bath to transfer the ink to paper. The charm of the technique is due in large part to the unpredictable results achieved when the ink swirls across the paper as it is lifted from the bath. Flexner departs from the traditional practice

through a series of interventions such as blowing at the still-flowing ink either directly or through a straw to redirect its flow, or by tilting or blotting the paper to forge images with strong landscape connotations. Sizing up the potential for image and performing these actions must all take place within seconds of removing the paper from the bath. Since all work on the image must be performed during the brief time in which the ink is flowing, the artist has to work intensely, without recourse to reasoned analysis.

The element of chance inherent in Flexner's process recalls the random methods used by the Surrealists to tap the unconscious mind. His imagery also resembles that of the Surrealists who drew inspiration from the psychoanalytic theories of Sigmund Freud. The grotto-like space, with its inconsistent, seemingly internal light source, drifting veils and bizarre geological and vegetative growths recalls the irrational dreamscapes of Surrealist art. What we see here is the stuff of dreams or dark fairy tales, or in psychological terms, the so-called region of the Id within the mental landscape.

Julie Mehretu frequently begins her abstract paintings, prints, and drawings with linear architectural depictions, as in Figure 14–7, which also exhibits a strong landscape component.

Expressive uncertainty characterizes this print. Its architectural image is rendered unstable by shifting viewpoints, giving rise to an impression of diverse interior spaces conflated into one image. Instability is heightened by the conflict between orderly geometric schemata and dense layers of curvilinear line, two approaches that occupy opposite ends of the aesthetic spectrum. These polarities are reinforced by the opposing forces of the work's two major spatial movements: ingress, suggested by the marks dotting a pathway along the bottom edge of the picture plane, and egress, suggested by the winged, biomorphic mass bursting out diagonally in the upper left quadrant. Throughout the work, a mix of symbols, pointing to states of both reason and irrationality, vie for our attention.

Mehretu's position in regard to Modernism and Postmodernism is complex. On the one hand, the artist's vigorous gestural attack references her Abstract Expressionist predecessors; indeed, the combination of ruled lines in this work, juxtaposed to the dense layers of gestural lines and marks, may be seen to point to conflicts inherent in Modernist practice—the rationalist idealism of Modernist architecture as opposed to the expressive abandon of Abstract Expressionist painting. On the other hand, Mehretu's apparent allegiance to subject matter and to the illusion of recessive space is indicative of imagistic possibilities reopened by Postmodernist artists. Postmodern as well is the theme of hyperconnectivity embedded in this work—Mehretu's metaphorical mapping of the mass movements

FIGURE 14–7
Julie Mehretu
Landscape Allegoies, 2004
Copperplate prints, using etching, engraving, dry-point, sugar-bite and aquatint. Plate size: 29.8 × 39.4 cm, Print size: 48.3 × 54.9 cm

of goods, information, and populations so common today across the globe. But it is this work's implied yet powerful allegorical narrative that truly balances the Modernist–Postmodernist ledger. What are we to make of the fierce, uncontrollable image so explosively exiting its architectural confines? And are we to regard the various pictorial clashes in Mehretu's work as a visual correlative for the polarization of values and ideologies in our contemporary world?

The drawings we have discussed under Realism display pre-Modern values (the virtues of mimesis) in conjunction with aspects of Postmodern practice. Under the topic of Abstraction we looked at drawings that are similarly eclectic in that they demonstrate both Modernist and Postmodernist approaches to image making. The drawings we will look at in the remainder of this chapter address issues more indicative of fully-fledged Postmodernism.

Expanded Format and Mixed Media

Traditionally, two-dimensional art invites the viewer to contemplate imagery in a fictive pictorial space. A conventional format, one that is small and rectangular, is admirably suited to this end. Its intimate scale invites the viewer to relinquish everyday reality and enter an invented world in miniature. The clear boundary of the picture frame separates the experience of pictorial contemplation from everyday life: The viewer looks through the rectangular shape as through a window or door into another realm of experience.

This tradition of framing continues in much of today's pictorial art, as can be seen by scanning the numerous contemporary drawings included in this and previous chapters of this book. But many other artists have deviated from this tradition. Employing unusual media and expanded formats, their goal has been to maximize the material existence of the art object and to minimize the viewer's escape from real time and actual space. One of these artists, Vik Muniz, is famous for making and then photographing skillful drawings from fugitive nontraditional media, such as chocolate syrup or sugar. Figure 14–8 shows one of a series of very large-scaled works assembled from junk. Working in a warehouse outside Rio de Janeiro, the artist positioned himself on a forty-foot-high scaffold in order to direct his crew in placing objects on the floor so as to recreate famous European paintings of classical mythological subjects. The works, which are about the size of a basketball court and took on average one and a half months each to assemble, are photographed from the scaffold and then dismantled.

The work we show is based on a small jewellike painting by the early German Renaissance painter, Lucas Cranach the Elder. In the original painting, the twin sibling deities Apollo and Diana pose rather coyly in a green bower within an ideal pastoral landscape. The image in the Muniz work subverts the original in scale, material, and perspective. Though the figurative image is instantly recognizable as derived from the Cranach, the Muniz recreation replaces the miniaturist beauty of Cranach's vegetation and other landscape elements with tons of urban detritus—nuts and bolts, cans, barrels, fire hose, plastic bins, hubcaps, and tires.

Muniz is in effect creating a sharp disjuncture between figurative image and the materials used to create it. In conventional figurative art the material presence of the medium takes a backseat to the illusion of form and space in the image. Here the figurative image is flat, but the medium is insistently present, reminding us of the sheer quantity of stuff our materialistic culture throws away as trash. In that context, the image of Cranach's twin deities, disembodied from its original and precious form, becomes just another disposable fragment of visual and material culture.

Another artist who uses discarded objects as a drawing medium is Michael Dinges. The example we show (Fig. 14–9) is from the Dead Laptop series, in which the artist uses laptop covers as easels for imagery reflecting on a host of computer-related issues relating to privacy, social interaction, passive reception of information, and the entropy inherent in all complex systems.

FIGURE 14–8
Vik Muniz
*Apollo and Diana, after Lucas Cranach
(Pictures of Junk)*, 2006
*Sikkema Jenkins & Co.
Art © Vik Muniz/Licensed
by VAGA, New York*

FIGURE 14–9
Michael Dinges
Homing Pigeons, Dead Laptop series, 2007
Engraved plastic, acrylic paint, 9¼ × 11¼"

The sociable group we see in *Homing Pigeons* is highly anthropomorphized. The two birds on the left appear to be exclaiming loudly, or even laughing, while the two on the right appear deep in conversation. At the center of this hubbub is a pallid apple, and we wonder if the birds are joking or gossiping about the appearance of this bizarre egg.

The apple is, of course, the Macintosh icon, and the tree in which these pigeons roost is an apple tree. It would be hard not to interpret the bitten apple as a monitory reference to Adam and Eve eating from the Tree of Knowledge of Good and Evil. Looking more closely for clues linking computers with the dangers of eating forbidden fruit, we may note the little scrolls winding loosely around the pigeons' feet. These scrolls bear the domain names of social networking sites: MySpace, YouTube, and FaceBook. The lure of these sites is that they offer the promise of a greatly expanded field of "friends." But how do conversations in virtual space stack up to meeting with friends face to face? Compared to the merriment of the pigeons in Figure 14–9, conversations by computer keyboard might seem dull, at best.

Although the multilayered imagery in this work can provoke various subject-matter interpretations, much of the meaning resides in its visual form. The busy, agitated patterns by themselves create an air of excitement to accompany the pigeons' chatter. Moreover, the decorative style of the engraved imagery and text recall styles associated with a variety of folk art media, including needlework samplers, scrimshaw, and trench art. In the past these decorative styles functioned to impose meaning and order onto ordinary objects and by extension onto the lives of their makers. Dinges likes to point out that the whalers who produced scrimshaw (engraved designs on whale tooth) and the active soldiers who produced trench art (engravings on brass bomb casings) were working on objects that could kill them. That observation leaves us wondering about the dangers inherent in computer use.

Dinges seeks to transform the mass-produced object into an artwork invested with an intense degree of craft. Like many Postmodern artists he is concerned

about the effects of contemporary mediated experience, but instead of simply pointing at our predicament, he offers a way forward. His work demonstrates the DIY (do-it-yourself) ethic of alternative youth cultures and shows that it is possible to reconnect with the real world by getting involved in creative craft.

Looking at Fig. 14–10, our attention is first drawn to the image of a curious little rake, since its strong dark linear pattern dominates the pale ground surrounding it. But almost immediately the recognition dawns on us that we are looking at a photo, and that the rake is drawn on the back of a hand clawing at a female torso. The combination of rake and hand is really quite elegant, and the visual pun lies in the raking action the artist's fingernails are performing on the skin of her torso.

After years of training in conventional observational drawing, Palewicz realized that she was as intrigued with the act of mark-making and the creation of surface as she was with producing images. Making a conceptual leap, she transferred that mark-making impulse to the surface of her own body, exploring ways to make marks in her own malleable flesh by pinching, biting, squeezing, creasing, and in this case, lightly abrading it.

Palewicz is amongst a number of women artists who, since the 1970s, have used their own bodies for expressive purposes. The female nude has of course been one of the most common subjects of art since the late Renaissance, but those depictions were by and large by male artists made with the intention of providing pleasure for male viewers. Women artists of the 1970s and 1980s undermined this practice, first by taking over the production of female images, and second by assigning greater value to characteristics considered essentially female. Feminist artists of the late 1980s and into the 1990s, more concerned with the politics of equality and real social and economic reform, often depicted the female body in ways that were more confrontational, producing at times images that would evoke disgust in order to drive their message home. Artists of the third wave of feminism, sometimes referred to as "postfeminist," are politically astute, but less puritanical, more inclusive, and more likely, as in the case of Palewitz, to employ gentle humor and highlight subjective experience.

Looking again at *Raking*, take note of the range of sensations evoked by the image—the tension in the clawlike gesture of the hand, the soft, receptive quality of the flesh, and the stinging pain associated with scraped skin. Each of these sensations is calibrated in such a way as to let us know that the artist is firmly in control. She is both subject (skin) and agent (fingernails) of a unique drawing action that prevents us from regarding the female body merely as an alluring object.

FIGURE 14–10
LYNN ELIZABETH PALEWICZ
Raking, 2005
C-Print, 40 × 26"

Narrative

Narrative art is one of the genres that has made a comeback in recent years. Throughout the period of early twentieth-century Modernism, when formalist artists were regarding narrative as extraneous to their work, radio, movies, and eventually television were delivering greater and greater doses of it to an eager mass audience. Today, narrative in the visual arts abounds in forms so various that we might, for convenience, organize them into two categories. Grand narratives deal with important contemporary issues that may include morality, politics, ecological and social viability, and various types of cosmology. Lesser narratives include more intimate biographical information, private fantasies, and issues of personal identity.

The mixed media drawing by James Barsness (Fig. 14–11) ingeniously blends Pop imagery with lore and philosophy about the elephant-headed Hindu god Ganesha. Among the most popular of all Hindu deities, Ganesha is regarded as the remover of obstacles. He is known also as Ganapati, which translates literally as "Lord of Categories." According to Hindu thought, all that can be conceived of by human thought is a category, and Ganesha is the embodiment of the principle by which the connection between all things (all categories) can be comprehended. Ganesha is often depicted riding a mouse (note the saddled mouse in the lower right-hand corner), symbolizing the unity of the great and the small, the microcosm and the macrocosm. In the Barsness drawing we see that Ganesha, the god who chooses to walk the earth in service of humankind, has joined forces with Superman, the Incredible Hulk, and some dubious-looking mustachioed Edwardian type dressed in tails, striped tights, and high-heeled shoes. This unlikely group of heroes appears to be rushing to the rescue as faces from the popular press gaze out at us. While comic book superheroes generally protect the innocent from physical dangers, Ganesha saves his devotees by helping them sort out their real spiritual needs from their illusory secular desires.

The drawings and paintings of Rita Ackermann depict a private fantasy realm, rife with problems from the contemporary pop music scene in which the artist also participates as a singer. In this notebook-sized drawing (Fig. 14–12) we see one of Ackermann's depictions of a landscape inhabited by a sisterhood of waifs. According to the artist, these nymphets support each other when they are suffering from, for example, physical or substance abuse. In this dreamlike scene, one child-woman riding a huge doglike creature assists another to emerge from a trapdoor in the slime. Others recline half conscious in some drug-induced haze, while a lascivious satyr escapes from the feminine domain by climbing an impossibly steep hill. The themes of dream

FIGURE 14–11
James Barsness
King of Categories, 2001
Acrylic, ink, collage and paper on canvas, 75 × 96¾"
© James Barsness. Image courtesy of George Adams Gallery, New York

FIGURE 14–12
RITA ACKERMANN
Purple Lady, 2000
Pencil on paper,
9½ × 7¾"

states and the femme fatale are strongly reminiscent of Art Nouveau, as is the decorative use of line and motif. Perhaps the artist, a native of Czechoslovakia but living now in the fast-paced New York world of clubs and art galleries, finds moorings in this decadent style, which flourished in her native land one hundred years ago.

Paula Rego is a renowned storyteller in paintings, etchings, lithographs, and drawings. *The Young Poet* (Fig. 14–13) is one of a series of drawings recasting the classical concept of the female muse. For this series Rego posed costumed live models (the two standing muses) alongside life-sized mannequins representing the young poet, monkey, and boy-child. Given the paucity of action, our reading is dependent upon clues provided by costume, gesture, and props.

The young poet, dressed in a party frock, peers out from her wizened paper-bag face through slit-like eyes. The two muses in historic costume represent opposing types. The woman on the left, encased in heavy Victorian garb, tries to uphold conventional bourgeois standards of propriety, despite the ludicrous winged monkey emerging from her voluminous skirts. The monkey in earlier Rego works is associated with jealousy and irrational actions born of frustrated sexual desire. The second muse, with her loosened bodice, wine bottle, and streaming hair, is the nineteenth century picture of a fallen woman. This interpretation is confirmed by her position at the foot of a ladder, a deliberate reference to depictions of Mary Magdalene in scenes of Christ being taken down from the Cross. Her pose could be considered sensuously languid, or alternatively contemplative of higher spiritual values. And where does the boy doll fit into this iconography? Is he a puppet to be manipulated according to the poet's ambitions? Or is he the young poet's childhood playmate, brother, future husband or future child? Rego, who claims to delight in the stories viewers tell themselves when confronted by her works, has deliberately left much to our imaginations.

FIGURE 14–13
PAULA REGO
The Young Poet, 2007
Graphite and conté
pencil on paper, 54 × 40⅛"

FIGURE 14–14
CHARLES AVERY
Avatars, 2005
Pencil on paper,
102 × 164 cm

The narrative art of Charles Avery is a multimedia excursion into the natural and cultural history of an unnamed island situated somewhere in the middle of the world. The artist presents maps, written anthropological accounts, and many figurative drawings, sculptures, and taxidermist specimens to introduce us to the people, deities, and unusual hybrid animals that dwell on this island. Colonialists long ago relegated the indigenous inhabitants to the slums of the island's major city of Onomatopoeia. The locals congregate in bars where they discuss the question of existence and consume large quantities of nasty-tasting, but dangerously addictive, hardboiled eggs pickled in gin. Tourism is a major part of the economy and local attractions include the Plane of the Gods where tourists can meet face to face with deities, including the giant Swimmer, an old god with sagging flesh.

The taxidermist shop featured in *Avatars* (Fig. 14–14) seamlessly welds the humdrum with the fantastic. Ordinary furnishings such as desk, radiator, fire extinguisher, umbrella stand, and fluorescent light fixture, are pictured alongside such unlikely specimens as the fat, headless two-tailed snake, and on the shelves above the snake, unidentifiable little creatures, some of which seem quite alive.

That a taxidermist's shop in Avery's concocted world sells avatars is not surprising; neither is the oddly resonant parallel it makes with the contemporary use of avatars in cyberspace. Trophy hunters have their quarry stuffed so that they might bask in the status conferred upon the hunter. Hunting trophies may even be considered talismans that transfer some animalistic power to their owners, thus conflating the identities of hunter and hunted. Avatars used in cyberspace, whether the three-dimensional alter egos used in role-playing games, or the user names assumed on social networking sites, also confer status associated with powerful character types, while complicating or masking the identities of the users.

Appropriation

In our introduction to this chapter we referred to the appropriation of mass media images by Pop artists beginning in the early 1960s. This was not an entirely new practice as Dada and Surrealist artists had many years earlier appropriated images from the popular press into their satirical political collages. But Pop artists, by appropriating both pop culture imagery and the formal bravura of abstract expressionism, managed to dismantle a prime formalist belief: that works of art had to demonstrate originality. As a result artists were liberated to expand the appropriating tactic from the realm of commercial art into other areas. No image was considered too sacred or too profane for appropriation; the most mundane of commercial images as well as those excerpted from great masterpieces of Western art were now considered fair game.

Later Postmodernists put a different spin on appropriation. They grouped all images, from the old masters to those of Madison Avenue under the umbrella term of "visual culture," to underscore the photo-mediated "hyperreality" that defines our advanced technological society. For the artist, visual culture, with all its attendant meanings, is now a rich repository for creative exploration.

The drawing *America Meets in a Parking Lot for a Date with Itself* (Fig. 14–15) is from Christian Holstad's ongoing Eraserhead series. As with other drawings in the series, the source material is an actual newspaper clipping. The appropriated image is transformed by the dual method of erasing the printed ink from selected areas of the photos and adding line, expressive marks, and value to other areas. The untouched parts of the original image maintain their photographic identity, challenging the viewer to reconcile the everyday reality of a very ordinary parking lot with the surreal drama taking place.

The encounter between the two men keeping a date in this image is fraught with ambiguity. The enigma is deepened, rather than explained, by their clothing and paraphernalia; the tall man wears a party hat bearing the words "I agree!" and the shorter man, dressed in hospital scrubs, offers a balloon-like object bearing the words "Go away." The psychology of the drawing is charged with contradictory messages; we may sense a mood of hilarity undercut by despair, or geniality soured by the prospect of humiliation.

Erased passages charge the work with additional meaning. The removal of value from the figure on the left makes him seem buoyant in spite of his corpulence; the second pale facial profile located in front of the strongly delineated one gives him a hesitant look, as if he is bobbing forward. The erasure in the head of the other

FIGURE 14–15
CHRISTIAN HOLSTAD
America Meets in a Parking Lot for a Date with Itself, 2003
Pencil and gouache on erased newspaper, 7¼ × 9¼"

man is ambiguous in that it could represent a stocking or ski-mask or alternatively, his skull exposed under taut skin and wisps of hair. The steamy clouds of white surrounding the shorter man suggest an energy field as does the ghostly presence located between the two cars directly opposite from our point of view. Do the black marks swarming behind the shorter man represent carrion-feeding flies, thus augmenting a sense of decay communicated by the bare skull?

Intimations of mortality and loss gathered from the act of erasure and the generally ghoulish imagery are reinforced by the transience of the medium. The newspaper photo used as the ground for this drawing was not intended to endure. Newspapers are disposable, and newsprint, a notoriously unstable paper, is rendered even more fragile by the act of erasure.

Alice Briggs has for many years appropriated images from northern Renaissance art into her highly detailed sgraffito, or scratchboard, drawings. Scratchboard is a stiff cardboard with two coatings, the first of white kaolin and the second of black ink. Imagery is made by scratching through the ink layer to reveal the white coating below.

In Briggs' drawing, "Exodus" (Fig. 14–16), figures appropriated from fifteenth century Flemish paintings demonstrate their anguish in a contemporary industrial lot backed by a towering trestle bridge. The figures departing in terror in the lower right and the crouching mad man in the lower left are lifted from a Last Judgment painting by Rogier van der Weyden, and the falling figures are excerpted from a scene of the damned cast into Hell from a Last Judgment painting by Hans Memling. The yard, surrounded by a razor-wire-topped fence, depicts the actual grounds of an abandoned cement factory in contemporary Ciudad Juarez, Mexico.

This is one of a series of drawings depicting the brutality of narco-terrorists, the government corruption that allows it to exist, and the horrific toll that drug-related crime takes on the population living on the Mexican side of the border. The images were produced as part of a collaborative project with writer Charles Bowden. Written exposé and the collected drawings have been published together in a book titled *Dreamland*.

The project reveals that drug-related crime has rendered Ciudad Juarez one of the most dangerous places on earth. The title of the work can be explained by the figures trotting across the bridge; they represent a recent mass exodus from Juarez. (By May 2010 two hundred thirty thousand people had fled the city.)

FIGURE 14–16
ALICE LEORA BRIGGS
Exodus, 2008
Sgraffito drawing,
20 × 16"

FIGURE 14–17
NICHOLAS DI GENOVA
Wasp Grunt with Riders, 2006
Ink and acrylic on Mylar, 15 × 11"

Nicholas di Genova (Fig. 14–17) draws on several sources in developing the fantastic creatures that populate his version of a post-human world. One can easily recognize imagery and stylistic characteristics taken from Japanese manga, transformer toys and scientific illustration.

Much of what can be observed in di Genova's work is hybrid in nature. According to the artist, the world he depicts is set in a time millions of years after the apocalypse when the earth is being repopulated with fast-mutating life forms. Some of these new life forms combine parts of recognizable animals. Many others are cyborgs, meaning they are part natural and part mechanical. The "grunt wasp" in Figure 14–17 appears to be part insect and part aircraft carrier. References to cyborgs along with other types of hybrid experience recur frequently in contemporary art and criticism. The science fiction version of the cyborg is a being incapable of forming meaningful social relationships, but which nonetheless has a strong desire for human contact (think of Frankenstein's monster as an early cyborg prototype).

Di Genova's technique of drawing with ink on the front of drafting film and applying acrylic color on the back is that of traditional animation. Although his technique and some aspects of his style and subject owe much to anime and sci-fi comics, his images are much more complex and visually sophisticated than any found in animation. Note the precision with which the insects are rendered as well as the small asymmetrical features in both wasps that may indicate mutations. Focus on the multistoried load that the grunt wasp bears and you will see that it is noticeably off-balance. The artist, however, has countered the precariousness of the burden by visually stabilizing the rest of the image through a series of well-placed verticals. This back-and-forth dialog between balance and imbalance is fundamentally disorienting, adding to the anxiety a viewer might feel when contemplating the fearful world di Genova depicts.

Social and Political Themes

Dissatisfaction with social or political conditions, a recurrent theme in Western art since the late eighteenth century, is still a motivating force in art today. Much of this work is intended to protest specific injustices, and a growing number of political

FIGURE 14–18
SUE COE
Please Help Us, 2006
Graphite
Courtesy of Galerie St. Etienne, New York

artists urge viewers to get involved. Still other artists are able to use the production of the art itself as an agent of actual social, political, or environmental change.

Sue Coe's work has effectively illuminated a range of social and political issues such as animal rights, apartheid, rape, racism, and the war in Iraq. The dramatic scene in Figure 14–18 is from a series of drawings that Coe made in critique of the inadequate government response to Hurricane Katrina. Its long-shot view includes many depictions of individual suffering compressed into one image. Examining the picture bit by bit, we see clouds pouring down rain and gales ripping up trees and power poles; we take in horrors such as floating corpses (one bearing a rat), and the desperate situation of a family gathered around a half-submerged vehicle. We see weakened swimmers calling for help while a huge storm surge bears down on them and alligators displaced from their destroyed wetlands. We see one small rescue boat battling heroically against the odds, as people cling to a tree or huddle on housetops with homemade signs asking for help.

The images in this work are familiar; the events before, during, and after the hurricane were heavily covered by the mass media. So why go to the trouble of making drawings about a much-photographed event? One answer could be that the extended amount of time needed to peruse this drawing in all its detail affords the viewer the opportunity to examine the subject and reflect on the events. But the power of the image lies not only in its subject matter but also in its form. Observe how the strong diagonals bearing down on the flood are picked up by swirling movements of wave and clouds. These large movements divide the picture into two spatial pockets separated by a storm cloud so abstract and so malevolent looking that we can regard it as a monster come to tear the world asunder. Note the expressive use of marks to indicate a massive downpour, of clouds boiling and lighting flashing. And throughout the entire image it is Coe's particularly tactile handling of the graphite medium that helps to elicit visceral responses in the viewer, responses that in this case range from horror to deep compassion.

Mel Chin is a political activist and artist with a long career in the field of public art. He is also one of many who have made work to protest the torture of prisoners held under suspicion of terrorism at Guantanamo. While many artists have shown graphic images of torture, or displayed the types of cages used for detaining suspects, Figure 14–19 is a work that employs imagery in a poetic rather than a literal sense. The drawing is based on a study by the pre-Raphaelite artist, William Dyce, which in turn is based on a fresco by Domenichino located in a monastery basilica at Grottaferratta near Rome. The subject of the fresco is the

miraculous healing of a child through the prayers of St. Nilus. In the fresco, one robed man supports the "possessed" child against his body while another pulls the child's mouth open so as to let the evil spirits out.

That mission of mercy is antithetical to bitter, contemporary realities the artist has chosen not to depict, namely techniques like waterboarding used to extract information from the mouths of political prisoners. Reflecting the artist's own anxiety in regard to state-sponsored torture, this drawing is intended to give voice to unknown political prisoners who have no voice and no place to go. The torn edges of the paper that graze the subject's extended fingers and toes refer to stressful confinement and an agonized psychological state removed from normal reality.

The brooding landscape seen in Figure 14–20, is actually a still from an animated film, *Felix in Exile,* by South African artist William Kentridge. The films are made from a series of charcoal drawings, one for each scene. The artist animates each scene by making and photographing a sequence of changes to the drawing. The ghosting of previous stages of the drawing imbue each successive image with the memory of previous action. The physical traces left by erasure are significant to Kentridge, whose stated intent is to preserve the memory of the South African apartheid system and its slow unraveling.

For this artist, landscape is an important and complex narrative sign, for under apartheid both the land and its people were colonized and exploited. In his films the land plays the roles of victim, participant, and witness to the apartheid system. The landscape outside Johannesburg, as shown in the still we have reproduced, is portrayed as deeply scarred by tire tracks and mine tailings. Throughout this film the landscape absorbs history as the corpses of apartheid's victims melt into it, while in the distance a great shape, half cloud-half rock, looms on the horizon. This spectral

FIGURE 14–19
MEL CHIN
Guantanamo, 2003
Pencil and colored pencil on paper,
16 × 11¾"

FIGURE 14–20
WILLIAM KENTRIDGE
Landscape
Charcoal and pastel on paper,
47¼ × 59"

image of "the immovable rock of apartheid," though oppressive, invites conquest, transforming this symbol of longstanding collective shame into a beacon of hope.

Trained in both anthropology and fine art, Kenyan-born Wangechi Mutu produces work that challenges fixed notions of race, gender, beauty, history, and geography. Combining hand-drawn elements with collaged photographic materials, she constructs female figures of disturbing beauty and power.

Gender and ethnic stereotypes abound in Figure 14–21, in which we see an energetic female performing a dance that appears to involve a lot of aggressive stomping and kicking. Exaggerated racial characteristics combine with stereotypical notions of African costume, including grass skirt and elaborate horned headdress, to let us know that we are looking at an exotic creature. Exoticism is enhanced by animalistic features such as her patterned skin and the hippopotamus heads that serve as hands clacking like castanets. Juxtaposed with the stiletto-heeled shoe, these features communicate an essence of dangerous sexuality.

A closer look will reveal that this Africanized sex goddess bears horrible wounds; her right foot is a mangled mass of blood and tiny motorcycles, and a splatter of blood indicates where other motorcycles have nailed a horn to the right side of her head; even the left foot and shoe seems buckled to her leg with a bloody motorcycle. This figure is an amputee sporting unusual prostheses. She is, in fact, a cyborg.

The tendency of patriarchal cultures to project their fears and desires onto women's bodies has had a horrifying impact on the female population of war-torn

FIGURE 14–21
Wangechi Mutu
One Hundred Lavish Months of Bushwhack, 2004
Cut-and-pasted printed paper with watercolor, synthetic polymer paint, and pressure-sensitive stickers on transparentized paper, irreg. 68½ × 42"

countries. Images of amputation in Mutu's work often refer to the mass rape and mutilation of women and children during the ethnic wars in Rwanda, and diamond wars in West Africa. In this regard, the small nubile girl supporting the dancer in Figure 14–21 might be seen to stand for those most vulnerable to predation. The damaged but still-dancing figure represents the survivor. She is the one who understands how fear and hatred can provoke attacks on the innocent; she also has the spirit to overcome her own misfortunes and the wisdom to lead the new generation into a better future.

The female figure in Zak Smith's *Crawler 2* (Fig. 14–22), like Mutu's wounded dancer, sports cybernetic parts as a fashion statement. And both women have endured by toughening up in response to the demands of contemporary culture. But while Mutu's dancer, in spite of her exoticism, can be considered an allegory for the suffering of all women, Smith's punk "girl" is an exemplar of a particular subculture and its ethic. The punk movement, which is inherently political, is also fascinated with body modification and with all things futuristic, extraterrestrial, or gothic.

The scene in *Crawler 2* recalls a scenario one might see in the *Weird Science* comics of the 1950s, in which armed space travelers are confronted by extraterrestrial monsters. Smith has translated that confrontation into a more earthly doomsday event located in a treeless urban plaza surrounded by stylized versions of contemporary architecture.

Smith's art is intense in its quantity and in its intricacy. Although he never directly appropriates imagery, he liberally quotes a variety of popular and decorative styles including those of comic books, fanzines, fabric design, op art, the Viennese Secessionist artist Gustav Klimt and even, in this case, the broken spheres of Italian sculptor Arnaldo Pomodoro. Sheer excess of pattern in costume, architectural setting, and even in the stalactite formations in the sky imply a suffocating fin de siècle atmosphere. But for all its references to styles outside the purview of "high art," Smith's style demonstrates a degree of visual awareness that locates his work firmly in the sphere of fine art rather than decorative

FIGURE 14–22
ZAK SMITH
Crawler 2, 2009
Ink on paper, 11 × 7"

art or illustration. This can be noted especially in the way that bright contrasts of black and white in the building to the right give way to subtle and downright beautiful passages of modulated grays in the patio tiles and in the girl's tank top.

Art and Technology

The art world, like our culture as a whole, has for a long time had a love/hate relationship with technology. While we would not want to do without our modern conveniences, we also recognize that technology separates us from direct contact with nature and the verifiable truths of physical reality. Since traditionally the visual arts recreate the physical world by accentuating tactile experience, most artists have been reluctant to give up the sheer sensuality of conventional art media (e.g., drawing, painting, sculpture) for the more disembodied forms of electronic media. A growing number of artists, however, now regard technology as an exciting tool by which to accomplish their artistic ends.

The lack of fixed physical form makes electronic media ideal for Postmodern explorations. Postmodern theorists have questioned the aura of uniqueness we sense in a fine work of art, that very quality that confers status and value on an exceptional art object. They speculate that specialized cultural conventions govern not only the way we respond to art, but also our tendency to assign power to the static art masterpiece. Digital art, by contrast, is open-ended or provisional in its form; it can always be easily edited or transformed altogether. Digital technology, aided by the Internet, has also made collaborative and interactive art possible on an unprecedented scale, thus answering the Postmodernist call for a more democratic approach to art making. This inevitably challenges traditional notions regarding authorship and ownership of an image.

Nam June Paik has long been hailed as a pioneer of technologically produced art. In his video work, Paik transformed a medium associated with mass entertainment and marketing into an interactive art experience. He proclaimed that the dissemination of video art would promote the coming of a "global village." His video works are alternately critical, meditative, and delightfully entertaining.

Three Elements (Fig. 14–23), is a laser installation Paik conceived for the Guggenheim Museum. It comprises three self-contained laser and mirror constructions based on the simple geometric shapes of circle, triangle, and square. The triangular piece we show here recalls the religious architecture of various cultures. Its shape, minimalism, and razor-sharp lines are reminiscent of an Egyptian pyramid, while the tall, central, light-filled space flanked by two smaller side aisles brings to mind a Christian basilica.

Within the work's triangular mirrored chamber, we perceive a space of seemingly infinite depth. Mesmerizing as the illusion is, however, we cannot hold onto it for long. This is because the image changes as motors redirect the lasers and also because we are aware of the apparatus used to create the illusion, since no attempt has been made to conceal it. Thus, our tendency to be hypnotized by the pleasing illusion is thwarted by our awareness that this artful deception is created literally of smoke and mirrors. In theatrically revealing the nature of his artifice, Paik makes us self-conscious collaborators who participate with the piece in real time. The nature of audience involvement compromises aesthetic distance and thus dispels the autonomy of the art object so prized by Modernism.

The images by Anne Wilson (Fig. 14–24) are from a video and sound installation in which fiber art (one of the most ancient of all extant technologies) is used in conjunction with the contemporary digital arts of stop-action animation and electronic music. The abstract configurations, or "physical drawings," shown in the stills have been crafted from black lace or lace-like textiles that the artist has obtained secondhand. These she alters through a work-intensive process of unraveling individual strands and then knitting or crocheting them back together, often using insect-specimen mounting pins as knitting needles.

FIGURE 14–23
NAM JUNE PAIK
Three Elements, 1997–2000
Lasers, mirrored chambers,
prisms, motors, and smoke;
Triangle, 128 × 148 × 48"

(a)

(b)

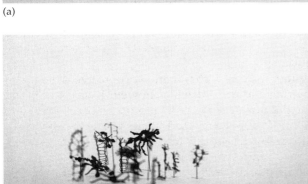

(c)

(d)

FIGURE 14–24
ANNE WILSON
Video stills from *Errant Behaviors*,
2004

 The tiny constructions along with the specimen pins constitute a cast of char-acters that were manipulated and photographed one frame at a time to make two videos, each of which is divided into twelve short segments. The videos are shown simultaneously on two large screens; each video is accompanied by a soundtrack. Since the segments are played in shuffled order, the combinations of actions appear-ing at any given moment on the two screens are almost endless in their permutations.

Although the lacy configurations are quite abstract, they take on a multitude of identities, both architectural and biological in character. In some sequences the camera looks down on formations that resemble the reckless growth of a futurist or extraterrestrial city. In a shift of implied scale, other sequences suggest the activity of an insect colony seen in slow motion. Close-up segments, like those in Figure 14–24, take implied scale down even further, showing primordial beings as they come quivering to life and multiply, take diverse forms or unravel, gather and disperse, pile up, or advance menacingly on one another. An original musical score by Shawn Decker, composed of both processed and found sounds, uses ominous sustained chords interspersed with passages of clinking, rattling, bubbling, and percussive chirps, to emphasize the somewhat malevolent character of the hive-like activity.

Lilla LoCurto and William Outcault have relocated part of their art-making process from the artist's studio to the high-tech laboratory. The artist couple has arranged to use equipment ordinarily employed in medical imaging to explore the content implications of digitally mapping the surfaces of their own bodies. They see three-dimensional imaging as a contemporary extension of the Cubist practice of projecting three-dimensional reality onto a two-dimensional surface without recourse to a fixed point of view. The three-dimensional scanner that they use, moves slowly around the body collecting many different profiles that are subsequently assembled by a computer into a hollow three-dimensional humanoid model in virtual space. Once back in the studio the artists use computer software they have developed to alter, reassemble, and choreograph the human shells that they use in their video animations. Drawings and prints, such as Figure 14–25, are spin-offs made midway through the production of the videos.

The composition of *telemon 6* may at first glance appear very abstract, but a closer look will reveal parts of precisely plotted figures. The easiest to locate is that of a seated male. His lower body, seen directly from above, is located on the left side of the drawing, and his torso and parts of his arms and face can be seen on the right side. The large translucent curving planes that partially veil or enclose the central imagery represent cross-cut segments of the body "shell" or topology.

In scanning their own bodies the artists discovered that the hollow shells suggest fragility, vulnerability, and anonymity, characteristics that they exaggerate through a variety of means. For example, cutting up the human shell and rendering it transparent increases the sense of fragility. Detecting a sense of vulnerability in the jagged tears that appear in the depicted flesh, they withhold from repairing them, even though software exists that would allow them to do so. Frequently they include their faces in the images to temper the anonymity this process brings to their depictions.

FIGURE 14–25
LILLA LoCURTO and WILLIAM OUTCAULT,
telemon 6, 2009
Pigment print, 24 × 34"

FIGURE 14–26
WILL YACKULIC
Untitled Outpost, 2009
Ink, gouache, watercolor,
typewriter on paper, 12 × 9¾"

Is the geodesic sphere in Figure 14–26 a satellite or a mirrored disco ball? A tantric mandala signifying the microcosm of the individual's inner world in relation to the macrocosm? A soothsayer's crystal ball? The crystal-powered spacecraft of the ancient people of Atlantis departing from their outpost on planet Earth to establish a new utopia in the Pegasus galaxy? The pilotless, cargo-free ship, bobbing light as a cork over the ocean waves, in Rimbaud's proto-Surrealist poem "The Drunken Boat," or the poet himself making that journey in a bubble, like Glinda, the Good Witch of Oz?

These are all interpretations, some supported by the artist's own poetical writings, that can reasonably be assigned to the uncanny drawings Will Yackulic makes with the help of a 1930s vintage, large-carriage manual typewriter. Using ribbons of black, blue, and red ink, he taps out the asterisks and hyphens that form images of sky and swelling ocean waves.

If we choose to see Yackulic's spheres as representing literal rather than metaphorical realities, then we are forced to locate them in the future. Pushing that interpretation we might ask if these are gigantic and highly technological surrogate biospheres serving as final human outposts in a world made inhabitable by catastrophic climate change. Or since there is no indication of scale in these works, can they possibly be tiny time capsules for the storage of data and DNA that have been set adrift by a human population that knows its own future on Earth is doomed?

It is not only the mysterious subject matter and the ambiguity of scale that make this work so beguiling. The typed punctuation marks, unlike those produced by laser or ink-jet printing, are insistently tactile because the metal typeface indents the paper and drives varying amounts of ink into the surface of the paper according to the force used in individual keystrokes. This imparts warmth to the image as do the bright twinkling glitches in the striated upper portions of the sky, the waves of energy radiating from either side of the sphere, and the reverse perspective of the waves that pulls the horizon close to us.

Globalization

"Interconnectivity" and "globalization" are words commonly used to describe twenty-first century culture. While most will agree that digital communication is a good thing, the drawbacks and benefits of globalization have been hotly disputed. On the one hand, the global marketplace has been used for the continued export of Western goods and culture, a situation decried by many as detrimental to previously colonized cultures struggling for redefinition and indigenous identity. On the

other hand, it could be argued that a global approach to worldwide issues of human rights, world health, population growth, national sovereignty, terrorism, and the environment offers the only hope for the long-term survival of the human species.

In this chapter we have already looked at art works that touch on global issues such as worldwide dissemination of information, foreign relations, colonialism, cultural cross-pollination, and intimations of a post-human future. We now look at works that address global issues more directly.

Globalization may be inevitable given the exponential growth of world population. One artist attempting to come to grips with the rapid rate of urban transformation is Berlin-based Franz Ackermann. A worldwide traveler, he documents the many foreign places he has visited in small gouache drawings he describes as "mental maps." These works do not aim to please the viewer with distinctive exotic scenes or picturesque views. Instead, they are records of urban locales that combine some of the aspects of street maps with more subjective recollections of specific architectural spaces. Although the artist never depicts people in his scenes, viewing a collection of his urbanscapes will give you the impression of an overpopulated world layered with activities relating to commerce, travel, and the endless building of skyscrapers.

In the mental map in Figure 14–27, note how the absence of nature or local scenery frustrates our ability to identify the place, yet we still recognize the all-too-familiar phenomenon of artificial environments that have supplanted real geography and cultural differentiation. Far-reaching jetties and cantilevered platforms have extended the shorelines of the three foreground landmasses. Modern buildings disrupt the natural skyline, while their foundations violate the Earth below sea level. The ocean itself is crisscrossed with wavy lines reaching like tentacles or nerve cell ganglia from the urban centers. These lines of differing intensities relate to international trade and may be interpreted as shipping lanes, real or intended, or perhaps lines of telecommunication. The impression we are left with is a biosphere already choked with human production and consumption, with no relief in sight.

The towering column we see in Figure 14–28 is Sandow Birk's fictitious monument celebrating the sixtieth anniversary of the ratification of the Universal Declaration of Human Rights (UDHR) by the fledgling United Nations. This document, which appears word for word on the column, identifies basic unalienable rights of the individual pertaining to education, family and marriage, health, housing, food, and employment. In 1948 the UN delegates who voted unanimously for this proclamation thought that recognition of these rights and their enactment through the laws of all nations, would result in lasting worldwide peace, international cooperation, and prosperity. The UDHR has in fact set standards for legislation in developing nations and has served as a basis for international law.

Birk's celebratory monument, however, like the neighborhoods surrounding it, is in a sad state of disrepair. It lists horribly to one side, where it is propped

FIGURE 14–27
Franz Ackermann
Untitled (Mental Map: plans for more trading), 2000
Watercolor and pencil on paper, $5\frac{1}{8} \times 7\frac{7}{16}$"

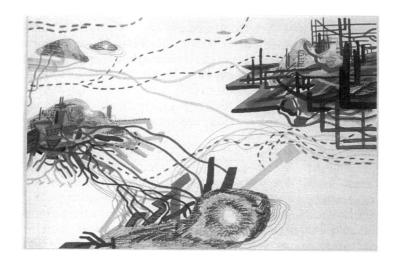

FIGURE 14–28
SANDOW BIRK
*Monument to the Universal
Declaration of Human Rights*, 2008
Ink on paper, 88 × 56"

by an ungainly conglomeration of trusses and utility pipes. At the top of the column, a triumphal figure representing the universal human has been joined by an array of satellite dishes, surveillance cameras, and cell phone transceivers.

Smoke-belching factories and tenements occupy the middle ground. In the foreground we see the rudimentary shacks and houseboats of the truly destitute. (These rundown habitations are modeled after the favelas of Rio de Janeiro and Manilla.) A razor-wire-topped fence separates the slums from the pathetic monument grounds with its single leafless tree (the only tree in the entire image). More video cameras mounted on lampposts keep a suspicious eye on the poor. In the distance, a gleaming city center, a veritable postmodern Babylon, is located at a safe remove from the monument and the miserable dwellings huddled at its base.

The skyscrapers Birk depicts include luxurious landmark architecture from worldwide trade centers such as Los Angeles, London, Dubai, Taipei, and Beijing. In juxtaposing the crumbling monument with structures representing international wealth and poverty, the artist alludes to the way that forces of economic globalism are eroding human rights and creating greater disparity between the rich and poor at home and abroad.

Ellen Driscoll's drawing (Fig. 14–29), like Franz Ackermann's, is a landscape with maplike qualities. It is one of a suite of drawings included in a gallery installation titled "Fastforwardfossil Part II," in which the artist conceived a future dystopia to warn us of the consequences of our rampant consumption of fossil fuels. The installation was centered on an intricate 28-foot-long model of a future city fashioned entirely from used PVC water and milk jugs. The suite of drawings depicted variations on the model structures set in bleak landscapes. This future human refuge,

FIGURE 14–29
ELLEN DRISCOLL
Untitled, 2007
Ink and pencil on paper,
11¾ × 34½"

FIGURE 14–30
KERSTIN KARTSCHER
*A Plan to Escape from the World's
Reversals*, 2004
Felt-tip pen and gel-ink pen on
paper, 27¼ × 39"

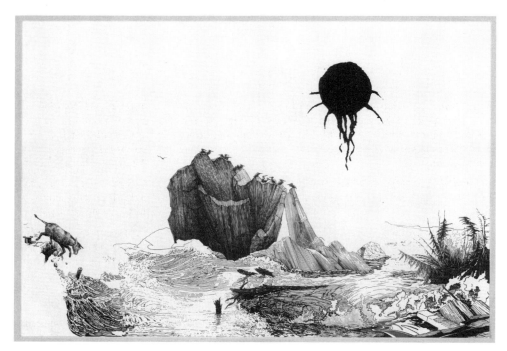

as conceived in the artist's model and drawings is located on the North Sea where corporations plan to build tract homes on oil rigs that already host shanty towns.

The drawing from the suite that we reproduce as Figure 14–29 depicts a watery landscape in which the only "landmass" is the platform of the oil rig in the upper right. In the foreground great transmission towers have fallen over, their slack wires and glass transistors pulled awry. Their disarray and ghostly pallor (reminiscent of the translucence of the PVC architectural model) suggest that they have outlived their purpose. Indeed, the frail lines of their lattice trusses are no match for the vast, gray, dominion of world-wide inundation.

The mysterious landscape by Kerstin Kartscher (Fig. 14–30) is unmoored in space and time. The presence of the diminutive donkey plunging unnaturally into the surf alerts us that something is not right in this future Eden. Even more troubling is the strange, dark astral body hanging in the sky. It is hard to assign specific meaning to this unfamiliar object, which dominates the picture by virtue of its intense blackness. Has it caused a cataclysm that has wiped human inhabitants from the face of the Earth, or is it merely the residue of a massive event? The fact that it is sending down roots or tendrils as if to drink from the ocean below suggests that it may contain some unknown life source that has come to take up residence on our beautiful planet.

And a beautiful planet it continues to be, whether or not humans still exist to witness the tracery of shoreline plants against the sky, the calligraphic swirls of sea foam on the waves, or the sculpted outcroppings of rock.

Glossary

Abstraction The process of selecting and organizing the visual elements to make a unified work of art. Also a twentieth-century style of art in which the particulars of subject matter are generalized in the interests of formal (compositional) invention.

Achromatic Denotes the absence of hue and refers to the neutrals of black, white, and gray. (See also *Chromatic* and *Neutrals*.)

Actual Gray Uniform value achieved by the continuous deposit of drawing media, such as blended charcoal or ink wash. (See also *Optical Gray*.)

Altermodern Alternative modern movement proposed by critic and curator, Nicolas Bourriaud, to supersede Postmodernism. Embraces new, hybrid forms of twenty-first century art that emphasize outgrowths of planetary culture, such as layered and fluid conceptions of time and universal networks of communication.

Ambiguous Space A visual phenomenon occurring when the spatial relationships between positive and negative shapes are perceptually unstable or uncertain. (See also *Figure–Ground Shift, Interspace,* and *Positive–Negative Reversals*.)

Analogous Color Scheme A color arrangement based on several hues that are adjacent or near one another on the color wheel. (See also *Analogous Colors* and *Color Scheme*.)

Analogous Colors Colors that are adjacent, or near one another, on the color wheel and therefore have strong hue similarity. One set of analogous colors is yellow, yellow-green, green, and blue-green. (See also *Analogous Color Scheme* and *Color Scheme*.)

Angling The process of transferring perceived angles in the environment to a drawing surface.

Appropriation The artistic reuse of imagery or stylistic characteristics of previously existing works of art or other cultural products. Post-modern artists use appropriation to change the context in which we see cultural artifacts, with the intent of causing the viewer to consider the layers of meaning attached to image or text.

Approximate Symmetry A form of visual balance that entails dividing an image into similar halves while at the same time avoiding the potentially static quality of mirror-like opposites associated with symmetrical balance. (See also *Asymmetrical Balance* and *Symmetrical Balance*.)

Artistic Block The interruption of an artist's natural creative output. Often accompanied by feelings of severe frustration and loss of confidence.

Asymmetrical Balance A dynamic form of visual equilibrium in which the two sides of an image do not mirror each other. This is achieved by adjusting such qualities as the scale, placement, and emphasis of visual elements in different parts of a composition. (See also *Approximate Symmetry* and *Symmetrical Balance*.)

Atmospheric Perspective A means for achieving the illusion of three-dimensional space in a pictorial work of art. Sometimes called aerial perspective, it is based on the fact that as objects recede into the distance their clarity of definition and surface contrast diminish appreciably.

Automatic Drawing An intuitive process practiced by the Surrealists which enabled them to tap subconscious sources of imagery.

Background The most distant zone of space in a three-dimensional illusion. (See also *Foreground* and *Middleground*.)

Basetone The darkest tone on a form, located on that part of the surface that is turned away from the rays of light. (See also *Chiaroscuro*.)

Blind Contour Line drawings produced without looking at the paper. Such drawings are done to heighten the feeling for space and form and to improve eye-hand coordination.

Brilliance The vividness of a color.

Cast Shadow The shadow thrown by a form onto an adjacent or nearby surface in a direction away from the light source. (See also *Chiaroscuro*.)

Chiaroscuro Refers to the gradual transition of values used to create the illusion of light and shadow on a three-dimensional form. The gradations of light may be separated

into five separate zones: highlight, quarter-tone, halftone, basetone, reflected light, and cast shadow.

Chromatic Refers to color or the property of hue. (See also *Achromatic* and *Hue*.)

Chromatic Gray Gray created by adding hue to a neutral or by mixing complements to achieve a neutralized color. (See also *Neutrals*.)

Color Scheme An association of selected colors that establishes a color harmony and acts as a unifying factor in a work of art. (See also *Analogous, Complementary, Discordant, Monochromatic,* and *Triadic Color Schemes*.)

Complementary Color Scheme A color arrangement based on hues that are directly opposite one another on the color wheel. (See also *Color Scheme* and *Complementary Colors*.)

Complementary Colors Colors that are directly opposite one another on the color wheel and represent the strongest hue contrast, such as red and green, blue and orange, and yellow and purple. (See also *Complementary Color Scheme*.)

Complex Local Color The natural range of hues of some objects that, under normal light, create the overall impression of a dominant local color. (See also *Local Color*.)

Cone of Vision A conical volume that constitutes the three-dimensional field of vision. Its apex is located at eye level; its base lies within the imagined picture plane. (See also *Picture Plane*.)

Constellation The grouping of points in a three-dimensional space to form a flat configuration or image.

Content The meanings inferred from the subject matter and form of a work of art.

Contour Line A line of varying thickness—and often tone and speed—used to suggest the three-dimensional qualities of an object. Contour line may be applied within as well as along the outer edges of a depicted form.

Convergence In the system of linear perspective, parallel lines in nature appear to converge (come together) as they recede.

Cool Colors Psychologically associated, for example, with streams, lakes, and foliage in the shade. Cool colors such as green, blue-green, blue, and blue-purple appear to recede in a relationship with warmer colors. (See also *Warm Colors*.)

Cropping Using a format to mask out parts of an image's subject matter.

Cross-Contour Lines Contour lines that appear to go around a depicted object's surface, thereby indicating the turn of its form.

Cross-Hatching The intersecting of hatched or massed lines to produce optical gray tones. (See also *Hatched Line* and *Optical Gray*.)

Diagrammatic Marks Those marks and lines artists use to analyze and express the relative position and scale of forms in space.

Diminution In linear perspective, the phenomenon of similarly-scaled objects diminishing, or appearing smaller as they recede.

Discordant Color Scheme A color arrangement based on hues that compete or conflict, resulting in a relationship of disharmony. (See also *Color Scheme*.)

Envisioned Images Depictions that are based wholly or in part on the artist's imagination or recall.

Eye Level The height at which your eyes are located in relation to the ground plane. Things seen by looking up are above eye-level (or seen from a "worm's eye" view); things seen by looking down are below eye-level (or seen from a "bird's eye" view). (See also *Horizon Line*.)

Figure The representation of a recognizable object or non-representational shape which may be readily distinguished from its visual context in a drawing. (See also *Ground*.)

Figure–Ground Shift A type of ambiguous space that combines aspects of interspace and positive–negative reversals. It is characterized by "active" or somewhat volumetric negative areas and by the perception that virtually all the shapes are slipping, or shifting, in and out of positive (figure) and negative (ground) identities. (See also *Ambiguous Space, Interspace,* and *Positive–Negative Reversal*.)

Figure–Ground Stacking A sequential overlapping of forms in a drawing, making the terms figure and ground relative designations.

Fixed Position Refers to the depiction of an observed object in accordance with its appearance from one physical position.

Flat-Bed Picture Plane A picture plane that mimics a horizontal surface, such as a desk or table top, rather than the conventional vertical of a window.

Foreground The closest zone of space in a three-dimensional illusion. (See also *Background* and *Middleground*.)

Foreshortening A method for depicting an object when its longest dimension is positioned at an angle to the picture plane.

Form The shape, structure, and volume of actual objects in our environment, or the depiction of three-dimensional objects in a work of art. Form also refers to a drawing's total visual structure or composition.

Form Meaning That aspect of content that is derived from an artwork's form, that is, the character of its lines, shapes, colors, and other elements, and the nature of their organizational relationships overall.

Form Summary A simplified form description of a complex or articulated object, usually for purposes of analysis or to render a subject's three-dimensional character more boldly.

Formal Refers to an emphasis on the organizational form, or composition, of a work of art.

Formalism A concept which places supreme value on aesthetic sensation and the perception of an artwork's form (such as composition and application of art elements). Formalists maintain that meaning resides within the artwork and considerations such as subject matter or the artist's motivations are of secondary importance. Related to the theory of *Significant Form*.

Format The overall shape and size of the drawing surface.

Frottage A technique that involves laying a support, such as a piece of paper, over a textured surface, and rubbing it with a drawing medium such as chalk or lead, in order to transfer a texture.

Gestalt A total mental picture, or conception, of a form.

Gesture Drawing A spontaneous representation of the dominant physical and expressive attitudes of a figure, object, or space.

Grisaille In reference to an image composed entirely in shades of gray.

Ground The actual flat surface of a drawing, synonymous with a drawing's opaque picture plane. In a three-dimensional illusion, ground also refers to the area behind or around an object (or figure).

Ground Plane A horizontal plane parallel to the eye-level's plane. In nature this plane may correspond, for instance, to flat terrain, a floor, or a tabletop.

Halftone After the highlight and quarter-tone, the next brightest area of illumination on a form. The halftone is located on that part of the surface that is parallel to the rays of light. (See also *Chiaroscuro*.)

Hatched Line Massed strokes that are parallel or roughly parallel to each other. Used to produce optical gray tones. (See also *Cross-Hatching* and *Optical Gray*.)

Highlight The brightest area of illumination on a form, which appears on that part of the surface most perpendicular to the light source. (See also *Chiaroscuro*.)

History Painting A picture that is usually painted in a grand or academic manner and represents themes from history, literature, or the Bible.

Horizon Line The line formed by the *apparent* intersection of the plane established by the eye-level with the ground plane. Often described as synonymous with eye-level.

Hue The name of a color, such as red, orange, or blue-green. The term *chromatic* is sometimes used to refer to the property of hue. (See also *Chromatic*.)

Installation Art A form of mixed media, multidisciplinary art that is created specifically for the architectural space or environment in which it is shown.

Intensity The saturation, or purity, of a color.

Interspace Sometimes considered synonymous with negative space. But in the work of some modern artists it may be applied more appropriately to describe shapes that simultaneously depict illusions of depth and some degree of form. (See also *Ambiguous Space*.)

Kitsch Usually used pejoratively to describe cultural artifacts of little or no artistic value or taste. Kitsch objects, often mass produced for an undiscriminating mass audience, may be sentimental in character.

Layout The placement of an image within a two-dimensional format.

Linear Perspective A system for representing deep space from a single point of view, it is based on the premise that things that are close appear larger than those things that are farther away. When drawing subjects characterized by parallel lines (box-like forms and architecture) the application of the rules of linear perspective will entail the systematic convergence of those lines in a drawing.

Local Color The actual color of an object, free of variable or unnatural lighting conditions. (See also *Complex Local Color*.)

Local Value The inherent tonality of an object's surface, regardless of incidental lighting effects or surface texture.

Luminosity Certain visual effects achieved through color or tonal interaction, for example, the effect of an illusion of light that appears to emanate from "inside" a color area.

Mass The weight or density of an object.

Mass Gesture A complex of gestural marks used to express the density and weight of a form.

Measuring A proportioning technique using a pencil to gauge the relative dimensions of objects as seen from a particular point of view. (See *Shape Aspect*.)

Middleground The intermediate zone of space in a three-dimensional illusion. (See also *Background* and *Foreground*.)

Mimesis The faithful imitation of natural appearances.

Modern Art A historical movement initiated in the mid-nineteeth century and continuing through the 1960s. The many strains of Modern Art share a tendency to reject traditional and academic forms and the aim of addressing content more relevant to modern life.

Modernism A movement within Modern Art characterized by the conviction that content resides chiefly in artistic form. Modernist art, often abstract or non-objective, recognizes the autonomy of the art object. (See *Formalism* and *Significant Form*.)

Monochromatic Consisting of one color.

Monochromatic Color Scheme A color arrangement consisting of value and intensity variations of one hue. (See also *Color Scheme*.)

Motif The repetition of a visual element, such as a line, shape, or unit of texture, to help unify a work of art.

Negative Shape The pictorial, flat counterpart of negative, or framed, space in the real world.

Neutrals Refers to black, white, and gray. (See also *Achromatic* and *Chromatic Gray*.)

Nonobjective A style of art in which the imagery is solely the product of the artist's imagination and therefore without reference to things in the real world.

One-Point Perspective A variety of linear perspective in which a rectangular volume is centered on the line of vision, thus causing all receding (horizontal) parallel lines to appear to converge, or meet, at one point on the horizon line.

Optical Color Refers to the eye's tendency to mix small strokes of color that are placed side by side or overlapped.

Optical Gray The eye's involuntary blending of hatched or cross-hatched lines to produce the sensation of a tone. (See also *Actual Gray* and *Cross-Hatching*.)

Outline Usually a mechanical-looking line of uniform thickness, tone, and speed, which serves as a boundary between a form and its environment.

Overall Image The sum total of all the shapes, positive and negative, in a drawing.

Overlapping The partial obscuring from view of an object by another object located in front of it.

Perceived Color The observed modification in the local color of an object, which is caused by changes in lighting or by the influence of reflected colors from surrounding objects.

Pictorial Refers to a picture, not only its actual two-dimensional space but also its potential for three-dimensional illusion.

Picture Plane The actual flat surface, or opaque plane, on which a drawing is produced. It also refers to the imaginary, transparent "window on nature" that represents the format of a drawing mentally superimposed over real-world subject matter.

Planar Analysis A structural description of a form in which its complex curves are generalized into major planar zones.

Positive Shape The pictorial, flat counterparts of forms in the real world.

Positive–Negative Reversals A visual phenomenon occurring when shapes in a drawing alternate between positive and negative identities. (See also *Ambiguous Space*.)

Postmodernism A movement initiated in the mid-20th century in reaction to Modernism in which emphasis on subject-matter meaning displaced the Modernist artist's preoccupation with form. (See also *Modernism*.)

Primary Colors The three fundamental colors—red, yellow, and blue—that cannot be produced by mixing other hues or colors. When mixed in pairs or combined in admixtures containing all three, the primaries are the source for all the other hues on the color wheel. (See also *Secondary Colors*.)

Principles of Design The means by which artists organize and integrate the visual elements into a unified arrangement, including unity and variety, contrast, emphasis, balance, movement, repetition, rhythm, and economy.

Proportion The relative sizes of part to part and part to whole within an object or composition.

Push-Pull Spatial tension created by color interaction.

Quartertone After the highlight, the next brightest area of illumination on a form. (See also *Chiaroscuro*.)

Reflected Light The relatively weak light that bounces off a nearby surface onto the shadowed side of a form. (See also *Chiaroscuro*.)

Relative Position A means by which to represent and judge the spatial position of an object in a three-dimensional illusion. Generally, shapes and lines appearing higher on the picture plane will appear farther away.

Relative Scale A means by which to represent and judge the spatial position of an object in a three-dimensional illusion. Generally, things that are larger in scale seem closer; when there is a relative decrease in the scale of forms (especially if we know them to be of similar size) we judge them to be receding into the distance.

Secondary Colors The three hues—orange, purple, and green—that are each the result of mixing two primaries.

Sgraffito A subtractive method of drawing that involves scratching through a layer of paint or ink to reveal a substrate of a contrasting color or value.

Shades A color darkened by adding black.

Shape A flat area with a particular outer edge, or boundary. In drawing, shape may refer to the overall area of the format or to the subdivided areas within the format.

Shape Aspect The shape of something seen from any one vantage point.

Shape Summary A simplification of the major areas of a complex three-dimensional form into flat shapes, usually for purposes of analysis.

Significant Form An aesthetic theory developed by English art critic, Clive Bell, in the early 20th century. It ascribes form in visual art with the power to affect the emotions of viewers. (See also "Formalism.)

Simultaneous Color Contrast The perceived enhancement of contrast between two different colors that are placed together.

Space In the environment, space may be defined as area, volume, or distance. In drawing, space may be experienced as either a three-dimensional illusion or as the actual two-dimensional area upon which a drawing is produced. (See also *Picture Plane*.)

Spatial Configuration The flat shape or image produced by connecting various points in a spatial field.

Spatial Gesture The gestural movement implied by a perceived linkage of objects distributed in space.

Station Point In the system of linear perspective, the fixed position you occupy in relation to your subject (often abbreviated SP).

Subject Matter Those things represented in a work of art, such as a landscape, portrait, or imaginary event.

Subject Meaning That aspect of content derived from subject matter in a work of art.

Subjective Color The arbitrary color choices used to convey emotional or imaginative responses to a subject.

Symmetrical Balance Symmetrical balance is achieved by dividing an image into virtually mirrorlike halves. (See also *Approximate Symmetry* and *Asymmetrical Balance*.)

Synesthesia The impression that of one of your five senses is being evoked when another sense is actually stimulated—for example, hearing a G major chord might evoke the color blue.

Tertiary Colors Colors made by mixing a primary and an analogous secondary color. Mixing red with orange, for example, produces the tertiary red-orange.

Three-Dimensional Space The actual space of our environment, or the representation of it, through a pictorial illusion.

Three-Point Perspective The kind of linear perspective used to draw a very large or very close object. In three-point perspective, the object is positioned at an angle to the picture plane and is seen from an extreme eye-level, with the result that both the horizontal *and* the vertical parallel lines appear to converge, or meet, respectively at three separate vanishing points.

Tint A color lightened by the addition of white.

Tonal Key The coordination of a group of values in a drawing for purposes of organization and to establish a pervasive mood. Tonal keys may be high, middle, or low.

Topographical Marks Any marks or lines used to analyze and indicate the surface terrain of a depicted object. Cross-contour lines, used to show the curvature of surfaces and hatched lines, when used to describe the inflections of planes, are both topographical marks.

Triadic Color Scheme A color arrangement based on three hues that are equidistant from one another on the color wheel. (See also *Color Scheme*.)

Triangulation Angling between a set of three points on the picture plane to accurately proportion the overall image of your drawing.

Two-Dimensional Space The flat, actual surface area of a drawing, which is the product of the length times the width of your paper or drawing support. Synonymous with the opaque picture plane and flat ground of a drawing.

Two-Point Perspective The type of linear perspective used to draw a rectangular volume when none of its faces is parallel to the picture plane. In this case the receding (horizontal) parallel lines appear to meet at two separate points on the horizon line.

Value Black, white, and the gradations of gray tones between them, or the lightness or darkness of a color when compared with a gray scale.

Value Shapes The major areas of light and shade on a subject organized into shapes, each of which is assigned a particular tone that is coordinated with the values of other shapes in the drawing.

Vanishing Point In linear perspective, the point on the horizon line at which receding parallel lines appear to converge, or meet.

Viewfinder A device that functions as a rectangular "window" on your subject. It is a useful aid for proportioning and layout.

Visual Elements The means by which artists make visible their ideas and responses to the world, including line, value (or tone), shape, texture, and color.

Visual Weight The potential of any element or area of a drawing to attract the eye.

Volume The overall size of an object and, by extension, the quantity of three-dimensional space it occupies.

Warm Colors Colors psychologically associated, for example, with sunlight or fire. Warm colors such as red, red-orange, yellow, and yellow-orange appear to advance in a relationship with cooler colors. (See also *Cool Colors*.)

Working Drawings The studies artists make in preparation for a final work of art or as a means of analyzing a work in progress.

Credits

INTRODUCTON

0–1 Art Resource, New York; 0–2 The Royal Collection © 2011, Her Majesty Queen Elizabeth II; 0–3 Teylers Museum, Haarlem, The Netherlands; 0–4 Santa Barbara Museum of Art, museum purchase; 0–5 Réunion des Musées Nationaux/Art Resource, New York; 0–6 Wadsworth Atheneum Museum of Art/Art Resource, New York; Purchased through the gift of James Junius Goodwin. 1950.605; 0–7 Harvard Art Museums/Fogg Museum, Bequest of Meta and Paul J. Sachs, 1965.312 Photo: Allan Macintyre © President and Fellows of Harvard College; 0–8 Bildarchiv Preussischer Kulturbesitz/Art Resource, New York; 0–9 Alte Pinakothek, Bayerische Staatsgemaeldesammlungen, Munich, Germany/ Bildarchiv Preussischer Kulturbesitz/Art Resource, New York; 0–10 Sonnabend Gallery, New York; 0–11 Sonnabend Gallery, New York; 0–12 Copyright Ed Ruscha; 0–13 Whitney Museum of American Art, New York; purchased with funds from the Drawing Committee 2000.252; 0–14 Museum purchase. Courtesy of San Diego Museum of Art. Copyright Robert Bechtle. Courtesy of Gladstone Gallery, New York; 0–15 Courtesy of A. Van Campenhout; 0–16 © 1969 Walter De Maria; 0–17 Courtesy of Mikal Korostyshevsky. Instructor: William Sayler, Pratt Institute; 0–18 Gift of Felix M. Warburg and his family, 1941 (41.1.35)/The Metropolitan Museum of Art/Art Resource, New York; 0–19 Gift of Felix M. Warburg and his family, 1941 (41.1.36)/The Metropolitan Museum of Art/Art Resource, New York; 0–20 R. G. Ojeda/Réunion des Musées Nationaux/Art Resource, New York/© 2011 ARS, © 2011 Estate of Pablo Picasso/ Artists Rights Society (ARS), New York; 0–21 R. G. Ojeda/Musee Picasso, Paris, France/Réunion des Musées Nationaux/Art Resource, New York/© 2011 ARS, © 2011 Estate of Pablo Picasso/ Artists Rights Society (ARS), New York; 0–22 R. G. Ojeda./Réunion des Musées Nationaux/Art Resource, New York/© 2011 ARS, © 2011 Estate of Pablo Picasso/Artists Rights Society (ARS), New York; 0–23 Courtesy of UR; 0–24 © 2011 Artists Rights Society (ARS), New York/SABAM, Brussels; 0–25 Whitney Museum of American Art, New York; Gift of Lloyd Goodrich 96.210a-hhhh. © Whitney Museum of American Art, New York; 0–26 © Ashmolean Museum, Oxford; 0–27 Courtesy of Kenneth O'Connell; 0–28 Courtesy of Gaia Persico

CHAPTER 1

1–1 © 2011 Estate of John Marin/Artists Rights Society (ARS), New York; 1–2 Whitney Museum of American Art, New York; Purchased with funds from the Friends of the Whitney Museum of American Art 60.64; 1–3 Courtesy of Sabine Deviche; 1–4 Courtesy of Daniel Bergman; 1–8 Courtesy of Dana Velan; 1–10 Harris Brisbane Dick Fund, 1941 (41.48.3), The Metropolitan Museum of Art/Art Resource, New York; 1–11 Collection of Mrs. Edwin A. Bergman. Art © Wayne Thiebaud/Licensed by VAGA, New York; 1–12

© John Lees, Courtesy of Betty Cunningham Gallery, New York; 1–13 Courtesy of A. van Campenhout; 1–14 Courtesy of Michael Kareken; 1–15 Drawing copyright of Jeanette Barnes, photo of work by John Jones; 1–16 National Gallery, London, Great Britain/Art Resource, New York; 1–17 Art © Wayne Thiebaud/Licensed by VAGA, New York; 1–18 Gift of Mrs. Alice H. Patterson given in memory of Tiffany Blake, 1945.15, The Art Institute of Chicago. Photography © The Art Institute of Chicago; 1–19 The Metropolitan Museum of Art/Art Resource, New York; 1–20 Whitney Museum of American Art, New York; Gift of Mr. and Mrs. Arthur G. Altschul 71.230; 1–21 The Baltimore Museum of Art: Thomas E. Benesch Memorial Collection, BMA1969.2. © The Estate of Richard Diebenkorn; 1–22 The Philip L. Goodwin Collection. (104.1958)/The Museum of Modern Art, New York, U.S.A./Digital Image © The Museum of Modern Art/Licensed by SCALA/Art Resource, New York,© ARS, New York Lower Manhattan, 1920. © 2011 Estate of John Marin/ Artists Rights Society (ARS), New York; 1–23 Netherlandish 14th Century (artist), The Death of the Virgin. Rosenwald Collection, Image courtesy of National Gallery of Art, Washington, DC; 1–24 The Museum of Modern Art/Licensed by Scala–Art Resource, New York; 1–25 The Samuel Courtauld Trust, The Courtauld Gallery, London; 1–26 The forest of pines (ink on paper), Tohaku, Hasegawa (1539–1610)/Tokyo National Museum, Japan/The Bridgeman Art Library International; 1–27 Courtesy of Ben Schwab; 1–28 Restricted gifts of Stanley M. Freehling and Joseph R. Shapiro, 1965.245, The Art Institute of Chicago. © Nolde Stiftung Seebuell; 1–29 The Metropolitan Museum of Art, Harris Brisbane Dick Fund, 1935 (35.103.19)/Art Resource, New York; 1–30 Courtesy of Georgeanne Cooper; 1–31 Courtesy of Will Pereira; 1–32 Collection of the Minnesota Museum of American Art; 1–33 Courtesy of Anne Wildey; 1–34 Courtesy of Ben Schwab; 1–35 Courtesy of Elyn Zimmerman; 1–36 Private Collection, Auckland. Courtesy of Ruth Cleland and Melanie Roger Gallery, Auckland, New Zealand; 1–37 The Pierpont Morgan Library/Art Resource, New York; 1–38 Courtesy of the Estate of Michael Mazur and Mary Ryan Gallery, New York; 1–39 Gift of the Estate of Grant J. Pick, 1963.397r, The Art Institute of Chicago,© 2011 Artists Rights Society (ARS), New York/ADAGP, Paris; 1–40 © The Estate of Nancy Spero Licensed by VAGA, New York/Courtesy of Galerie Lelong, New York; 1–41 The Art Institute of Chicago. Photography © The Art Institute of Chicago; 1–42 Courtesy of Jennifer Wroblewski; 1–43 © 2011 Succession Giacometti/Artists Rights Society (ARS), New York/ADAGP, Paris; 1–44 Courtesy of Lee Deigaard; 1–45 Courtesy of Amanda Nurre; 1–46 Courtesy of Georgeanne Cooper

CHAPTER 2

2–1 Andrew Topolski, "Overground II"; Gift of Werner H. and Sarah-Ann Kramarsky, Image courtesy of National Gallery of Art, Washington; 2–2 Solomon R. Guggenheim Museum, New York;

Gift of James J. Hanafy, 1976 76.2265; **2–3a** Courtesy of Michelle Cooke; **2–4** The Museum of Modern Art/Licensed by SCALA/Art Resource, New York; **2–5** Art © George and Helen Segal Foundation/Licensed by VAGA, New York; **2–6** © 2011 Artists Rights Society (ARS), New York/ADAGP, Paris; **2–7a** Photograph courtesy of Barb Bondy, Auburn University; **2–7b** Courtesy of Betsy McCallen; **2–8** Arthur Heun Purchase Fund, 1951.1, The Art Institute of Chicago. Photography © The Art Institute of Chicago; **2–9** The Metropolitan Museum of Art/Art Resource, New York; **2–10** © Neil Welliver, Courtesy of Alexandre Gallery, New York; **2–11** Solomon R. Guggenheim Museum, New York; Gift of Norman Dubrow, 1984. 84.3196; **2–12** Digital Image © The Museum of Modern Art/Licensed by SCALA/Art Resource, New York/© Sigmar Polke; **2–13** © 2003 Willem de Kooning Revocable Trust/© 2011 The Willem de Kooning Foundation/Artists Rights Society (ARS), New York; **2–14** Courtesy of Bethany Berg; **2–15** Courtesy of Jamie Geiser

CHAPTER 3

3–1 Alinari/Art Resource, New York; **3–2a** Scala/Art Resource, New York; **3–5** Courtesy of Haley Askenas; **3–8** Courtesy of Jessica Englund; **3–9** Jennifer O'Donogue, Cochise College, Arizona; **3–11** Courtesy of Alan Dworkowitz; **3–12** Dorling Kindersley; **3–13** Pearson Education/PH College; **3–14** Courtesy of Jack Long; **3–15** Courtesy of Angela Burch Tingle

CHAPTER 4

4–1 Whitney Museum of American Art, New York; purchase 31.463/Courtesy of Kraushaar Galleries, New York; **4–2** The Art Institute of Chicago. Photography © The Art Institute of Chicago; **4–3** © Vincent Desiderio, Courtesy of Marlborough Gallery, New York; **4–6** Courtesy of the Addison Gallery of American Art, Philips Academy, Andover, MA; **4–7** Courtesy of Joel Janowitz. Photo by Greg Heins; **4–8a** Courtesy of Julia Huang; **4–8b** Courtesy of Nicholas Leopoulos; **4–9** Reprinted by permission of Esquire. © 1966 by Esquire Magazine and the Hearst Corporation; **4–10a** Alinari/Art Resource, New York; **4–11** Alinari/Art Resource, New York; **4–12** RKO/Album/Newscom; **4–19** Courtesy of Jacob Etheredge; **4–20** Bequest of Irving K Pond, 1939.2243, The Art Institute of Chicago. Photography © The Art Institute of Chicago; **4–25** © Craig Mcpherson, Courtesy of Forum Gallery, New York; **4–26** Courtesy of Nancy Wilkins; **4–27** Courtesy of Toni Spaeth; **4–31** Digital Image © The Museum of Modern Art/Licensed by SCALA/Art Resource, New York; **4–34** Courtesy of Diane C. Olivier+H99; **4–36** Courtesy of Nam Kim. Instructor: William Sayler, Pratt Institute

CHAPTER 5

5–1 Copyright Claes Oldenburg and Coosje van Bruggen. Courtesy of Leo Castelli Gallery; **5–2** The Baltimore Museum of Art: Thomas E. Benesch Memorial Collection, BMA1974.5; **5–3** Ashmolean Museum, Oxford, England, U.K.; **5–4** The Royal Collection © 2003, Her Majesty Queen Elizabeth II; **5–5** Private Collection; **5–6** The Museum of Modern Art/Licensed by SCALA/Art Resource, New York; **5–7** Philadelphia Museum of Art: Bequest of Jules E. Mastbaum, 1929; **5–8** The Museum of Modern Art/Licensed by SCALA/Art Resource, New York, © 2011 Succession H. Matisse/Artists Rights Society (ARS), New York; **5–9** Courtesy of Lowell M. Brown; **5–10** Art © Wolf Kahn/Licensed by VAGA, New York; **5–11** Courtesy of Mark Ferri Intreccio; **5–12** Courtesy of Ying Kit Chan; **5–13** Courtesy of C. Brent Ferguson. Instructor: William Sayler, Pratt Institute; **5–14** The Museum of Modern Art/Licensed by SCALA/Art Resource, New York; **5–16** Photo courtesy of the Museum of Art, Rhode Island School of Design. © 2011 Estate of Pablo Picasso/Artists Rights Society (ARS), New York; **5–18** Solomon R. Guggenheim Museum, New York; Gift of the artist 83.3026; **5–19** Yale University Art Gallery, Gift of Sally and Wynn Kramarsky; **5–20** Courtesy of Yusuke Ito; **5–21** Courtesy of Hea Jung Kim; **5–22** Courtesy of Herbert Olds; **5–23** Courtesy of the estate of Michael

Mazur and Mary Ryan Gallery, New York; **5–24** © The Trustees of The British Museum/Art Resource, New York; **5–25** Courtesy of Tamara Malkin-Stuart; **5–26** Fine Arts Museums of San Francisco, Achenbch Foundation for Graphic Arts purchase and William H. Noble Bequest Fund, (1978.2.31); **5–27** Whitney Museum of American Art, New York; Gift of Gertrude Vanderbilt Whitney 31.548a-b; **5–28** Solomon R. Guggenheim Museum, New York; 48.1172.X189. Photo: Robert E. Mates; **5–29** Courtesy of the Chihuly Studios; **5–30** Courtesy of Alison Norlen; **5–31** The Metropolitan Museum of Art/Art Resource, New York, Robert Lehman Collection, 1975 (1975.1.862); **5–32** Courtesy of Sean P. Gallagher; **5–33** Gift of The Frederick and Lucy S. Herman Foundation, 2006.11.12, Collection University of Virginia Art Museum; **5–34** Courtesy of Brad Kuennen; **5–35** Ashmolean Museum, Oxford, England, U.K.; **5–36** Harvard Art Museums/Fogg Art Museum, Bequest of Grenville L. Winthrop, 1943.542, Photo: Imaging Department © President and Fellows of Harvard College; **5–37** The Metropolitan Museum of Art/Art Resource, New York, Rogers Fund, 1919 (19.125.2); **5–38** Minneapolis Institute of Arts. © 2011 Artists Rights Society (ARS), New York/VG Bild-Kunst, Bonn; **5–39** Whitney Museum of American Art, New York; Gift of Mr. and Mrs. Walter Fillin 77.39; **5–40** Courtesy of Grosvenor Gallery (Fine Arts) Limited; **5–41** Gift of The Frederick and Lucy S. Herman Foundation, 2007.15.32, Collection University of Virginia Art Museum; **5–42** Courtesy of William Conger; **5–43** © Estate of John T. Biggers/Licensed by VAGA, New York; Courtesy of Michael Rosenfeld Gallery, LLC, New York; **5–44** Courtesy of Marc Spangenberg

CHAPTER 6

6–1 © Claudio Bravo, Courtesy of Marlborough Gallery, New York; **6–2** The Samuel Courtauld Trust, The Courtauld Gallery, London; **6–3** Collection of The Rose Art Museum, Brandeis University, Waltham, Massachusetts; Gift of the Friends of the Rose Art Museum Acquistion Society. Art © Wayne Thiebaud/Licensed by VAGA, New York; **6–4** The Estate of Avigdor Arikha; **6–6** Courtesy of Jen Harris; **6–7** Courtesy of Zena Alieva; **6–8** Courtesy of Jordan Horn; **6–9** Photo courtesy of the Museum of Art, Rhode Island School of Design. © 2011 Estate of Pablo Picasso/Artists Rights Society (ARS), New York; **6–10** Francine Seders Gallery, Seattle, WA; **6–11** Collection of Mr. and Mrs. James A. Fisher, Pittsburgh, PA; **6–14** Courtesy of Darice Polo; **6–15** Courtesy of M. Austin Gorum, Instructor: William Sayler, Pratt Institute; **6–16** Princeton University Art Museum, Gift of Miss Margaret Mower for the Elsa Durand Mower Collection, x1968 1; **6–17** The Museum of Modern Art/Licensed by Scala/Art Resource, New York; **6–18** Whitney Museum of American Art, New York; Purchased with funds from Peggy and Richard Danziger 78.55. © Chuck Close, Courtesy of The Pace Gallery; **6–20** Courtesy of Masa Aoe; **6–21** Photolibrary; **6–23** Courtesy of the Newspace Gallery, Los Angeles, CA; **6–24** Courtesy of Mitosh Patel; **6–25** © Copyright in this photograph reserved to the Ashmolean Museum, Oxford; **6–26** The Metropolitan Museum of Art/Art Resource, New York; **6–27** Christian Jean/Louvre, Paris, France/Réunion des Musées Nationaux/Art Resource, New York; **6–28** Collection of Phoenix Art Museum, Gift of Edward Jacobson; **6–29** © Philip Pearlstein, Courtesy of Betty Cuningham Gallery, New York; **6–30** Courtesy of Phillip Chen; **6–31** Courtesy of John Rockwell; **6–32** Robert Hull Fleming Museum, University of Vermont, Gift of Henry Schnakenberg (1971.2.10); **6–34** Mrs. Florence M. Schoenborn Fund. (585.1970)/The Museum of Modern Art/Licensed by Scala/Art Resource, New York; **6–35** © Claudio Bravo, Courtesy of Marlborough Gallery, New York; **6–36** Courtesy of the Mary Ann Currier; **6–37** Art © Estate of Robert Arneson/Licensed by VAGA, New York; Image courtesy of George Adams Gallery, New York

CHAPTER 7

7–1 Art © James Rosenquist/Licensed by VAGA, New York; **7–2** The Museum of Modern Art/Licensed by SCALA/Art Resource, New York, John B. Turner Fund. (414.1969); **7–3** Courtesy of Lee Bontecou; **7–4** Whitney Museum of American Art, New York; purchase 33.78;

7–5 Courtesy of Charles Stiven; 7–6 Courtesy of Artist and Metro Pictures; 7–7 © Andrew Wyeth. Private Collection; 7–8 The Pierpont Morgan Library/Art Resource, New York; 7–9 © Nolde Stiftung Seebuell; 7–11 Courtesy of the ACA Galleries, New York; © 2011 Estate of Luis A. Jimenez, Jr./Artists Rights Society (ARS), New York; 7–12 Restricted gift of Mrs. Irving Forman, 1968.42, The Art Institute of Chicago, Photo courtesy of George Adams Gallery, New York; 7–13 Courtesy of the Nancy Hoffman Gallery; 7–14 Gift of Mr. and Mrs. Charles B. Benenson. (261.1966)/The Museum of Modern Art/ Licensed by SCALA/Art Resource, New York; © 2011 C. Herscovici, London/Artists Rights Society (ARS), New York; 7–15 Courtesy of J. Marlene Mueller; 7–16 Courtesy of Chereen Tanner; 7–17 Courtesy of Spiro Koulouris; 7–18 Courtesy of Marcia Smartt; 7–19 © 2011 Artists Rights Society (ARS), New York/VG Bild-Kunst, Bonn; 7–20 © 2011 Succession Giacometti/Artists Rights Society (ARS), New York/ADAGP, Paris; 7–21 Scala/Art Resource, New York; 7–22 © Ernst Barlach Lizenzverwaltung Ratzeburg, Hamburg, Germany; 7–23 Courtesy of Elizabeth Murray; 7–24 Courtesy of Crystal Bray; 7–25 Bibliotheque Nationale, Paris; 7–26 © Frank Auerbach; 7–27 Courtesy of John Bennett; 7–28 The Samuel Courtauld Trust, The Courtauld Gallery, London; 7–31 Courtesy of Susan Hlaudy

CHAPTER 8

8–1 Courtesy of the New York Academy of Medicine Library; 8–2 Courtesy of the New York Academy of Medicine Library; 8–3 Courtesy of the New York Academy of Medicine Library; 8–4 Courtesy of Ellen Steinnon; 8–5 Courtesy of Mynke Buskens, www.drawings.nl Photo: Peter Cox; 8–7 Courtesy of Colin Kilian; 8–8 Whitney Museum of American Art, New York; Felicia Meyer Marsh Bequest 80.31.27. © Estate of Reginald Marsh/Art Students League, New York/Artists Rights Society (ARS), New York; 8–9 Courtesy of Roni Callahan; 8–10 Courtesy of Jennifer Wong; 8–11 Courtesy of Brent Lashley; 8–12 Courtesy of the New York Academy of Medicine Library; 8–13 Courtesy of the New York Academy of Medicine Library; 8–15a Gérard Blot/Louvre, Paris, France/Réunion des Musées Nationaux/Art Resource, New York; 8–18 Courtesy of Mindy Carson; 8–19 Courtesy of Aidan Schapera; 8–20 Courtesy of Martha Mayer Erlebacher; 8–21 Courtesy of the New York Academy of Medicine Library; 8–22 Courtesy of the New York Academy of Medicine Library; 8–23 Courtesy of the New York Academy of Medicine Library; 8–24 French 17th Century (artist), Kneeling Man Bound to a Tree, c. 1685, Woodner Collection, Gift of Andrea Woodner. Image courtesy of National Gallery of Art, Washington, DC; 8–25 Courtesy of Erika Johns; 8–26 Courtesy of Rodiney Gustke; 8–27 Courtesy of Rob Anderson; 8–28 British Museum, London, Great Britain/© The Trustees of the British Museum/Art Resource, New York; 8–29 © V&A Images/Victoria and Albert Museum, London; 8–30 © Copyright in this photograph reserved to the Ashmolean Musueum, Oxford; 8–31 Wien Albertina; 8–32 Courtesy of the New York Academy of Medicine Library; 8–33 ©James Valerio. Image courtesy of George Adams Gallery, New York; Collection of Ambassador and Mrs. Edward Elson. Photo: eeva-inkeri; 8–34 Courtesy of Erika Johns; 8–35 © Copyright in this photograph reserved to the Ashmolean Museum, Oxford; 8–36 Courtesy of the New York Academy of Medicine Library; 8–37 Courtesy of the New York Academy of Medicine Library; 8–38 Courtesy of Daniel Ludwig; 8–39 © Steven Assael, Courtesy of Forum Gallery, New York; 8–40 © Steven Assael, Courtesy of Forum Gallery, New York; 8–41 Arkansas Arts Center Foundation Purchase: 1988. AAC Coll. 88.43. Courtesy of Forum Gallery, New York, Los Angeles. All Rights Reserved; 8–42 Courtesy of Emil Robinson; 8–43 Courtesy of Kupferstichkabinett-Berlin. Staatliche Museen zu Berlin. © 2003 Bildarchiv Preussischer Kulturbesitzz. Foto: Jorg P. Anders; 8–44 Courtesy of Emily Kelly; 8–45 Harvard Art Museums/Fogg Museum, Bequest of Grenville L. Winthrop, 1943.910 Photo: Katya Kallsen © President and Fellows of Harvard College; 8–46 Courtesy of Erika Johns; 8–47 Art © Jon F. Anderson, Estate of Paul Cadmus/Licensed by VAGA, New York; 8–48 Courtesy of Lorraine Shemesh; 8–49a Whitney Museum of American Art, New York; Gift of Bella and Sol Fishko (76.25). © Estate of Raphael Soyer, Courtesy of Forum Gallery, New York; 8–50 Courtesy of Mary Schartman; 8–51

The Pierpont Morgan Library, New York, U.S.A./Art Resource, New York; 8–52 Courtesy of Michael A. Colbert; 8–53 Courtesy of Brandon Raygo; 8–54 Courtesy of Dan O'Connor; 8–56 © James Valerio. Image courtesy of George Adams Gallery, New York. Collection of Kenneth Spitzbard; 8–57 Courtesy of Brent Lashley; 8–58 Courtesy of Kaitlyn Fitz; 8–59 Réunion des Musées Nationaux/Art Resource, New York; 8–60 Courtesy of Carolina Curran; 8–61 Courtesy of Andrew Casto; 8–62 Courtesy of Andrew Casto; 8–63 Courtesy of Kaitlin Fitz; 8–64 Courtesy of Aidan Schapera; 8–65 Courtesy of Tess Wrathall

CHAPTER 9

9–1 Digital Image © The Museum of Modern Art/Licensed by SCALA/Art Resource, New York; Courtesy of Elizabeth Peyton and Gavin Brown's Enterprise; 9–2 Private Collection, New York; Courtesy of Bridgewater/Lustberg Gallery; 9–3 © Philip Pearlstein, Courtesy of Betty Cuningham Gallery, New York; 9–4 © Sidney Goodman, courtesy Seraphin Gallery, Philadelphia; 9–5 Used by permission of the artist, Courtesy of Forum Gallery, New York, Los Angeles, All Rights reserved; 9–6 © The Estate of Alice Neel, Courtesy of David Zwirner, New York; 9–7 Courtesy of Jack Rutberg Fine Arts, Inc., Los Angeles, © Jerome Witkin; 9–8 © Susan Hauptman, courtesy of Forum Gallery, New York; 9–9 Archiefdienst voor Kennemerland, Haarlem, The Netherlands (53-9219G); 9–10 © V&A Images/Victoria and Albert Museum, London; 9–11 Courtesy of the Lisson Gallery, London; 9–12 Bittleman Works LLC; 9–13 © John Lees, Courtesy of Betty Cunningham Gallery, New York; Photo: Pelka/Noble Photography; 9–14 Courtesy of Sean P. Gallagher; 9–15 Art © Wayne Thiebaud/Licensed by VAGA, New York; Photo courtesy of the Allan Stone Gallery, New York; Photo: Ivan Dalla Tana; 9–16 Norton Simon Art Foundation, Gift of Mr. Norton Simon; 9–17 Museum De Lakenhal, Leiden, The Netherlands; 9–18 Collection of Shelley and Ann Weinstein—G.A.D. Courtesy of Wanda Hansen Gallery–Studio Space; 9–19 © G. Daniel Massad, courtesy of Forum Gallery, New York; 9–20 Art © Estate of Tom Wesselmann/Licensed by VAGA, New York; 9–21 Collection of the Minnesota Museum of American Art. Art © Janet Fish/Licensed by VAGA, New York; 9–22 Copyright Lucas Samaras. Courtesy of Pace/MacGill Gallery, New York; 9–23 Courtesy of the Francine Seders Gallery, Seattle, Washington; 9–24 Antonio Lopez Garcia, Courtesy of Marlborough Gallery, New York; © 2011 Artists Rights Society (ARS), New York/VEGAP, Madrid; 9–25 Digital Image © The Museum of Modern Art/Licensed by SCALA/Art Resource, New York; Courtesy of Robert Birmelin; 9–26 Courtesy of the Printworks Gallery, Chicago; 9–27 Bildarchiv Oesterreichischen Nationalbibliothek. Picture Archive ONB, Vienna; 9–28 © 2011 Red Grooms/Artists Rights Society (ARS), New York; 9–29 © Luiz Cruz Azaceta. Image courtesy of George Adams Gallery, New York; 9–30 Courtesy of Mary Joan Waid; 9–31 Courtesy of Elyn Zimmerman; 9–32 Digital Image © The Museum of Modern Art/Licensed by SCALA/Art Resource, New York; Gift of R. L. B. Tobin in honor of Lily Auchincloss. The Museum of Modern Art, New York; Courtesy of Paul Wonner & William Brown Foundation; 9–33 Courtesy of the Manny Farber Estate and Quint Contemporary Art; 9–34 Courtesy of Jason Butler; 9–35 Courtesy of Tom Bennett; 9–36 Courtesy of Jennifer Plourde; 9–37 Courtesy of Daniel Nilsson; 9–38 Courtesy of David Larson; 9–39 Courtesy of Claudia Hershner; 9–40 Courtesy of Tiffany Gobler; 9–41 Courtesy of Sherilyn Hulme; 9–42 Whitney Museum of American Art, New York; Purchased with funds from The Lauder Foundation, Leonard and Evelyn Lauder Fund 96.68.123/Gary W. Harm, deceased, nephew of Wanda Gag

CHAPTER 10

10–1 Museum of Fine Arts, Boston, The Hayden Collection-Charles Henry Hayden Fund, 10.35. Photograph © 2011 Museum of Fine Arts, Boston; 10–3 Museum of Fine Arts, Boston, Gift of Dr. Hans Schaeffer, 55.28. Photograph © 2011 Museum of Fine Arts, Boston; 10–8 Bildarchiv Preussischer Kulturbesitz/Art Resource, New York; 10–9 Art Resource, New York; 10–10 © 2011 Renate, Hans & Maria Hofmann Trust/Artists Rights Society (ARS), New York; 10–11

Arkansas Arts Center Foundation Collection: Purchase. 1985.85.040; **10–16** Courtesy of Trevor Ponder; **10–17a** Courtesy of Amanda Nurre; **10–17b** Courtesy of Amanda Nurre; **10–17c** Courtesy of Amanda Nurre; **10–18** Courtesy of Heather Convey. Instructor: Billy Lee, University of North Carolina at Greensboro; **10–19** Courtesy of Ryan Kersh; **10–20** Museum of Fine Arts, Boston; Gift of Quincy Adams Shaw through Quincy Adams Shaw, Jr. and Mrs. Marian Shaw Haughton 17.1485. Photograph © 2011 Museum of Fine Arts, Boston; **10–21** Vincent van Gogh Foundation/National Museum, Amsterdam, The Netherlands. Stedelijk Museum; **10–22** © Ed Paschke, Whitney Museum of American Art, New York; purchase, with funds from the Drawing Committee 84.46; **10–23** Courtesy of Graham Nickson; **10–24** © 2011 Joel Shapiro/Artists Rights Society (ARS), New York; **10–25** Art © Alex Katz/Licensed by VAGA, New York, New York; **10–26** Whitney Museum of American Art, New York; gift of Dr. Marilynn and Ivan C. Karp 75.50; **10–27** Gift of Mr. and Mrs. Herbert Fischbach./The Museum of Modern Art/ Licensed by Scala/Art Resource, New York; **10–28** Whitney Museum of American Art, New York; purchase, with funds from an anonymous donor 79.40. Art © Estate of David Smith/Licensed by VAGA, New York; **10–29** Courtesy of the Burchfield-Penney Art Center; **10–30** Courtesy of the Michael Ananian; **10–31** © Christopher Sickels; **10–32** Courtesy of Taylor Hsiao: **10–33** Courtesy of Noelle Fridrich; **10–34** Courtesy of David Andrews; **10–35** Courtesy of Matthew Kruse; **10–36** Courtesy of Julie McCreedy; **10–37** Arkansas Arts Center Foundation Collection: Purchase. 1984.043; **10–38** Courtesy of Tom Bennett

CHAPTER 11

11–1 Art © Lester Beall, Jr. Trust/Licensed by VAGA, New York; **11–2** Copyright in this Photograph Reserved to the Ashmolean Musuem, Oxford.; **11–3** © 1997 Sue Coe. Courtesy of Galerie St. Etienne, New York; **11–4** Courtesy of Madden Harkness; **11–5** Courtesy of the Printworks Gallery, Chicago; **11–6** Rijksmuseum Kroller Muller, © 2011 Artists Rights Society (ARS), New York/ ADAGP, Paris; **11–7** Courtesy of Ronald Feldman Fine Arts, New York; **11–8** Arkansas Arts Center Foundation Collection: Purchased with a gift from Virginia Bailey. 1987.024.001; **11–9** Copyright ©2003 by Universal Studios. Courtesy of Universal Studios Publishing Rights, a Division of Universal Studios Licensing, Inc. All Rights Reserved., Courtesy of the Academy of Motion Picture Arts and Sciences; **11–10** Art © Estate of Robert Smithson/Licensed by VAGA, New York; **11–11** Reunion des Musees Nationaux/Art Resource, New York; **11–12** Courtesy of Daniel Quintero; **11–13** Courtesy of David Fox; **11–14** Courtesy of Michael Ananian; **11–15** Collection: Whitney Museum of American Art, New York; purchase 52.25. © 1952 The Charles White Archives; **11–16** Gift of Joseph R. Shapiro, 1959.244, The Art Institute of Chicago, Photography © The Art Institute of Chicago; **11–17** Restricted gift of Margaret Fisher, 1979.123, The Art Institute of Chicago. Photography © The Art Institute of Chicago; **11–18** Art © Estate of Robert Arneson/Licensed by VAGA, New York; Image courtesy of George Adams Gallery, New York; Collection of Kenneth Spitzbard; **11–19** Arkansas Arts Center Foundation Collection: Purchase, Tabriz Fund, 1983.024.002; **11–20** Private Collection, Courtesy of Joshua Neustein; **11–21** Copyright Lucas Samaras. Courtesy of Pace/MacGill Gallery, New York; **11–22** © 2011 The Pollock-Krasner Foundation/Artists Rights Society (ARS), New York; **11–23** Courtesy of Jonathan Borofsky; **11–24** Courtesy of ACA Galleries, New York; **11–25** Courtesy of Charles Stiven; **11–26** Courtesy of the Koplin Gallery Inc., Los Angeles.; **11–27** Collection of Arnold & Marilyn Nelson; **11–28** Worcester Art Museum, Worcester, Massachusetts; Gift of Daniel Catton Rich in memory of Bertha James Rich; **11–29** Solomon R. Guggenheim Museum, New York Estate of Karl Nierendorf, By Purchase 48.1172.547, © 2011 Artists Rights Society (ARS), New York/ ADAGP, Paris; **11–30** © 2011 Artists Rights Society (ARS), New York/ADAGP, Paris; **11–31** Courtesy of Clive King; **11–32** Inter-American Fund. (179.1967)./The Museum of Modern Art/Licensed by Scala-Art Resource, New York; **11–33** Courtesy of Ronald Feldman Fine Arts, New York; **11–34** Courtesy of Jen Pagnini;

11–35 Courtesy of Amy Globus; **11–36** Courtesy of Mark Licari; **11–37** Courtesy of Artist and Metro Pictures; **11–38** Courtesy of Christine Karkow; **11–39** Courtesy of Christopher Arneson

CHAPTER 12

12–1 Courtesy of The Color Wheel Co.; **12–2** Courtesy of the Printworks Gallery, Chicago; **12–3**www.joynerart.com; **12–4** Courtesy of Margaret Lanterman; **12–5** Courtesy of Jim Butler; **12–6** © Arnaldo Roche Rabell. Image courtesy of George Adams Gallery, New York; **12–7** Courtesy of Kravets/Wehby Gallery; **12–8** Courtesy of Ed Shay; **12–9** Courtesy of Casey Crisenberry; **12–10** Courtesy of Kim Cadmus Owens and Holly Johnson Gallery, Dallas; **12–11** Courtesy of the David Nolan Gallery; **12–12** Courtesy of Jan Gregory; **12–13** Courtesy of Robert Lostutter. Collection of Howard and Judith Tullman; **12–14** Courtesy of Richard Hull and Western Exhibitions; **12–15** Courtesy of the Salander O'Reilly Galleries; **12–16** Artwork copyright: Francesco Clemente, Courtesy of Mary Boone Gallery, New York; **12–17** Courtesy of Ed Shay and Charlotte Rollman, Roy Boyd Gallery, 1979; **12–18** © George Atkinson; **12–19** Courtesy of Mary Ann Currier; **12–20** Courtesy of Neal McDannel; **12–21** Courtesy of Bill Cass; **12–22** Courtesy of Tibor de Nagy Gallery, New York; **12–23** Copyright Triple Aught Foundation, 2011; **12–24** Courtesy of Jan Gregory; **12–25** Courtesy of the Printworks Gallery, Chicago; **12–26** Courtesy of Will Mentor and P. P. O. W. Gallery, New York; **12–27** Photo: Wm. H. Bengston, Chicago; **12–28** Courtesy of the Printworks Gallery, Chicago; **12–29** Courtesy of Jamie Kemp

CHAPTER 14

14–1 Courtesy of Daniel Ludwig; **14–2** Courtesy of Edgar Jerins; **14–3** © Craig McPherson, courtesy of Forum Gallery, New York; **14–4** Courtesy of Kim Cadmus Owens and Holly Johnson Gallery, Dallas; **14–5** Courtesy of Probir Gupta and Alexia Goethe Gallery, London; **14–6** Courtesy of Roland Flexner; **14–7** Courtesy of Julie Mehretu and the Carnegie Museum of Art, Pittsburgh; A.W. Mellon Acquisition Endowment Fund (2006.32.74); **14–8** Vik Muniz, "Apollo and Diana, after Lucas Cranach (Pictures of Junk)", 2006. Sikkema Jenkins & Co. Art © Vik Muniz/Licensed by VAGA, New York; **14–9** Courtesy of Michael Dinges and of Packer Shopf Gallery; **14–10** Couresy of Lynn Elizabeth Palewicz; **14–11** © James Barsness. Image courtesy of George Adams Gallery, New York; **14–12** Courtesy of Andrea Rosen Gallery, New York and Sadie Coles HQ, Ltd., London. ARG# AR2000-031; **14–13** © Paul Rego, Courtesy of Marlgorough Fine Art; **14–14** Courtesy of Charles Avery; **14–15** Digital Image © The Museum of Modern Art/Licensed by SCALA/ Art Resource, New York; The Judith Rothschild Foundation Contemporary Drawings Collection Gift. Work courtesy of Victoria Miro Gallery; **14–16** Courtesy of Alice Leora Briggs; **14–17** Courtesy of Fredericks + Freiser, New York; © Nicholas Di Genova; **14–18** © 2006 Sue Coe. Courtesy of Galerie St. Etienne, New York; **14–19** Digital Image © The Museum of Modern Art/Licensed by SCALA/ Art Resource, New York; © Mel Chin, Photo: John Lucas; **14–20** Courtesy of William Kentridge and the Marian Goodman Gallery, New York/Paris; **14–21** © Copyright Wangechi Mutu, Fund for the Twenty-First Century (99.2005) Collection of the Museum of Modern Art, New York./Licensed by SCALA/Art Resource, New York; **14–22** Courtesy of Fredericks + Freiser, New York; © Zak Smith; **14–23** Collection of Nam June Paik. Photograph by David Heald. © The Solomon R. Guggenheim Foundation, New York; **14–24** Video still from Errant Behaviors, 2004, Video and sound installation, Composer: Shawn Decker, Animator: Cat Solen, Post-Production Animator and Mastering: Daniel Torrente, Copyright 2004 Anne Wilson; **14–25** Courtesy of Lilla LoCurto and William Outcault; **14–26** Courtesy of Will Yackulic and the Gregory Lind Gallery, San Francisco; **14–27** Courtesy of Franz Ackermann and Gavin Brown's Enterprise; **14–28** Courtesy of Sandow Birk; **14–29** Courtesy of Ellen Driscoll; **14–30** Digital Image © The Museum of Modern Art/Licensed by SCALA/Art Resource, New York; Courtesy of Galerie Giti Nourbakhsch, Berlin, and the Artist

Index